AMERICAN FOLK MASTERS

FOR BESS LOMAX HAWES AND J. HARPER WHITE

AMERICAN FOLK MASTERS
THE NATIONAL HERITAGE FELLOWS

STEVE SIPORIN

COLOR PHOTOGRAPHY BY MICHEL MONTEAUX

HARRY N. ABRAMS, INC., PUBLISHERS, NEW YORK,
IN ASSOCIATION WITH THE MUSEUM OF INTERNATIONAL FOLK ART, SANTA FE,
A UNIT OF THE MUSEUM OF NEW MEXICO

American Folk Masters accompanies the exhibition *America's Living Folk Traditions,* which originated at the Museum of International Folk Art, a unit of the Museum of New Mexico, Santa Fe. The following museums also participated in the exhibition:

Nevada State Museum and Historical Society, Las Vegas, Nevada
Old Pueblo Museum, Tucson, Arizona
Balch Institute, Philadelphia, Pennsylvania
Sun Cities Art Museum, Sun City, Arizona
Craft and Folk Art Museum, Los Angeles, California
Nora Eccles Harrison Museum of Art, Logan, Utah
Anchorage Museum of History and Art, Anchorage, Alaska
McKissick Museum, University of South Carolina, Columbia, South Carolina
Cedarburg Cultural Center, Cedarburg, Wisconsin

Harry N. Abrams, Inc.:
Editor: *Margaret Donovan*
Assistant Editor: *María Teresa Vicens*
Designer: *Maria Miller*

Museum of International Folk Art:
Charlene Cerny, Joyce Ice, Judith Chiba Smith

Title page: Woman's dance skirt. By Georgeann Robinson, Bartlesville, Okla. Appliqué ribbonwork on wool, 34 x 65", c. 1970

Library of Congress Cataloging-in-Publication Data

Siporin, Steve.
American folk masters: the National Heritage Fellows /
Steve Siporin; color photography by Michel Monteaux.
p. cm.
Includes bibliographical references (p.) and index.
ISBN 0-8109-1917-6.
1. Folk artists—United States—Biography.
2. Ethnic arts—United States—History—20th century.
I. Monteaux, Michel. II. Museum of New Mexico. III. Title.
NX504.S57 1992
745'.092'273—dc20
[B] 91-40510
 CIP

Introduction copyright ©1992 Bess Lomax Hawes
Copyright ©1992 Museum of International Folk Art
Published in 1992 by Harry N. Abrams, Incorporated, New York
A Times Mirror Company

CONTENTS

ACKNOWLEDGMENTS

This book, more than most, rests upon the work of others. Because so many have contributed, my gratitude to each cannot be acknowledged individually. My goal was to be a faithful conduit; to the extent that I have succeeded, you will read and see the combined work of dedicated artists, scholars, photographers, arts administrators, and other public servants. Any failures in accuracy and interpretation are my own.

First, thanks go to the artists whose work is represented and discussed here. There would not be a book without them.

Second, I want to thank, and call attention to, a group of scholar/activists who generally receive little public recognition. They are the state and local public folklorists who nominated and seconded the nominations of the majority of the National Heritage Fellows. Their nominations were supplemented by transcriptions of oral interviews, published and unpublished articles and essays, field photographs and audiotapes, as well as by inspired letters of support. As this book could not have been written without the artists, neither could it have been written without the rich documentation provided by the public folklorists. In many ways, these individuals are the scholarly equivalents of the artists they study and honor: they, too, are largely unheralded, they work locally, and they use intellect, body, and spirit to support and strengthen American folk traditions. These folklorists are experts on American culture at the grass-roots level, and their passionate documentary work has sustained the National Heritage Fellowships.

Their colleagues in academia—the folklorists, ethnomusicologists, and other scholars of culture—also wrote movingly about their nominees, and I have depended on their words and scholarship throughout.

Some of the most telling testimony has been rendered by friends and neighbors of the Fellows, and I have borrowed insights and eloquence from them. The voices of all these nominators are joined together to make my text.

I want to thank Bess Lomax Hawes for the Introduction and to express my gratitude to her and her former staff—Dan Sheehy, Barry Bergey, Pat Sanders, Rose Morgan, and Pat Makell—for sharing what is, after all, their own creation and for trusting me to represent it fairly. They went out of their way to create opportunities for me to learn more about the Fellows and the nomination and selection process. They also read the text and helped keep my vision focused.

Joe Wilson, Richard Kennedy, Meg Glaser, and Pete Reiniger of the National Council for the Traditional Arts guided me through their archive on the National Heritage Fellows ceremonies, and Nick Spitzer and Guha Shankar of the Smithsonian Institution's Office of Folklife Programs helped me to find films, photographs, and recordings of the Fellows in their holdings.

The concept of the book originated with Charlene Cerny, Director of the Museum of International Folk Art—an energetic woman who was not only the source of many good ideas, but who had the commitment to carry them out. She and Judy Chiba Smith, the curator of *America's Living Folk Traditions*, the exhibition which the book accompanies, were my closest colleagues in conceiving and writing the text; they were always supportive yet frank, and therefore comfortable to work with. Judy also organized and wrote the artists' biographies in the Directory of Fellows and coordinated the photography for the book. I thank Michel Monteaux, a photographer whose technical excellence is matched by deep respect for the folk object, and Sam Antupit and Maria Miller, whose design work has brought everything together harmoniously.

A book can portray folk art through photography, but it has no means to convey folk music. Readers are encouraged to seek out and listen to the recordings of the National Heritage performers; Craig Miller and Kip Lornell's discographic references in the Directory provide a good starting point.

Barre Toelken first introduced me to folklore, and now his Preface will introduce you to the National Heritage Fellows. I thank him for sharing his intellectual and spiritual understanding of folk culture, for his critical reading of my text, and for his encouragement.

George Holt also read and commented on my manuscript. His suggestions came at a critical moment, and he helped me think more deeply about the assumptions and goals of efforts of this kind. Barry Ancelet, Glenn Hinson, Nick Spitzer, John Vlach, Frank Werner, and Hank Willet reviewed my remarks on individual artists and particular traditions that they know firsthand.

I thank three editors. The first is my wife, Ona, who sometimes seems to be a magician. She knows how to guide my worst writing into my best, and

she is wise not only about language but about tradition and art as well. The second is María Teresa Vicens, who skillfully edited the Directory of Fellows and assisted Margaret Donovan in various tasks during the preparation of the book. Margaret herself, Senior Editor at Abrams, made the hardest part of the writing into the most satisfying. Her excellence with words is matched by her human warmth.

Finally, my thanks go to Carolyn Fullmer, Marci Hatfield, and Shelley Keller; without their computer knowledge and patience, I would still be typing.

Steve Siporin

On behalf of the Museum of International Folk Art, I would like to express my deep appreciation to Bess Lomax Hawes, Director, Folk Arts Program of the National Endowment for the Arts (1977–92), and staff members Dan Sheehy and Barry Bergey for all their support and assistance with this publication and the exhibition *America's Living Folk Traditions*. I am grateful to the Museum of New Mexico Foundation and the L. J. Skaggs and M. C. Skaggs Foundation for their assistance in the funding of this publication and to Jillian Steiner Sandrock, the Skaggs Foundation's former Program Officer, for her continuing guidance and friendship. I also thank the International Folk Art Foundation and the Museum of New Mexico Foundation for their generous collections and exhibition support.

One of the most gratifying aspects of this project has been the opportunity to work with Steve Siporin. He proved to be an amiable, enthusiastic, and dedicated colleague. I wish to take this opportunity to thank my associates at the Museum of New Mexico, especially Judy Chiba Smith, the project coordinator, who developed the Museum's collection of work by the National Heritage Fellows and curated the exhibition; Joyce Ice, for her knowledge of folklore and her editing skills; Stephen Becker, for ideas that helped shape this book; Dana Everts Boehm, for lending her expertise and guidance on folklore and folk artists; Blair Clark, for his photographic skills; and Judy Lokenvitz, for her assistance with the filmography. The gathering of the numerous photographs for this book and the related exhibition was made possible through the efforts of Jeff Place, Archivist, Office of Folklife Programs; the National Council for the Traditional Arts; and Marjorie Hunt, Meg Glaser, Robert Garfinkle, and the many photographers who gave so generously of their time and work. Finally, I wish to acknowledge the contributions of all the scholars and researchers who unselfishly shared their knowledge with the Museum for both this publication and the traveling exhibition *America's Living Folk Traditions*.

Charlene Cerny, Director
Museum of International Folk Art

PREFACE

In 1973, a major charitable foundation called off its national program
of large cash awards for excellence in teaching for a very persuasive reason:
in the ten-year history of the program, which had been designed to call atten-
tion to fine university-level teaching, it had received only one brief notice in
the media, a single line in *Time* magazine. Since the foundation had not
succeeded in bringing university teaching into the public arena as a notable
issue, the board members decided they could better spend their money
nurturing education in other ways.

Fortunately for us all, the Folk Arts Program of the National Endowment
for the Arts has enjoyed a more successful history. It has made a major
impact on the public's understanding of what art is and has enriched the
lives of many Americans by engaging in a simple and relatively inexpensive
effort—making us aware of the power, depth, and richness in the vernacular
arts of the United States. The Program's modest grants go primarily to
nurturing the folk artists in their own communities, so that they can continue
to create meaningful expressions of living cultural value.

At about the same time that the educational award was suspended for
apparent lack of public interest, Nancy Hanks, then chairman of the National
Endowment for the Arts, asked folklorist Alan Jabbour if he could find any
support for a program that would maintain and encourage those kinds of art
which seemed to fall outside the formal categories of fine art, ballet, music,
and the like. Jabbour in turn invited me to become part of a group of
folklorists who would help him test the waters by spending small amounts
of NEA grant money on projects in the folk arts. Since many in the arts
community already used the term "folk art" to designate the work of naive or

untrained artists, some people in the Endowment expected us to fund the makers of weathervanes, carousel horses, and rural paintings. Others, who thought of the "folk" as relatively unsophisticated in art, expressed puzzlement that we were even bothering with such marginal materials.

Whatever the NEA expected, we knew we had access to a far richer resource than anyone in the agency had imagined: an entire multicultural nation full of people who created art every day in response to the demands and aesthetics of their own communities and according to their own exercise of talent. We knew of quilters, potters, and whittlers, of pipers, fiddlers, love flutists, and guitar pickers, of step dancers and tap dancers, of Latino muralists, Native American hideworkers and beadworkers, and nisei dancers. In short, we knew that the country was not lacking in artists who got their training from each other and who in so doing received an artistic education far different from anything they could have encountered in an art school. Their personal talents and their community values were elements of an enduring kind of art that had not received much attention, and we wanted to see if other Americans agreed with us about its importance. The subsequent successes of the Folk Arts Program indicate the warmth with which Americans responded to these attempts to encourage and nurture the traditional folk arts.

Later, when Bess Lomax Hawes took over the direction of the Folk Arts Program and invited me to stay on as a panel member, I was delighted. By that time I had realized that I had done nothing so exciting and meaningful in my professional career as a folklorist as actually to have had a hand in demonstrating the importance and richness of the vernacular arts to people who had never considered them before. When I became chair of the panel, I inherited the challenging opportunity of presenting our proposed funding decisions to the National Council on the Arts. This group made the next-to-last decisions (before final action by the NEA chair) on the expenditure of federal monies on art, and they took their job seriously. Providing them with rationales for why the nation should support, as art, endeavors like Native American basketmaking, African-American tap dancing, Hispanic rawhide braiding, Southeast Asian pipe playing, blacksmithing, and quilting turned out to be a delicate and demanding enterprise. But they listened and were supportive.

The results were extremely rewarding. We were able, for instance, to provide the small New Mexico village of Chimayo with lapel microphones and a loudspeaker system so that its centuries-old traditional play, *Los Moros y los Cristianos*, could still be performed, on horseback, to increasingly large audiences. (When the horses needed to be shod, however, we were able to help out only by listing the farrier's supplies as "art materials.") When a number of Folk Arts Program panelists visited a restaurant in the Chimayo

area for a meeting, the word got around, and by the time we left, the foyer was filled with the members of the men's society that sponsors and enacts the play. One of them, an elderly man, stepped forward and said, "We only want to thank you for helping us keep our culture. I've lived here since before the income tax came to be, and this is the first time any of our money ever came back to help us."

In another instance, the Cook Inlet Native Association of Anchorage, Alaska, applied to the Folk Arts Program for funds to have Paul Tiulana, a King Island Eskimo who later became a National Heritage Fellow, make an *umiak*, a distinctive Eskimo boat constructed of wooden ribs with a walrus-hide cover. Presenting this project to the National Council was not easy, for its members had been guided by the idea that folk art functioned primarily within definable communities, and here was an urban community well outside Eskimo country asking for money to produce a boat that was far from its normal cultural and geographical context. In actuality, Tiulana had been asked to produce this piece of practical ethnic art for the Eskimos who live in Anchorage, many of whom reside in homes for the elderly and miss their home cultures deeply. Taking them on occasional outings or picnics in an *umiak* would be one way of employing their indigenous arts to ameliorate the trying circumstances of their lives.

Even so, at the funding meeting one puzzled Council member quizzed me: "How can this be art? For one thing, don't you know that walrus hides *stink*? Where will this 'art object' be on display for art lovers? Are we being asked to provide transportation for old folks instead of encouraging art? Let's reexamine this proposal!" And so we did. In the ensuing discussion, we were able to describe the year-long search for the keel and wooden ribs (most of which are "found" pieces of weathered wood); the hunting of the walrus, with all its attendant customs and problems; the careful splitting of the walrus hide (a demanding task done by women using the Eskimo *ulu*, a curved knife, in which the entire hide, slippery and heavy as it is, is split so that it doubles in size, without sustaining any punctures). We discussed the stunning engineering of the boat, which is made in such a way that the stresses and tensions are shared by twelve to fourteen points along the hull—more complex a support system than that in jet-aircraft wings. And then we talked about the more recognizable "artistic" aspects of the *umiak*: its clean, graceful, flowing lines and its symbolic dimension (the hunter, or the picnicker, rides inside the skin of the animal he then goes out to hunt, or snack on, anticipating that the meat of the animal will soon be inside *him*).

The proposal passed, and in spite of the difficulty in matching hunting, skinning, and construction realities with regular grant-report deadlines (the project took two years to complete), Paul Tiulana made the *umiak*. It now stands displayed on a framework outside the Anchorage Museum of History

and Art, when it is not being used by elderly Eskimos to go on picnics. It is this kind of rich interaction between art and everyday life that has been at the heart of the Folk Arts Program's aims ever since its inception.

When Bess Lomax Hawes urged, in the late 1970s, the development of special National Heritage Fellowships to highlight particular, outstanding exponents of the folk arts, she added a more visible dimension to the Folk Arts Program. Probably not many American taxpayers will attend the *Moros y Cristianos* play in Chimayo, New Mexico; what is important is that the people there have the encouragement to go on maintaining an artistic expression of great antiquity and deep cultural meaning. But through the Heritage Fellows program, the nation can get an occasional closer look at those people who have been responsible for keeping the arts alive in families and communities across the land. We seldom hear about these folks, because they perform principally for their own communities, yet they undergird the nation's sense of art, and in this they are as important as any other artists, no matter how famous. The Heritage program allows for a few of these people to experience increased attention and an enhancement of national prestige; however, we need to keep in mind that our communities are full of others like them who may never get recognized publicly for their artistic efforts. In this sense, the National Heritage Fellowships are symbolic, for they are really meant to suggest how many accomplished folk artists, not how few, live and practice among us. This is a theme that comes out time after time in statements by the Fellows themselves.

Steve Siporin's task in this catalogue has been to provide a record of the significance the Fellows have had for the arts and to capture as much of their vitality and creativity as is possible in a printed account. Siporin, a nominator for some of the Fellows and an active public-sector folklorist, has previously directed folk arts programs in Oregon and Idaho. As curator of the traveling exhibition *"We Came to Where We Were Supposed to Be": Folk Art of Idaho*, he has become intimately acquainted with many of the artists and with the fieldworkers who have "found" and encouraged them. In the courses he teaches in folk art and public-sector folklore, Siporin is training new folklorists who see it as their professional obligation (and personal pleasure) to nurture folk art and artists as well as to study them. For these reasons, and for his own deep commitment to folk art, Siporin is a particularly appropriate person to have been chosen for this task. His professional conviction and enthusiasm have given us a compelling account here of the artists in our midst.

But to augment this catalogue with live exemplars, the reader should attend one of the awards presentations. There, one sees not only the artists and some examples of the art, but also hears the modest, moving statements of people who have given their lives to a community-based aesthetic without ever a thought of becoming recognized for it. Almost without exception, they

give credit to their communities, their families, and their friends, who taught them the arts, and unanimously discount themselves as anything special. In this, they are both right and wrong; although not "special" in the usual sense of having developed an *avant-garde* genre or following a particular personal vision, they are certainly special in other ways. Their comments in this catalogue and on the stage at the awards presentation are proof of that.

When I attended the 1989 National Heritage Fellowships ceremony on the George Washington University campus, I was unprepared for the rush of emotion I (and others around me) felt as Charles Kuralt warmly presented the folk artists to a packed house that included members of Congress, media people, folklorists and academics, prominent representatives of the arts community, and members of the Washington public. The enthusiastic acclamation of these dedicated artists was deeply moving, both for them and for the audience; everyday people from all walks of life and from all ethnic groups were publicly thanked and cheered for their contribution to the living fabric of our culture.

As I left the ceremony, I recalled what an elderly Coos basketmaker had once answered years ago when asked why she hummed a tune as she softened materials for her baskets in her mouth: "Why, after all, a basket is a song made visible, you know." In a wider sense, these Heritage Fellows are the ones who are singing our culture, creating tangible or intangible articulations of the shared, deep wellsprings of art that identify us as human. In this exhibition and its catalogue, Bess Lomax Hawes, the Folk Arts Program of the National Endowment for the Arts, the Museum of International Folk Art, and Steve Siporin have joined forces to make it possible for us to listen more fully for the music.

Barre Toelken
Utah State University

13

INTRODUCTION

The National Heritage Fellowship Program has been in formal existence since 1982, but its planning began a good five years before that. Perhaps it would be helpful to some cultural strategists of the future to outline here a few of the considerations that went into the eventual realization of this deceptively simple idea: to provide federal recognition to some of the nation's most outstanding folk artists. It sounds pretty easy, put that way, but it all took a remarkable amount of doing, and only a sketchy outline of the history of this program will follow. I apologize in advance for the many names that must be omitted in deference to considerations of time and space.[1]

It was during my very first conversation with Nancy Hanks, then Chairman of the National Endowment for the Arts, where I started working in 1977, that the topic of the Japanese Living National Treasures program came up. She thought the Arts Endowment ought to try such an idea out in the United States; at the time, I was not so sure. But later I did look into how the system worked in Japan and I was deeply impressed, even deeply moved, by what I found.

One immediately noteworthy fact was that the Japanese program had grown out of a long-standing and extremely serious effort on the part of the Japanese people to protect their cultural heritage. As early as 1950, centuries-old local regulations of various types had been consolidated into a remarkable piece of legislation defining Important Intangible Cultural Properties as "intangible cultural products materialized through such human behaviours as drama, music, dance, and applied arts which have a high historical or artistic value." At first only those Intangible Cultural Properties that were in possible danger of loss were placed under protection; later the

rule was relaxed and a registration system was set in place to include those of especially high historical or artistic value as well as those that have "conspicuous local characteristics." As of 1983, fifty-nine kinds of crafts alone had been registered as Important Intangible Cultural Properties by the Japanese government, along with seventy persons and eleven groups, who are defined as Holders of the Properties.

Holders receive a Living National Treasure Award, a recognition that is not to be taken lightly. An annual stipend goes with it, as do ongoing responsibilities to represent, further, and advance the highest standards of the particular art through demonstrations, teaching, and continued practice. According to their various temperaments and inclinations, Holders may also be invited to testify on matters concerning the arts, to host visiting delegations, to judge contests or settle controversies, to concern themselves in every way with the needs of the art form and its practitioners. At the same time, the Japanese government both purchases the works of the Holders and keeps records, through film and other documentary means, of the techniques and methods used to produce them. It also supports annual exhibitions of the Holders' work, maintains a registry of private and public owners of important pieces of traditional art, and provides a grants program for groups that wish to learn, practice, or simply study the art forms.

This highly thoughtful, multifaceted system arose in Japan after the three-hundred-year period of national isolation came to an end in the mid-nineteenth century. The opening of the nation's doors to immigration at that time stimulated a headlong plunge into Western-influenced modernization, in its turn raising fears that the older, peculiarly Japanese, art forms that had become so exquisitely refined during isolation might be shoved aside, allowed (or encouraged) to degenerate, or be forgotten. Clearly this was a matter of national, not simply governmental, concern, for the response of the Japanese people to these fears was to devise a truly remarkable structure of cultural statesmanship. The Important Intangible Cultural Properties idea has had powerful and important effects domestically and has set high standards for the rest of the world.

However, when I tried to imagine how an equivalent system might function in the United States, I came up against two apparently insuperable obstacles. The first was the simple issue of time depth: it takes time for a culture to make significant changes. The current system in Japan has been in place for forty years, and before that, almost a century of worried attempts, improvised pieces of local legislation and institutional rulings, and manifestoes by no longer existent councils and artists' organizations had delved into the problem from every possible point of view. Thus, the tradition of considering indigenous Japanese art forms to be of genuine *national* importance had been in place for at least a century and a half, not even mentioning the three

centuries of isolation before that! We cannot explore here the history of official and unofficial attitudes toward either indigenous or imported art in the United States, but at the very least we can say with assurance that we haven't had much practice in thinking about a national approach to either kind of traditional art. Such a lack of widespread popular concern also made the introduction of a brand-new system of recognizing our traditional art forms extremely chancy, to say the least.

A second problem stemmed from the vast differences between the histories of the two nations. During the last of the period of Japanese isolationism, the United States was taking the opposite course: encouraging immigration and welcoming the arrival of ever larger populations (at least from certain sections of the world) so as to increase the available work force. Some people here worried that such large numbers of newly arrived immigrant peoples, complete with their own cultural pasts and presents, might dilute or even radically alter the national character. There was, however, almost immediate acceptance of the comforting hypothesis that there existed a national "melting pot"—an enormous and all-encompassing crucible into which all contending artistic and cultural traditions would contentedly dissolve to emerge as true-blue American (though retaining their Old World color and charm). The slow but steady abandonment of local and ethnic traditions taking place in the early twentieth century could then be cited as proof of the efficacy of "the American way." We did indeed have a system in place, but it was one that was not especially interested in those art forms "with conspicuous local characteristics"—in other words, folk arts.

Even considering the formidable problems just mentioned, the Important Intangible Cultural Properties idea continued to exert a fundamental appeal. Most people just loved the whole concept, and it refused to die. So in the late seventies we began, as time permitted, to bring up the topic of individual awards and honorifics for American folk artists at our regular advisory-panel meetings. The panel system is key to the operation of the National Endowment for the Arts; it consists of rotating groups of experts, chosen by the Endowment, who assemble periodically and, under circumstances of great tension—extreme time pressure combined with low budget figures— face the very likely insoluble problems of the particular art form they represent, recommending policies and grant monies alike. It's an improbable system that works improbably well.

As I had rather expected, all the panels consulted were intrigued by the general concept of some kind of living national treasures program, but they had a number of new and interesting objections to raise. Folk arts, they pointed out, are above all the cultural possessions of groups, whether those groups affiliate themselves by virtue of sharing a religion, occupation, ethnicity, geographical area, language, or any other common factor. In the

United States, with its long history of religious freedom, open immigration, and industrial expansionism, there are enormous numbers of observable folk groups, all of which have, to a greater or lesser extent, developed active artistic traditions. How could one even begin to ascertain the numbers of groups that should be considered in such a program? In addition, since the traditional art forms have generally been developed by vast numbers of people over time within each group, who was going to say which individual practitioner should be the particular one honored? And if we could achieve consensus as to which tradition to honor and which artist was preeminent in it, would not this public recognition have a dampening effect on the artists *not* selected and thereby on the art form itself? Would it not create jealousies, or stimulate unhealthy competition? In other words, might not the attempt to further an art form by this means have a discouraging or distorting effect— exactly the opposite of what was intended?

Oh dear. We debated it this way and we debated it that. We considered the effect of such an award on an individual artist in a remote New Mexico Hispanic village as well as on Serbian-American contemporary urban steel workers/musicians. We came to no conclusion and put the idea to rest, only to have it rise up again the next year before a new panel, and before another panel in another year after that. I believe I am accurate in stating that in all these many discussions nobody ever exactly wanted to do it, but everybody thought it ought to be tried. So, at long last, in 1980, a recommendation was made that the National Endowment for the Arts should set up a program to recognize each year an indefinite number of individual traditional artists, who would be selected from nominees proposed by the general public. The award, it was recommended, would consist of a certificate of honor and a check for $5,000 (a sum that was agreed to as being simultaneously impressive but not so great as to encourage any recipient to change a lifetime's living pattern).

This recommendation went before the National Council on the Arts, an advisory body of artists and arts experts appointed by the President of the United States to counsel with the Chairman of the Endowment on matters of substance in the world of the arts and to make recommendations on all applications for his or her consideration. And there, to our considerable surprise, a whole new series of objections arose.

The legislation that set up the National Endowment for the Arts had been especially cunningly crafted to allay any conceivable possibility that partisan politics might affect the development of the nation's cultural future. The Arts Endowment was not supposed to select official artists or fund official structures; it was not to do anything that could conceivably smack of "official art." It was designed to help all kinds of art grow, develop, and flourish and to ensure that that art would succeed or fail not according to official federal standards but ultimately according to the response of its multiple audiences.

The National Heritage program (as we had come to call it) came uncomfortably close, in many Council members' opinion, to a kind of official governmental sanction, a kind of federal seal of approval. In fact it came close to being an "award," a federal privilege that is very properly allowed to only a few parts of the federal government, the Office of the President being one. In point of fact, the agency was simply not legally authorized to give honorary awards, and that was that.

I have to say the entire Folk Arts Program was stunned. It had taken a long time to get this far, and we argued with vigor for our point of view but gradually began to find ourselves reluctantly agreeing with the Council's reservations. From an administrative standpoint, their concerns formed an interesting mirror for the panel's; in a way, each represented a side of the same problem. We would have to work on the original plan itself.

We began to shift it slightly. The first change sounds like a bureaucratic double-shuffle but, like the best administrative ploys, had a far greater significance. We decided that the $5,000 checks could be called "Fellowships," thereby no longer appearing to be lifetime achievement awards but simple contributions toward the artistic future of the particular recipient. This not only made the grants legally possible but moved the program back toward the idea of the "living treasures," which we had begun to lose sight of.

We also decided to try for a relatively large number of artists each year rather than only one or two; the program would thus be changed from an honorific to an ongoing, workaday endeavor in which we could continue to demonstrate the wide-ranging variability of the traditional arts in our nation. In the years to come, the focus of the program also changed from internal to external: it became obvious that the Heritage program was of major educational value, that it was a great instrument for informing the American people as to their own cultural history. And there was certainly no dearth of suitable artists; one year, indeed, the nominating panel recommended seventeen, a number that turned out to be self-defeating since no one could remember all the artists selected!

Then there was another slight shift of emphasis. (It is fascinating from the point of view of understanding cultural strategies how frequently simple shifts of weight turned out to be more significant than brand-new ideas.) We began talking about honoring the art form, or its regional variation, rather more specifically than the artist. We had always talked as much about the multitudinous traditional arts as about individual artists (the Japanese had also distinguished between Cultural Properties and their Holders), and we found that the artists themselves not only appreciated but seconded this shift of emphasis. Part of it was sheer modesty; they would say things like, "You think I do this pretty well, but you ought to have seen the old fellow I learned

from. If he was still around, you wouldn't even look at me." But part of it also seemed to place them in their appropriate positions in the long line of master-to-learner that is so essential a part of traditional artistic production. Most of them felt better that way, seeing themselves as part of the human chain, passing their art along, supported on both sides, not showing off so much, not so individually conspicuous.

The first National Heritage Fellowships were given out in 1982 at a gala ceremony that took place in the Departmental Auditorium on Constitution Avenue in joint sponsorship with the Office of Folklife Programs at the Smithsonian Institution. In subsequent years, the Arts Endowment took over the program entirely and moved the event first to Ford's Theatre and then to the Lisner Auditorium at George Washington University. The formal events were and still are put on through the able management of the National Council for the Traditional Arts. We added a Congressional reception on Capitol Hill to the celebration, and it keeps on making my heart turn over to see, every year, these representatives of the finest of America's traditions standing together under the flags and red velvet portieres and gilded ceilings of the Congressional hearing rooms. It's *Mr. Smith Goes to Washington* brought to a new reality every September, and there is nothing corny about it. Each year's group is indeed as remarkable as the last.

Today, after more than ten years, we've learned a lot of things—some on the down side and some on the up. We've learned not to worry too much about local jealousies being aroused by the Fellowships. There may have been hard feelings in a few cases, but nothing that we've heard of so far has caused real concern. Most traditional artists I have known seem to rejoice when they hear of another's good fortune; maybe tomorrow it will be theirs. And maybe it will. One of the nice things about the National Heritage Fellowships is that they are structured so as to include any number of significant artists in a single field. There is no reason, for example, why a different fiddler cannot be named every year; there are certainly an infinity of superlative fiddlers spread about over the American landscape.

Some things have turned out unexpectedly. We had initially believed that if the first group of Fellowship holders presented a cross section of the American cultural surround, then in future years an imbalance would not be noticeable—that we could recognize ten quilters from the Midwest, for example, and no one would care. We had not realized how visible the entire program would be, how deeply people would come to care that their particular tradition, their part of the nation, their ethnicity, their sex, their religion, language, or occupation, be included. We also learned that the first representation of any group in the Heritage program has a special significance. Many Hawaiians told us, for example, that their classic hula tradition should be recognized first, since it has a particularly deep meaning

for Hawaiians, and that afterward it would be fine to honor such imported traditions as quilting, but the hula must come first. And so it did; one of the most senior traditional *kumu hulas* (hula masters) was nominated, and Mrs. Emily Kau'i Zuttermeister received a National Heritage Fellowship in 1984.

We also learned to consider each year some qualities we had not thought necessary to represent at first. One, ironically, has to do with success. The emotional impact of the entire Fellowship presentation is so great that we discovered many people had developed the sentimental notion that every traditional artist had been discovered languishing in an obscure corner somewhere, neglected and despised, until the great Folk Arts Program had come along. Each year, therefore, the panel tries to recommend one or more traditional artists who have done very well indeed in the mainstream of the arts—a world-famous bluegrass singer like Bill Monroe, for example, or a decoy carver like Lem Ward, whose sculpted birds bring thousands of dollars apiece from fanciers across the nation. The panel also likes to include an example of an artist whose work is outstanding but who has not yet reached a venerable age, someone, perhaps, like the extraordinary Irish step dancer Michael Flatley.

We continue to tinker with the system; we may—or possibly may not— have a long way to go. Mostly we try to keep as flexible as the American artistic scene is. Nominations are now made for the lifetime of the artist. Once nominated, the work of every artist is examined regularly by the advisory panel. This is partly to conserve work but mostly because each year there are many more worthy nominees than we can recognize and because future panels may properly wish to alter both the guidelines and the criteria for their selection.

We have come to the conclusion that there are some things this particular system cannot do. For example, we cannot legally give a postmortem recognition, even to the most eminent artist; every year we sadly find that a few nominated artists have passed on before we could honor them. It is awfully difficult also, under our current procedures, to give an award to a group; the system is designed for individual recognition, and our various attempts to utilize it for the support of the numerous artistic groups that are central to many traditions have resulted in an inordinate number of bureaucratic/ administrative problems. Perhaps some visitor to this exhibition, some reader of this catalogue, will be inspired to invent a new strategic concept to address the difficult problem of how an individualistic culture can appropriately interconnect with more group-centered peoples.

For the National Heritage Fellowships are indeed still evolving. They did not spring intact and complete from anyone's brow; they were tentatively and even dubiously set into motion, and their development has been uncertain and full of surprises. This essay and this book, then, simply present various

current reports on the action, on things as they might appear from several perspectives at this particular time. No doubt, other books will be written on this subject from different viewpoints, stressing different features; other commentaries upon the program will appear. I hope so. We are not yet ready for a final word or an official summary, for the people are still bringing forth remarkable artists and art forms of depth and brilliance. And we are not yet ready, I believe, to comprehend fully just what has been going on here.

For clearly something unusual has been happening. In an earlier piece of writing on the subject, I said: "Of all the activities assisted by the Folk Arts Program, these fellowships are among the most appreciated and applauded, perhaps because they present to Americans a vision of themselves and of their country, a vision somewhat idealized but profoundly longed for and so, in significant ways, profoundly true. It is a vision of a confident and open-hearted nation, where differences can be seen as exciting instead of fear-laden, where men of good will, across all manner of racial, linguistic, and historical barriers, can find common ground in understanding solid craftsmanship, virtuoso techniques, and deeply felt expressions."[2]

This may well be why so many Americans have responded with such deep joy to this small program: it represents that side of our national tradition in which all Americans can take pride. And that is not a small contribution.

Bess Lomax Hawes
Director, Folk Arts Program
National Endowment for the Arts
1977–92

THE EDGE OF THE MESA

"Anything that could be thought about, he made it."

On a December day in 1888, two cowboys, Richard Wetherill and
Charlie Mason, were searching for stray cattle in a juniper and pinyon forest
on a high mesa in southwestern Colorado. As their search led them to the
edge of the mesa, Wetherill and Mason made a monumental discovery.
Across the canyon, through momentary breaks in the blowing snow, they
caught glimpses of "a magnificent city." Perhaps thinking they were snow-
blind or bewitched, they crossed the canyon to see if the city was real or a
mirage. What they found was the Cliff Palace of Mesa Verde.[1]

Since the early 1900s, Mesa Verde has attracted millions of visitors. Few
realize it is our first national park devoted to culture, the work of humanity,
rather than the wonders of nature. It was also the first place ever designated
a World Heritage Site—meaning an international body of cultural conserva-
tionists recognized it as being of primary importance to all humanity.

The discovery of Mesa Verde is a fact, but I would like to claim it as a
metaphor as well. Working cowboys, not archeologists, made the greatest
discovery in American archeology.[2] Yet we rarely attribute the qualities
associated with discovery—innovation, imagination, creativity—to traditional
people like cowboys. As Wetherill and Mason discovered the Cliff Palace in
the course of their ordinary work, so do folk artists discover beauty and
meaning in the events and materials of their daily lives. From common
objects like scraps of old clothing and pieces of wood, they sew quilts and
carve puzzles; from everyday experience, they shape tales; and from timeless
customs, they recover meaning. We speak of such artists as being tradition-

bound, perhaps missing what tradition frees them to discover. When such art is seen as unreflective, automatic, or uncreative, its reality is distorted, and we fail to recognize that even the "maintenance" of tradition requires constant innovation. Unfortunately, American folk art and performance are still generally portrayed as old, quaint, picturesque, repetitive, and out of touch. And as such, they are relegated to civilization's shadows, to a minor, peripheral status. But, in fact, folk expression is at the very core of civilization: that is one of the main points of the National Heritage Fellowships and of this book.

I fix upon two cowboys' visions through the snow, at the waning of the old year's light and at the mesa's edge of the known world, because traditional artists—like cowboys Duff Severe (a saddlemaker from Pendleton, Oregon), Luis Ortega (a rawhide braider from Paradise, California), and "Brownie" Ford (a singer and storyteller from Herbert, Louisiana)—*do* take us to places we've never been and show us things we've never seen, through their extraordinary everyday art. Just as our world and our conception of human endeavor would be impoverished without Mesa Verde, so our knowledge of art and performance, and their roles in our own lives, remain artificially narrow and unsatisfying without an awareness of the profound contributions of traditional folk art. Because the National Heritage Fellows are the recognized masters of tradition in the United States, they offer us the best opportunity for creating an appreciation and awareness of the significance of traditional art and performance.

Each year since 1982, the National Endowment for the Arts has recognized outstanding traditional American folk artists through a special ceremony and concert in Washington, D.C., and through the awarding of $5,000 cash fellowships. The program, as Bess Lomax Hawes mentions in the Introduction, was inspired by Japan's Living National Treasures, a concept that acknowledges that nation's masters of traditional crafts. Ten years into the program, the NEA has named nearly 150 National Heritage Fellows in all areas of traditional art, in all parts of the country, and among a wide variety of ethnic, religious, linguistic, and occupational groups. The Fellows are selected not only because of their outstanding achievements as individual artists, but also because they represent entire traditions. In honoring them, whole traditions are acknowledged and brought to the public's attention.

What is the process that has led to their identification and to the honor given them? The National Heritage Fellows are selected through a free, open, and thoughtful process. Any American can nominate any other American. Nominations consist of an essay or cover letter describing the artist's career and life, the traditionality of his or her art, its community basis, and other related aspects such as artistic quality and significance. Such

nominations are accompanied by sample documentation of the artist's performance (audio or video tape recordings) or material art (slides or photos). Letters of support—often from scholars knowledgeable about the particular tradition—are usually solicited by the nominator. A national panel of experts reviews the nominations and makes its recommendations to the presidentially appointed National Council on the Arts. The National Council in turn passes its own recommendations on to the chairman of the National Endowment for the Arts, who makes the final decision.

This process involves a great deal of effort and sensitivity, but its success ultimately depends on the nominations received. Neither the National Endowment for the Arts nor the national panel of experts it utilizes can select a National Heritage Fellow without a nomination from the country at large. Nominations themselves take effort. The nominator must ask certain significant questions. Would an interview with the artist (and accompanying transcription) convey the needed information most effectively? What is the best way to photograph or videotape his or her work? Is this art form really traditional? Is research needed to demonstrate its traditionality? Are there others in the community who can tell me more? Are there others I can ask to write letters of support for the nomination? There is no reward or recognition for the nominators beyond the satisfaction of knowing that a deserving person has been recognized and honored and that the tradition has been strengthened. For many nominators, that has been ample compensation.

Reflecting traditional cultures in America, the Fellows transform the abstract idea of cultural diversity into a concrete reality; they are an exceedingly diverse group. Global in their origins—from Native Americans to European immigrants, from the descendants of kidnapped Africans to recently arrived Southeast Asians—they have all become rooted here. Among their numbers are two ex-boxers (recognized for their skill as dancers), a nun, a creator of an internationally popular musical tradition and singers of ancient songs, those who make objects they will only give away and those who sell their works for thousands of dollars. There are big egos as well as the seemingly egoless. Some are gentle, some scarred.

To discover what ties the Fellows together is one of the aims of this book. To do so, I have organized my material by concepts rather than by more conventional categories such as artistic medium, skill, region, or ethnicity. By this approach, the artists and their work can be discussed in terms of their relationships to tradition. Thus, Chapter Two, "Inheritors," focuses on those born to a tradition who carry it forward relatively unchanged; Chapter Three, "Innovators," presents those who preserve a tradition through major changes; and Chapter Four, "Conservers," deals with those who learn and revive a dying tradition, often becoming its advocates.

The categories overlap, and almost all the artists participate in each to some extent. Thus, some artists will appear in more than one chapter. The first category, "inheritors," is the largest and characterizes most of the artists for at least the first part of their lives. Some traditions seem to be concentrated in one of the three categories: musicians, for instance, seem to be innovators, and African-American musical traditions seem to be particularly inventive. Native Americans are most strongly represented in the "conserver" category.

Even though these categories are not neat and definitive, for most of the artists one of the three experiences will dominate. My purpose is not to categorize the artists—they obviously defy conventional categories—but to weave a narrative that is more than a list of short biographies. In doing so, I have not been able to write about every National Heritage Fellow. That has been painful and difficult for me, because the creative life of each is a fascinating story, and every one is worthy of retelling. (Basic information about each Fellow not discussed in the text is available in the Directory, which follows the Notes.) The real purpose of this book, in any case, is not to present biographical portraits; it is rather to communicate the power of America's aesthetic folk traditions through a picture of master traditional artists and performers.

The categories are useful, then, because they describe three ways in which tradition remains viable in the lives of individuals and communities and at the same time makes their lives meaningful. Tradition shapes and takes shape in different ways. We may mistakenly assume it is the possession solely of the first category, the inheritors, but living traditions are not unchanging. Taken together, these three categories may provide the basis for a more complex (but, one hopes, jargon-free) perspective on "tradition" as dynamic rather than static, as process more than product—as something quite different from the freezing of a particular moment from the past.

These master folk artists, taken as a group, remind us how rich our cultural diversity is and how great art can grow from everyday experience. We often hear rhetoric about the value of pluralism, but here—in vernacular art—is the treasure itself. The ethnic and regional diversity of these folk traditions provides a strong antidote to the misleading vision of a homogeneous America we see presented every day in the mass media. The Fellows project a powerful artistic and spiritual image of American cultures that delights Americans.

That image is not always one of harmony, nor are the Fellows a gathering of saints; great folk art, like great fine art, grows out of trouble and grief as well as joy. Contrary to stereotyping, these artists are not just simple people who don't know any better than to be good and virtuous, nor do they all live

in poor but wholesome backwater towns. Many come from areas of America plagued with crime, unemployment, high infant mortality, drug and alcohol abuse, and other problems. The diverse beauty they have created is not divorced from the troubled communities where fate has placed them.

The members of this select group share critical characteristics at a level far below the surface. Chief among these is the profound choice they have all made: they all chose tradition. Seduced by metaphors, we may think tradition somehow continues under its own steam, mechanical and inevitable, with a momentum of its own. In reality, tradition is completely human—like mercy, it bears a human face—and it exists solely through the agency of human action. Only because individuals decide to learn, practice, and perfect the skills they witness in their families and communities do traditions continue. They are not "inevitable," nor are their practitioners "unthinking" or "naive."

Coming to Washington, D.C., to receive the National Heritage Fellowships reinforces the artists' sense of obligation to their teachers and to tradition. Every year at the Fellowship ceremonies, several of them express the same sentiment: that once there was someone else who knew the tradition better, and that that person was the one who should have gotten the award. National Heritage Fellow Duff Severe said it clearly in 1982, at the first ceremony: "The old fellows I learned saddlemaking from, . . . they were real craftsmen. There were about eight of them in the shop where I worked, and every one of them had white hair, had been working saddles most of their life. . . . And I feel like they're the men that should be getting this award instead of myself, because they were really masters."[3]

Bess Hawes has sometimes responded with a story of her own. She remembers that as a small child she believed

that somewhere there was a castle and that if you could find the castle and you found the right door, you would go in and there would be a staircase. And if you found the right staircase and went all the way up to the end, and you found the right door to open, at the end you would come into a room where there were all the books in the world and a little old man sitting there. And if you asked him anything you wanted, he would know the answer. And I used to think that if I could just find that castle and find that room and find that staircase, that there would be someone there that would know everything that I didn't know. Then I got to be grown up, and it sort of went in the back of my mind. And then I got to be a teacher. One day I walked into the class, and it was full of people, and they were looking at me, and they were so eager and so excited, and I suddenly felt, "O lord, I'm the old man in the castle!—I'm supposed to know all these things and I don't really know them and what will I do???" And I almost panicked, and I almost ran out the door. It was a very frightening thing for me to think about, and I realized that I'm a

grown up now and I would have to face the fact that I was probably the best person around that knew those things and could answer those questions. I wasn't all that good, but maybe I was okay, at least I was what was there at the time.[4]

Bess tells this story because the sense of debt these masters feel to their own masters is real, and this sudden recognition, at the national level, is so unfamiliar as to make them wonder if they are impostors. To this, Bess replies: "But we have to face up to the fact that each one of us in our own place is the best we can be for the time we can be. You are the very best people to tell everybody else the very things about your own particular art form; there isn't anybody else. There isn't somebody at the end of the staircase that knows more than you. You're the one at the end of the staircase."[5]

What Bess describes is not always a comfortable position, particularly if it was not sought. Recreating—whatever the mix of inheritance, innovation, and conservation—is frightening because it is creating, making, and composing, rather than turning on the tapedeck or admiring the object someone else has made. National Heritage Fellow Doc Tate Nevaquaya, for instance, brought back Native American courting flute music from oblivion by gathering bits and pieces of music and information from fellow Comanches and members of other tribes, from small-town museums, and from national collections. Without arrogance or pride, he found out that somehow he had become the expert, the one at the end of the staircase. All the Fellows, and the many other traditional artists they represent, have taken on that same responsibility for a tradition. They have had the courage to put both themselves and the tradition at risk.

"Courage" is the right word, not just because true creativity always requires it, but because there is so much to *dis*courage traditional artists in the modern world. In a society that takes pride in always looking toward the future, traditional artists can easily run the risk of being miscast as "blindly obeying tradition."[6] Clearly, that idea does not get us far in understanding them. In reality, the Fellows, through independent artistic action, sustain their own communities. They are to be distinguished from contemporary "modern" artists, not on the basis of competency or creativity, but because so many of them have voluntarily taken on the yoke of tradition and responsibility to community—even to the extent of playing down their personal visibility and the importance of their own contributions.

National Heritage Fellow Almeda Riddle offers a good example. She was "the great lady of Ozark balladry," a singer of more than two hundred unaccompanied traditional songs.[7] But when Joan Baez once asked her why, when they both sang the same song to the same melody, they sounded so different, Almeda replied, "Well, Joan, when you sing a song, you *perform* the song,

Cuatro, *ten-string guitar.*
By Julio Negrón Rivera,
Morovis, Puerto Rico.
Jagüey wood,
34" long, 1988

Quilt,
Dresden china pattern.
By Mabel Murphy,
Fulton, Missouri.
Cotton appliqué,
117 x 86", 1980

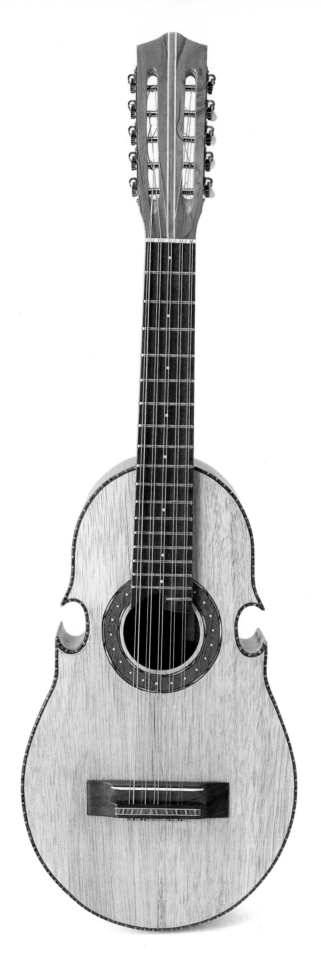

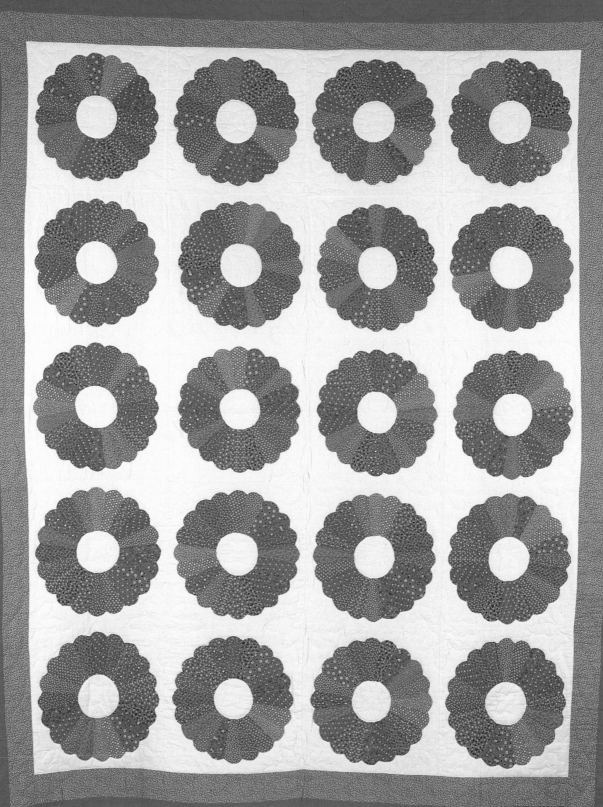

and so you get in front of it. When I sing, I *present* the song, and so I'm somewhere off behind it."[8] Almeda Riddle's style was typical of traditional Anglo-American balladry and storytelling, in which the ideal performer becomes subordinated so that the story or song can become all the more visible. That could be a metaphor for a great deal of folk performance worldwide.

There is much that all artists and musicians, whether we call them folk or "fine," have in common. All risk their reputations by expending effort in areas that can label them as lazy, shiftless, foolish, or worse. Some folk musicians, like the famous blues musicians and National Heritage Fellows Sonny Terry and Brownie McGhee, experience the elation that comes with wide recognition and enormous audiences. Yet, even with such recognition, they may taste the same painful loneliness as the "fine" artist, which Fellow Lem Ward, master decoy carver, once described in a poem as "the aches for understanding." At times, though, folk artists and performers may experience the particular reward of their field of work—which is to be united with tradition and with their communities.

It takes more than artists to sustain tradition. Tradition breathes not only because they assume responsibility for creating it anew with each performance or work of art, but also because community audiences remember and respond.

Most folk artists embody home-grown traditions, and their audiences are usually local and small. Thus, they are not "stars" in the usual sense.[9] On the other hand, folk artists are often very well known in the places where they live; sometimes they are remembered for several generations. For instance, we can eavesdrop on the eloquence of one local storyteller and rhetorician by reading the magnificent oratory of Chief Joseph of the Nez Perce—famous, perhaps, because he spoke in Washington, D.C., not just in the Wallowa country of eastern Oregon. But his language was the same in both places. Or, subtly paralleling Thoreau's famous words "I have travelled a good deal in Concord," folk artists may invest so much of themselves in what is local that we have to come to them (aesthetically, if not physically) to behold their visions. National Heritage Fellow Julio Negrón Rivera and his family, for instance, have literally "travelled much" throughout the island of Puerto Rico, performing the forms of mountain music known as *seis*, *aguinaldo*, and *vals*, as well as religious songs, thus reinforcing the essence of Puerto Rican identity. Don Julio is also recognized as an outstanding maker of local musical instruments, including the *cuatro*, a uniquely shaped ten-string guitar that is Puerto Rico's national musical instrument.[10]

Or think of Mabel Murphy, the 1989 National Heritage Fellow from Fulton, Missouri, whose quilts are beautiful enough to make you cry. As

I, the only child, have no
relative.
The sky will darken.
I, the only child, will go with
the wild spirits
To embrace a drowsiness.
I, the orphan child, will go
with the ghosts
To embrace a sleep.[11]

Bua Xou Mua

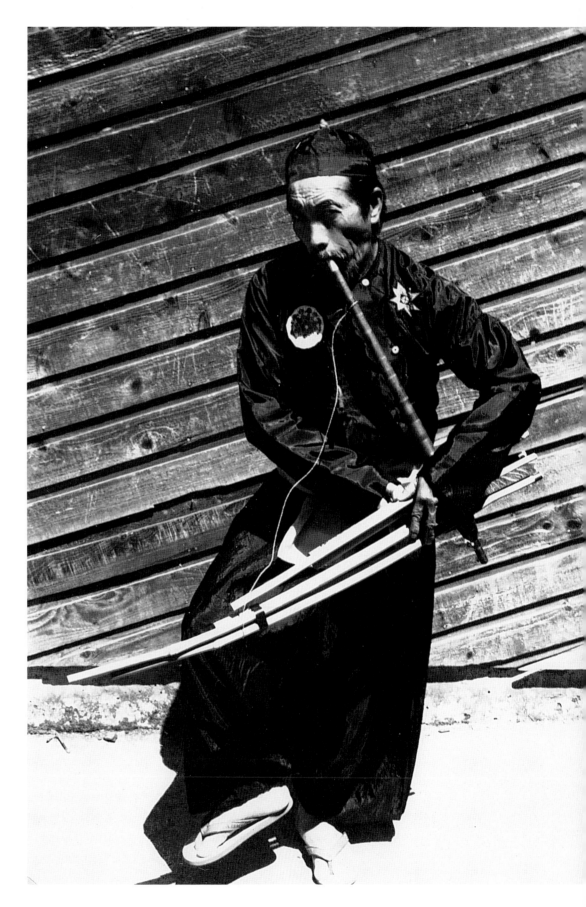

Margot Roberson wrote of Mrs. Murphy, "While she has pieced over 100 quilt tops, had several exhibitions . . . , conducted workshops, been written up . . . , Mrs. Murphy has never practiced her art for personal gain or glory. She has, indeed, followed the tradition strictly and worked on quilts as the women in our county have for generations—as gifts, and for home."[12] Mabel Murphy's generosity has traveled a good deal in Fulton: she has taught quilting to hundreds of women through classes and quilting circles that meet regularly in her home. Like Julio Negrón Rivera, she is a star—but in a local sky. Maybe we do not look at the night sky over our own neighborhoods often enough. Are we too *un*provincial? Do we know more about the horizons we cannot see than about our own?

None of the folk artists acknowledged through the National Heritage Fellowship is unknown locally or isolated from his or her surroundings. For instance, the reputation of National Heritage Fellow Genoveva Castellanoz, maker of *coronas*, extends over a wide geographic area, from eastern Oregon to eastern Idaho. Yet, because the Mexican-American community Eva serves is largely invisible to the dominant Anglo-American society of the region, she is not well known as an artist outside her own ethnic community.

There are other master folk artists who are revered by their dispersed communities. National Heritage Fellow Bua Xou Mua was a shaman, dancer, and musician in his home in Laos. He held spiritual and political authority through mastery of traditional Hmong culture. Because of the Vietnam War, and the ensuing decimation and dispersal of the Hmong of Southeast Asia, Bua was displaced from his home and his culture. At first, the difficult transition to life in Portland, Oregon, threatened to destroy his health. In 1981, however, he began to teach and counsel Hmong high school students, to perform rituals for the reassembled Hmong community in Portland, and to dance before a broader, non-Hmong public. Bua thus resumed his natural role, and his health returned. His son, Lee, hopes to become the first Hmong medical doctor ever, a fitting profession for the son of a shaman, a traditional healer. Lee has learned much from his father, including traditional instrumental music and songs.

A few of the National Heritage Fellows have become "stars" in the conventional sense. These artists are well known nationally and so familiar to us that they may seem "commercial," and we may not recognize their grounding in local traditions. Bill Monroe, Earl Scruggs, and Doc Watson are good examples.

Monroe, the creator of bluegrass music and inspirer of countless bluegrass festivals, is known not only in Kentucky and Tennessee, but throughout the world. There is probably no country music station in America that has not played his music, nor juke box that has not listed Bill Monroe and His Bluegrass Boys. Still, commercial success should not be allowed to obscure

Monroe's folk roots. His bands, for instance, have always been composed of the same instruments—fiddle, banjo, guitar, and mandolin—as appear in familiar traditional country string bands. The sentiments expressed in his lyrics derive from English and Scottish balladry and Anglo-American historical experience in the upland South. Monroe's kinetic synthesis of old-time fiddling, white blues, Black guitar-picking, and intense mountain gospel music has been described by folklorist Alan Lomax as "folk music in overdrive."[13]

Much of what can be said concerning Monroe applies also to Earl Scruggs, who played in his band for many years. Like Monroe, Scruggs was an innovator from within a tradition. Growing up in a musical family in Shelby, North Carolina, he was a child prodigy who began playing the banjo by age four. By the age of ten, he had created his own syncopated picking method based on older local techniques observed and learned from relatives and friends. This "Scruggs picking" style, a distinctive element of bluegrass music, spread throughout the world. Scruggs himself has been compared with the greatest performers of classical music. He has been likened to Paganini and termed the Segovia of the five-string banjo. Unlike those other great virtuosos, however, Scruggs derives his mastery from an informal musical tradition carried forward by local, everyday musicians within a regional community.

For many of us, the first music we understood to be "folk music" was made by the guitar and voice of Doc Watson, or by someone imitating him. By the 1960s, Watson was already well known in the universe of popular culture and mass entertainment. For twenty-seven years, he recorded albums and toured coffee houses, college campuses, nightclubs, and festivals. All this popular activity might have obscured the society he came from—a society that gave birth to a musical style upon which he expanded brilliantly—but Watson's voice and guitar tunes always carried more than a hint of a local, traditional world.

He was born Arthel Watson, the sixth of nine children, in 1923 in Stoney Fork, North Carolina, and was blinded by an infection at the age of two. From his mother, he heard old-time ballads, and sitting on her lap in church, he listened to traditional hymns. His father sang, played banjo, and led family Bible reading and hymn singing each night. His annual Christmas gift was a harmonica, and when he was ten or eleven, his father made him a banjo, saying, "'Here son. Take this and learn to play it real well. . . . You get where you can play that thing pretty good; it might help you get through the world.'"[14] It did. A guitar—which is the instrument Watson came to be known for—followed at age twelve. Like Scruggs, Watson has been compared to classical masters (in his case, Horowitz and Heifitz), and he has been called the "best [guitar] picker that ever was."[15]

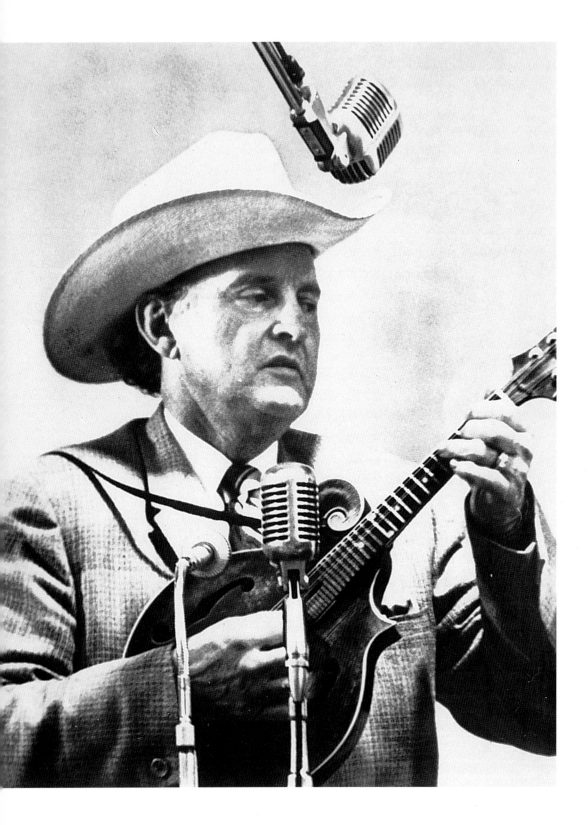

Bill Monroe,
bluegrass musician

Folklorist Henry Glassie's consideration of folk architecture as one of the fullest artistic expressions of a society's values illuminates a central fact about all artists, whether folk or "fine." Characterizing American folk architecture, Glassie says, "The soul's duty is more important than the body's comfort"[16]—that is, the builders of the vernacular have often chosen features and plans that emphasize and foster interaction, community, and human connectedness rather than building only for convenience, privacy and shelter.

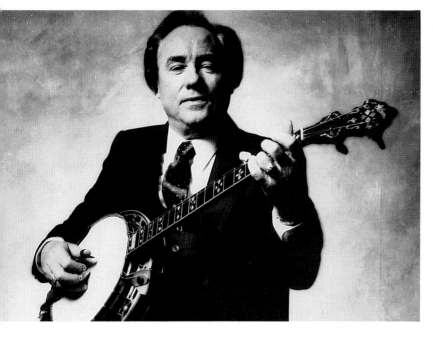

This idea of "the soul's duty" can be taken as that which impels any artist—the something in the soul that seeks expression regardless of obstacles. But for folk artists and performers, the phrase has the additional meaning that Glassie gives it: the harnessing of talent for the good of the community that is the artist's home. The National Heritage Fellows and other traditional artists can even be said to *create* (and maintain) community through their work.

Earl Scruggs,
bluegrass banjo player

The Fellows are unified in their artistic stature as well as in their sense of duty to community. Despite the obstacles many have faced, they manifest the ideal of mind, body, and spirit combined in the work of art to a surprising degree. They are not perfect people; what perfection they have achieved is in

Arthel "Doc" Watson,
Appalachian guitar player, singer

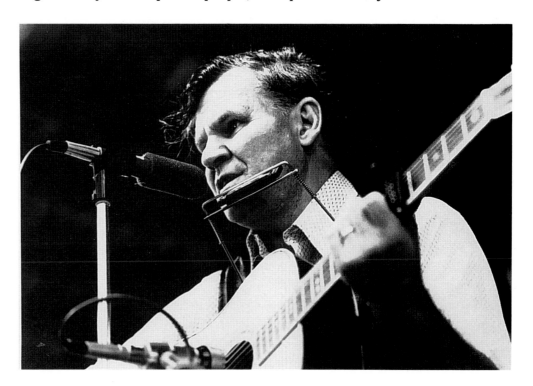

their art. Yet their lives—at least those of the older Fellows—seem to have the consistency of theme and spirit that characterizes the works of art themselves. Some of these lives—and some of these objects, songs, and stories—demonstrate pain and suffering. Most are stories of persistence in adversity.

Lucinda Toomer, for instance—a National Heritage Fellow from Columbus, Georgia—is known for her African-American quilts. When she received the award in 1983, she had been quilting for almost ninety years. Her quilts are beautiful because they are at once intellectual (the products of distinctive ideas about design), physical (the excellent work of a skilled hand), and spiritual (the transformation of sorrow and joy into art).

The work of art that is intellectual but not spiritual leaves us cold and is easily forgotten. Ultimately, it is not art, because mind without spirit is sterile. The men and women who have received National Heritage Fellowships, whether or not they are practicing members of organized faiths, tend to project strong spiritual inclinations. America's religious diversity is well represented, though not advertised, among the Fellows. But even the intellectual and the spiritual are not enough. Those who have not learned the techniques involved in manipulating a medium are not artists either. They may have something to say, but it cannot be communicated. All the National Heritage Fellows have demonstrated technical excellence, which is, in fact, the first criterion considered by the panel that chooses them.

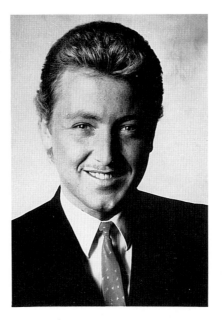

Michael Flatley,
Irish-American
step dancer

Those who have engaged all their intellectual, physical, and spiritual faculties are really the only ones worthy of the name of artist. How do artists achieve such integration within themselves? How do they find the center that is the source of authority? There are probably as many ways as there are artists, but for folk artists, tradition can be a teacher and an ally: tradition has seen to it that the ideas on which their art is founded have been worked on and shaped for a considerable period of time and by a great number of skilled artists.

The integration of intellect, spirit, and skill is evident in even one of the youngest of the National Heritage Fellows. Michael Flatley was recognized for his mastery of Irish step dancing when he was thirty years old, in 1988. Born in Chicago to immigrant parents, Flatley is a local star within that city's large Irish community. He has taken his great athletic ability (he was once

the Chicago Golden Gloves middleweight boxing champion) and applied it to one of his ethnic community's most vibrant and revered traditions, with spectacular results.

When he was only seventeen, Flatley became the first American ever to win the senior men's All-World Irish Step-Dancing Championship in Dublin, a distinction that made him the world's leading Irish dancer. He is also an accomplished Irish flutist who won the All-Ireland Concert Flute Championship for three consecutive years from 1974 to 1976. He is now retired from competition, with 168 dancing championships to his credit.

As a group, the National Heritage Fellows form an essence of American essences and fully project the multiplicity of American life. Thus it is no accident that among these artists there are not just one, but two, ex-boxers, and both of them are dancers. A boxer's legs are as critical as his punch, and in both cases—Michael Flatley and Howard "Sandman" Sims, the remarkable African-American tap dancer—art and boxing meet in ways we associate more readily with Eastern martial arts. After the Golden Gloves, Flatley declined a possible boxing career in order to tour with the Chieftains, the leading contemporary Irish band. Sims also left the ring, but he took his specialty, and his name, from it: "I used to do some fancy steps when I was standing in the rosin box, and the people liked that better than my fighting."[17] He went on to invent an act using a board lightly sprinkled with sand, which created a distinctive cool and slippery sound—thus, "the Sandman."

Sims had begun dancing when he was three. As he says, "I had eleven brothers and sisters—I was the baby—and every one of them could dance. I didn't have time to crawl. I had to get up and dance with the rest of them."[18] Music and movement impel him, and like other Fellows, he was conscious of his own passion early on. In 1991, seventy years later, he was still astounding audiences with the percussive sounds of his feet.

There are many other National Heritage Fellows who began at a young age. José Gutiérrez started to play *jarocho* guitar at age seven. When he was a small boy, Sonny Terry reached up to a high shelf to get the harmonica he had been longing to play. As a baby, Eppie Archuleta slept under the loom she was to weave upon—as soon as she could reach it. For others, the rhythm of creation manifests itself later in life. For Hugh McGraw, the beginning of his devotion to the Sacred Harp was like the blinding moment of religious conversion. And for Miguel Manteo, the marionette theater was an ever present passion; it was only a matter of finding time for it.

I have met only a few of the National Heritage Fellows in person, but I have encountered most of them—as you now will—through their artistry and their life stories. In these master tradition-bearers, knowledge of art has been

I was *born* dancing.
I'm *still* dancing.
I can't *quit* dancing.
I dance a *whole lot*.[19]

Howard "Sandman" Sims

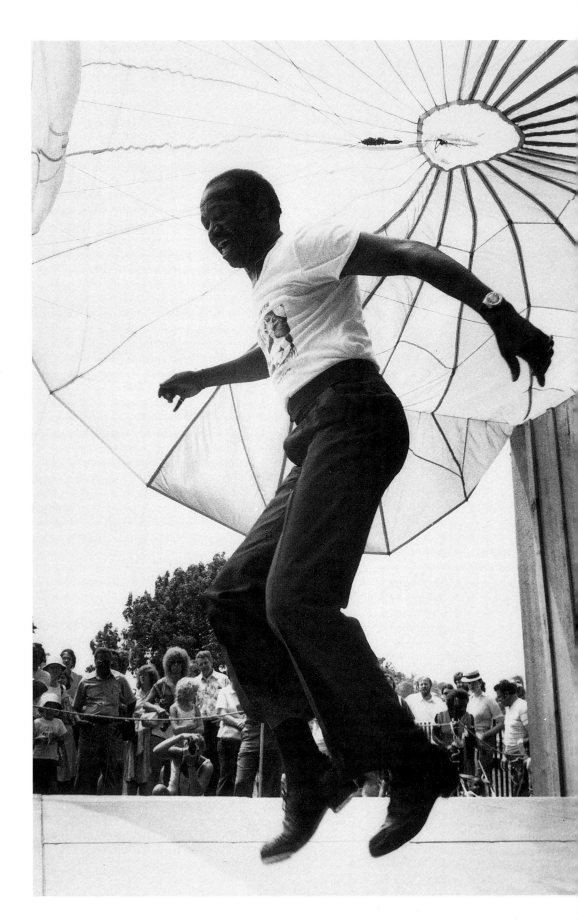

matched and furthered by knowledge of self, and they have transformed themselves into subtle presences in their work. Each of them began by trying to make tradition part of themselves, but ended by becoming part of tradition. In the music and objects they have made, they have become part of something that came before them and that, thanks largely to their own work, may go on after them. They connect worlds; they are the active channels through which tradition reaches us in the present. They carry it, they change it, they conserve it. They *are* it.

The National Heritage Fellows are a group of unvanquished spirits, an inspiring national treasure of human indomitability. Each is a remarkable individual with an epic story to tell. Some tell theirs modestly, others with great flourishes—National Heritage Fellow Horace "Spoons" Williams once said he wanted a live audience of five million people. Although their authority was hard-earned, few have become hard-edged. Many of them have known poverty, and some still do. All create dignity through art and music. All of them also listen to the voices of their traditions. Whether inheritors, innovators, or conservers, all respond to their traditions from inside their communities and from inside themselves. Tradition's effects upon them are matched only by their effects upon tradition.

The closer attention we pay to all that the National Heritage Fellows have done, the less we will find that is predictable. At first we may hear them say the things we expect them to say, but if we keep looking and listening, we will have to reject our old ideas about tradition and creativity, triviality and greatness, self-expression and egotism, community and individuality, aesthetics and meaning. These masters of art and life—though most of us will never meet them—can be our teachers.

Chapter Two

INHERITORS

"It still lives."

As infants and children, we learn particular ways of perceiving the world from what we see around us. We see our parents' faces and smile back, but what else do we see, lying in bed or laced into a cradleboard? Surrounding us are objects, the products of ideas. These objects communicate coded ideas, keep them alive, and in turn shape our own minds. Yet, even as adults, we have little impact on the mass-produced items that comprise the majority of objects we encounter today. Most of the time, our only choice is whether or not to buy them. When objects are made locally, for a local market, however, individuals have a greater influence. They can tell the maker directly what they think of the design, what works for them and what does not. The buyer can even ask for a certain pattern or combination of colors, or bring the object back for repair and modification.

At this local level, individuals like the National Heritage Fellows have a major influence on tradition, whether through continuing, innovating, or conserving an inheritance. Those who continue a tradition—who simply practice an art with steadfastness, sometimes in great aloneness, as if the current news of the world did not matter but was just a passing illusion—I call the "inheritors." These individuals tend to have a farsighted vision of history; as time passes, the world may catch up with them in realizing the value of what would have been lost but for their faithfulness.

National Heritage Fellow Ray Hicks, the inheritor of an ancient storytelling tradition, is a good example. Hicks understands the laws of nature with mind and heart, and he believes that nothing is ever really lost. When he talks about

galax, a wild plant that grows in the mountains around his home in North Carolina, it is easy to see that he is also talking about stories: "These seeds that He's created is going to repeat themselves. Even if they die out in some sections. They're going to be repeating in some other sections. Coming out, bearing seed out of its own kind. I've learned it in my own life. . . . That's the same galax I pulled when I was a little boy. And the same galax that was created. If it was gone, there wouldn't be none agrowing here."[1]

Storytellers, folklorists, and historians of the English language have flocked to the porch of Ray Hicks's unpainted frame house, perched on a slope on Beech Mountain, where North Carolina is almost Tennessee, just to listen to him talk. They want to hear the "purest example of the speech of the Scotch-Irish and English pioneers who settled southern Appalachia in the late seventeen-hundreds[,] . . . a speech that has preserved Chaucerian and Elizabethan locutions."[2] They also want to hear his stories—his "Jack tales"—before there is no one left to tell them. But Ray thinks the stories are like the galax: they have lasted a long time, and they won't die. To him, television is a temporary distraction, not as good as Jack tales: "The television . . . when they'd first get one in their homes, just cut it [the telling of tales] all off. When they'd get tired of the television, you could go in their homes and they'd accept the Jack tales. But when they first got that television in their home . . . you couldn't tell them no Jack tales till they got wore down on that. Because I know, I've told them."[3]

Most Americans know the story of Jack and the Beanstalk from illustrated books and animated cartoons. Few are aware, however, that the beanstalk episode is only one of perhaps fifty in an oral cycle of tales about an unpromising youth who vanquishes all kinds of giants, including Death himself. In Hicks's Death story, Jack traps Death in his magic sack by saying "Whickety-whack, come down into this sack" and then ties the sack to the top of a big poplar tree. A million years pass, and no one dies. One day Jack goes for a walk: "He hadn't walked very far when he heard something coming—rickety-rack, bumpity-bump, rickety-rack, bumpity-bump. . . . Here comes an old woman who just went to bones and hide. Her knee joints . . . was a-skreeking and her nose was a-bumping her knee joints. Her bones would go rickety-rack, and her nose would go bumpity-bump."[4] Jack realizes that he is responsible, that a world without death is a nightmare. He sets Death free: "And they said that when he untied it, Jack was the first that fell dead. That was the end of Jack."[5]

In the Blue Ridge Mountains of North Carolina, a man wrestles with Death in his stories and through his storytelling, just as great storytellers have always done. They are all like Scheherazade who, by telling her tales over the course of a thousand and one nights, explicitly won a victory over time and death. With the gifted teller, time itself seems to stop, or to pass without

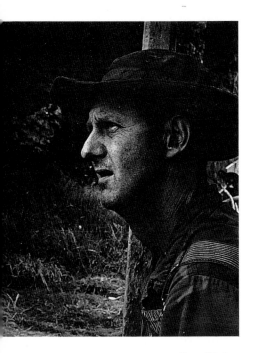

Ray Hicks,
Appalachian storyteller

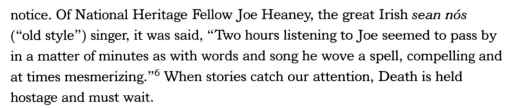

notice. Of National Heritage Fellow Joe Heaney, the great Irish *sean nós* ("old style") singer, it was said, "Two hours listening to Joe seemed to pass by in a matter of minutes as with words and song he wove a spell, compelling and at times mesmerizing."[6] When stories catch our attention, Death is held hostage and must wait.

Storytellers defy the passage of time in another way as well: the same stories have been told over and over. It has been suggested, for instance, that the hero Jack is a latter-day version of Homer's Odysseus—and certainly Jack's outwitting of the giants reminds us of Odysseus's resourcefulness in the cave of the Cyclops. Thus, Ray Hicks's victory also lies in being part of a long tradition and in keeping it alive in his generation. Joe Wilson, director of the National Council on the Traditional Arts, puts it well: "Ray tells a story for the audience that's there, of course, but he also tells it for the audience that isn't there—the kin who told him the story. And he has to do as good as they did. Ray constantly plays to an audience of superlative, departed storytellers."[7]

Like the work of all folk artists, Hicks's performances manifest both dynamic and conservative traits. He responds to, say, an audience of laughing children by playing up the "rickety-rack" sounds and the bent shape of the aged lady who wanted to die. At the same time, Hicks is responding faithfully to the long line of storytellers who brought the stories to him. Like the galax, the stories have not disappeared.

Ray Hicks, whose family has lived in the same region for eight generations, was born to a tradition in his grandfather's house. His mother is a superb teller of the Jack tales, as was his cousin, National Heritage Fellow Stanley Hicks from Vilas, North Carolina, who died in 1990.

Stanley Hicks's many talents convey a sense of the broad range of folklore traditionally passed along within families in Appalachia. Besides telling the traditional stories, he used to sing the old ballads and dance in the flat-footed "jumping jack" style. From his father, he learned how to make dulcimers and banjos of impeccable, simple beauty. Just as Ray Hicks finds a kind of immortality in stories, his cousin Stanley saw the immortal in material folk art: "Here's my dad's dulcimer. There's his dulcimer he built years ago—it still lives, it's still there. And the same way by myself, when I'm gone, there's some of my stuff for the young uns . . . you know, it still lives."[8]

"It still lives" could be the theme for all traditional art and performance, but it is particularly appropriate for the inheritors. For instance, in the work of Ray and Stanley Hicks, something British that no longer lives in Britain remains alive in America.

The same holds true for the traditions of many other inheritors, whether they are National Heritage Fellows or not. Immigrants leaving their homelands take their culture with them, but

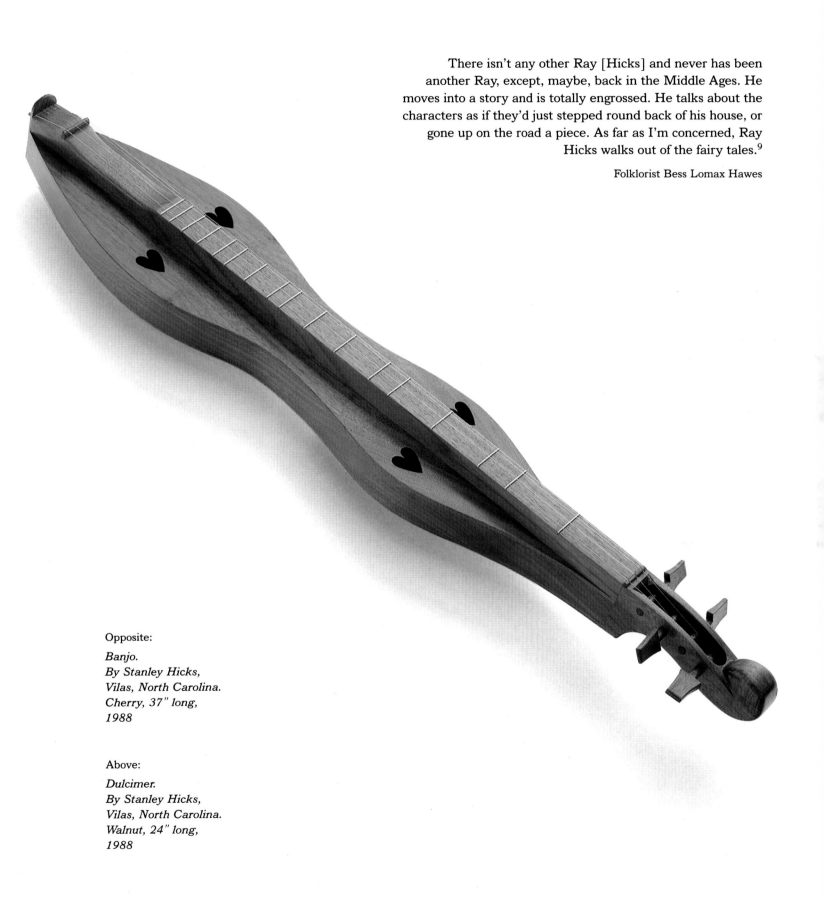

There isn't any other Ray [Hicks] and never has been another Ray, except, maybe, back in the Middle Ages. He moves into a story and is totally engrossed. He talks about the characters as if they'd just stepped round back of his house, or gone up on the road a piece. As far as I'm concerned, Ray Hicks walks out of the fairy tales.[9]

Folklorist Bess Lomax Hawes

Opposite:

Banjo.
By Stanley Hicks,
Vilas, North Carolina.
Cherry, 37" long,
1988

Above:

Dulcimer.
By Stanley Hicks,
Vilas, North Carolina.
Walnut, 24" long,
1988

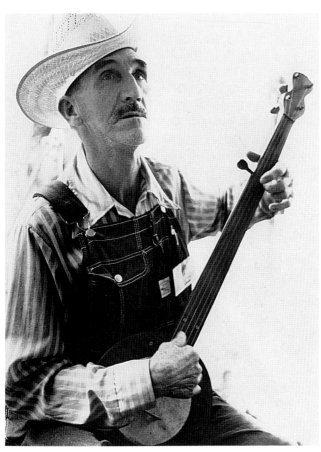

Stanley Hicks,
Appalachian instrument maker,
musician, storyteller

they lose regular, daily contact with that culture at its core, where it continues to change. These migrant culture-bearers thus often become the preservers of traditions no longer practiced in their culture's hearth; immigrants abroad sometimes save what was lost at home.

National Heritage Fellow Mary Jane Manigault's African-American forebears have been in America as long as those of the Hickses and other immigrants from the British Isles.[10] Mrs. Manigault, from Mount Pleasant, South Carolina, makes coiled grass baskets and sells them in the open-air Market Square in nearby Charleston. Her work represents the best of an old but vital tradition. In 1984, when she received her Fellowship, it was written of her: "Mrs. Manigault stands out because of the excellence of her work, the sculptural quality of her forms and her imaginative use of natural design and color. She experiments but never overdecorates; she works quietly as exemplar to her community, keeping the standards up, displaying always the eternal values resident in fine workmanship, and the aesthetic impact of a venerable artistic tradition."[11]

How old is the tradition Mrs. Manigault has inherited and carried forward? No one really knows. Her style is found throughout Africa, and there is little to differentiate the coiled grass baskets of African Americans from those of Africans.[12] This fact is all the more remarkable since it is unlikely that kidnapped slaves would have been able to bring any baskets with them. All they could have brought was technical knowledge and ideas about baskets, from which they and their descendants reconstructed an African tradition.

Mary Jane Manigault's baskets descend from ones originally used for storage and for winnowing rice, as part of a material culture complex that accompanied rice agriculture. It was, after all, the African slaves, not the English colonists, who knew how to grow and clean rice, which by the seventeenth century had been part of West African culture for sixteen hundred years. Cultivation of this crop was new to the English settlers on the South Carolina coast, who were encountering a land and climate unlike England's but much like Africa's. In one of the great injustices of history, slaves provided not only the labor for rice cultivation, but the knowledge and skill as well, while English settlers and investors prospered from it.[13]

Today, in the same area of South Carolina, African-American descendants of these slaves use originally African techniques to produce an astounding array of baskets. The work of Mary Jane Manigault, for instance, displays

"a dazzling variety in shapes, natural color combinations, and sizes."[14] Folklorist John Vlach summarizes the African coiled grass basket's evolution in America in these words: "An African craft that began with functional intentions thus has become an art medium with primarily aesthetic motivation."[15] When faced with the indivisibility of their utility and beauty, however, one wonders if these dimensions were ever totally separate.

The problems Anglo, African, and Native Americans encountered in trying to preserve their inheritances are different in some ways from those later immigrants faced. Simply by being the first, the earliest Anglo settlers—in Virginia, Massachusetts, Pennsylvania, and elsewhere—had the power to define a great deal of American culture.[17] For example, we Americans still speak English, though only a minority of us have English ancestors. And, partly because African Americans were excluded from the mainstream culture for so long, the ancestors of artists like Manigault developed a dynamic, expressive culture of their own, one based on African roots, borrowings from European, Caribbean, and Native American cultures, and historical experiences such as slavery. The large number of African-American Fellows is a testimony to their creative, expressive, community-based traditional culture—a distinctive American treasure.[18] Native Americans, like indigenous peoples everywhere, faced an aggressive external threat to their cultural inheritance, which was based on an ageless and sacred relationship to the land. Seeking to rupture this relationship, because it undermined their own recent, secular claims to the same land, European Americans have been equally concerned with destroying native culture and native peoples. Thus, Native Americans have had to counter policies consciously and directly opposed to their cultural inheritance as well as their existence. Excluded from mainstream America, like African Americans, Native Americans have nevertheless preserved much of their traditional culture.

But for the massive numbers of immigrants from Southern and Eastern Europe who arrived in the United States in the era from 1880 to 1920, the situation was different. Some kind of American culture had already been established, and many Americans viewed the massive influx of foreigners—26,240,000 between 1870 and 1921[19]—as a threat to American institutions. Thus, immigrants of that era and those following felt pressure to assimilate, "Americanize," become part of the "melting pot."

According to the metaphor of the "melting pot," the national identities of all the immigrants would be "melted down" in the crucible of American life, and a new, stronger alloy, a new kind of person—an American—would emerge.

Making things with your hands keeps your head together. When you sew baskets, you just concentrate on that one thing. You have to have long patience. You can't be a nervous somebody and make baskets. You have to sit in one place and really get into what you are doing. You can't have your mind running on all kinds of different things. You have to have a settled mind.[16]

Mary Jane Manigault

Mary Jane Manigault, African-American basket maker

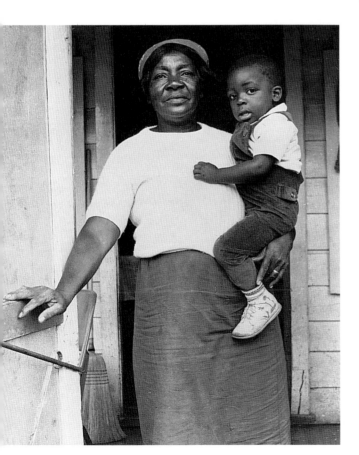

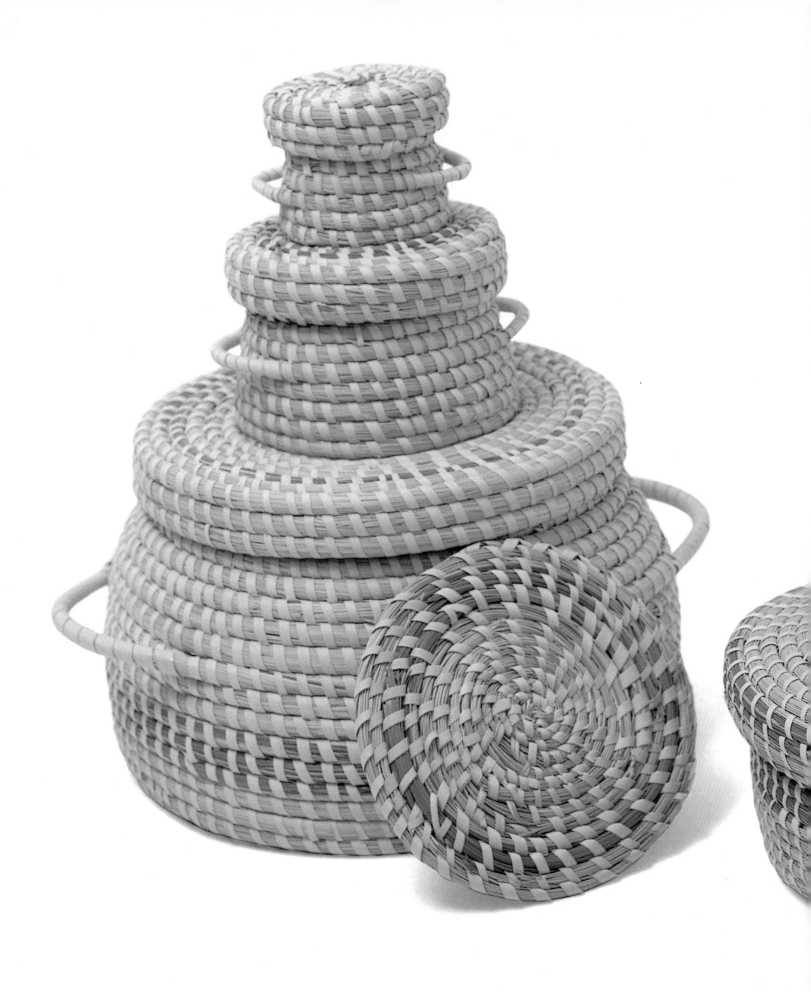

From left:

Sewing basket.
By Mary Jane Manigault,
Mount Pleasant, South Carolina.
Coiled sweet grass with
palmetto and pine needles,
12" high x 11½" diameter, 1979

Hot pad.
By Angie Manigault
(granddaughter of
Mary Jane Manigault),
Mount Pleasant, South Carolina.
Coiled sweet grass,
6½" diameter, 1979

Cake box basket.
By Mary Habersham
(daughter of Mary Jane Manigault),
Mount Pleasant, South Carolina.
Coiled sweet grass with
palmetto and pine needles,
5" high x 9½" diameter, 1979

This idea theoretically respected the cultures the immigrants brought with them insofar as it recognized that everyone brought something of value that could contribute to a new, American identity.

In practice, however, many of those who used the melting-pot rhetoric meant something else—that the immigrants' cultural attributes would "melt" away completely and that these new Americans would be "recast" into the Anglo norm. The expected "alloy" spoke only English. Just as many American Indians who grew up in this era have painful recollections of being punished for speaking their own languages in school, immigrants can tell you the same thing: they, too, were punished for speaking their mother tongues in public.

The actual melting pot, as opposed to the ideal one, was not colorblind. As one Native-American poet put it in a brief poem, entitled "The American Melting Pot": "It's all right/If you melt white."[20]

It is also true that many immigrants wanted to assimilate. They wanted their children to succeed as Americans in American terms and not be discriminated against or judged by Old World standards. They embraced American values—which for many also meant "modern" values—and rejected much of their tradition as burdensome, oppressive, and no longer relevant. Within individual ethnic groups, a humor even sprang up that made fun of Old World ways.[21] Many immigrants who cast their heritage aside, however, soon came to regret it. To paraphrase one comment, "We previously hated ourselves for being *x*s [substitute any ethnic minority group], we now frequently hate ourselves for *not* being *x*s."[22]

But other immigrants held on to their inheritance and consciously maintained their Old World ways throughout this difficult era. They claimed their inheritance and preserved it for their communities. Sicilian marionettist Miguel (Mike) "Papa" Manteo and Jewish klezmer clarinettist David Tarras are two National Heritage Fellows who exemplify this kind of faithfulness.

The Manteo family knows a story that takes 788 hours to tell. Similar in content to the *Iliad* and the *Odyssey*, it is performed with marionettes four to five feet high and weighing up to one hundred pounds.

Until his death in the summer of 1989, Mike Manteo was their master marionettist. He had been called "a brilliant talker and storyteller who never fails to charm an audience" and "a spellbinding story teller who can make the tenth-century phantasmagoria come alive for anyone who listens."[23]

The Manteos' story has its roots in the medieval French epic the *Song of Roland*. Anthropologist Anna Chairetakis speaks of how the epic was transformed by the Italian Renaissance poet Ludovico Ariosto into *Orlando Furioso* and then transformed again and again by generations of Sicilian puppeteers into an intricate series of adventures, romances, and battles. The Manteo family's version consists of 394 episodes and takes 13 months of nightly performances to tell.[24]

Mike Manteo's precious inheritance from his father, Agrippino, included not only the intangible knowledge of performance and technique but also 500 *pupi*, or marionettes. Agrippino grew up in Catania, Sicily, where he fell in love with that city's marionette shows, including the one established by his father in the mid-1800s. Thus, the Manteo *opera dei pupi* (marionette theater) is well over one hundred years old—as are some of the puppets. When Agrippino emigrated to Mendoza, Argentina, in the early 1900s, he gave performances behind his bakery. Arriving in New York in 1919, he found that Sicilian marionette theaters had already been performing there for at least thirty years. An article in one of the earliest issues of the *Journal of American Folklore* recounts a visit to the Teatro dei Marionetti of Carlo Comardo, a native of Palermo. The show described in the article sounds almost identical to those the Manteo family was putting on one hundred years later.[25]

D. H. Lawrence gives a vivid account of a puppet theater performance he attended in Sicily early in this century: "So we watched the dragon leap and twist and get the knight by the leg: and then perish. We watched the knights burst into the castle. We watched the wonderful armour-clashing embraces of the delivered knights, Orlando and his bosom friend and the little dwarf, clashing their armoured breasts to the breasts of their brothers and deliverers. We watched the would-be tears flow.— And then the statue of the witch suddenly go up in flames, at which a roar of exultation from the boys."[26]

Agrippino Manteo established his theater, known as Papa Manteo's Life-Sized Marionettes, at 109 Mulberry Street, in the heart of New York's Little Italy. By 1919, Italians had been arriving in the city in large numbers for almost four decades, and thus the theater played to an audience familiar with both the puppets and the stories. That familiarity, however, did not prevent spectators from willing the "suspension of disbelief" and becoming involved in the stories. As Mike Manteo recalled, "One time a guy popped up from his seat, pulled out a gun and then—boom, boom—he took two potshots at the villain. 'Take that, you bastard,' he said. 'You're dead now.'"[27]

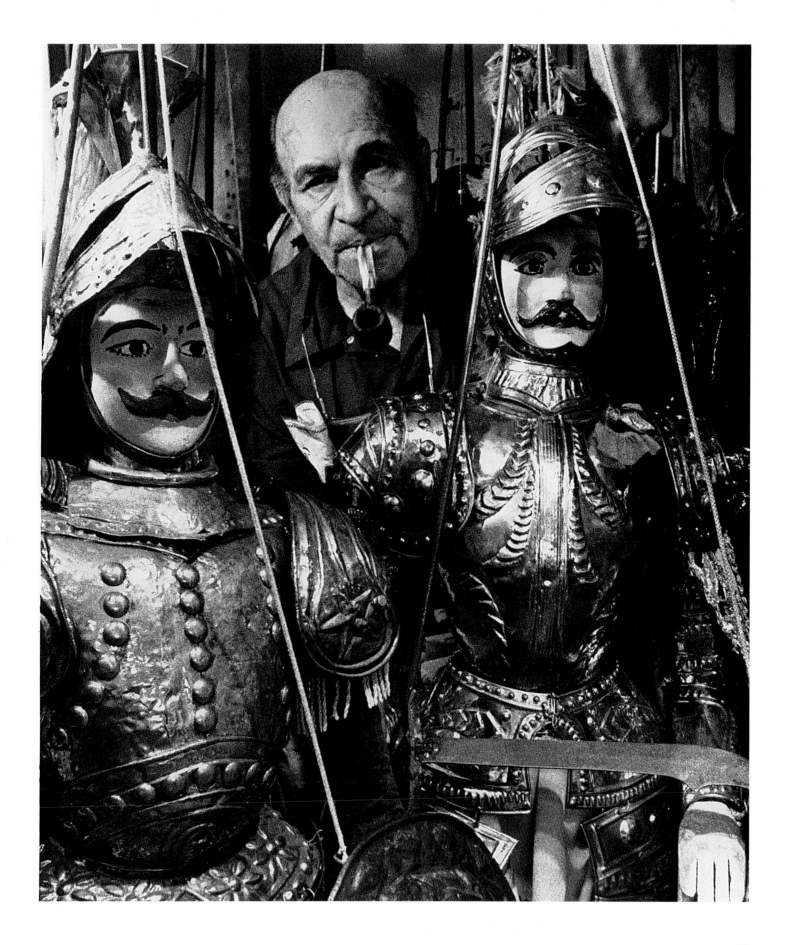

Normally, the members of the audience got enough realistic battles in the show without having to pull out guns themselves. The marionettes, for instance, are designed to allow decapitation during sword fights, though timing is important, as Mike's sister Ida explains: "You need perfect timing, especially when you cut off the head. My God! Mike is perfect. He releases the hook to the head at the exact time my husband, who is a very good fighter, hits him. It's a beautiful effect and the audience loves it."[28] The audience indeed loved it. "Sometimes, the cries of the puppeteers were drowned out by the real cries of the audience."[29]

Although based on the plot of *Orlando Furioso*, the dialogue is improvised each time, and the words are accompanied by piano music, songs, and the clashing armor of the constant one-on-one combats. There may be as many as one hundred marionettes on stage at once, creating the effect of great masses. Each puppet has its own name, so there is a lot to remember—especially, Mike Manteo once said, who was killed the night before. Over the course of hundreds of nights, each of the hundreds of puppets in this original cliff-hanger serial develops a character, a story, and a fate of its own. But the climax is always the death of Roland, "blowing on a horn in a desperate attempt to summon help, while blood spurted from his eyes, ears, mouth . . . staged with a specially designed Orlando puppet head and beet juice for blood."[30]

Each time they give a performance, the Manteo family members breathe life into the musty medieval epic as they animate their puppets—some newly made of wood, old hubcaps, broken toasters, silks, and velvets, others one-hundred-year-old heirlooms from Sicily. The youngest children guard the sand bucket, kept to the side of the stage in case of fire. Above and behind the stage, on "the bridge," the men manipulate the hundred-pound marionettes with a system of rods, one rod controlling head movements and the other the arm that holds the sword. A cord guides the arm with the shield, and the legs hang freely. On the ground, two family members—one male, one female—"throw" the voices of the marionettes.

The image of the generations working together to perform their inheritance spans the gulf of time, demonstrating how the puppet theater is tied to the organic life of a family. As Mike Manteo once recalled: "When I was a little boy, the first thing I do, when I started to walk, I get on stage and I sit by a pail of sand (you know, you got the fire department rules), and I sit there and I look. I'm just about seven, eight years old. And I look at my father, and I look at the men that were working on the bridge and you gather all this and gather the language too. The same thing with my sister. My sister at the age of, not even fifteen, already she started to throw voices at my father's tuition. . . . And then I was envying those people up there that manipulated those heavy marionettes. . . . Then as I got old, I got promoted. I was allowed to get on the bridge."[31]

During the 1920s and early 30s, Italian immigrants patronized Agrippino Manteo's theater nightly. In 1938, with dwindling audiences and the death of his eldest son, Johnny, Agrippino closed the theater. He died a few years later.

Mike became the new master of the puppet troupe and briefly reopened the theater in Brooklyn in 1942. But during his working years as an electrical contractor, it was difficult for him to find the time to maintain a regular puppet theater. Still, the puppets remained the Manteo family's true passion—they were cared for and repaired, and occasional performances were staged. The theater was featured at the Smithsonian Institution's Festival of American Folklife in 1975 and at the World Puppetry Festival in Washington, D.C., five years later. By the late 1980s, the Staten Island Institute of Arts and Sciences had begun staging some episodes of the Manteos' *Orlando*. Perhaps American audiences will encourage the next generation of Manteos to keep their epic tradition alive. For the Manteos and their audiences, even the "death" of one marionette is unbearable: "They may be marionettes, but when somebody died, and my father and my sister would put on a beautiful scene—with such sadness, my father crying, my sister crying, and the people—you could hear them sniffle, too."[33]

Like the Sicilian marionette theater, Jewish klezmer music has been enriched over time by its practitioners. For generations, *klezmorim* (Yiddish for musical instrumentalists) in Eastern Europe assimilated Ukrainian, Rumanian, Gypsy, and other local tunes and styles into the dance music they played for weddings and other social occasions. Arriving in America as part of the mass migrations from 1880 to 1921, klezmorim added to their fluid repertoire the sounds of minstrel music, ragtime, vaudeville, and jazz, performing for the Yiddish theater, films, bar mitzvahs, and on the radio. Fortunately for us, they also recorded thousands of 78 rpm records.[34]

Dave Tarras, dubbed "King Klezmer" by a new generation of revivalist klezmorim in the late 1970s and early 80s, was an immigrant from the *shtetl* (small village) of Ternovka in the Southern Ukraine. There had been klezmer musicians in his family for three generations, and he was already a skilled performer when he arrived in New York in 1921. His instrument, the clarinet, had become the usual lead instrument of the klezmer band during the nineteenth century. Earlier, the lead had been carried by the fiddle, accompanied by other stringed instruments (viola, cello, and string bass) as well as by flutes and the *tsimbl* (hammered dulcimer). During the nineteenth century, klezmer bands added brass instruments (trumpet, trombone, and tuba) and more woodwinds, including the clarinet, as they incorporated elements from other kinds of music. Despite innovations, however, the almost human laughing and crying of the clarinet might still be thought of as the trademark of the klezmer band.

That was his life [Agrippino's], and it seems to me that he left that tradition to us. We love our marionettes. You see all what you see here? We're all fanatics about the marionettes.[32]

Miguel "Papa" Manteo

In the immigrant milieu of New York City in the 1920s, Dave Tarras, like Agrippino Manteo, could perform for a knowledgeable Old World audience at weddings and other celebrations. But, as with Italian audiences, Jewish audiences were soon to change: "By the 1930s the general Jewish population had moved away from old style things and had become more American, and this type of music was dropped . . . except for a few [practitioners] like

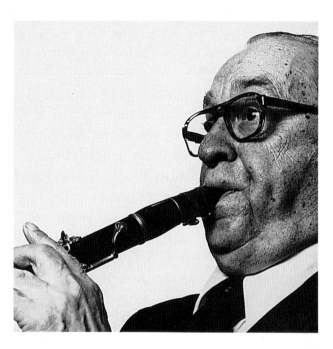

David Tarras,
klezmer clarinettist

clarinetist Dave Tarras."[35] Tarras, in fact, was sought after by the Yiddish theater, by famous cantors like Jan Peerce, and by noted Jewish composers and orchestra directors. Although he played for them, he continued to perform klezmer music as well, producing records with other immigrant musicians—like Abe Schmatz, Max Leibowitz, Shloimke Becerman, and Naftule Brandwine—for a relatively small number of listeners within his ethnic community. Reflecting the multi-ethnic nature of klezmer musical history, he also recorded for non-Jewish audiences, as, for instance, in his version of "Galatas" for a Greek market (*Galata* referring to an old Greek, Jewish, and Armenian area of Istanbul).

In the mid-1970s, klezmer music was rediscovered by a new generation of Jewish and non-Jewish folk music enthusiasts and performers who first learned of it from the old 78s. They soon found out, however, that one of the greatest klezmer musicians was not only still alive but still playing klezmer. A comeback concert was followed by an album, *Dave Tarras: Master of the Jewish Clarinet*. The klezmer revival was under way. Some of the new musicians sought Tarras out and learned his style firsthand, others learned by listening to his recordings. But all the present-day klezmer groups—bands like Kapelye, the Klezmorim, the Mazeltones, the Klezmer Conservatory Band, the Ellis Island Orchestra, Zmiros, and Klezmer V'od—are indebted to a faithful keeper of the music, Dave Tarras.

When Dave Tarras, and millions of others like him, first came to America, they were called immigrants. The exhilarating and trying experience of adjusting to a new language, culture, and country, however, forged a new identity for them—what we today call ethnic identity. Ethnicity saved from the Old World what was felt to be essential and relevant, it recorded the transition to the new, and it recast the whole in terms that created a particular identity: Cajun, Japanese-American, Polish-American. Ethnic identity was not inborn, nor was it the creation of government or other institutions; it was the communal creation of immigrants sharing solutions to the new and harrowing challenges they faced, among them the danger of being swallowed up in anonymity and anomie. Ethnic identity was a social

and spiritual safety net that worked. And it still is for many Americans: in the 1980 census, the first in which Americans could identify themselves in terms of their own ethnicity, 83 percent did so.[36]

Nevertheless, as time passes and America appears to become ever more homogeneous, we might begin to wonder about ethnicity. Is it really there any longer? How and where and when is it expressed? Except in certain places, most of us do not experience ethnicity on a daily basis. And although we might recognize more ethnic expression if we knew how to look, there are other good reasons for its elusiveness. First, ethnicity is often private rather than public. Second, it is situational, expressed only on particular occasions. These two ideas need to be examined, one at a time.

A great deal of ethnic self-expression takes place within people's homes and in religious settings rather than on the street. It was National Heritage Fellow Joe Heaney's father "who, according to Joe, would always counsel him never to sing a song in public until he was totally familiar with its essence—not just the surface realities of the words and music."[37] This is good advice for any performer, but it has special meaning for those ethnic artists who would consider sharing the intimacy of culture-based communication with the general public. What bears the deepest of meanings for members of an ethnic group may be a passing curiosity to the outsider who catches only the surface of meaning.

Though Joe Heaney was the inheritor of "a great store of songs and ancient lore from his father . . . , his art . . . forged in an area long renowned for its wonderfully talented singers, and his own style . . . redolent with the subtle complex nuances of Connemara *sean nós*," he sang in public only rarely until late in his life.[39] In Ireland, he won first prize at the Feis Cheoil in 1940, establishing himself as a major singer of traditional music.[40] But after he emigrated to America in 1962, he spent many years working as an elevator operator in Manhattan. A story is told about a famous television talk-show host who visited Ireland and noticed a photograph in an honored place behind the bar in a pub. "Who's that?" he asked. "Why that's Joe Heaney, the greatest singer to come from here. He lives in New York."

"And he operates my elevator and works as a doorman," thought the American. When Merv Griffin returned to the United States, he invited Joe Heaney to appear on his show.[41]

When Heaney was included in the first group of National Heritage Fellows in 1982, he articulated his own talent as one inherited from a community that held its artists in high regard: "These people inspired me. After a hard day's work, they'd sit down around the fire. They forgot their tiredness. . . . They sang their songs and told their stories. . . . I grew up admiring these people, and they always gave me good advice. Wherever you go, bring your identity with you. Your identity is your language, and your songs, and your stories."[42]

The Rocks of Bawn

My shoes they are well worn now
My stockings they are thin
My heart is all-a-trembling
For fear I might give in.
My heart is all-a-trembling
From clear daylight till dawn
And I'm afraid I'll never be able
To plough the Rocks of Bawn.[38]

Joe Heaney's favorite song

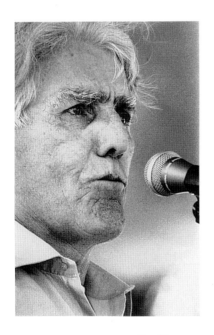

Joe Heaney,
Irish-American singer

Speaking about the creation of song and poetry, Heaney stressed the poet's debt to the spoken language: "Poems are composed by poets. Our one poet in particular said that he never composed anything. It's the words that other people said that he put together and put it in poetry."[43]

The privateness and humility of Heaney's ethnicity are also characteristic of other groups in the United States. For instance, the rooms of Norwegian homes in the upper Midwest are typically decorated with rosemaling and woodcarving, two traditional Norwegian arts. Marion J. Nelson, the director of Vesterheim, the Norwegian-American Museum in Decorah, Iowa, writes that "the appeal of rosemaling today . . . lies to a great extent in the ethnic associations with the art. It has become the symbol of an ethnicity to which the Norwegian-American people again feel a desire to be linked."[44] Especially in northeast Iowa, southern Minnesota, southern Wisconsin, and eastern South Dakota, bookshelves and small tables become Norwegian-American shrines. A lucky owner might have a mangle, spoon, or bowl carved by National Heritage Fellow Leif Melgaard or a plate, chair, or chest painted by National Heritage Fellow Ethel Kvalheim. While not the only producers of such objects, Melgaard and Kvalheim have created objects whose importance lies in their representativeness as well as in their excellence. They stand for all the unnamed woodcarvers and rosemalers who make the tradition and who, in doing so, articulate their shared ethnic heritage.

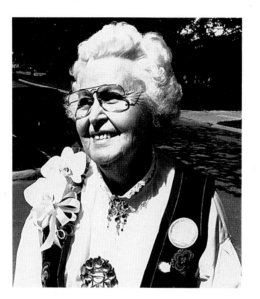

Ethel Kvalheim,
Norwegian-American rosemaler

Ethel Kvalheim inherited a tradition that had nearly died out. In Norway, rosemaling, or "rose painting," was at one time practiced by itinerant male painters who decorated walls, ceilings, furniture, and other items. Over the course of time, distinctly regional styles developed, among them Telemark, Hallindal, and Hardanger, all named after provinces in Norway. Its heyday in the rural areas of Norway lasted from early in the eighteenth century through the nineteenth.[45] Thus, Norwegian immigrants to America—who came mainly from rural districts like Telemark and Hardanger during the period from 1840 to 1915—left their country at a time when the tradition was thriving. The rosemaled objects they brought with them, including spinning wheels, ale bowls, and other everyday domestic items, soon became treasured family heirlooms. Sometimes rosemaling appeared even on the exterior of the wooden trunks that contained all the immigrants' possessions.

There is no evidence of rosemaling's being practiced in America until about 1930, when one man, Per Lysne of Stoughton, Wisconsin, "discovered that after over twenty years of striping wagons, he could again make a living on the family art of rosemaling."[46] Lysne's father had been a rosemaler in Norway, and wagon striping—painting decorations on wagons—is not far removed from rosemaling. Lysne adapted the tradition he knew from Norway to a variety of objects and "chose to work with American colors, including pinks and other pastels, to satisfy American home decor tastes, instead of sticking with traditional Norwegian colors [blues, greens, reds, yellows, and whites]."[47] Thus, Per Lysne was an innovator as well as a revivalist within the tradition.

Ethel Kvalheim, a young neighbor who lived only a block away from Lysne, used to stop to talk with him and to watch him work in his garage studio. In 1942, she began rosemaling herself, experimenting with the technique but also studying the heirloom examples that decorated the homes of other Norwegian Americans in and near Stoughton. When rosemaling workshops by visiting Norwegian masters began to be offered at the Vesterheim Museum each summer in the late 1940s, Ethel Kvalheim was one of the first students. A keen observer with natural artistic gifts, she became a key link in the American revival of rosemaling. As folklorist Janet C. Gilmore writes, "She took inspiration from him [Per Lysne] and became, artistically, one of his few direct descendants . . . whereas 'everyone' had some of Lysne's work in their homes at one time, now 'everyone' has some of Kvalheim's. Locals acquire her work to display symbolically in their homes and businesses as badges of their ethnic and community identity."[48] Well before she became a National Heritage Fellow, Kvalheim was the acknowledged "premier senior rosemaler of the United States."[49]

Although rosemaling in America has become a popular phenomenon, extending well beyond its ethnic Norwegian origin, Kvalheim carries the heritage forward as a native heir. She practices not only Norwegian-American styles, but is a master of Norwegian regional styles as well. The seemingly endless list of her prizes and awards, including the first Gold Medal of the Vesterheim Museum and National Rosemaling Association in 1969 and the Medal of Saint Olaf from the King of Norway, come from Norwegian as well as American judges.[50]

Like Per Lysne, Kvalheim has been a teacher and model for many other rosemalers, and her excellence has helped Stoughton maintain its preeminence as the center of traditional Norwegian-American rosemaling. Works like her 1976 rosemaling of the entire interior of the Stoughton Home Savings and Loan Bank make a powerful statement about the connection between tradition and community. But most of her work has been done on small objects like bowls, plates, pitchers, lidded boxes, and planters, evoking

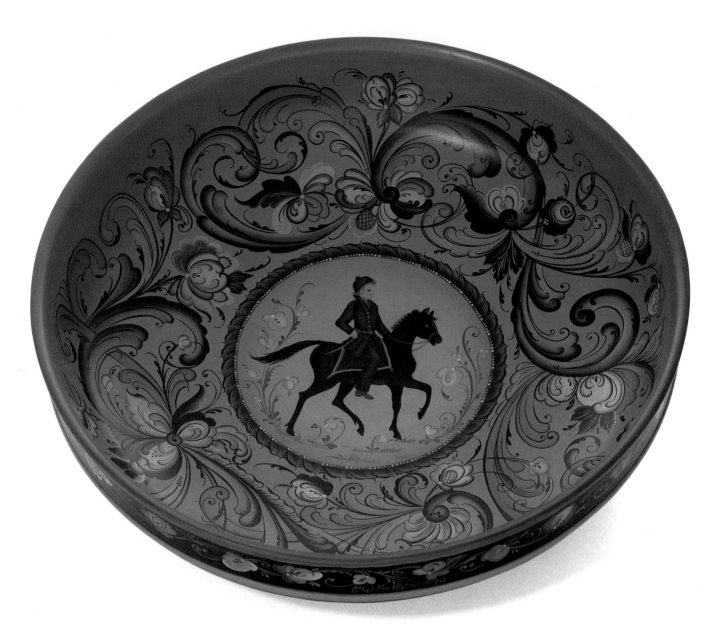

Bowl.
By Ethel Kvalheim,
Stoughton, Wisconsin.
Wood, painted in the
Telemark style,
16" diameter,
c. 1989

Porringer.
By Ethel Kvalheim,
Stoughton, Wisconsin.
Wood, painted in the
Telemark style,
10" high,
c. 1989

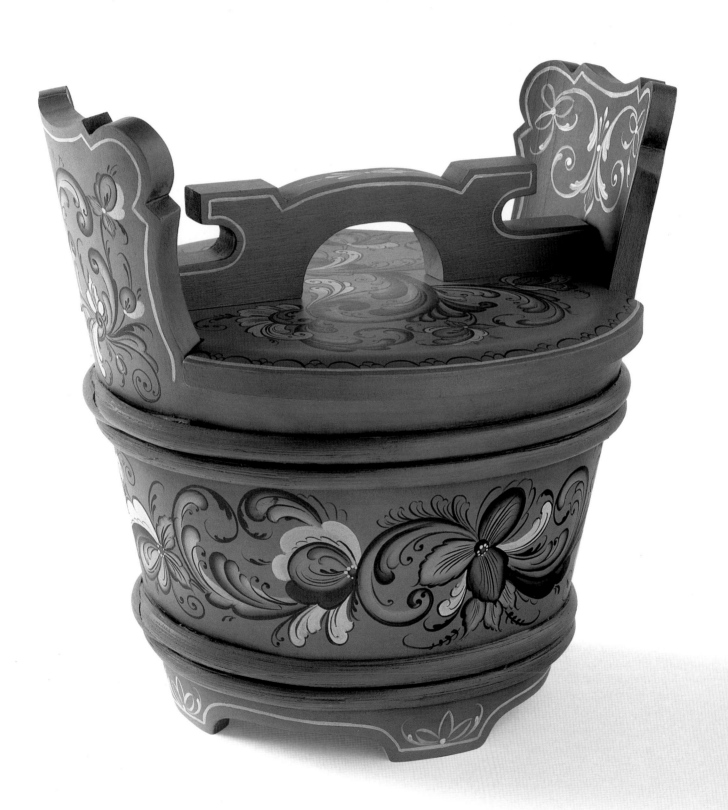

the homey intimacy of ethnicity in America. Kvalheim herself is a quiet person, continually learning from her own experimentation and from other rosemalers. Her work has had widespread exposure, appearing in books on rosemaling, in magazines, and in national and international exhibitions.

In contrast to rosemaling, woodcarving was a well-nourished tradition among Norwegian Americans from their earliest days in America. As Marion J. Nelson writes, "Woodcarving has been the most consistently practiced traditional craft among the immigrants from Norway. There is not a decade since 1860 without significant work."[51] In fact, a 1978 exhibition of Norwegian-American woodcarving presented the work of forty-three artists known by name, including National Heritage Fellow Leif Melgaard.[52]

Norwegian woodcarving has flourished in the upper Midwest not only because of its ample woods, reminiscent of Norway's forests, but also because some immigrants, like Melgaard, had "formal" training in crafts schools in the old country. Since folk art skills are usually thought of as informally communicated, one might expect that such training would disqualify an individual from being considered a folk artist. Discussing this issue in his book *The Spirit of Folk Art*, Henry Glassie writes that "the potential for cultural disruption makes formal schooling emblematic of all that is not folk."[53] Formal schooling usually brings national culture to the local level and often in turn suppresses indigenous ideas and expressions. But to think of the classroom as epitomizing the opposite of the folk process is actually a simplification, for much that *is* folk goes on within schools.[54]

Glassie describes another kind of place to learn, the atelier, an ancient and widespread system whereby artists work together, in a family or a "school," communicating skills, techniques, and aesthetic traditions in varying degrees of formality. This system has been the most widespread and efficient in producing crafts throughout history and for most of the world. Glassie calls the atelier the very emblem of an integrated society, because he considers folk art to be "the result and cause and symbol of cultural connectivity."[55]

In other words, when a school is culturally connected—as was Melgaard's in early-twentieth-century Norway—it may produce folk artists as well as folk art. Melgaard's school—the Craft School of the Museum of Industrial Arts in Dakka—was part of a movement to care for indigenous culture: "By the last decades of the nineteenth century, a conscious effort to preserve the native artists of Norway had begun. Schools in traditional wood-carving were established in Oslo and in the rural communities where the traditions had been strongest."[56] The creation of such schools marked the onset of modernity and a growing awareness of an endangered cultural heritage. Melgaard's school approximated the atelier in its purpose and character. Designed to conserve culture, to be a tool for the continuance of an inherited

tradition, it relied on acknowledged masters of tradition as teachers. Classes were small, students were serious, and much time was set aside for work.

Born in 1899 to a peasant family in rural Norway, Melgaard was encouraged to carve by his uncle, a talented local woodcarver. At seventeen he enrolled at the Craft School in Dakka for six weeks, the length of the course of study. (That was all the "formal" instruction he received in a sixty-year carving career.) His training at the school included cabinetmaking and, most significantly, woodcarving with the great teacher Lillevik, the master of a tradition called Gudbrandsdal. Employing magnificent elaboration of leaves, vines, scrolls, and grotesque animals, Gudbrandsdal forms the basis for Norwegian carving in America.[57]

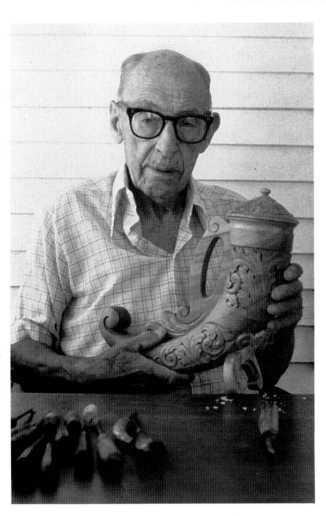

Leif Melgaard,
Norwegian-American woodcarver

Melgaard came to the United States in 1920 and worked for a while as a farmer for an uncle in Minnesota. Eventually settling in Minneapolis, he was a carpenter and cabinetmaker from 1926 to 1964. During this time, he continued to carve, sometimes receiving special commissions to do ornamental work. Nelson writes that "when his wood carving ability was allowed to blossom forth upon his retirement, he could work with complete mastery in figure carving, Italian Renaissance carving, and the Norwegian Baroque carving."[58] Melgaard's work ranges from spoons, plates, and cupboards to large, complex structures like the altar at the Norwegian Lutheran Memorial Church in Minneapolis.

Another master of woodcarving, National Heritage Fellow George López, offers an instructive contrast with Leif Melgaard. López's santos (carved religious figures) are stark, flat, and unadorned, while Melgaard fills every space with the most ornate and baroque permutations. López commonly carves crosses, animals, and especially the human figure in a religious attitude, while Melgaard adorns everyday, inanimate objects, like bowls and spoons. One is a Hispanic Catholic from northern New Mexico, a descendant of ancestors who began settling this area of the Southwest in 1590, the other, a first-generation Norwegian Lutheran immigrant to the Midwest. Each, in his own way, clarifies the essence of his ethnic group's spirit through a transformation of the same natural material. The underlying importance of both men's work is that their visions are not theirs alone. They are shared by the many generations of woodcarvers they represent—at least six in López's family itself—and by the communities that depend on their work for ethnic and spiritual identity.

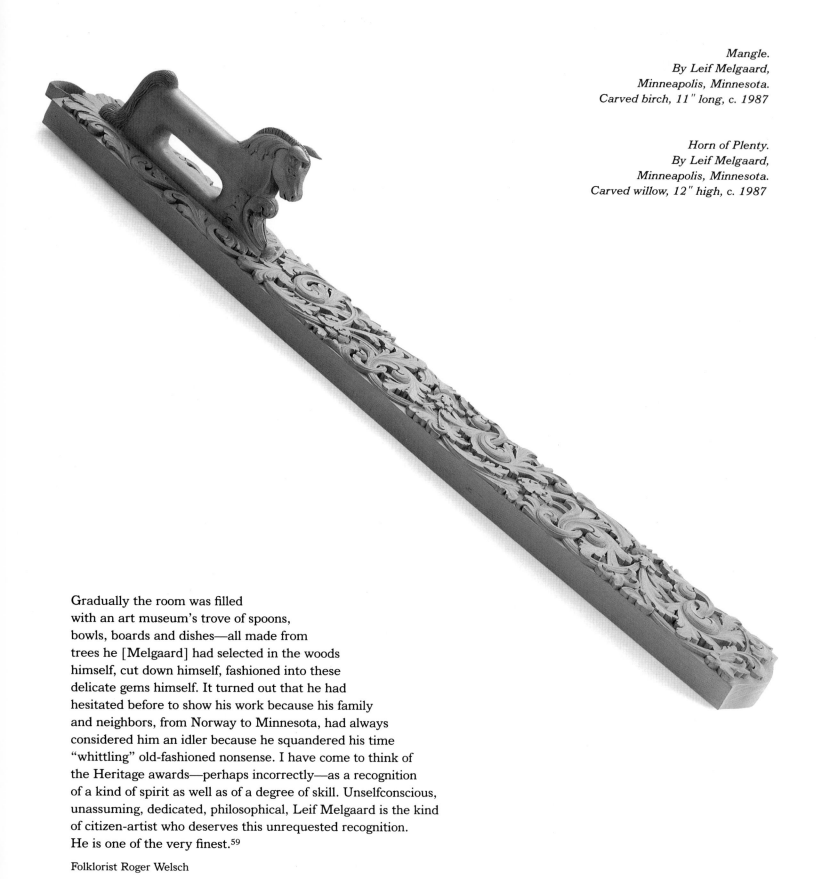

Mangle.
By Leif Melgaard,
Minneapolis, Minnesota.
Carved birch, 11" long, c. 1987

Horn of Plenty.
By Leif Melgaard,
Minneapolis, Minnesota.
Carved willow, 12" high, c. 1987

Gradually the room was filled
with an art museum's trove of spoons,
bowls, boards and dishes—all made from
trees he [Melgaard] had selected in the woods
himself, cut down himself, fashioned into these
delicate gems himself. It turned out that he had
hesitated before to show his work because his family
and neighbors, from Norway to Minnesota, had always
considered him an idler because he squandered his time
"whittling" old-fashioned nonsense. I have come to think of
the Heritage awards—perhaps incorrectly—as a recognition
of a kind of spirit as well as of a degree of skill. Unselfconscious,
unassuming, dedicated, philosophical, Leif Melgaard is the kind
of citizen-artist who deserves this unrequested recognition.
He is one of the very finest.[59]

Folklorist Roger Welsch

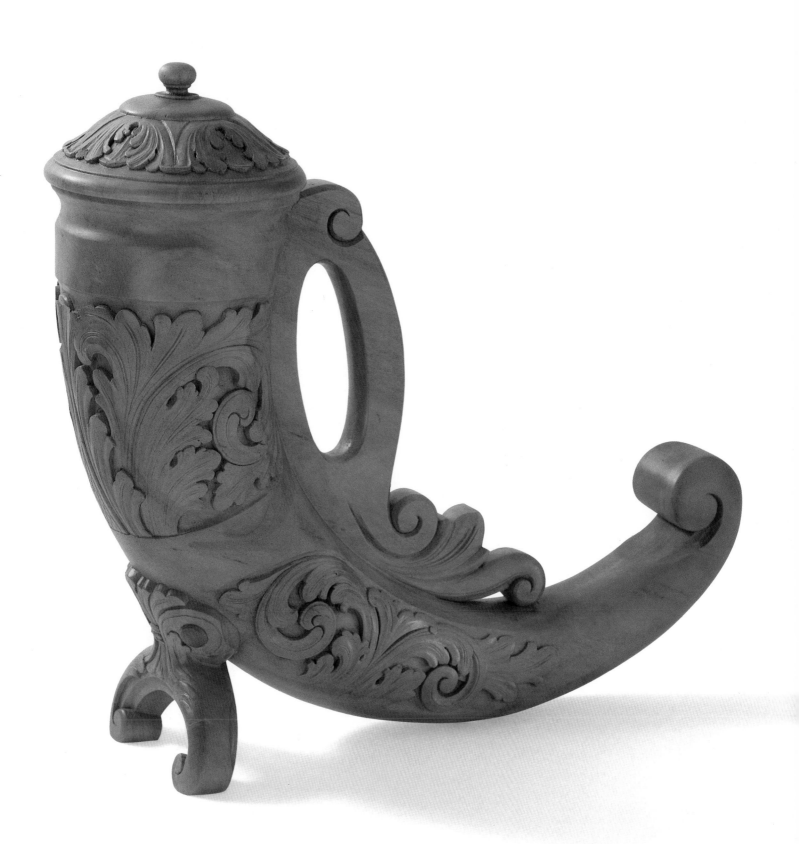

George López,
Hispanic woodcarver

If the National Heritage Fellowships had been established when José Dolores López was alive, he would have been recognized for the brilliant innovations he made within his tradition. His son George was, however, named a Fellow for continuing the inheritance redefined by his father. Both kinds of folk artists—innovators and inheritors—are a necessary part of tradition, and they often follow each other in just such a sequence as the Lópezes'.

José Dolores López was born in Córdova, New Mexico, in 1868.[60] Learning from his father, Nasario, who was also a carver, José worked at carpentry and furniture making, but his main occupation was farming and ranching. There had been a local tradition of carving and painting santos that dated back to the eighteenth century, but it seems to have become dormant by José Dolores López's time. Although he built many kinds of furniture, often painted with playful decorative motifs such as animals and flowers, he did not begin to carve santos until relatively late in his career.

José Dolores López took up the carving of santos in 1917, partly to occupy a mind worrying over a son gone to war, partly in response to rapidly changing conditions in northern New Mexico beginning at the turn of the century. Decisions by the federal courts and actions by the Forest Service had reduced the access of local farmers to traditional grazing lands, with the result that the agricultural economy was deteriorating. At the same time, a new economy was being created, as Santa Fe and Taos began to emerge as distinguished artist colonies. José read the situation well: his creativity as an artist gave him a way to survive with no loss of dignity. With exquisite integrity, he created a style that emphasized the wood itself, substituting chip-carving for the painting of detail. While he paid attention to the suggestions of Anglo patrons, he interpreted their ideas in his own way. Inspired by drawings in old books, but also by the santos and *bultos* (sculptured figures) in local chapels, his work was religious, whether or not non-*Mexicano* patrons—interested in beautiful objects independently of their community-derived basis and meaning—realized it. Folklorist Charles Briggs writes that "relatives and neighbors recall the delight which he took in carving."[61]

Though José Dolores López did not become wealthy, he created an artistic and economic foundation that not only his own family but many others have continued to build on. All his children became woodcarvers, and today his great-grandchildren keep the tradition alive in Córdova, which is known as a town of artists who carve in López's style. His work remains in the Córdova church.

The most famous of José Dolores López's inheritors is his son George, born in 1900. Like many native Córdovans of his generation, George was forced by the changing economic base to find work away from home for much of the year. At the age of nineteen, he began working for the railroads on jobs that

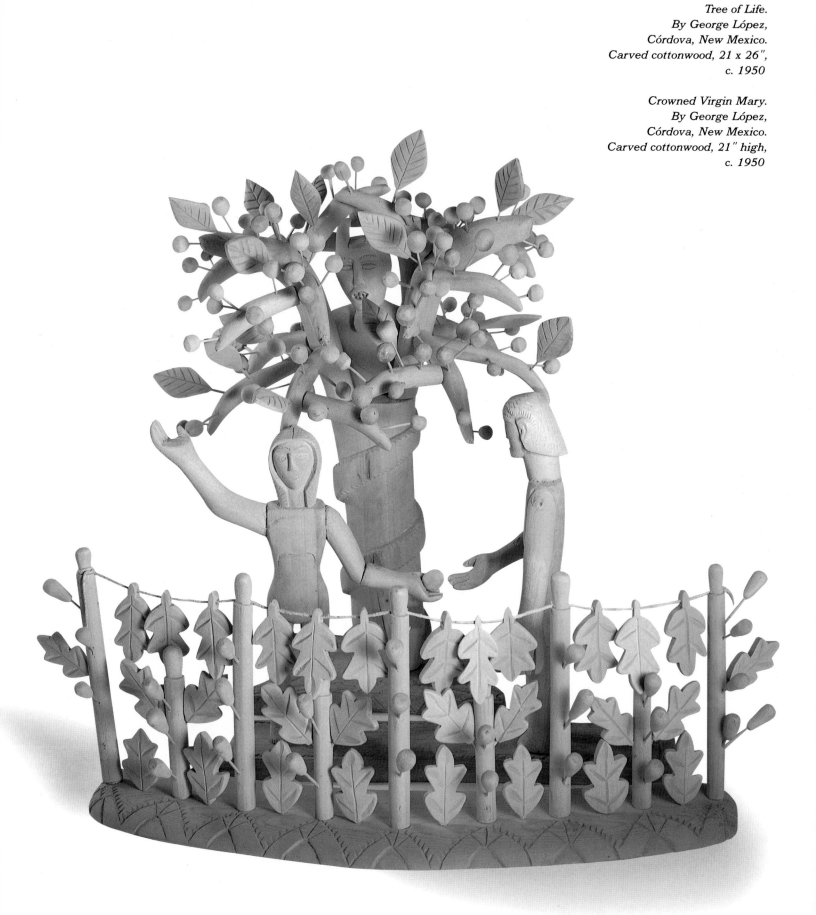

Tree of Life.
By George López,
Córdova, New Mexico.
Carved cottonwood, 21 x 26",
c. 1950

Crowned Virgin Mary.
By George López,
Córdova, New Mexico.
Carved cottonwood, 21" high,
c. 1950

In the mountains of northern New Mexico, in the village of Córdova, José Dolores López developed an original style of carving that thrives today among his great-grandchildren. . . . His son George gathered the old man's energy, made it his own, and scattered it into a profusion of crosses, stark saints, and trees full of animals that stand like fragments of a shattered spirit. . . . Studying his work and the treasures surviving from his father, remembering the lessons of childhood, the next generation has kept the family's art surging with life. . . . Sabinita López Ortiz has quickened the style, streamlining it toward expressive essences. Gloria López Córdova has made it a vehicle for exquisite workmanship, while refining and expanding the repertory of forms. Their carving and the carvings of their children interlock into a neat unity that is the spirit of old José Dolores alive in the world.[62]

Folklorist Henry Glassie

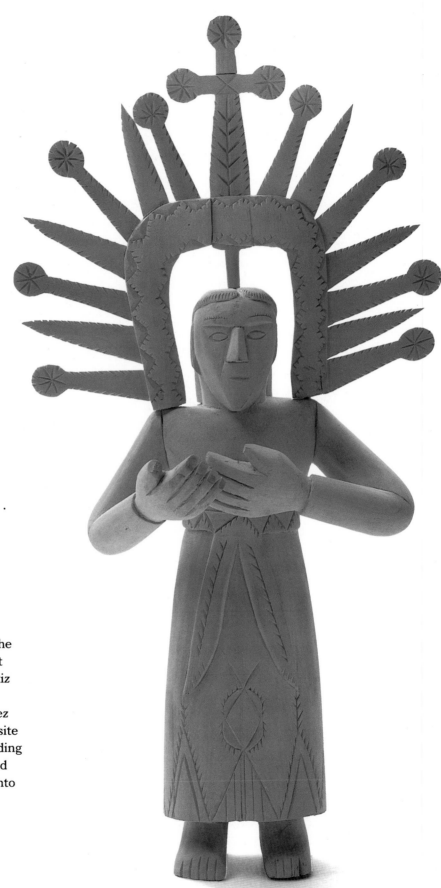

took him to other parts of New Mexico, Colorado, and Wyoming. He later worked at the atomic plant in Los Alamos. By the 1950s, his carvings were in such demand that he was able to turn to carving as a full-time occupation and, finally, work out of his home.

Following his father's example, George took the aspen, cedar, cottonwood, and pine of the Sangre de Cristo mountains and engraved it with expressions of his people's deepest beliefs. His first major piece was a Tree of Life, depicting Adam, Eve, and the serpent in the Garden of Eden, carved in 1937. But the santos are his most familiar works, and his reputation rests upon them. Among George's many honors has been participation in the Smithsonian Institution's Festival of American Folklife. His work is displayed in the permanent collections of museums throughout the United States as well as in London and Paris.

National Heritage Fellows like Joe Heaney, Ethel Kvalheim, and Leif Melgaard provide good examples of how ethnicity may be a private, home-based kind of expression, and thus not often publicly seen. Another reason ethnicity may not be highly visible is that its expression is usually situational. Ethnic identity, for many Americans, is only one of several identities: occupational identities, for instance, come to the fore at work, family identities control life at home, and religious identities are often stimulated by specific symbols, events, and ceremonies.[63] Even though we may constantly carry around an inner sense of ourselves as Chinese American, Anglo American, or Greek American, the particular behavior that expresses that identity externally is evoked by some situations and not by others.

Much of the time, ethnicity—like these other identities—may be deeply felt but not outwardly visible. This latent ethnicity is triggered and expressed only on certain occasions, like holidays. A Japanese-American family, for instance, may participate as fully in local life as everyone else does, but become totally immersed in Japanese folk culture during their Obon festival and on New Year. One of the most enduring of ethnic traits seems to be allegiance to traditional foods, and many families prepare some item, if not a whole menu, of traditional foods on holidays and special occasions.

Several Eastern and Central European ethnic groups decorate Easter eggs—fragile symbols of rebirth and return—with the ancient, local symbols of their beloved homelands, symbols which now, in America, express ethnicity as well as religious belief. The Ukrainian art is called *pysanky*, Croatians make *pisanica*, and Moravians, Czechs, and Slovaks dye *kraslice*. National Heritage Fellow Kepka Belton, of Ellsworth, Kansas, is a fine example of the persistence of the Czech tradition of egg decorating at Easter; she belongs to the fourth generation of her family to have made *kraslice* in Kansas.

All traditional ethnic celebrations, whether annual holidays or those touched off by rites of passage, derive their deepest expression and emotion

from folk artists. In both good and bad times, these cooks, musicians, dancers, and makers of objects draw on the group's inheritance, channel it through their art, and literally recreate the group through shared emotion. Folklorist Robert J. Smith writes that "the prime function of the festival is to provide occasion and form for positive group interaction, which is a necessary condition for the continued existence of the group."[64] Without folk artists, there would be no music to get lost in, no songs to intoxicate and hypnotize, no food to savor, no objects rich in memory and association to touch and see. In short, where ethnicity and festivity are concerned, folk artists are the irreplaceable magicians who play to all our senses—sight, hearing, smell, taste, and touch—bringing shared inheritance, and ourselves, to life.

Masks, like communities, come to life on certain dates of the year. Probably one of the most ancient of art forms, they still command our attention by bearing powerful, inherited messages that make us reconsider everyday reality. Think of the bank teller or grocery clerk who wears a mask and costume on Halloween. Suddenly, in not recognizing the person behind the mask, we realize that we rarely acknowledge the real individual behind the everyday mask of bank teller or grocery clerk. Paradoxically, the mask unmasks what is hidden in the business of every day and serves as a gateway to recognizing our common humanity. Like other expressions of ethnicity in America, masks derive their power partly from the fact that we do not see them all the time but only on particular, annual occasions. Set aside, their power contained, they explode on the scene on these special days.

Wandering masked figures, who provide the playful fright that delights children and startles adults, have been part of the *carnaval* (carnival) tradition in Puerto Rico since at least the mid-eighteenth century. Each year, as new masks are needed for *carnaval*, the artists of Ponce and other southern Puerto Rican towns devote all their skills to developing their own styles of devilish designs. These papier-mâché countenances (*máscaras de cartón*) have horns sprouting in all directions, bared teeth, and long, jutting snouts projecting in garish splendor. They are made by layering sheets of paper and gluing them together with wheat-flour paste. When the right thickness is achieved, the layered paper is formed around a mold and dried. Elements like horns and teeth can be added to the basic shape by the same process. Once constructed and dried, the mask is painted with bright oil paints—red, yellow, blue, green, and black.

National Heritage Fellow Juan Alindato from Ponce is a master of the *máscara de cartón*.[65] A dockworker for most of his life, he learned his mask-making skills from his wife's aunt, Francisca Salvador. Although Alindato's fantasy monsters draw on the work of the many makers of *máscaras de cartón*, they are among the most finely crafted and powerfully expressive. Their presence as living beings is undeniable. His masks are widely sought

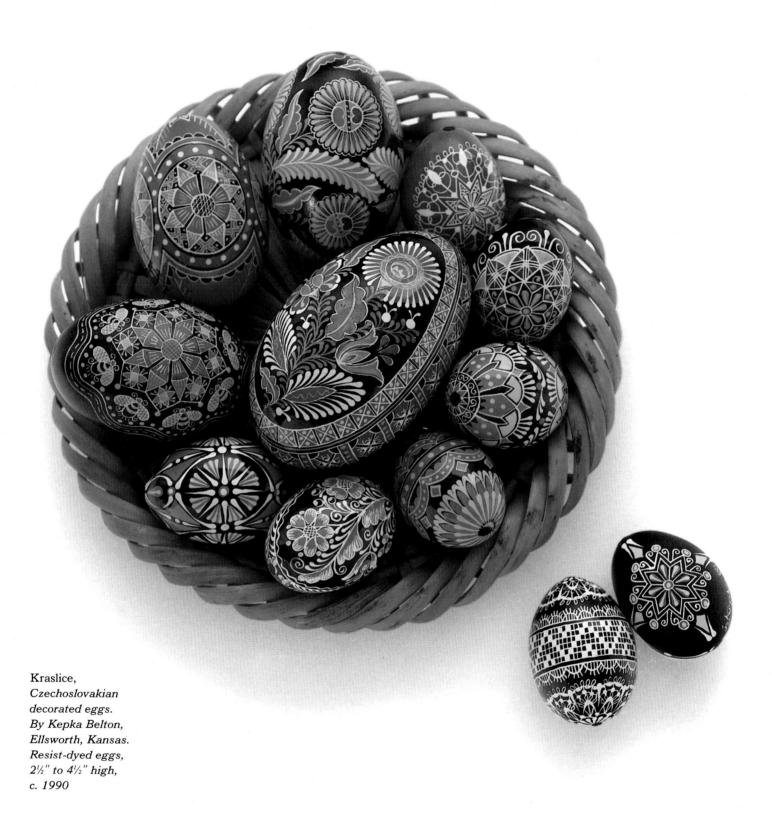

Kraslice,
*Czechoslovakian
decorated eggs.
By Kepka Belton,
Ellsworth, Kansas.
Resist-dyed eggs,
2½" to 4½" high,
c. 1990*

Vejigante de Ponce,
*carnival mask.
By Juan Alindato,
Ponce, Puerto Rico.
Painted papier-mâché,
20" high, c. 1988*

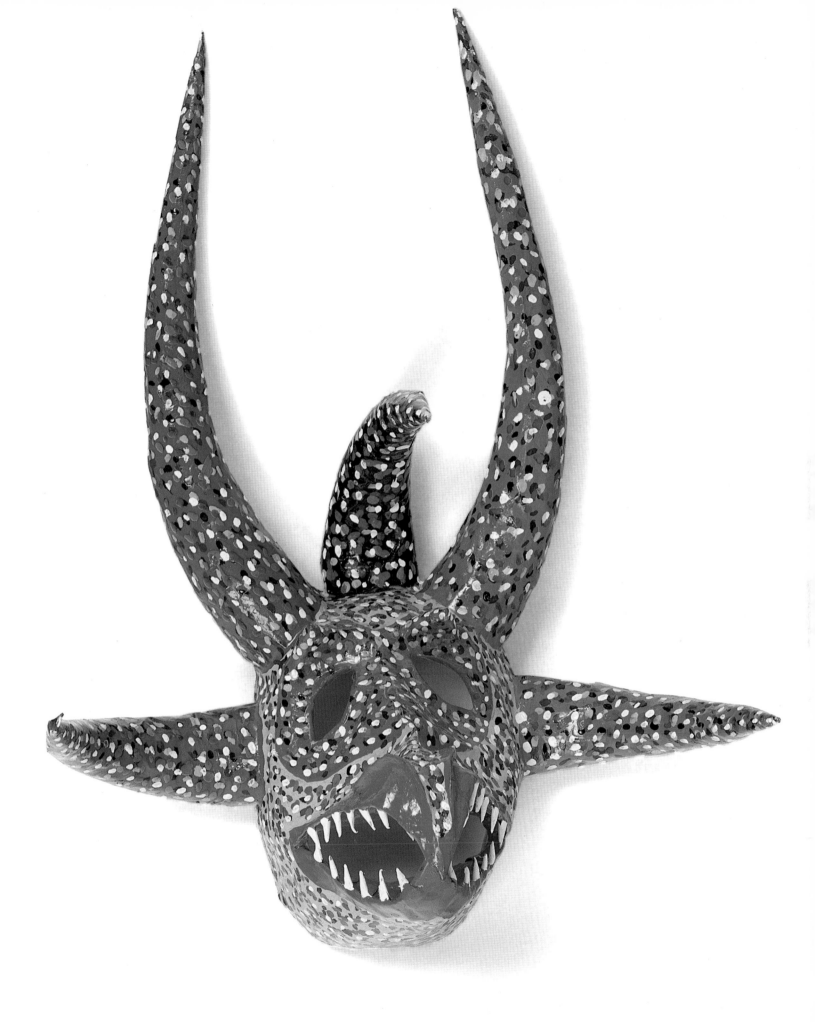

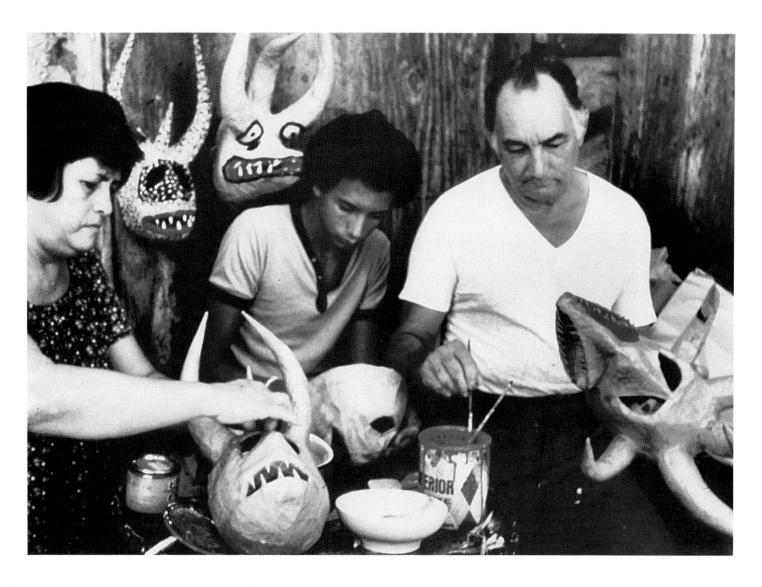

after in his own community, for exhibitions in the continental United States and Europe, and by private collectors.

Alindato has involved his whole family (including his five children) in his mask-making enterprise, which has become a family business as well as a small atelier, and he has also given workshops and demonstrations in his community. He epitomizes the folk artist who carries a tradition forward without major changes, who finds an inexhaustible source of expressiveness within that tradition, and who works with total involvement and the highest standards of excellence.

Other bearers of Hispanic folk traditions, in other parts of the United States, have also grown up surrounded by their inheritance and have become rallying points of ethnicity within their communities. They are also loved outside their own ethnic groups—Hispanic musicians and their music attract millions of other Americans. Among the National Heritage Fellows, there are three Mexican-American accordionists, besides the influential songwriter,

guitarist, and singer Lydia Mendoza, the "lark of the border."[66] The words to Mendoza's songs, or even just the melodies, can effortlessly evoke powerful emotions.

Whenever ethnicity emerges in celebratory fashion, musicians are practically a necessity—sometimes they themselves even call forth ethnicity. José Gutiérrez and his energizing *jarocho* music provide many Mexican Americans, and others worldwide, with a medium that touches them deeply.[67] Gutiérrez is a total artist: he not only sings and plays all the musical instruments in a *jarocho* ensemble—like the *jarana* (rhythm guitar), the *mosquito* (the smallest of *jaranas*), the *requinto* (melody guitar), and the *jarocho* harp—he knows how to make them all, and does, as well. Born in 1942, near Veracruz, Mexico, on a ranch named "the palm tree coast" (*la costa de la palma*), Gutiérrez could not have avoided hearing and seeing local music performed even if he had wanted to. Like other *jarochos*—as the people of this region are called—he grew up farming, shrimping, and fishing. But his grandfathers, father, and uncles were musicians, and he began to play when he was seven.

Mexico has developed a wealth of regional musical traditions—*mariachi* music, originally from Jalisco in western Mexico; *conjunto de arpa grande*, from Michoacán; *conjunto tamborita*, from Guerrero; the *trío huasteco*, from the Huasteca; and, of course, *jarocho*, from Veracruz—to name a few.[68] Many of these regional traditions can be heard in the capital, and many of the finest musicians are attracted to the artistic opportunities the metropolis provides. As a young man, Gutiérrez moved to Mexico City to play in the best modern *jarocho* ensemble in Mexico. By the late 1960s, he was touring throughout Europe, the Philippines, Australia, South and Central America, and Canada. He eventually settled in Norwalk, California, near Los Angeles, but has been an artist-in-residence at the University of Washington in Seattle, served as master artist/instructor at the Centro Cultural de la Raza in San Diego, and acted as master teacher and artist for many apprentices in California. Gutiérrez has performed before the nation's most highly regarded forums for the presentation of folklife—the National Folk Festival, the Smithsonian's Festival of American Folklife, the Old Town School of Folk Music in Chicago, and the World Music Institute in New York City.

The experience of hearing Gutiérrez and his *jarocho* ensemble play cannot be described, nor can it be forgotten. The excitement and intensity of *jarocho* music rise above language. Musically complex, multi-voiced, and fast-paced, *jarocho* music combines elements of Spanish and African musical traditions to create a sound that is simultaneously forceful and playful. Improvisation is a valued part of the tradition, and Gutiérrez will often sing about members of the audience, describing them in formulaic phrases that joke, tease, and narrow the gap between performer and audience. As communicated by

He [José Gutiérrez] can remember staying up till all hours of the night listening to the men of his family making their music, until at last he would fall asleep on the floor at his uncle's feet still clutching his beautiful little guitar.[69]

From *The National Heritage Fellowships 1989*

José Gutiérrez, Mexican-American jarocho musician

Gutiérrez, *jarocho*'s thick, compelling sound often captivates outsiders and creates interest in the culture that produced it.

Inheritance is passed not only from one generation of an ethnic group to the next, but also between workers who are members of the same occupational group. For many Americans, in fact, occupational identity provides a sense of self more fundamental than ethnicity. Folklorist Robert McCarl, who studies the culture of American workers, writes: "Fire fighters, doctors, houseworkers, and the members of any work culture perceive the world differently because their work forces them to describe their experiences in occupational terms and that description reinforces their unique vocational perspective."[70]

Metaphors from occupational experience sometimes overflow into everyday speech; thus, we all know what a "false alarm" or a "milk run" is, but we rarely think back to the occupational origins of these terms. For the fire fighter or the delivery man, on the other hand, these terms and all the language of their jobs resonate with meaning that grows from lived experience. Each occupation is rich, not only in its store of metaphors, but also in its informally communicated work technique, material culture, custom, and even performed traditions like music and story.[71]

Different occupations manifest and emphasize artistry in different ways. Sheet metal workers and welders, for instance, take pride in the craftsmanship and excellence of their welds—in other words, in the work technique

itself. Miners have created beauty of expression in their well-known repertoire of songs, while transportation workers have found meaning in their artful occupational narratives.[72] Cowboys have utilized all these areas—work technique, song, and story, as well as a complex and beautiful material culture—to express and to celebrate the character of their particular occupation.

Much of the cowboy style has been borrowed by others, and it still serves as a powerful symbol. The cowboy way of life, largely based on Hispanic roots, is widely recognized as an original American contribution to culture. Yet its romanticized, exaggerated, and stereotyped image—not to mention a changed economy and technology—lead many people to believe that there is no such a thing as a "real" cowboy any longer. There is. Cowboys and ranchers still raise the cattle that many of us eat as an occasional steak or hamburger, and the distinct occupational culture of ranch life still exists, especially in the arid West.

Paradoxical as it may sound, in an occupation marked by dirt, dust, mud, hay, sweat, manure, and blood, aesthetics play a large part in the cowboy's life. Some cowboys not only brand "in a most artistic way,"[73] they seem to be artists in everything they do. National Heritage Fellow Duff Severe of Pendleton, Oregon, is as fine an example as we are likely to find.

As a singer and storyteller, Severe traveled around the West and Hawaii with the National Cowboy Tour in 1983 and 1984. In 1987, he journeyed to Morocco to take part in a touring exhibition of American folk art in North Africa and the Middle East.[74] His saddles and rawhide work have appeared in folk art exhibitions and their accompanying catalogues.[75] Severe was named a Fellow in 1982, along with the other distinguished members of that first group.

Severe was born in the small Mormon town of Oakley, Idaho, in 1925. (Although he ended up in Oregon, his family is still involved in creating cowboy gear in the Oakley area: Bob Severe, a cousin, is one of the finest traditional saddlemakers in Idaho.[76]) Severe was born into a ranching family. As he says, both his grandfather and father braided rawhide, not to sell, but because "they needed articles on the ranch. . . . You just had to make your own things or go without."[77] When Severe talks about braiding rawhide into horse gear, he is succinctly describing the transformation of natural materials into beautiful forms, the essence of art: "I remember when I was about— must have been about—fourteen, when I really observed—not only my father, but other old western cowboys—that'd take these old bloody, hairy hides, and they'd take the hair off and clean 'em up. Pretty soon they'd have something beautiful braided out of it. It really impressed me, and I thought, that's something I really want to learn. So I learned what I could from those old fellows. . . . All my life I've been trying to add to what I learned from them."[78]

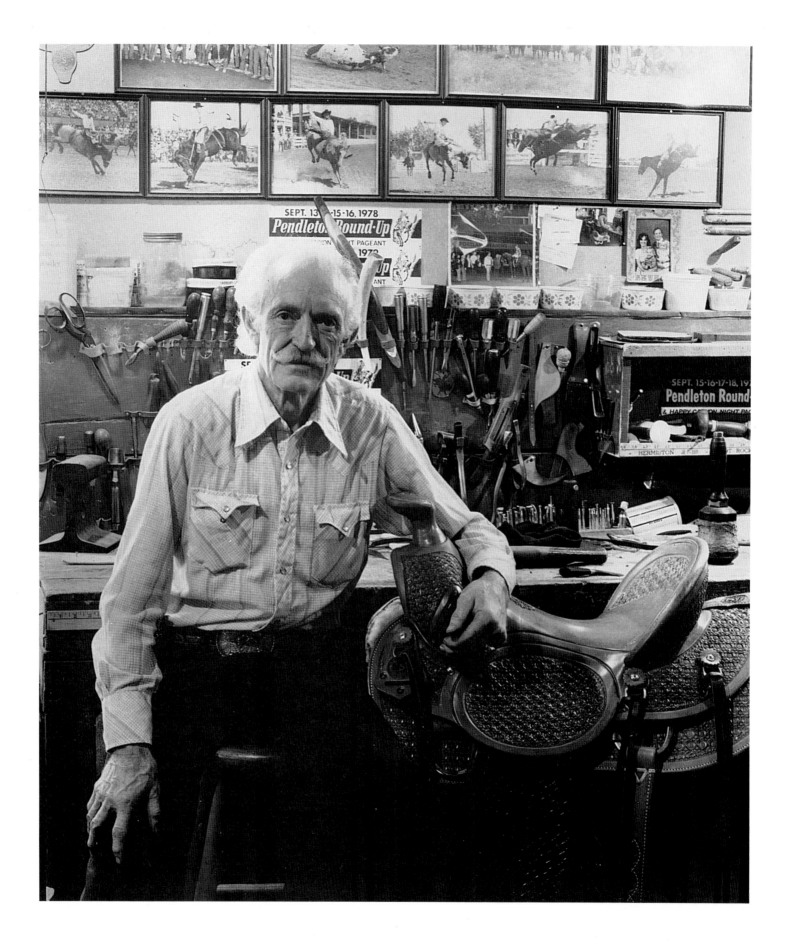

Advancing his own braiding skill far beyond the fundamentals, Severe did succeed in adding significantly to what he learned in Idaho. He used his knowledge of braiding to decorate bottles and decanters as well as the more traditional items. And he even managed to learn the techniques of Luis Ortega (another National Heritage Fellow, nominated by Severe), a man generally considered to be the greatest rawhide braider ever, and one who, like many old-time rawhiders, guards his knowledge closely. (The story of how Severe learned from him will be told later.) From the older master, Severe learned how to add color to rawhide, a technique that had been Ortega's great innovation.

Although his rawhide work is famous, Severe has made his living as a saddlemaker. The Severe Brothers Saddle Company specializes in official rodeo saddles and supplements this stock in trade with orders from working cowboys and buckaroos from far and wide. Severe originally learned his saddlemaking skills through a four-year apprenticeship, beginning in 1946, with the historic Hamley Saddle Company in Pendleton. After ten years with Hamley's, he began a saddle business with his brother, Bill. Bill specialized in building the wooden saddle tree that is the inner "skeleton" around which the saddle is built. Duff concentrated on building, carving, and decorating the leather part of the saddle.

As the business grew, the Severe Brothers hired other craftsmen and also took on apprentices. Both of Bill's sons, Randy and Robin, apprenticed in the shop. Of Duff as a teacher, Randy had this to say: "He was such a valuable teacher because he had the working knowledge and experience. He could not only teach me how to make a saddle, but he had the perspective on why a saddle should be made a certain way, on how you make a saddle adapted for cutting rather than roping. . . . He's an encyclopedia of knowledge that way."[80]

The artistic and cultural heritage that Duff Severe embodies and communicates has its roots in the Mexican tradition of the *vaquero* (cowboy). Eastern Oregon marked the northern periphery of the vaqueros' impact, and cowboys in that area, as well as in northern California, Nevada, and southwest Idaho, are still called "buckaroos" (an anglicized form of *vaqueros*). But the influence of the vaqueros reached much farther west than Oregon: even before there were vaqueros in what became buckaroo country, a handful of Mexican cowboys had already created a cattle industry in Hawaii. Since they were Spanish-speaking, they were known to the Hawaiians as *los españoles* ("the Spanish"), and cowboys in Hawaii today are simply called *paniolos*. The fascinating combination of Hispanic and native Hawaiian aesthetic ideas represented by the *paniolo* tradition was recognized by the naming of Clyde "Kindy" Sproat as a National Heritage Fellow in 1988.[81]

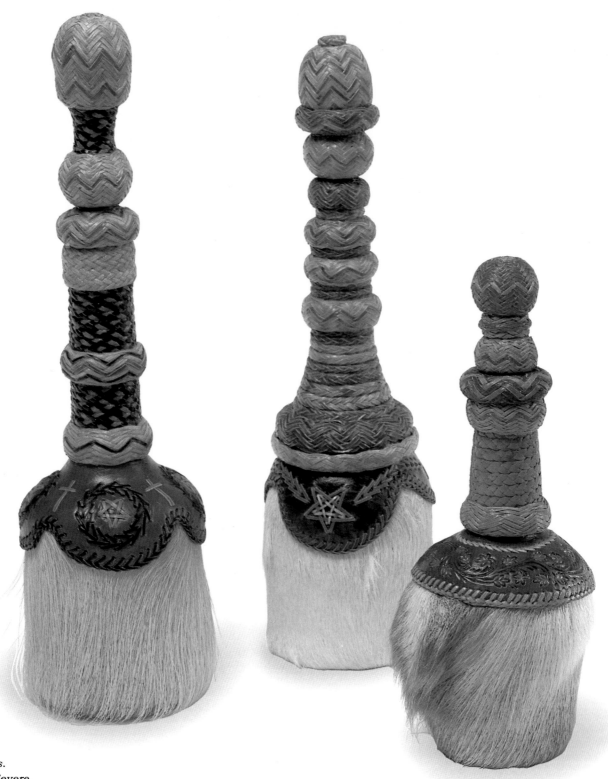

Decanters.
By Duff Severe,
Pendleton, Oregon.
Braided rawhide with fur (elk,
Rocky Mountain bighorn sheep,
and caribou) over glass,
15", 14", and 10" high, c. 1987

The first Mexican vaqueros in Hawaii were brought over from California in about 1830 to solve the problem of feral cattle, which had been introduced as domestic animals thirty-five years earlier. These original cattle (also brought from California, then part of Mexico) had been allowed to roam at will and were protected from slaughter by royal decree. Their numbers grew rapidly, and by the 1820s they were taking human life and destroying crops. The Hawaiians' solution was to hire Mexican vaqueros who caught and domesticated the wild cattle; in the process, they taught their skills, including musical ones like playing the guitar, to the first native cowboys. The impact of those first few vaqueros is still felt today, both artistically and commercially (some of the biggest individually owned ranches in the United States today are on the Big Island of Hawaii).

Today, the material culture of Hawaiian cowboys exhibits features both shared with, and distinctive from, other cowboy traditions of Hispanic origin. Both Hawaiian and Western cowboys cultivate the skills of rawhide braiding and horsehair rope twisting, and they both count on the protective and aesthetic qualities of vaquero-derived equipment like "bull-dog" and "mule-ear" *tapaderos*, or "taps." On the other hand, cowboys wearing leis around their necks and sporting hatbands made of fresh flowers, dried flowers, sea shells, feathers, or dyed sisal rope radiate a bright, colorful presence that contrasts boldly with that of the cowboys of the continental West, whose gear varies mainly in its dry shades of brown, tan, and silver. The colors seem, in both cases, to correspond to the cowboys' actual environments—the green, fecund, flower-rich landscapes of Hawaii contrasting with the arid, bunchgrass plateaus and rock-rimmed canyons of the Intermountain West. The cowboys of Hawaii have succeeded in integrating their Hispanic cultural origins with the local environment and with native Hawaiian ideas.

Clyde Sproat epitomizes this syncretistic heritage of native and imported culture, for his enormous song repertoire reflects both sources. As he was growing up in a remote valley (two hours by mule from the end of the road) on the Big Island of Hawaii, singing was an important source of entertainment for his family. Their songs included traditional Hawaiian, cowboy, patriotic, and Civil War melodies—some four hundred in all. His Hawaiian mother would play the five-string banjo for the family in the evenings. Sproat speaks eloquently about these times: "We sat on mats that were woven from the leaves of the pandanus tree and watched the reflection of the sun rising up the east wall of the valley, then dancing on the trees at the very top of the ridge before slowly fading out of sight. I sang my heart out. At that time I felt like we were singing the sun to sleep, so in the morning as he crept over the west ridge with his long shadowy legs, he would be warm and friendly and let us have another good day of swimming and fishing in the stream and doing all the things that little boys do in a day."[82]

Clyde "Kindy" Sproat, Hawaiian cowboy singer, ukulele musician

When Sproat was a little older, his family moved to town, to Niulii, where the six boys could go to school, but the summers were still spent in the remote valley of Honokane Iki. In town, he listened in at the saloon to hear the "sweet, haunting" slack-key guitar players—masters like John Akina, John Kama, Kalei Kalalia. He also had the positive experience of a grade-school principal who was a master musician and assembled the children every day to sing Hawaiian songs and learn their meaning. Sproat found

himself responding to this musical and narrative heritage: "While other kids my age were playing hide and seek and other games, I wasn't interested in playing games. I wanted to listen to the songs, stories and watch the old timers doing their dances. I was then thought to be a strange kid. I heard and saw things then, that made an impression on my mind that are still in my heart to this day."[83]

The songs Sproat heard were not the ancient Hawaiian chants that had once been accompanied mainly by percussion instruments. They reflected instead the change to western melodic forms and were accompanied by new stringed instruments like the banjo and guitar. By his time, Hawaiians had already made these new melodic modes and instruments their own. The ukulele that Sproat plays, for instance, is an instrument thought to have been derived from the Portuguese *branguiha*.[84] Yet the lyrics of his songs are solidly based in the Hawaiian language.

Sproat's importance as a tradition bearer lies not only in his song repertoire and the quality of his singing voice but also in his role as an articulate guide to the Hawaiian oral tradition. When he performs, Sproat provides his audiences with explanations and interpretations of the songs, delivering oral history, translations, proverbs, stories, and stories about stories, as well as music. As he says, "Every song's got a story, and every song I sing, I *see* the story."[85]

Like many folk artists, Sproat modestly shifts the spotlight away from his own individual talent to his community heritage: "Where I live I'm not considered a musician, not a very good one and I agree because I have no knowledge of music and music theory. My only connection with music is playing my 'ukulele and singing the songs of old that keep haunting me."[86] These comments have to be understood as coming from a musician who has been awarded the National Heritage Fellowship, has performed at Carnegie Hall, the National Cowboy Poetry Gathering, and the National Folk Festival, and has been a member of the national Cowboy Tour. But when Sproat himself talks about performing, he does not mention these events. He talks instead about singing with fellow soldiers in the barracks and alone on night patrols during World War II, singing at fairs and local events in Japan, where he was stationed after the war, singing at orphanages, old people's homes, for family gatherings and local festivals.

The gentle love that Clyde "Kindy" Sproat radiates is the core of the old Hawaiian heritage. Among those who share the same spirit is National Heritage Fellow Raymond Kaleoalohapoinaolehelemanu Kane, the living master of traditional slack-key guitar. Kane's middle name is a poem in itself, meaning something like "the voice of love that moves as a bird and cannot be forgotten." The name is appropriate, for it describes Kane's singing voice, his instrumental music, and his dedication to a heritage that also "cannot be forgotten."[88]

I hope and pray that someday I will find someone interested enough to learn these songs and stories. . . . Someone in whom I could impart this feeling that I have inside my heart and every fiber of my body of the love for Hawai'i, its songs and tales.[87]

Clyde "Kindy" Sproat

Kane earned his lessons in slack-key guitar—beginning at the age of nine—in an unusual way: "On the beach in Nanakuli, it was hard to convince the old folks to teach me. They liked their fish and I was a good diver to catch the fish. So we traded—I caught the fish, they teach me slack key."[89] The old folks were "hard to convince" because part of the tradition was private. Like the knots in rawhide braiding, many slack-key guitar tunings are personal, "trade secrets." Even in concerts, some performers have been known to turn away from the audience to change tunings.

The basic technique of slack-key guitar (in which the strings are loosened, or "slackened") is to retune the guitar so that, without pressing down on the strings with the left hand, a chord can be sounded just by strumming or picking with the right hand. This "open tuning" allows not only for beautiful effects accomplished by pressing and sliding fingers on individual strings or across whole frets, but also for other features such as harmonics and the "unplayed sound."

Harmonics are produced by touching the string lightly at precise mathematical points (the midpoint of the string, for instance) to produce higher-pitched, delicate, bell-like notes. The "unplayed sound" has an effect similar to the rich sweetness of harmonics. Because open, unpressed strings vibrate sympathetically (without being strummed) to certain pitches, a "halo" effect is automatically created when those pitches are sounded, and a fuller, richer sound emerges. Some open tunings are standard and have names, like the "taro patch" or the "maunaloa." But others, as Raymond Kane began to learn at age nine, are private.

Kane has not kept his knowledge from anyone, but has shared freely over the years, both in performances and by instruction. The most notable of his many public concerts was his solo recital in 1973 at the University of Hawaii, a turning point that resulted in broadly increased public interest in slack-key guitar. Wanting to guard the heritage, not his personal position in it, he is keenly aware of the pressures on Hawaiian music and concerned about preserving the slack-key guitar in its traditional style. He taught slack-key, under the sponsorship of the Hawaii Music Foundation, from 1975 to 1981 and has recently served as master artist for advanced, individual apprentices through the Folk Arts Apprenticeship Program of the Hawaii State Foundation on Culture and the Arts.

Like Clyde Sproat, Kane performs in informal settings, such as neighbors' luaus, evenings on the beaches, and other "back porch" settings. And also like Sproat, Gutiérrez, and so many of the folk musicians who have inherited a tradition, he is not a professional in the sense that he does not make his living from music. Kane's profession, before he retired, was that of a welder—and his thick, strong, calloused hands show it. They make the guitar look like a toy, and they seem too broad to be able to pluck a single string by

itself or hold only one string at a time against a fret. But Kane does just that: the sound is pristine, and the big hands are tender. The voice is rugged and husky, but the sweet sound of the Hawaiian language makes it soft and loving. Kane *is* a professional in the deepest sense of the term: self-imposed standards, love of and obedience to tradition, and dedication to excellence.

Kane's life has not been as smooth and flowing as his music. By the early 1980s he was suffering seriously from asbestosis (due to working with asbestos products), emphysema, and sleep apnea. Believing he would die soon, he stopped playing guitar. In 1986, he obtained a device that provides him with a continuous flow of oxygen and allows him to sleep at night. With newly renewed energy and hope, he was ready to get a new guitar and start again: "I went [to Kauai craftsman Michael Sussman's workshop] with a friend who was going to get his ukulele fixed and at the time I heard my slack-key music playing in the background. It was my tape. So I tapped him on the shoulder. 'You like that kind of music?' 'Oh yeah,' he said. 'You like that guy playing?' 'Oh yeah, he's my favorite,' he said." Kane then shook Sussman's hand and introduced himself: "He dropped everything and said 'I'd like to make a guitar for you.'" Kane says it's the best guitar he's ever owned.[91]

Like other inheritors, Kane conserves tradition by practicing it and often by contesting contemporary trends. Ricardo D. Trimillos, ethnomusicologist at the University of Hawaii, writes of him, "He is one of the few current slack-key instrumental virtuosos who also sings. There has been a tendency among contemporary slack-key specialists only to concentrate upon the instrument and not combine it with singing, its original context."[92] Ultimately, Kane's music is good not because it is old, but because of his excellence as a musician: his vast repertoire of songs and tuning styles, his sense of timing and articulation, and his knowledge of a style from the inside. Kane is the living moment of a tradition, the bearer of a technique and a repertoire of songs he learned sixty years ago from masters like Albert Kawelo, Henry Kapauna, and George Ka'ea.

Bessie Jones was another National Heritage Fellow who remained in direct contact with the "oldest and strongest songs of her people."[93] She was born into an African-American family early in this century in the rural town of Dawson, Georgia.[94] Her grandparents were slaves, and as a young child Bessie learned the songs they sang while working in the fields. They also taught her history: "My grandparents, they teach me everything I know about slavery. Things they went through with."[95] As a child in Dawson, she also learned perhaps a hundred children's games (often with songs) as well as hymns and other religious music sung at the community church.

This remarkable repertoire indicates that even at a young age Bessie Jones had a special gift. Her marriage and departure to her husband's home,

It's sweet. It's good for the soul. . . . That's what slack key is all about.[90]

Raymond Kane

82

*Bessie Jones,
African-American singer,
storyteller*

Mama went away and she told me to stay
And take good care of this baby.

Go to sleep, go to sleep
Go to sleepy, little baby.

All them horses in that lot,
Go to sleepy, little baby.
Can't you hear them horses trot?
Go to sleepy, little baby.

Go to sleep, go to sleep
Go to sleepy, little baby.

If I rock this baby to sleep,
Go to sleepy, little baby,
Someday he will remember me,
Go to sleepy, little baby.[96]

Traditional Sea Island song
sung by Bessie Jones

Saint Simons Island, only added to her growth as a buoyant, living reservoir of African-American musical heritage. Saint Simons Island, a part of the long chain of islands that skirt the Atlantic coastline from Georgia north through the Carolinas, was one of the most distinctive areas of traditional African culture in the United States, an area visited time and again by scholars interested in African-American folk songs, folk religion, and folktales, and especially in the Gullah dialect of Black English spoken there.[97] By the time Mrs. Jones arrived on Saint Simons, the local African Americans had already created their own group dedicated to the preservation of their native choral tradition, the Georgia Sea Island Singers.[98] Although Mrs. Jones was an outsider, she was invited to join the group, one of the few "mainlanders" ever so honored. She stayed to become the group's leader in children's songs and games, and sang with the Georgia Sea Island Singers for the rest of her life.

As a woman who took care of children all her life—baby brothers and sisters, her own children and grandchildren, neighbor kids, and the children of her employers—Mrs. Jones had sage advice for parents. She talked about how traditional games and songs are "good for children"[99] and how even rocking is important: "I think babies should be rocked at times, of course. I don't think a baby ever should be throwed aside. It gives them—well, I don't know—I think you should rock him *some* anyway, if you just shake him a little while. It does something for him. He's better—like he's nursed. You can see sometimes when you carry him in the room and he just *knows* you're going to throw him away—carry him in a room and shut the door and stick a bottle or a pacifier in his mouth. And he'll just look at you, and it looks like he ain't not ready. He just know you're going to carry him in the room and throw him away, and he go to pulling to you and cleaving to you. Well, he *need* that cleaving to you. He *need* you to take a little more pains with him at that time. . . . He sure do. . . ."[100]

The bonding with infants that Bessie Jones describes is just as much a part of the African-American "clapping plays" she also knew and taught. Clapping plays like "Green Sally Up," "One-ry, Two-ry," and "Head and Shoulder, Baby" are based on cooperation. Done in pairs, these routines create a rhythmic bond—standing for a deeper one—between members of the group. The complex use of pitch in the hand clapping reflects the varied pitches in African drumming—only one of the many ways in which this African-American tradition continues African artistic ideas.

Besides Bessie Jones, the remarkable Sea Island culture has produced other National Heritage Fellows, like basket maker Mary Jane Manigault and blacksmith Philip Simmons. Janie Hunter is another National Heritage Fellow from the Sea Islands who has retained a great deal of the African and early African-American artistic traditions in her work. Mrs. Hunter is a

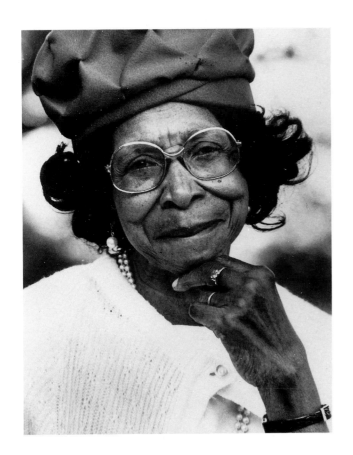

Janie Hunter,
African-American singer,
storyteller

singer, a teller of classic animal tales, a quilter, a broom maker, and an expert in local folk medical practices. As a multi-faceted inheritor, she is an important teacher in her community.[101]

Born on Johns Island, South Carolina, Mrs. Hunter grew up not only in a traditional community but in the midst of an artistic family. Some of her songs came from her father, who was a fisherman and farmer, others from her church—all are sung in a voice once described as "strong and clear as a clarion bell."[102] Today, Mrs. Hunter is a key member of a local religious singing group called the Moving Star Hall Singers, named after the "praise house" where the community meets to sing and clap in celebration of God.

In recounting her animal tales, Janie Hunter carries forward one of the most precious American oral traditions —one that bears clear signs of its West African origins as well as of the slavery and post-Emancipation experience. Her Rabbit character has its origin in the many trickster figures—others were Anansi the Spider, Old Man Tortoise, and Monkey—that inhabit the rich animal-tale traditions of West Africa. By featuring such underdogs who outwit stronger animals, these tales assumed new meanings for slaves, who had no power except that conferred by their wit, intelligence, and inherited culture. Sometimes the trickster animal will become a trickster human, as in the stories about the slave John outwitting his master or about "Aunt Nancy" or "Ann Nancy" (derived from Anansi the spider).[103] The stories were, and are, tales of encouragement, which even today buoy up the human spirit with their insight and charm.

Master storytellers like Janie Hunter are rare treasures today. The small ranching community of San Cristobal, New Mexico, has such a treasure in National Heritage Fellow Cleofes Vigil.[104] Señor Vigil tells traditional Hispanic tales that he learned from his parents and especially from his grandfather. These tales are both steeped in regional history and clearly related to old European folktales. Seventy years ago, Cleofes heard his grandfather tell these stories by the hearth on long evenings; today he tells them at museum events and festivals throughout northern New Mexico.

A favorite is his story about the local Hispanic guide who outwits his exploitive tourist employers:

Two tourists from the East came to the Sangre de Cristo Mountains for the first time. They couldn't believe how beautiful these mountains are. Very rich people from the East, *turistas.*

So, they decide to buy equipment, camping equipment . . . and go spend a few days up in the high mountains. The problem was they didn't know how to cook outside. So they hire a native guy for a cook. They got the best sleeping bags and all the best equipment they could get. They bought it. . . . And they started going up to the mountains.

On their way up to the high mountains, they met a sheepherder with a flock of sheep. And they decide to buy a lamb and barbecue it up in the high mountains. They asked the native cook if he knows how to barbecue a lamb.

He says, "Sure, I know. I know how to cook anything."

So they bought a lamb and they took it up there, to the high mountains.

That night they found a good place where they camped. They ate the whole lamb, except the head. They told the cook to cook that head. . . .

He said, "Sure." So he dug a hole by the fire, wrapped the head in something and buried it, and put a lot of hot coals on top.

Then they went to bed, and one of the tourists said, "Oh, let's see, . . . that lamb head, who's going to eat it. That head is too small for three guys to share it. Why don't we make a deal? Whoever dreams the most beautiful dream tonight will have that head for breakfast tomorrow."

So the other tourist says, "Ok, it's a deal."

"What about you, cook?"

"It's a deal. Ok."

So they went to bed, and the poor native cook wrapped himself in a *serape*. He couldn't sleep very well. The ground was too bumpy and the *serape* was too thin. The two rich *turistas*, they snore right away. They have nice, comfortable sleeping bags. Finally, at dawn, the cook got up and he put more wood on the fire. Then he got a little hungry and he thought about that lamb head and he dug it and it was all done. So he ate it. He ate, and he disposed of the bones and everything. He ate the tongue, the brains, and whatever little meat is in the lamb's head. Next morning when they got up, these rich tourists said, "Oh, let's see. Let's see who's going to have that lamb's head for breakfast. Let's bring our dreams out."

"I dreamed that a band of angels came from heaven, and they took me up. Body and soul! What about you, pardner?"

"Do you know," the other tourist said, "Do you know that I had the same dream?"

"How come?"

"The same dream, man."

[They were] thinking that they were going to share that lamb's head together, that for sure the cook couldn't have a better dream than that.

Then he said, "What about you, cook? What did you dream, man?" "Do you know that I had the same dream, but it was a little bit different? I dreamed that you two guys were going in the hands of angels up to heaven, and when I saw you with the angels going to heaven, I thought, 'There's no need to let that head go to waste. I ate it!'"[105]

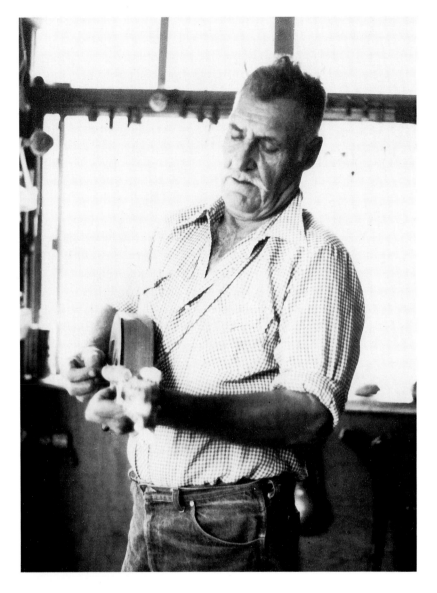

*Cleofes Vigil,
Hispanic storyteller, singer*

One might think that this story was invented recently and reflects current tensions in the Southwest. While certainly contemporary and topical, it is also an ancient tale (known to folklorists as "Dream Bread") in which the cunning trickster always belongs to the same ethnic or religious group as the teller and his or her audience.[107] This tale has been found throughout North and South America, Europe, India, Japan, and Central Asia as well as parts of the Middle East.[108]

Cleofes Vigil's family is descended from the original Spanish settlers who centuries ago came to the Sangre de Cristo mountains and the high, fertile valleys nearby. The area they have inhabited ever since is a Euro-American core culture area even older than those of coastal New England, south central Pennsylvania, and tidewater Virginia—the places we usually think of as the oldest sources of European culture in North America.

El Hombre Completo de Siglos Pasados.
By Cleofes Vigil,
San Cristóbal, New Mexico.
Carved piñon wood, 21" high, c. 1983

Cleofes Vigil was thus born into a centuries-old traditional culture. At the age of thirteen, he became a member of the fraternal order known commonly (and pejoratively) as Los Penitentes. This group, whose proper name is The Brothers of Our Father Jesus, today forms a recognized lay religious society of the Roman Catholic Church. The Brotherhood sponsors "pious observances, especially during Holy Week" and provides "year-round mutual aid for members and unobtrusive charitable acts for neighbors."[109]

When Cleofes Vigil became a member as a youth, he chose to devote himself "to the Passion of Jesus and commit himself to lead a simple, selfless and exemplary Christian life."[110] Although the Penitentes are sometimes thought of as a "secret society," it is more accurate to describe them as private. Known for his clear voice, Sr. Vigil is one of the few Penitente singers who does not mind singing the traditional songs in public—and has done so, on occasion, at the National Folk Festival and the Smithsonian's Festival of American Folklife and on university campuses.

Sr. Vigil also practices the traditional arts of playing the mandolin and carving santos. He continues to ranch and raise fruit and vegetables in his ancestral homeland. Of his music, he says: "I play the mandolin and sing old songs and religious chants. My religious chants came from Spain with the first settlers and are very old. . . . I have kept them, and know many for different occasions, and of course I would like to share this history of the mountains of the Sangre de Cristo with my people and others. . . . I talk Spanish and some English, and some of my music is a mixture of Indian and Spanish. All of this history has been passed to me by my ancestors and I have preserved it because to me, it is beautiful and penetrates the heart."[111]

All the inherited traditions "penetrate the hearts" of those who carry them forward. If the traditions did not have this affective dimension, there would be no reason to keep them alive in the latter half of the twentieth century, nor would there be the means. Unlike other kinds of culture, folk culture has nothing automatic or institutionalized about it. There must be deliberate choice and effort on the part of performers and audiences, makers and users, producers and consumers, for folk tradition to continue. Only the meaningful stays alive.

This conscious investment of the spirit in keeping a tradition alive may be seen in the case of duck decoys. Since most decoys today are mass-produced and inexpensive, it is no longer necessary for duck hunters to carve or buy handmade ones. Still, in many parts of the country, decoy carvers continue not only to shape these beautiful wood sculptures, but also to lug them around by the dozen in gunny sacks, place them in the icy water on sharp, clear mornings, and, occasionally, shoot them. Hunters shoot their own decoys when, perhaps a bit like Pygmalion, they are so taken with their own artwork, that they themselves are fooled. When a duck decoy carver/duck

hunter shows you the shot in his own decoy, he is camouflaging pride in his own work as an artist with the irony of being fooled as a hunter.[112] It is a good joke—and a reminder that there is still much more involved in hunting than the efficient killing of animals for food. Sometimes, for instance, the ritual of hunting bonds male family members.

National Heritage Fellow Harry V. Shourds II represents three generations of decoy carvers in his own family. His grandfather, Harry Vinuckson Shourds (1871–1920), is well known to duck hunters and decoy collectors as perhaps the best decoy maker ever. He lived near Barnegat Bay in New Jersey, an area once renowned for both its hunting and its decoy-carving tradition, and his grandson remains nearby, in Seaville, New Jersey. Harry Shourds has continued his grandfather's heritage with his own distinctive modifications. Even intimately inherited traditions are subject to the slight, but constant, variation that characterizes all folk expression. For Shourds, as for others, such variation is the imprint of the artist's individual personality: "I hate to copy someone else, even if it's someone in my family. . . . I make a duck the same way as my father and grandfather did, but as far as copying their style of carving or their patterns, I don't. I make my own ducks. And I think each one of them did, because you can tell them apart. You can tell my grandfather's duck from my father's duck and you can tell my duck."[113]

Decoy carvers pay attention to differences that evidently do not matter to ducks. John Vlach points out that "ducks will approach unpainted chunks of wood or Styrofoam that are floating in the water. Thus, for some hunters the least ducklike object imaginable is perceived as a good decoy."[114] Carvers, however, talk more in terms of the decoys' functioning to get the birds to come down from the air and land in the water. They design decoys—and equally important, they set patterns of decoys in the water—to give the message that "this is a safe place." Traditional carvers like Shourds also concern themselves with efficient design. Shourds's decoys in the Barnegat Bay style, for instance, use "inletted flush lead weights." Although all working decoys employ weights for balance, self-righting, and stability, Shourds's have their weights placed on the inside to create a more compact body, which in turn allows the hunter to carry a greater number of decoys in the small, one-man Barnegat Bay boat known as a "sneakbox."[115]

Harry V. Shourds II, wildfowl-decoy carver

In addition to these concerns regarding function and design, however, today's carvers recognize that the impulse toward ever more realistic detail that characterizes twentieth-century decoy carving goes "beyond necessity."[116] This tendency has led to decoys that are made not to be put in the water, but to decorate the study and the office. (Lem Ward, another National Heritage Fellow who was a decoy carver, will later provide us with an opportunity to examine this change.) The older tradition is not unrealistic,

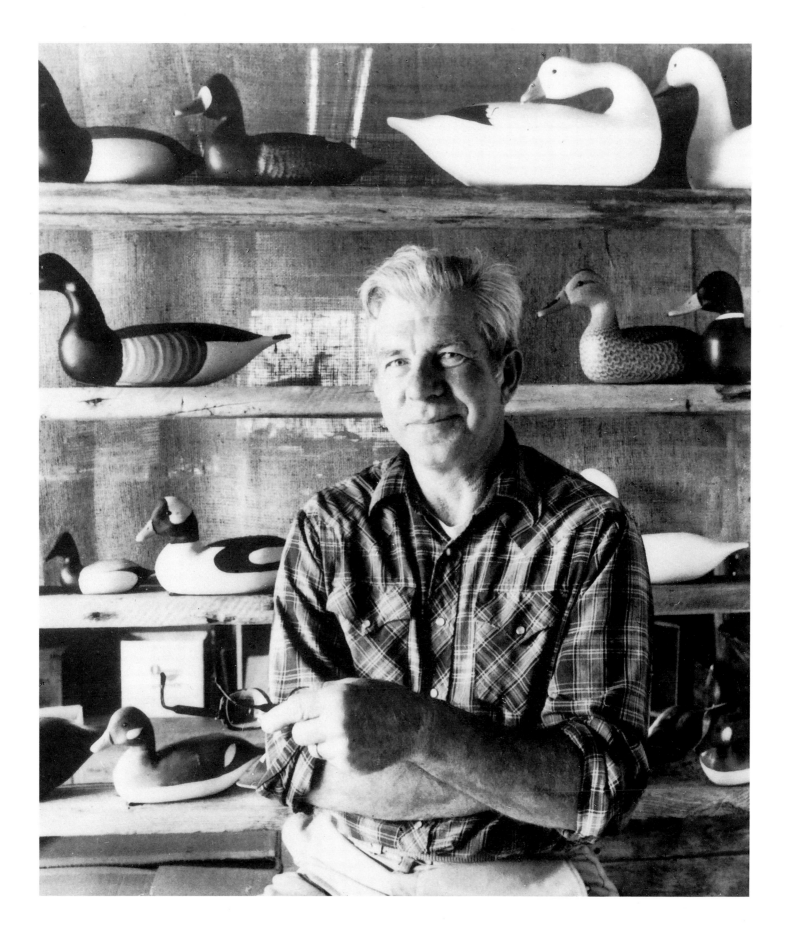

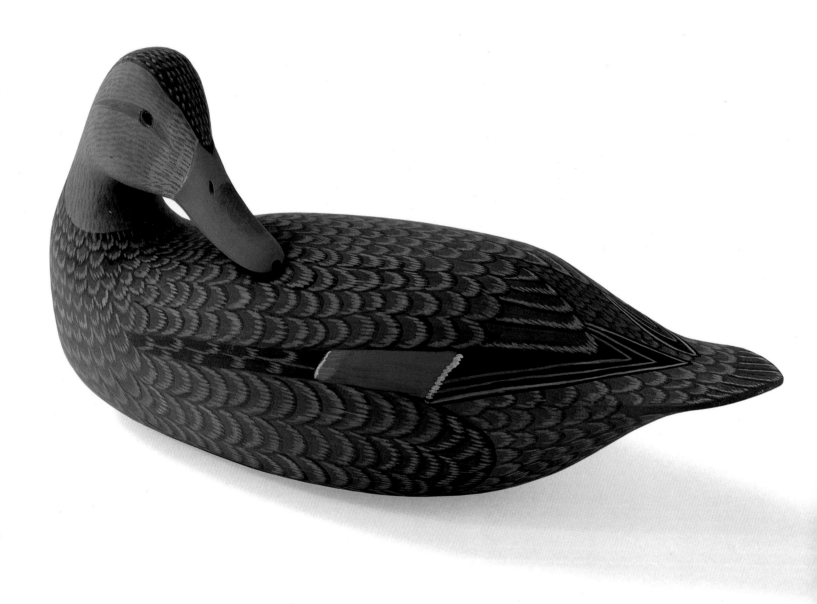

Mallard hen decoy.
By Harry Shourds II,
Seaville, New Jersey.
Carved and painted cedar,
7 x 14½", 1990

but it does incorporate something beyond realistic detail. Shourds tells us just what this is: "I like to put a little dream into it."[117]

Part of the dream, however, has become a nightmare. At the banquet honoring the National Heritage Fellows in 1989, Shourds said, "It's really sad to make a duplicate of a bird that is no longer on this Earth." The destruction of the wetlands in New Jersey and elsewhere, oil spills, contamination of the food chain with destructive chemicals—these and other poisonings of the environment have drastically reduced the number of ducks, and even eliminated species that had graced the world only a generation or two ago. Now, Shourds uses decoys to attract birds just so he can look at them. He does not want to shoot them anymore. He says there are too few left. Thus, the duck decoy, made originally in North America by Native Americans, could become one of the most ironic symbols of our time: what mass production could not put an end to, the destruction of the environment may. Today we see Harry Shourds's ducks in museums throughout the East, but we need to continue to see their living relatives in the water as well.

Modern-day decoy carvers like Shourds and Lem Ward, the other decoy carver to have been named a National Heritage Fellow, inevitably have to deal with hunting as an affective bond between hunter and hunted, a truly ancient subject of both art and ritual. Shourds's feelings are surely, if subtly, carved and painted into his birds. He gives us a clue when he says, "I found a happy medium . . . [between his grandfather's heavy, thick ducks and his father's daintier ones]. . . . I put a smile on their beaks . . . and make them happy."[118]

The discovery of ancient duck decoys in caves in northern Nevada confirms the long history of this indigenous American practice. A much more common archeological find—perhaps the most common of all—is pottery, once the most ordinary household utensil in cultures as distant and unrelated as those of the Native-American Southwest, the ancient Middle East, and ancient China. Like the carving of duck decoys, the making of pottery persisted as a practice even after modern technologies produced other materials to assume its functions. For some—paralleling the carvers and painters of decorative wildfowl—pottery became an art form with no utilitarian purpose; for others, it became an exquisite craft, distanced from its folk roots. For three of the National Heritage Fellows—Margaret Tafoya, Burlon Craig, and Lanier Meaders—neither art, nor craft, nor heritage was neglected. The inheritors of distinct, long-standing ways of working in clay, these three master artists have preserved these traditions and continue to communicate them today.

Margaret Tafoya was born in 1904 at Santa Clara Pueblo, in the area that was to become the state of New Mexico.[119] The pottery tradition she inherited through her mother—that of the Tewa people—reaches fifteen

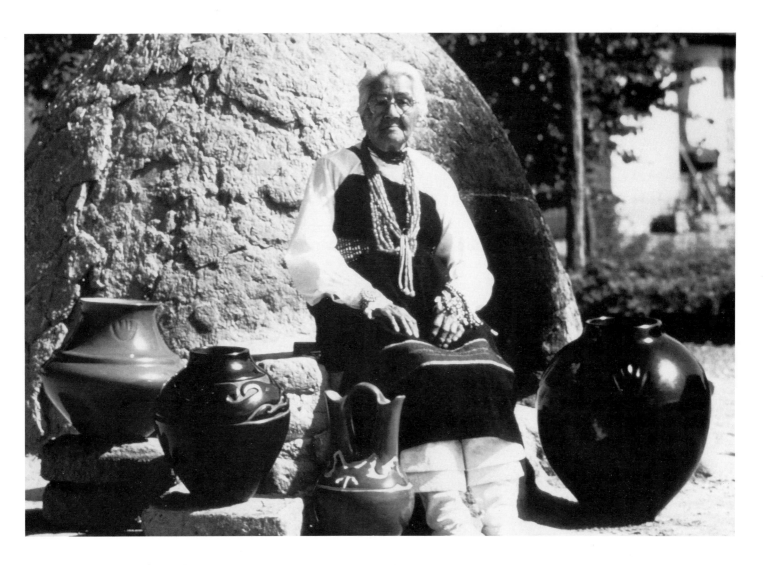

Margaret Tafoya,
Santa Clara Pueblo potter

hundred years into the past. Even today, on a crisp fall afternoon, the plaza of Santa Clara Pueblo radiates a sense of timelessness, as the sunlight filters through golden cottonwood trees and the smell of burned cedar from a recent pottery-firing lingers in the air. In this place, "the basic understanding of the clay—its selection, processing, and forming . . . has remained fundamentally unchanged" since about A.D. 500.[120] Tafoya, for instance, digs clay only from Santa Clara land—the places where her ancestors took it—and her construction technique is the technologically simple but artistically complex one of building upwards through coil upon coil of thick clay. The firing of the work—with wood and cow manure—has also remained relatively unchanged across the centuries.

As with all true folk tradition, however, some aspects of Tewa pottery have been dynamic. The polished red and black wares that are the trademark of the contemporary Tewa work seem to have been developing by about 1700. Decorative intaglio designs impressed or carved on the surface of the pot are a recent innovation, possibly begun by Margaret's mother, Serafina. Serafina

created the indented bear-paw design that, Margaret says, can be used on water jugs: the bear, who always knows where water is, is a good luck symbol in the arid Southwest. While the specific imaging of the symbol (the bear paw) and its use (to decorate water jugs) are new, the vocabulary of symbols from which the image derives (the bear and water) is traditional. Today, Santa Clara pottery is recognizable as much by such characteristic motifs—like the water serpent and rain clouds—as by its distinctive polished red and black surfaces.

I have dressed my children with clay. It has enabled us to survive.[121]

Margaret Tafoya

Margaret Tafoya's enormous *ollas* (wide-mouthed earthen jars) derive from the traditional ones used by the Tewa for storing water, meal, flour, grain, and other commodities. Like the old storage vessels, they may be thirty inches or more in height. Tafoya learned to make these huge pots—along with everything else about traditional style and technique—from her mother. Today she is the only living potter who continues to make *ollas*. Of the traditional learning process, Margaret Tafoya says: "My girls, I didn't teach them . . . they watched and learned by trying. I was taught to stay with the traditional clay designs, because that was the way it was handed down to my mother and me. I am thankful for my mother teaching me to make large pieces. I watched her and tried to do like she did. And, I did."[122] This statement places the responsibility for learning on the student rather than the teacher—a healthy dynamic by all accounts. But Mrs. Tafoya's humble description also understates her impact as a teacher, for the results are unmistakable: today, four generations of the Tafoya family create pottery in the ancient traditions of the Tewa.

In the past, pottery had ceremonial, as well as utilitarian, functions for the Tewa, and some of its religious significance still lingers in the perfection and wholeness Margaret Tafoya brings out of the clay. Although pottery took on new significance in the local economy during the ceramic revival beginning in the 1920s, this "commercial" aspect, in its essence, was not something new. For at least a thousand years, pottery was a major trade commodity among the pueblos of the Southwest. Each pueblo specialized in a different kind of pottery, and the resultant sophisticated and complex market created connections among communities. The arrival of the Spaniards, and then other Euro-Americans, probably only increased the commerce in ceramics. It was not until the late 1800s that industrial, mass-produced objects began to replace local pottery.[123]

Ironically, the same forces that worked to replace the traditional pottery in the area created new markets for it elsewhere. Modern communications networks, coupled with the publicity given to local culture by Anglo artists, not only revived artistic interest but also increased financial rewards. The waning of the old market occurred slightly before Margaret Tafoya's birth, but in her own lifetime, a new market has grown dramatically: "Forms that

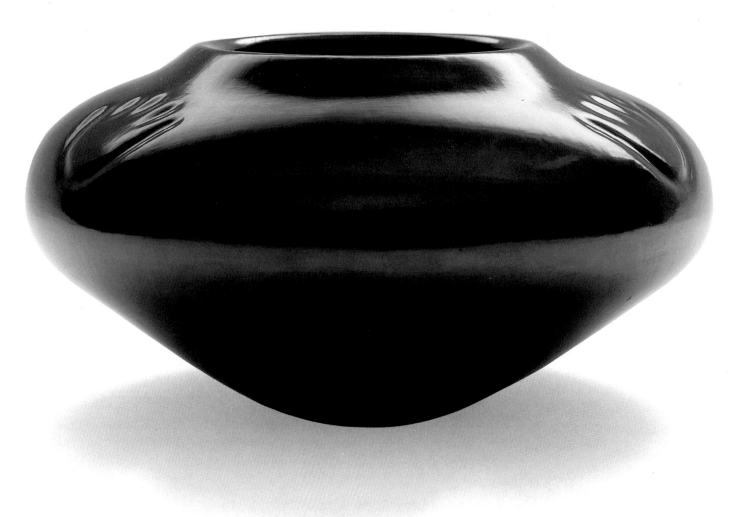

Bowl.
By Margaret Tafoya,
Santa Clara Pueblo, New Mexico.
Carved and polished earthenware,
7½" high x 14" diameter, c. 1984

Wedding jar with rain cloud motif.
By Margaret Tafoya,
Santa Clara Pueblo, New Mexico.
Polished red earthenware,
7½" high, 1983

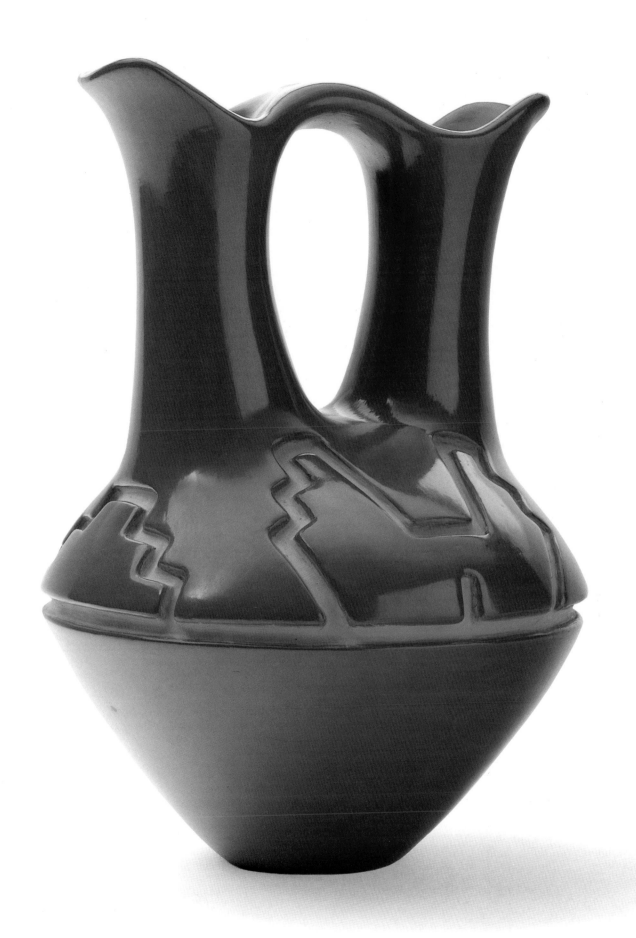

were on the verge of extinction were now being produced for sale, and successful experimentation flourished. Artistic concerns and marketing potentials now largely overrode earlier utilitarian considerations. . . . Against this background of rapid change and continuing excellence, Margaret Tafoya's pottery reflects the best expressions of the Santa Clara ceramic revival."[124]

At the other end of the country, in the Piedmont region of North Carolina, in the town of Vale, Burlon Craig fires his huge, wood-burning "groundhog" kiln for from eight to ten hours. He and Lanier Meaders of Mossy Creek in north Georgia—both National Heritage Fellows—represent an Anglo-American tradition in pottery that, like Tafoya's, stretches far into the past. Earthenware, for instance, had been produced in England for thousands of years before the European discovery of America.[125] Stoneware, the particular tradition of Craig and Meaders, came to England from Germany in the 1670s and was being produced in America by the early 1700s.[126] It is based on the use of the potter's wheel, in contrast to Tafoya's Tewa tradition of building coiled shapes.

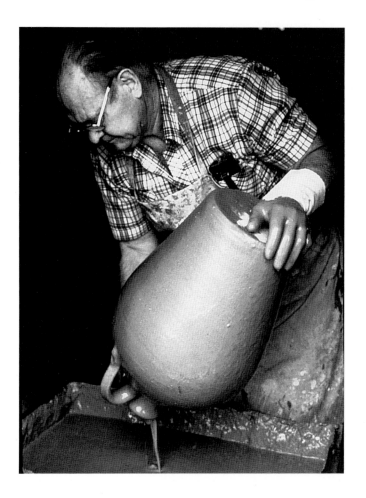

Burlon Craig, potter

Pottery fulfilled many of the same domestic tasks for English and other colonists as it did for the inhabitants of the pueblos of the Southwest. It was everywhere: folklorist Terry Zug has identified approximately five hundred major traditional potters who worked in North Carolina from the mid-eighteenth century to the present.[127] (He also has identified thirty-three "modern" potteries.[128]) For Georgia, folklorist John Burrison has listed over four hundred folk potters who were active in the same time period.[129] That seven towns in Georgia have been named "Jugtown" is another indication of the importance of pottery in the region.[130]

Lanier Meaders's Mossy Creek community has a history as one of the largest pottery centers in the South and has been home to over seventy potters since the 1820s.[131] It is not by accident that both Mossy Creek and Vale are part of the same Piedmont region, which is rich in good clay.

The same technologies that temporarily reduced pottery production in Santa Clara Pueblo also affected traditional pottery regions in the South. Yet, against all odds, potters like Craig and Meaders persisted in practicing one of the most ancient and continuous of inheritances—turning the potter's wheel and firing earth into useful, beautiful containers.

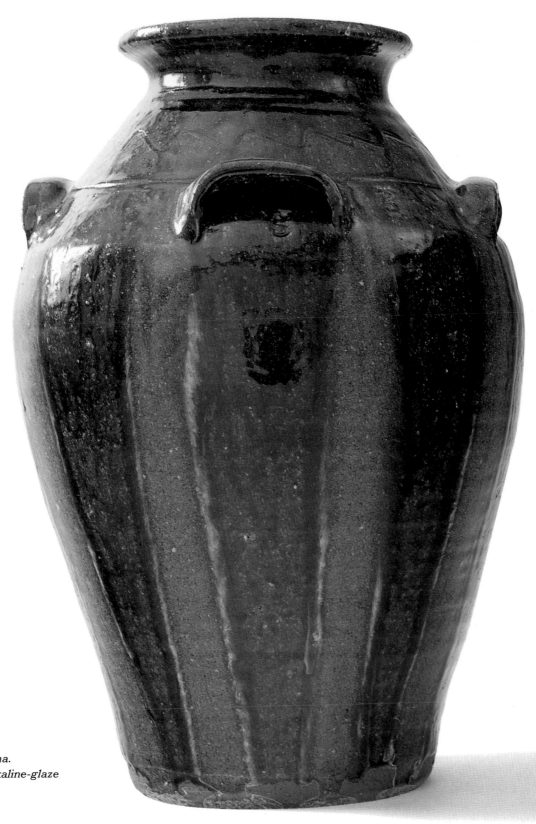

Five-gallon jar.
By Burlon Craig,
Vale, North Carolina.
Stoneware with alkaline-glaze
glass runs,
19" high, c. 1987

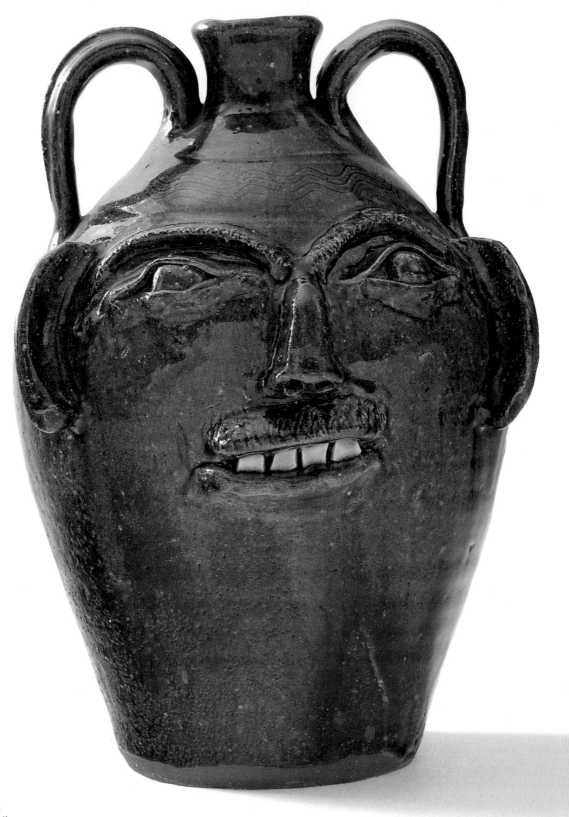

Face jug.
By Burlon Craig,
Vale, North Carolina.
Stoneware with alkaline-glaze glass,
15″ high, c. 1982

I could no more stop this than I could fly an airplane. All of my movements, all of my work that I've done all my life has led straight to this place right here. And every time I come about it, I get just a little bit deeper into it.[132]

Lanier Meaders

Today, Meaders still produces crocks that his neighbors use for making sauerkraut and pickling beans.[133] However, the making of highly popular face jugs—which was once only a small part of both Meaders's and Craig's production—has become a major activity for each of them. Apparently derived from an African-American tradition, face jugs have been found in the region since the nineteenth century.[134] Lanier Meaders learned to make them from his father.[135] In a description of North Carolina potters from the mid-eighteenth up to the early twentieth centuries, Terry Zug says, "On rare occasions, they turned a whimsey or two, perhaps a face vessel to parody the looks of some neighbor or a ring jug to demonstrate their virtuosity."[136] Until recently, the face jug—the "ugly jug"—was the exceptional piece, not the stock in trade.

The compromise these National Heritage Fellow potters have made between the creative individual's vision and the community's preferences make them the most difficult of all to categorize as inheritors, innovators, or conservers. As inheritors, they have been steadfast in maintaining a traditional technology, at the personal expense of demanding labor pursued over a lifetime. But they have conserved the tradition by emphasizing one part of it, the face jug, and in the process have transformed both the tradition and the face jug itself. As Henry Glassie writes, Meaders "not only makes more of them to meet the market, he has altered his father's model, making his jugs less like jugs, more like heads."[137] Meaders and Craig are thus inheritors technologically and innovators artistically, though even their innovations are clearly derived from tradition.

A further irony: these two potters reverse the usual relationship of dynamism and conservatism as it is communicated between the artist and the client. In many folk traditions, artists must curb their individualistic, innovative urges in order to conform to community-held standards, which are usually more tradition-bound than their own. In the case of Craig and Meaders, the most conservative impulse comes from the folk potters themselves; both have taken on, as their mission, the reining-in of market impulses toward the entirely innovative. They produce the popular face jug, for instance, but by using a traditional technology. Craig and Meaders are thus conservers as well as inheritors and innovators.

What other art is as old as pottery? It may be weaving. Not only does weaving provide clothing and blankets to keep us warm and protected—it is also one of language's oldest metaphors. Think of the Fates weaving destiny on a loom. And storytelling, another of the ancient arts, is described as spinning and weaving wherever in the world weaving is known.[138] For National Heritage Fellow Jennie Thlunaut, a master Tlingit Chilkat blanket weaver from Klukwan, Alaska, the interrelationship of storytelling and weaving was not only a metaphor, it was literal.[139] As Tlingit Elder Austin

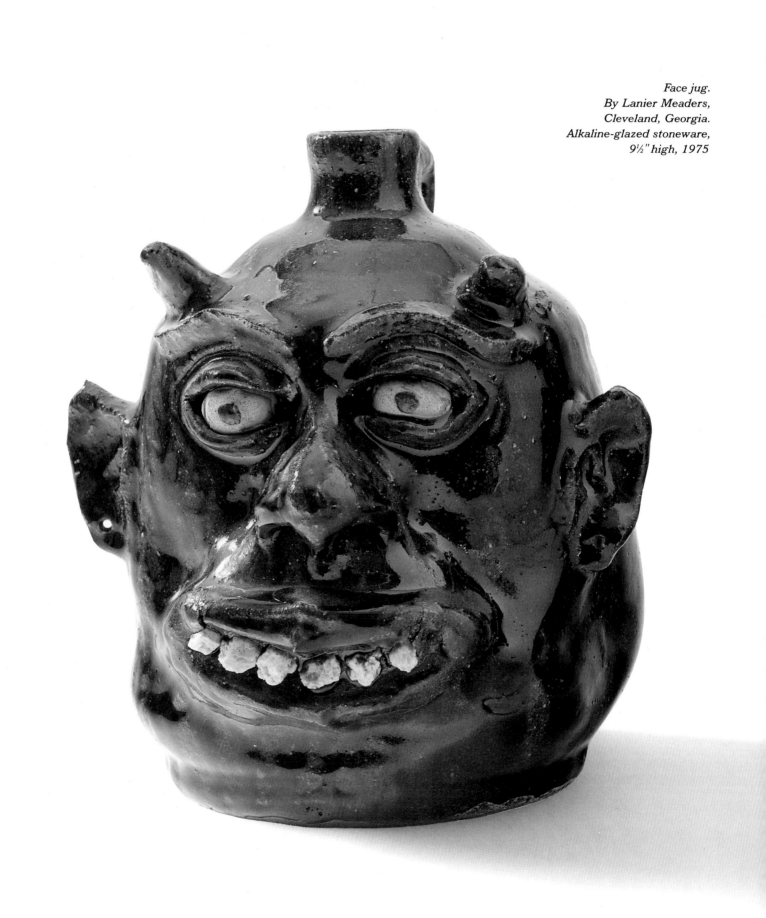

Face jug.
By Lanier Meaders,
Cleveland, Georgia.
Alkaline-glazed stoneware,
9½" high, 1975

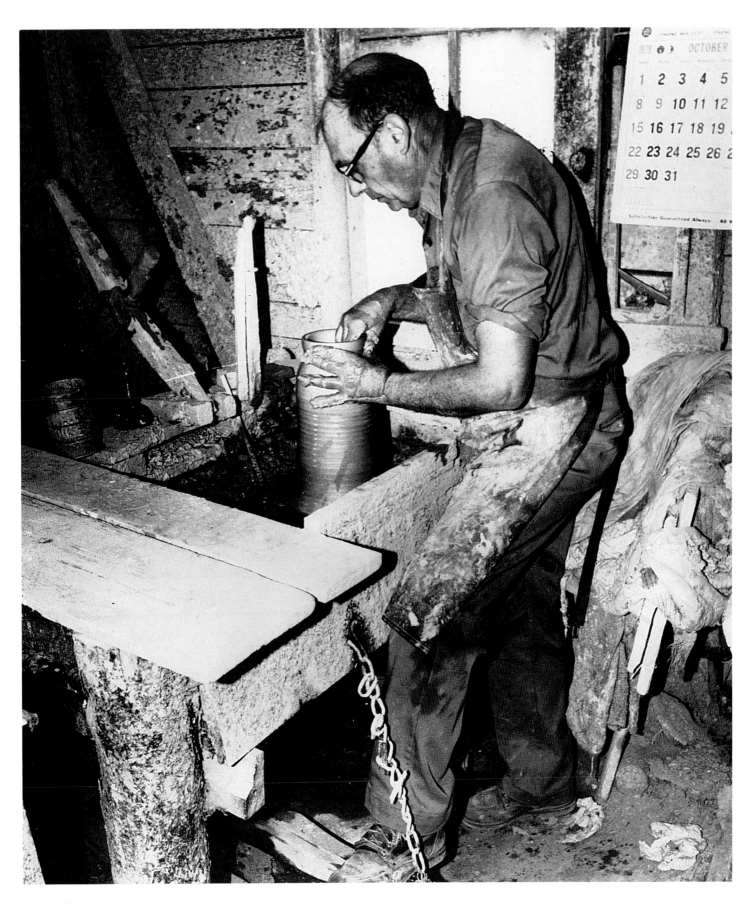

Lanier Meaders, potter

Hammond said, "The Tlingits were not writers of books, they wove their history into their garments and they wear their history on their backs."[140] The weaver is both the inheritor and the creator of heritage.

Jennie Thlunaut was born Shax'saani Keek's (Younger Sister of the Girls) in 1892 in the Chilkat territory of the northern Tlingit in southeast Alaska.[141] It was normal, in that time, for her people to follow a cyclical subsistence— fishing the rivers and shores; hunting large and small animals and birds; gathering seaweed, wild celery, potatoes, rhubarb, clover, roots, berries, and herbs; and traveling in canoes—all in due season. "Like any other Tlingit child . . . she played on the beach . . . and threw rocks into the river. . . . Shax'saani Keek's listened to the great stories of Tlingit history told during the lavish potlatches, stories that told of clan migrations and feats, which were still held in her childhood era."[142]

Jennie began learning to weave blankets from her mother when she was about ten years old. She was also learning to sew moccasins, do porcupine quillwork and beadwork, and construct split spruce-root and grass baskets. The Tlingit Chilkat blanket is considered one of the most complex in the world, and Jennie, in her own words, "worked steadily" from May to September of 1908 to complete her first one. Social anthropologist Rosita Worl and her associate Charles Smythe write that "Jennie's definition of steady means working continuously through the daylight hours of the long summer day and stopping only a few moments to eat."[143] In her lifetime, Jennie Thlunaut wove over thirty blankets and shirts. Although these could

Jennie Thlunaut,
Tlingit Chilkat blanket weaver

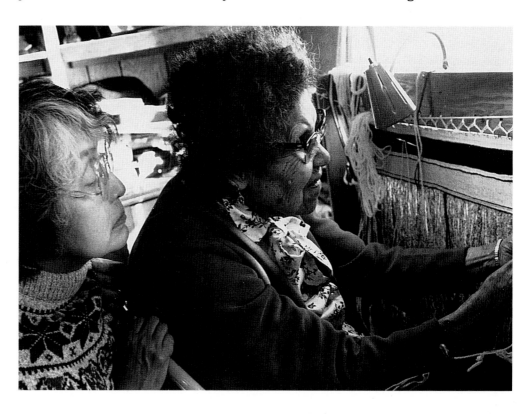

have sold for $10,000 to $16,000 each, she gave many away to friends, in the traditional manner. Others were commissioned for ceremonial use. She kept none for herself.

The Chilkat blanket has its origins in mythology: the knowledge of weaving was a gift brought by Raven to humans from the spirit world. The woven blanket became part of the Tlingit nobility's ceremonial regalia, and weavers were often commissioned to make blankets to commemorate events in a clan's history. The blankets are especially spectacular when they are swirling through the air and transformed by the power of dance. Dance is the Chilkat blanket's natural habitat; it is in movement that the design, with its long-fringed borders, comes to life.

Related to the stylized, symmetrical animal figures the Tlingits carve in wood, the designs of the blankets are the crests of family or clan groups and serve as property markers and emblems of the group. The woof is spun of mountain goat hair; the warp employs mountain goat hair spun together with prepared cedar bark. Working on a vertical loom, the weaver employs different stitches for different sections and mixes straight stitches with curvilinear shapes.

Jennie Thlunaut was considered the last Chilkat weaving master. But in 1985, a year before her death, fifteen native Alaskan weavers were assembled to study with her. Before they began, she told them, "I don't want to be stingy with this. I am giving it to you, and you will carry it on."[144]

Other weaving traditions and other weaving masters have been recognized through the National Heritage Fellowships. Yang Fang Nhu, a Hmong immigrant from Laos, weaves on the ancient and complex backstrap loom. Yet another kind of weaving, the making of lace, does not even require a loom but can (impossibly, it seems) be done with only a needle and linen thread. One of the masters of this art was National Heritage Fellow Genevieve Nahra Mougin of Bettendorf, Iowa, whose creations are as miraculous as the gold spun from straw in fairy tales.[145]

Mrs. Mougin's parents were immigrants from Lebanon who raised eleven children while farming in Illinois and Iowa. Genevieve Mougin came by her skill in the traditional way, from her mother—who had learned from *her* mother—beginning when she was seven years old. As an adult, in 1954, she visited Lebanon and saw work similar to hers called "Phoenician lace." (The same art is variously known throughout the Middle East as Phoenician, Syrian, Armenian, Arabian, or knotted lace.)

Mrs. Mougin used to wear two pairs of glasses when she worked. The delicacy and intricacy of the work demanded immense patience. An eight-inch doily or snowflake would require forty hours of work, and her forty-eight-inch drum tablecloth, the largest piece of her life, took two-and-a-half years to complete. She would begin from the center, moving outward, each stitch

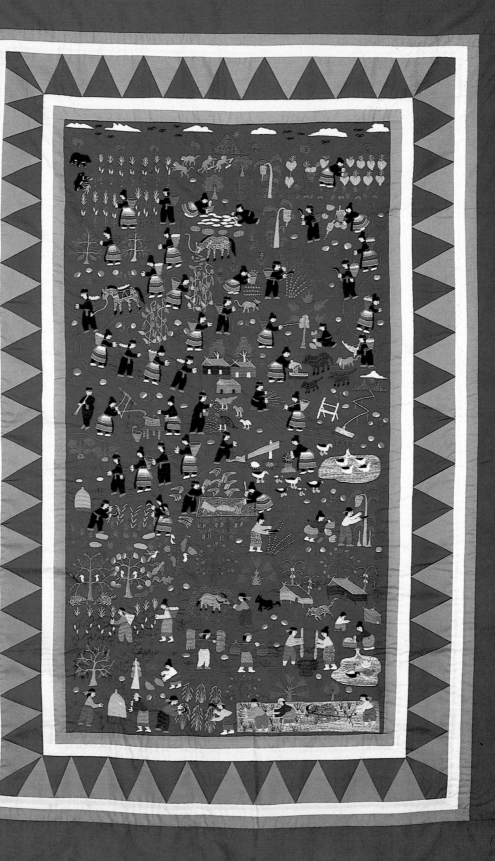

Opposite:

Story cloth.
By Yang Fang Nhu,
Detroit, Michigan.
Embroidery on cotton,
55 x 38", 1978

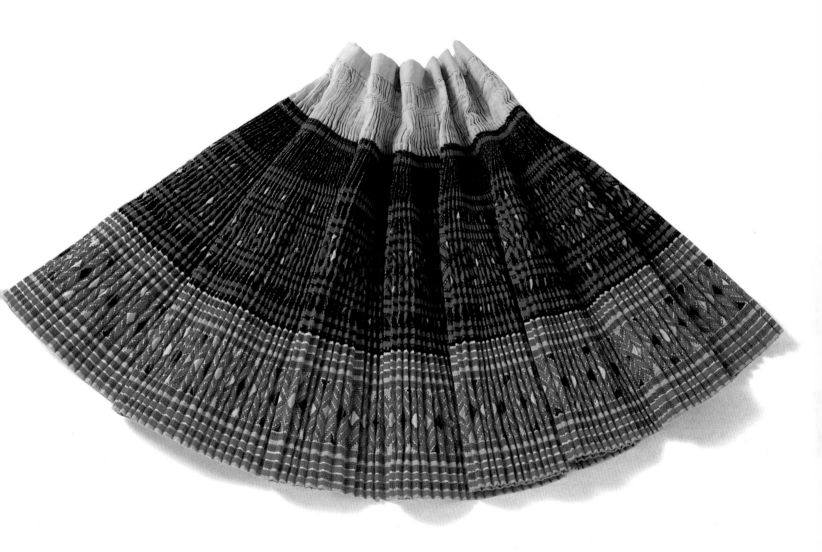

Above:

Hmong skirt.
By Yang Fang Nhu,
Detroit, Michigan.
Batik, embroidery,
and appliqué on cotton,
25 x 43", c. 1965

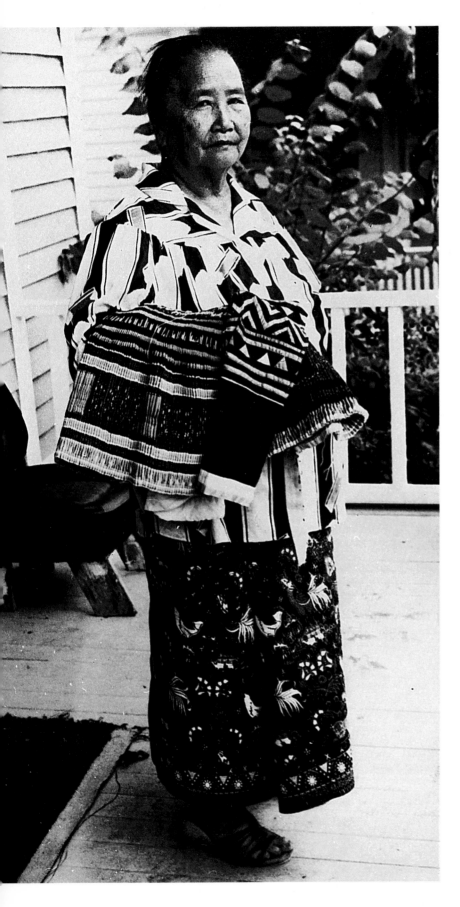

Yang Fang Nhu,
Hmong weaver, embroiderer

Fang Nhu, as a young child of 5 or 6, stood by her mother's loom and watched her push the sword shuttle carrying the bobbin of weft thread back and forth through the warp. Her mother's rhythmic leaning back and swaying forward against the leather belt around her back made the loom come alive. Fang Nhu watched intently, memorizing the movement and the structure of the loom. In her heart, she wanted to weave. By 15 years [of age] Fang Nhu [had] learned all the intricacies of making cloth. She knew how to grow the hemp, harvest it, break it down into fibers, soak it, spin it, set up the loom, and weave the hemp into fine white cloth that would accept indigo dyeing, batiking, embroidery, appliqué, and pleating.[146]

Folklorists Winnie Lambrecht and Carolyn Shapiro

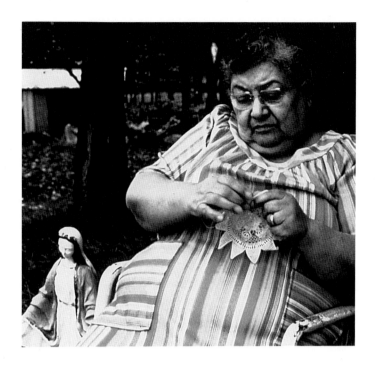

I like to give lace
to my family.
It's our heritage.[147]

Genevieve Mougin

Genevieve Mougin,
Lebanese-American lace maker

forming a single knot, so that every design was concentric, symmetrical, beautifully geometric, like the snowflakes they often resembled. And, like snowflakes, every piece was different, for Mrs. Mougin learned a traditional process rather than a set of fixed patterns. By combining traditional motifs, she could attain an apparently infinite number of variations. New—but closely related—designs emerged every time her hands, needle, thread (and mind) met.

Genevieve Nahra Mougin is one of several National Heritage Fellows who enlivened an inherited needlework tradition. Sonia Domsch, a Czech-American bobbin lace maker from Atwood, Kansas, and Sister Rosalia Haberl, a German-American bobbin lace maker from Hankison, North Dakota, are equally delightful and surprising reminders that needlework and other technically demanding folk traditions live because artists persevere. We would err, though, if in trying to gain an overall perspective on the inheritors, we thought of them solely in terms of persistence. This quality is clearly, if often quietly, present in every inheritor, but as National Heritage Fellow Alex Stewart reminds us, so are pleasure and joy: "Anything that you delight in, it ain't any trouble for you t'do it, but somethin' you don't delight in, it's pretty hard."[148]

Stewart was a cooper and woodworker from Sneedville, Tennessee. With a native skill that had been tuned and tempered by years of daily experience and accumulated knowledge, Stewart made all the traditional cooper's wooden wares—churns, barrels, buckets, tubs, and piggins. He also made chairs, baskets, bowls, rolling pins, and musical instruments. Speaking of his work in his small sawmill and blacksmith shop, Stewart said: "I've made all

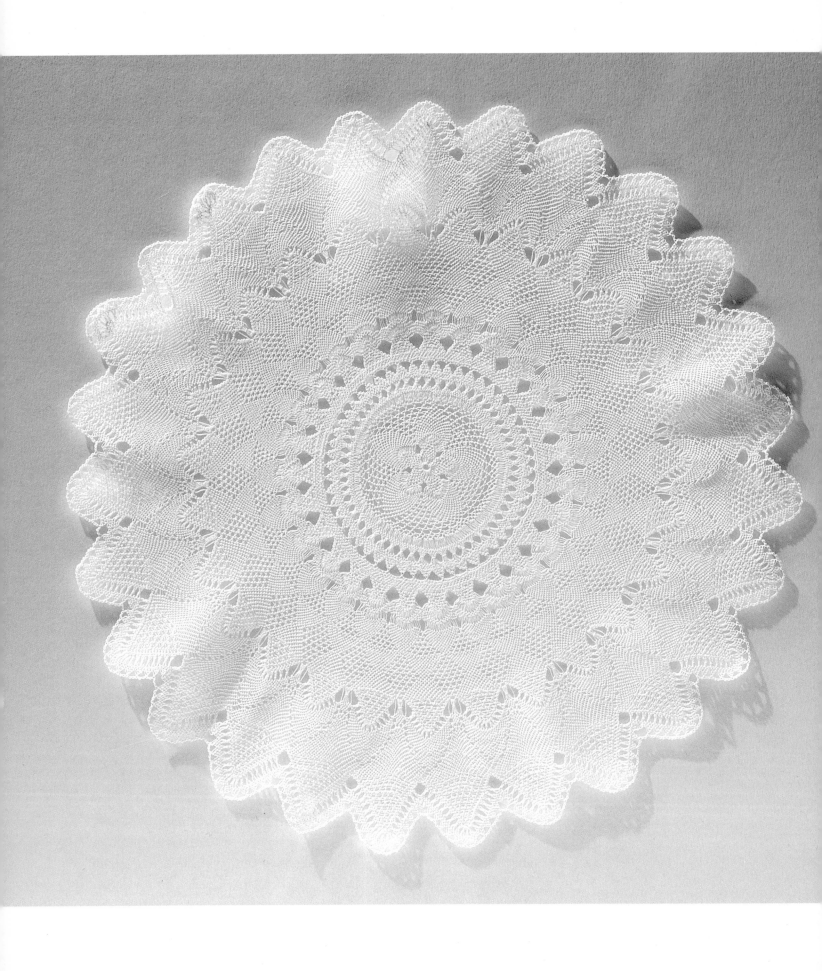

Opposite:

"Phoenician lace" doily.
By Genevieve Mougin,
Bettendorf, Iowa.
158-count linen thread,
12" diameter, c. 1985

This page:

Bobbin-lace doily.
By Sister Rosalia Haberl,
Hankinson, North Dakota.
Linen, 25 x 7", c. 1988

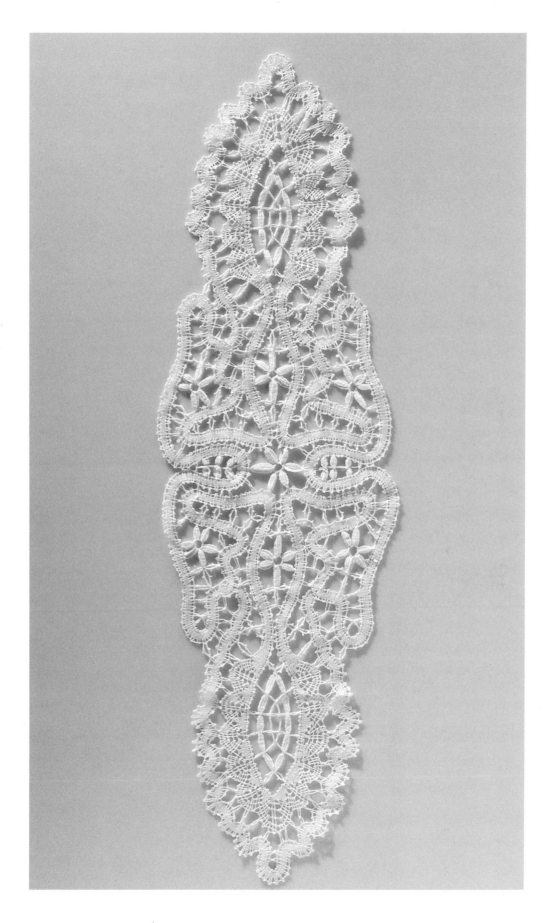

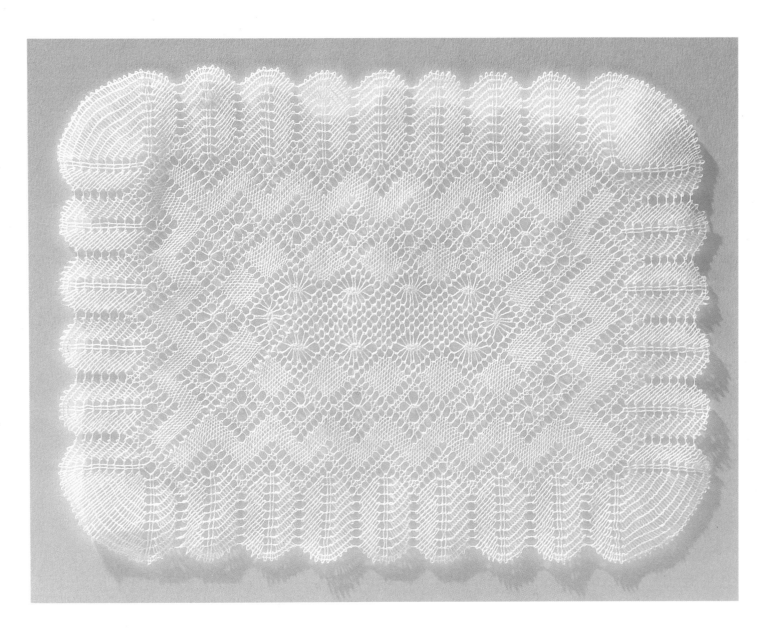

Bobbin-lace doily.
By Sonia Domsch,
Atwood, Kansas.
Linen, 8 x 11", 1988

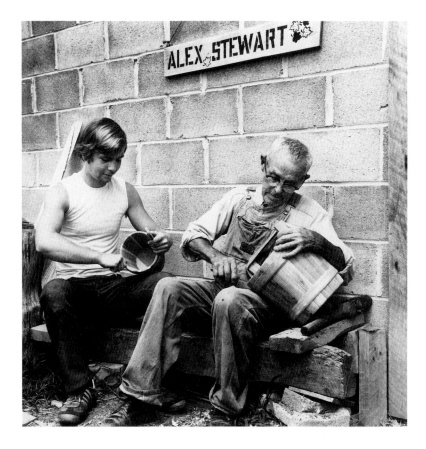

My concern has been to show Alex as I honestly believe him to be: Wise beyond all eighty-seven of his years, curious as a cat, tough as a pine-knot, independent as a hog on ice, industrious as a honey-bee, and as handy as the pocket on your shirt.[149]

Bill Henry, apprentice
to Alex Stewart

Alex Stewart,
cooper, woodworker,
with grandson Rick

my tools, matter of fact, everything I've got. My grandfather, I learned this from him. He made everything—wheels, anything that could be thought about, he made it, and I got the pattern off of his."[150]

More than most of his neighbors, Stewart had tapped the enormous reservoir of traditional, agrarian, mountain lore. Others in his community conserved and practiced elements of the Upland South heritage, but Stewart combined it all—and created with the profound concentration that only major artists are capable of giving to their work. Before receiving the National Heritage Fellowship in 1983, at the age of ninety-one, he had already been recognized for his mastery beyond the borders of his native region.[151]

As an inheritor of a folk tradition, Alex Stewart is particularly representative—not because he was the best of the best, or because he was the last traditional cooper, or even because he persevered. Rather, it is because his reasons for living an American heritage are among the most profound: "I can make anything that can be made out of wood, and I don't use nails or glue. It's better than the stuff you buy, and it makes me feel good."[152] Stewart's words leave us with a glimpse of the fulfillment and joy that unite all folk artists. There is no need to romanticize them; in the midst of the difficulties that every life delivers, they have found something clean and pure.

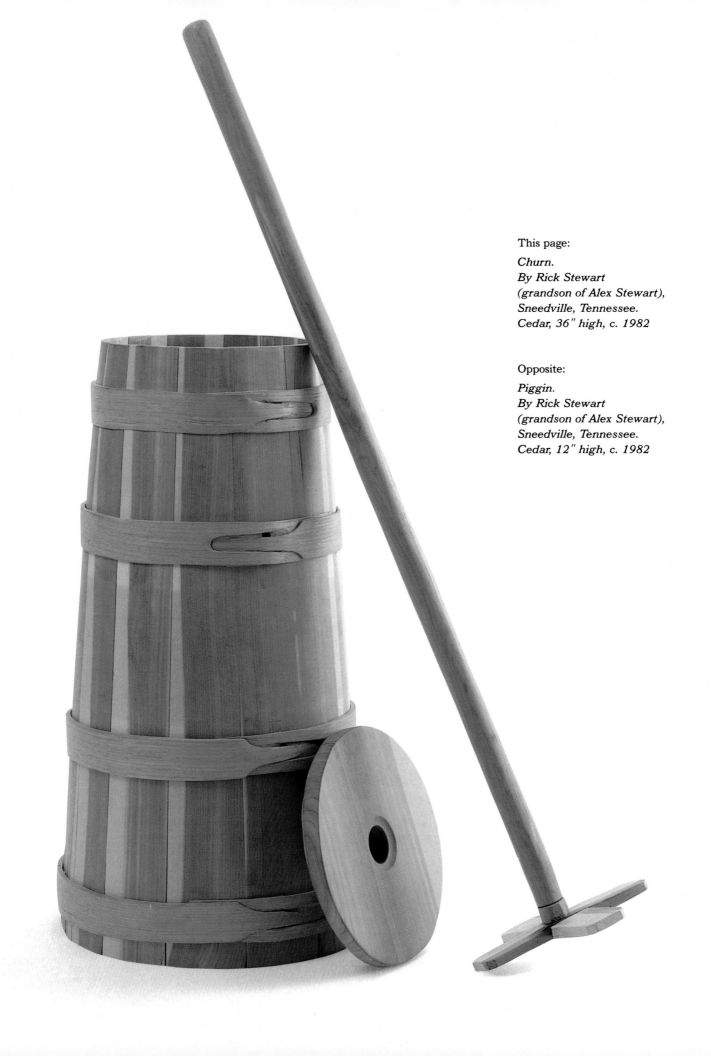

This page:
Churn.
By Rick Stewart
(grandson of Alex Stewart),
Sneedville, Tennessee.
Cedar, 36" high, c. 1982

Opposite:
Piggin.
By Rick Stewart
(grandson of Alex Stewart),
Sneedville, Tennessee.
Cedar, 12" high, c. 1982

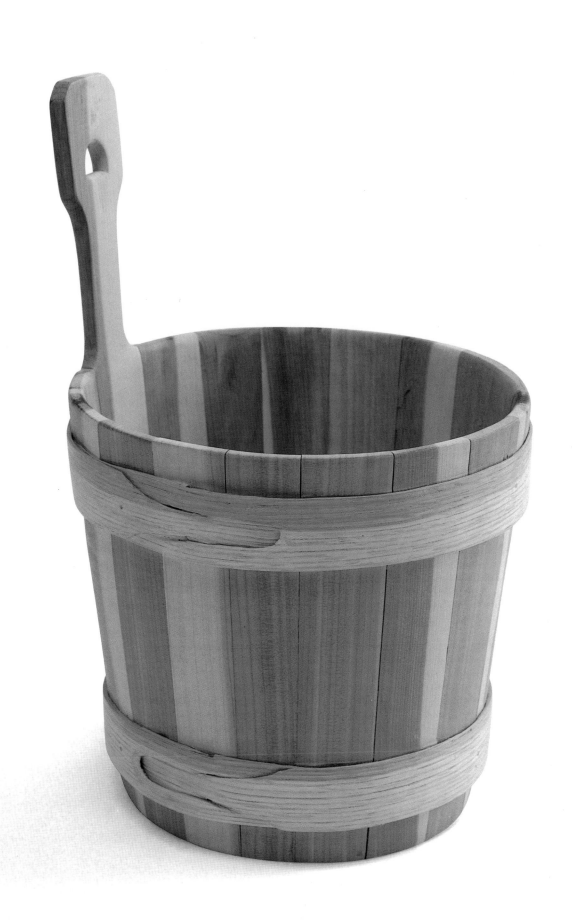

Chapter Three

INNOVATORS

"You've got to change to stay alive."

What is inherited is not always utilized exactly as it was received. Different places, or even just different times in the same place, require ingenuity on the part of tradition bearers seeking to find a balance between what worked in the past and what works today. National Heritage Fellow Philip Simmons, for instance, has repeatedly found solutions to the contrasting demands of tradition and modernity, both in his individual creations and over the span of his long career as a blacksmith in Charleston, South Carolina. As Frank Hodsoll, then chairman of the National Endowment for the Arts, said in the 1982 ceremony honoring the first group of Fellows, "Philip Simmons is probably the most important single reason that Charleston has remained Charleston." Yet, as John Vlach writes of Simmons, "It would not be accurate to label Philip a romantic because of his affection for times past. He does not allow his thoughts to dally in yesterday's glories; rather, he uses the past as a resource."[1] Or, as Philip Simmons himself puts it, "[You] look backward to see forward. To see forward, that's the question."[2]

Philip Simmons began his apprenticeship in Charleston with Peter Simmons (not a relative) at the age of thirteen.[3] Peter, born in 1855, had been a slave, and his father had been a blacksmith on a plantation. In 1924, when Mr. Simmons became an apprentice, there were eight other African-American smiths at work in the city, and "blacksmithing had been an Afro-American craft in Charleston for almost two hundred years."[4] Charleston—and other major Southern cities such as New Orleans, Savannah, and

Mobile—had developed a tradition of beautiful ornamental ironwork gates, balconies, fences, and window grills during the nineteenth century. In Charleston, a great deal of the finest work seems to have come from the shop of a German ironworker named Christopher Werner, whose designs were often executed by his African-American blacksmiths. What was created was a brilliant hybrid of a European artifact with African aesthetic ideas, in some ways paralleling the African-American quilts of women like National Heritage Fellow Lucinda Toomer.

Philip Simmons's apprenticeship lasted four years, and he became Peter Simmon's favorite pupil. He also learned from other Charleston blacksmiths, not all of them African-Americans, and eventually became Peter's partner. Finally, he took over the shop and acquired apprentices of his own. But the changing nature of industrial society in the 1930s and 1940s gradually eliminated much of the traditional work of blacksmithing, and the trade dwindled. Toolmaking, for instance, once a mainstay, became a rare job.

During this period, when the future of blacksmithing seemed doomed, Philip Simmons made a change that allowed his work to survive, develop, and actually become more expressive. He sought a new clientele in the area of ornamental ironwork: "And after the horse-buggy wheels go, something come to me. Say, 'You a blacksmith, you can bend those iron [to look] just like most pattern[s]. You could do a better job. You could make it look like the old originals 'cause you got your forge.' When I got on the forge and people came in. 'Mr. Simmons, I got a broken place in my gate. Could you repair it?' I go there and repair it. . . . And finally I work and I keep my pride, do my work with pride. . . . Finally I start making the whole gate. I said, 'I got the forge and I turn 'em out like the old original.'"[5] Since his first decorative commission in 1939, "Charleston and the surrounding area . . . [have become] an archive of Philip's progress and achievement. . . . He has turned out more than two hundred gates. He has also made balconies, stair rails, window grills, and fences."[6]

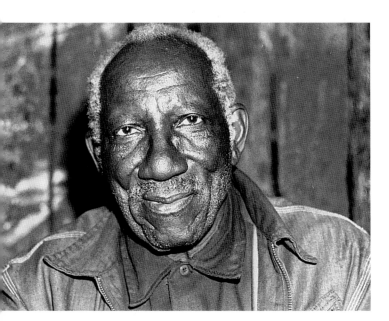

Philip Simmons, African-American blacksmith, ornamental ironworker

The demand for Philip Simmons's services grew as the Historic Charleston Foundation began to promote the restoration of old properties. His familiarity with the entire inventory of Charleston ironwork, coupled with his technical skill and knowledge, meant that he could not only repair and replace antique pieces but could also use contemporary technology to create new works that fit aesthetically with the old. Simmons initiated the sculptural use of animals in Charleston ornamental ironwork, employing snakes, egrets, and other forms in pieces like his masterful star and fish gate. His command

"Star" window grill.
By Philip Simmons,
Charleston, South Carolina.
Painted wrought iron,
29" high, 1988

of the tradition allowed him to explore new ideas with subtlety and without violating a sense of continuity. As Vlach writes: "It is commonly assumed that the use of contemporary technology sounds the death knell for traditional crafts, but we see in Philip's case that his professional life has flourished with new modes of metalwork. . . . His works, in general, still flow in the mainstream of the Charleston tradition."[7]

Philip Simmons defies the threats to tradition in other ways as well: like his teacher before him, he has taken on apprentices. Two of his most constant pupils were Ronnie Pringle and Silas Sessions. They started at about the same age as he himself began and have worked for him for almost thirty years, becoming master blacksmiths themselves.

At the opposite end of the country, in Paradise, California, another innovator looks back on eighty-five years of work. He, too, has taken a utilitarian tradition and, without losing any of its working nature, has expanded its aesthetic dimension so that it is considered "art" first and "craft" second. The artist is National Heritage Fellow Luis Ortega, the art is rawhide braiding.

Even with the widespread availability of synthetic and manufactured materials, many cowboys and buckaroos in the American West today continue to create their own working tools—ropes, bridles, bosals (nosebands), hacamores (headstalls), reins, and whips—out of the hides of cattle and the hair of horses. The reasons given for the use of "old-time," handmade horse gear are many and range from the working practicality of natural material, to matters of style, identity, and pride, to the symbolic (and unconscious). But, as folklorist Gary Stanton writes, "The simple truth is that a buckaroo who uses rawhide riatas or a horsehair headstall makes a personal choice for the handmade object."[9] He also chooses community control over the tools of his trade instead of control by outside manufacturers.

In much of the West, the cowboy tradition is mainly Hispanic in origin, as indicated by the barely anglicized Spanish names of working tools: riata or lariat (rope, from *la riata*), taps (stirrup covers, from *tapaderos*), hacamore (from *jaquima*), macarty (horsehair rope, from *mecate*), and so on. Even the word "buckaroo" derives from the Spanish term for cowboy, *vaquero*, which comes from *vaca*, cow. Hispanic vaqueros taught the cowboys who established the cattle industry in the region after the Civil War. Even earlier in the nineteenth century, as we have seen, they passed their skills on to Hawaiians. Today, although the original vaqueros are gone from Hawaii and the West, their traditions remain.

Luis Ortega is a living link between the ancient Hispanic cattle tradition and the modern cattle culture. His ancestors came to the United States directly from Spain; one of them, José Francisco de Ortega, is credited as the first European to discover San Francisco Bay by land, in 1769. Luis Ortega's

I know how long wrought iron supposed to last. I build a gate, I build it to last two hundred years. If it looks good, you feel good. I build a gate and I just be thinking about two hundred years. If you don't you're not an honest craftsman.[8]

Philip Simmons

family has lived in California ever since then, having originally received lands in the area occupied today by Vandenberg Air Force Base. With roots going back to the beginnings of the vaquero tradition in the West, Mr. Ortega was thus, like Philip Simmons, in an unimpeachable position to make innovations that would be congruent with tradition.[10]

Born in 1897 on the Spade S Ranch in California, Luis Ortega grew up speaking both Spanish and English and was introduced, as a youth, to the vaquero style of cowboying by his father, the foreman of the ranch. He began to learn how to braid rawhide at the age of seven, partly from other vaqueros on the ranch, but mostly from a 110-year-old Indian. Of his ancient mentor, Ortega says, "Because of his age, he was far-sighted and couldn't see too well up close, but he would tell me how to select and cure the hides and then cut them into strands."[11]

Listening to Mr. Ortega speak is probably the closest one can come now to the vaquero era. He describes herding cattle into Santa Maria and Guadalupe in 1911, the year he left home to buckaroo between Santa Maria and Salinas, California. During World War I, he went to Mexico, to the state of Chihuahua, to bring cattle to the United States by train.

Mr. Ortega's recollections of these days provide a remarkable source of historical description, a perspective unavailable in conventional histories. As he describes it, the vaqueros' labor was hard and repetitious, but their life still had its rewards. At the end of the working day, after a big dinner, they would bring out their musical instruments, which were kept in the chuck-wagon—usually a mandolin, accordion, harmonica, and, rarely, a guitar. Ortega himself played tunes on the harmonica like "Red River Valley," "The Missouri Waltz," and "When the Work's All Done This Fall."

As a buckaroo, Ortega worked not only in California, but also at the frontiers of the buckaroo region—near Klamath Falls and Lakeview in southern Oregon, and Jordan Valley on the Idaho border. He spent several winters near Lakeview feeding cattle and making rawhide objects—bosals, hobbles, riatas, and reins—for $35 a month. In the 1930s, Ortega stopped buckarooing to devote himself full time to his rawhide braiding. Already well known for his fine work, he realized he could make a better living as a craftsman than as a cowboy. He was also dissatisfied with the changes that were occurring in the buckaroo's job about that time. The working cowboy was fast becoming a handyman who stacked hay and mended fences; the proud horseman was losing his place.

Although Ortega's Rawhide Shop in Santa Barbara at first employed a few other craftsmen, he eventually found he did not like managing others and so decided to make his business a solo operation. He left Santa Barbara with a promise to himself that he would "get so high up in this rawhide game that nobody would ever catch up."[12] In this he has surely succeeded. Moving to

Walnut Creek in 1941, he began by doing "fancy" work and invented the process for dyeing rawhide, which allowed him to introduce color into his work without using tanned leather. Cowboys and others found the subtle colors of Ortega's rawhide much more pleasing than those of tanned leather, and for a while Ortega was the only one who could produce this handsome effect. After another move to Cottonwood, he officially retired to Paradise more than twenty years ago. Yet, in 1985, at the age of eighty-eight, Luis Ortega felt he was at the height of his artistic powers and continued to produce work for special orders.

Luis Ortega is an exceedingly careful man. That is obvious from the appearance of his work and also from his meticulous conservation of his powers as a craftsman. In his early years, for instance, he made many riatas. He realized, though, that if he continued to do this, the coarse, broad work involved would make his hands insensitive. So he "slowed down on those" and developed the extremely fine, precision work characteristic of his bridles and hacamores.[13] Since about 1960, Ortega's work has been bought mainly by people interested in it as art or as the equipage of show horses. Although no working cowboy could spend $500 for a pair of hobbles or $1,000 for a quirt, twenty-four examples of Ortega's work are on display at the Cowboy Hall of Fame in Oklahoma City.

Unlike many folk artists who do not label themselves as such, Luis Ortega does use the term, and in full cognizance of its prestigious connotations. His business card reads "rawhide artist," and the appellation is accurate. No other worker of rawhide is in his league: he has set the standards, made an art of a craft, yet remained utterly faithful to the aesthetics of the vaquero's and buckaroo's working tools. His work is eminently usable; it is just that no one would want to use something of such beauty for everyday work.

Unlike Philip Simmons, Ortega did not take on apprentices, for it was not part of the buckaroo tradition. Older rawhiders did not show younger men how to braid; they kept their techniques secret. For one thing, doing rawhide work was a source of income for men who were paid very little—why create competition? For another, rawhide braiding was a riddle to be solved; you earned your right to do it by puzzling it out, by experimenting, by hard mental work. Cowboys relied on resourcefulness in their daily life, and the challenge of rawhide braiding provided an opportunity to develop self-reliance and skill through painful trial and error.[14]

Although Ortega did not take on apprentices, it is not quite accurate to say that he had none. There was one he did not know about—National Heritage Fellow Duff Severe. As a working cowboy and saddlemaker from Oregon, young Duff Severe was familiar with the already legendary rawhide work of Luis Ortega, as well as with the tradition of guarding one's rawhide knowledge. During World War II, Duff served in the Navy and was stationed

for a while in San Francisco, not far from Ortega's shop in Walnut Creek. When Severe got time off, he would visit Ortega to hear stories about buckarooing in the early 1900s. Ortega braided as he talked, and Duff noted each movement. Duff says he never mentioned rawhide braiding because he was afraid Ortega would put his work away if he did. Duff would go back to the base and practice braiding, then come back again on another day. In this way, he was able to learn from the recognized master of rawhide braiding without giving himself away. Through Duff Severe's folktale-like solution, Ortega's masterful innovations entered tradition.[15]

Severe did not take without giving back. He nominated Ortega as a National Heritage Fellow and praised him as the best rawhide braider in America—perhaps the best there has ever been. Duff himself guarded his patiently learned rawhide skills for most of his career. Although he worked as a saddlemaker and took on saddlemaking apprentices, he would not teach rawhide braiding. After he received the National Heritage Fellowship in 1982, he began to realize that his knowledge of rawhide braiding might perish with him, so he applied to the National Endowment for the Arts for an apprenticeship grant. His apprentice, nephew Randy Severe, has become the next link in a chain of traditional knowledge, and Ortega's innovations have thus been preserved.

As Luis Ortega brought color, precision, and exquisite fineness to rough cowhides, and Philip Simmons hammered hard iron into graceful birds and flowing shapes, Claude Joseph Johnson took the raw material of sound, "the singing voice including every possible expressive effect from growls to cries,"[16] and shaped it into hymns, spirituals, and unforgettable sermons. His grounding in tradition seems to make him an inheritor. But, as folklorist Brett Sutton has written, "Dr. Johnson, as a maker of new songs, has also demonstrated an ability to create new materials out of traditional elements, and thus stands as a living example of the innovator on whom all traditional cultures must rely for survival."[17]

Dr. Claude Joseph Johnson was a member of the African-American community of Atlanta from the age of three until his death at seventy-seven in 1990.[18] When he was only seven years old, he had a dramatic conversion experience:

> The truth about it is that I was converted under that song, "I heard the voice of Jesus say,/Come unto me and rest./Lay down thy weary one, lay down,/Thy head upon my breast." Now, when I heard grandma singing that song, I would continue to hum that song during the day. So when I was converted that Friday, I heard that song. I wasn't singing it. Nobody was singing it, because it was soon in the morning. . . . When I heard that song it was dark out there, and I was cutting the kindling by moonlight. And all at once, everything just got light all around me like a flashlight.

Something started to going all over me, just like somebody was blowing warm, hot air on me. Then I got real light and I remember screaming. I left the cutting of the kindling and ran in the house and told Grandma "I got it! I got it! I got it!" And she picked me up in her arms and I tried to tell her what happen out there—'bout the light."[19]

Johnson had already led his first shape-note song, "The Prodigal Son," two years earlier, while standing on a table at the front of the church. According to scholars William and Janice Dargan, "This event so stirred the people to shout and rejoice that he was unable to finish the performance."[20] He was ordained and giving sermons by the age of ten and began his first full-time pastorate at twelve.[21] Later in his long career, Johnson sought formal training, receiving B.D., B.Th., and D.D. degrees. He sang and preached in Atlanta from 1918 until his death, three years after receiving the National Heritage Fellowship.[22]

The permission that the African-American church communities freely gave Dr. Johnson to lead them is deeply traditional in itself and is also intimately connected to the kinds of musical performances central to those churches. The African-American musical tradition Dr. Johnson lived within is based on a reciprocal "call-and-response" pattern in which the leader is echoed by his congregation. Widespread in Black Africa, this pattern was realized in pre-Emancipation America through a process called "lining out." The leader would sing a single line of a hymn, and the congregation would sing it back; the next line would follow, and so on through the song. "Lining out" developed during slavery, when hymn books were rarely made available

Claude Joseph Johnson,
African-American
religious singer, orator

to African-Americans, who were in fact often punished for literacy. The practice also reflects a much more ancient African cultural preference for lively interaction in spiritual matters. (Today, "lining out" has evolved into "surge singing," in which the parts of the leader and the congregation overlap, support, and decorate each other in a spontaneous fashion.)

The Dargans have pointed out that, within this tradition, it was not C. J. Johnson's preaching or his singing that set him apart. Like hundreds of other Black ministers, he preached in the whooping style and sang the old lined hymns and spirituals.[23] That, of course, was what made him traditional. But, unlike other Black preachers, Johnson had an uncanny awareness of who he was and of his unique place in the history of African-American culture.[24] This awareness informed his own compositions, his poetic sermons, and his lasting documentation of his tradition and his community.

> Now this word hooping [whooping], it's really a cry. You cry out loud. And in doing so, I found in my preaching that it seem to bring spiritual movement or something in the hoop [whoop]. Preaching right straight along, people are listening to the words and then there comes a time when you wanna cry out, there's something motivates on the inside. It just make you wanna, just scream out for the Lord! And in doing so, it has its power.[25]
>
> C. J. Johnson

Dr. Johnson's most innovative idea was to record the hymns and spirituals of his tradition in their authentic settings—in churches, often unaccompanied, and not formalized or standardized in any way—and then to distribute them back into the community. With the sensitivity of a native ethnographer, he documented this tradition from the inside, making more than twenty commercial recordings between 1965 and 1990. These recordings were (and still are) sold in neighborhood stores within the African-American church communities. As Sutton writes, Johnson "turned this potentially destructive mechanism of audio recording into an extension of cultural patterns that have been a part of the American black tradition for hundreds of years."[26]

Johnson's innovation sprang from a historic vision of time. He himself said, "I could die easier, knowing that I've set a plan down here for young people to come on up singing hymns."[27] It was as if, while remaining fully alive in the present, he could also look back at his own time and place from the future and see what would one day be valued as most deeply characteristic.

Innovation and its close cousin, improvisation, seem to be identifying features of African-American folk expression. Scholars have written eloquently about improvisation as the organizing principle of the African-American aesthetic sensibility in arts like blacksmithing, woodcarving, and quilting. African-American quilts, for instance, are based on different compositional rules than those of the Anglo-American quilting tradition, which places a high value on symmetry, repetition, certain color combinations, and the use of squares, straight lines, and neat, tight stitches. Often, you need only one

*Pieced strip quilt.
By Lucinda Toomer,
Dawson, Georgia.
Cotton, 82 x 61", c. 1975*

block to know what an entire Anglo-American quilt looks like. A woman making a traditional African-American quilt, on the other hand, is improvising on a theme. She begins with an idea, sometimes a motif, and produces variations by turning it upside down, on its side, making it big or small, or reversing its colors. Improvisation-in-composition is the guiding principle, rather than the carrying-out of a preformulated, repetitive pattern. Thus, if Anglo-American quilts can be said to emphasize geometric symmetry, African-American quilts can be seen as "geometry in motion."[28]

National Heritage Fellow Lucinda Toomer of Dawson, Georgia, was a prolific African-American quilter, making as many as twenty quilts a year. Several were featured in major exhibitions, and two are in the permanent collection of the American Museum of Natural History in New York. Lucinda Toomer's work provides an ideal model for understanding African-American aesthetics, as John Vlach illustrates:

> Afro-American strip quilts are random and wild, seemingly out of control. Even the subdued example of an Afro-American quilt by Lucinda Toomer of Dawson, Georgia, shows a distinct tendency toward improvisation. She alternates thin solid strips of color with wide strips composed of blocks of diamonds. But then her strips are not all exactly the same width, and the blocks of diamonds have as many as six colors scattered randomly about as a carefree counterpoint to the strict formality of the block motif. Furthermore, the strips which constitute the borders of the quilt are not all made of the same material but rather are pieced together from odd bits of corduroy. Mrs. Toomer thus strikes a visual balance between precision and random variation. Rigid block patterns have been worked into a free-flowing strip arrangement. The variation here in color and size of strip reflect[s] an improvisational approach to design which is analogous to the instrumental break in a jazz composition. Having established a theme with diamond blocks and solid strips, Mrs. Toomer plays variations by changing a few colors and altering the dimensions of her motifs. Though her manipulations of the design do not change the basic motif, these slight changes do create a meandering pattern of random improvisation.[29]

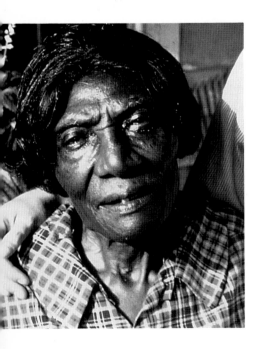

*Lucinda Toomer,
African-American quilter*

Improvisation and innovation, as aesthetic principles in themselves, are much more familiar to the general public through African-American music than through African-American material culture. The names of the numerous Black musicians—Creole or French-American as well as African-American—who have been recognized as National Heritage Fellows constitute an honor roll of dynamic, creative performers. Musicians like Alphonse "Bois Sec" Ardoin, John Cephas, Clifton Chenier, Elizabeth Cotten, The Fairfield Four, Canray Fontenot, John Lee Hooker, Brownie McGhee, Alex Moore, Sr., Willie Mae Ford Smith, Sonny Terry, Henry Townsend, and Horace "Spoons" Williams can all be called "innovators."

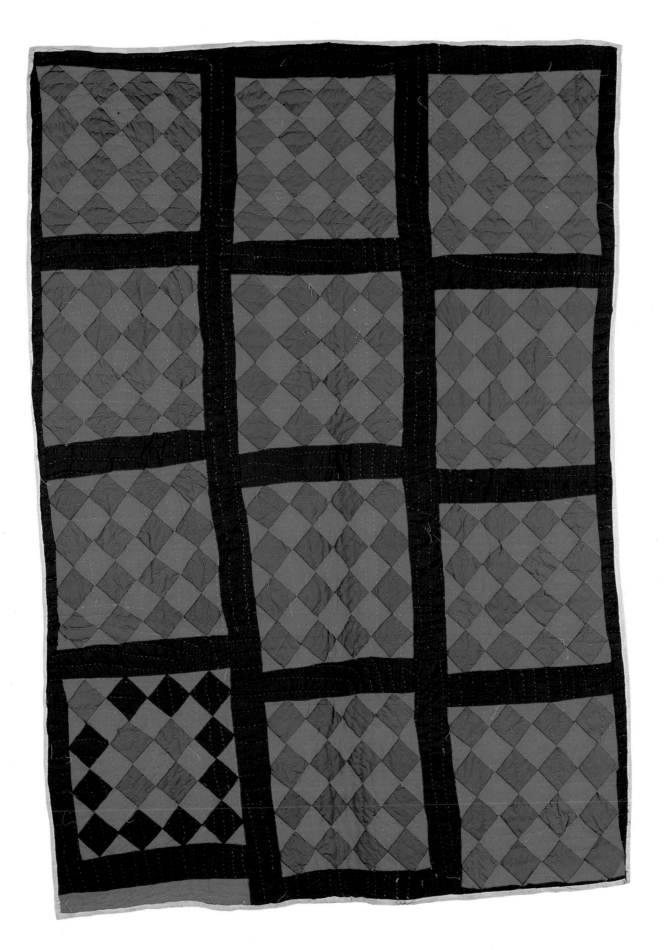

Written words are a poor substitute for any kind of music and cannot convey the spontaneous feeling of the whoops and hollers Sonny Terry used to perform on his harmonica. But one of his stories does at least allow us to recognize how clearly Sonny perceived the importance of improvisation in his music. He was auditioning to play for the Broadway musical *Finian's Rainbow*: "The guy walked up to me, and said, 'Sonny, there's one thing you got to do, man.' I said, 'What is that, man?' He said, 'You got to play the same song in the same way every night, man.' I said, 'I can't do it, man.' He said, 'You got to do it, man.' 'I can't do it, man.' 'You got to do it, man.' 'I can't do it, man.' We went over that thing about ten or fifteen minutes."[30] When Sonny found out how well he would be paid, he agreed to the job, but the idea of playing the same tune exactly the same way every time was clearly not the preferred performance mode of a traditional African-American musician who depended on his powers of inspiration and improvisation rather than written music. When Sonny played the tune in question from *Finian's Rainbow* at the concert celebrating the first National Heritage Fellowships in 1982, it had "about 25 different kinds of whoops."[31]

The ability to improvise and innovate within a tradition implies a knowledge of the tradition that is at the same time abstract, instinctive, and deep. Musical improvisers who work in a tradition possess a knowledge of principles, not just products; of melodic conventions, not just tunes. Their artistry is in their fingers, feet, and voice, not just their mind. Innovators find their way to the wellsprings of tradition by becoming the living wellsprings themselves.

At the concert honoring the first Fellows, Sonny Terry teamed up with Brownie McGhee, his partner for many years. McGhee had also been named a National Heritage Fellow for his brilliant blues guitar music. Together they took the old traditional song "John Henry" and bounced it back and forth between the harmonica and the guitar and between their voices, each rich in emotion and personality. The constant musical play between the two was as clearly in the form of "variations on a theme" as was the quilting of Lucinda Toomer. Yet the traditional tune and words, stretched to new vocal shapes and unanticipated pitches, were never lost. The members of the audience knew what they were hearing, but they had never heard it like this before: they had never heard it so good.

Perhaps part of the ability to innovate within tradition comes from the life experiences of these men and women. Brownie McGhee introduced his performance at the Fellowship awards with a short conversational monologue, which, within a few brief lines, turned into poetry and then into music: "I've lived, I've loved,/I've laughed, and I've cried./But my story's very simple—/I still got my pride./I was born—and I'm living—with the blues." Brownie then struck a blues riff on the guitar, and the audience knew that everything that

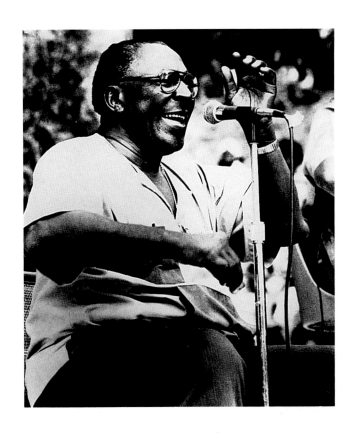

*Sanders "Sonny Terry" Terrill,
blues musician*

*Brownie McGhee,
blues guitarist*

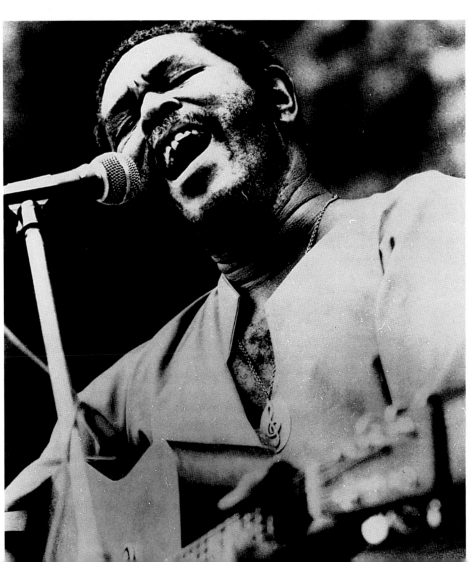

followed would touch them, because they had already been pulled into the heart of a dark history: "From my childhood,/To where I am now—/I ain't gonna worry,/I'll get by somehow./My momma had 'em,/My daddy must of had 'em, too—/That's why,/I was born,/With the blues."[32]

When Brownie McGhee says he was "born with the blues," he speaks for a whole generation of talented Black musicians, talkers, and dancers. Many of these great performers have had a hard beginning and a hard time most of the way after that. Canray Fontenot, the magnificent Black Creole fiddler, has worked cane fields and sharecropped much of his life. Horace "Spoons" Williams—master not only of the unlikely medium of spoons and bones, but also of African-American poetry—left home at thirteen to work at a series of backbreaking jobs. John Lee Hooker, blues guitarist and singer, ran away from his home in Clarksdale, Mississippi, at fourteen and headed to Memphis and then Detroit, bringing Delta country music to the city. Henry Townsend, blues musician and songwriter, left his home in Shelby, Mississippi, walking north on a highway after a series of confrontations with his father. He was nine. He said, "I came to be a man about age nine. I had to."[34] For all these performers, the improvisational aesthetic of their African heritage was reinforced by the necessity to live by their wits in America.

National Heritage Fellow Horace Williams was born in rural South Carolina in 1910.[35] He began beating out rhythms on gourds, jugs, tin pans, and eventually spoons and bones (animal rib bones, grasped in pairs like spoons), at an early age. In the long tradition of the economically, but not musically, deprived, he set about "transforming common articles into tools of artistry."[36] He took to the road as a young boy after having defended his mother from a white bill collector who had hit her. Even before he left, he had seen unforgettable sights—like the lynching of five black and two white men: "Seven of 'em on a single tree. That sight stayed with me a while."[37] He had to hide in a ditch to save his own life, knowing he, too, would be killed if he were discovered. Scenes like this, and those he witnessed as a soldier in World War II, led to some of his most powerful poetry. In his wanderings, Williams labored at all kinds of jobs—washing dishes, cooking, mining, logging, laying railroad track, building roads, fishing for menhaden, working as a carnival roustabout.

For many years, Williams played the spoons and bones for whatever audiences he could find. His usual concerts were impromptu performances, sometimes accompanying blues guitars and pianos in local bars, on streetcorners, and at house parties. When he settled in Philadelphia, in the late 1940s, "he kept playing his spoons, entertaining within the African-American community and acquiring a city-wide reputation as master of rhythms. Hence the name by which he is recognized on the streets of black Philadelphia—'Spoons.'"[38]

Music was all I had growing up. Music and animals. . . . I'd play my spoons, make up some stories, and it was like cutting a hole in the clouds to let the sun shine through.[33]

Horace "Spoons" Williams

130

But Spoons's verbal eloquence—in traditional African-American forms like the boasting toast and in his own personal narrative monologues like "A Black Man Talks to God"—was private, reserved mainly for family and friends within his own community. In the last years of his life, before his Fellowship award in 1985, he performed his poetry, as well as the spoons, before wider audiences: at the National Storytelling Festival, the Smithsonian's Festival of American Folklife, the Festival of Black Storytellers in Philadelphia, and artists-in-schools programs (to which he would bring fifty pairs of spoons for the children to play).

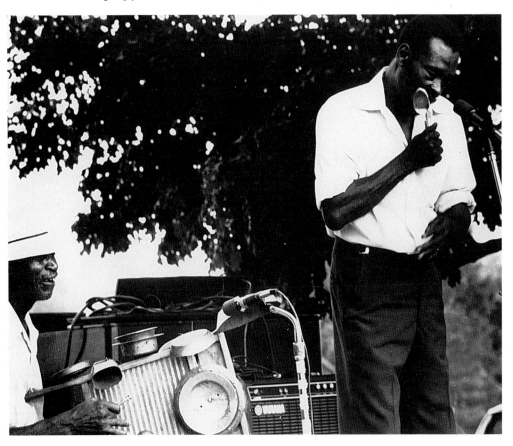

Horace "Spoons" Williams, spoons and bones player, poet, with Robert "Washboard Slim" Young

A moving tribute to Horace Williams comes from William Cran, a film producer for British Broadcasting Corporation Television. He and his crew filmed Spoons for a series entitled "Mother Tongue: The World Journey of the English Language." Cran wrote: "The two days we spent filming him were among the most memorable of my professional career. It goes without saying that his spoon-playing kept us spellbound for hours, while the rhymes and poems he has made up were sometimes hilarious and sometimes deeply moving. . . . In my view, Spoons is an important and powerful folk artist."[39]

Horace Williams's percussive manipulation of rhythm and tone bears comparison with some of today's avant-garde music, another innovative sound that broadens our notion of what music is. But if "music" is no longer

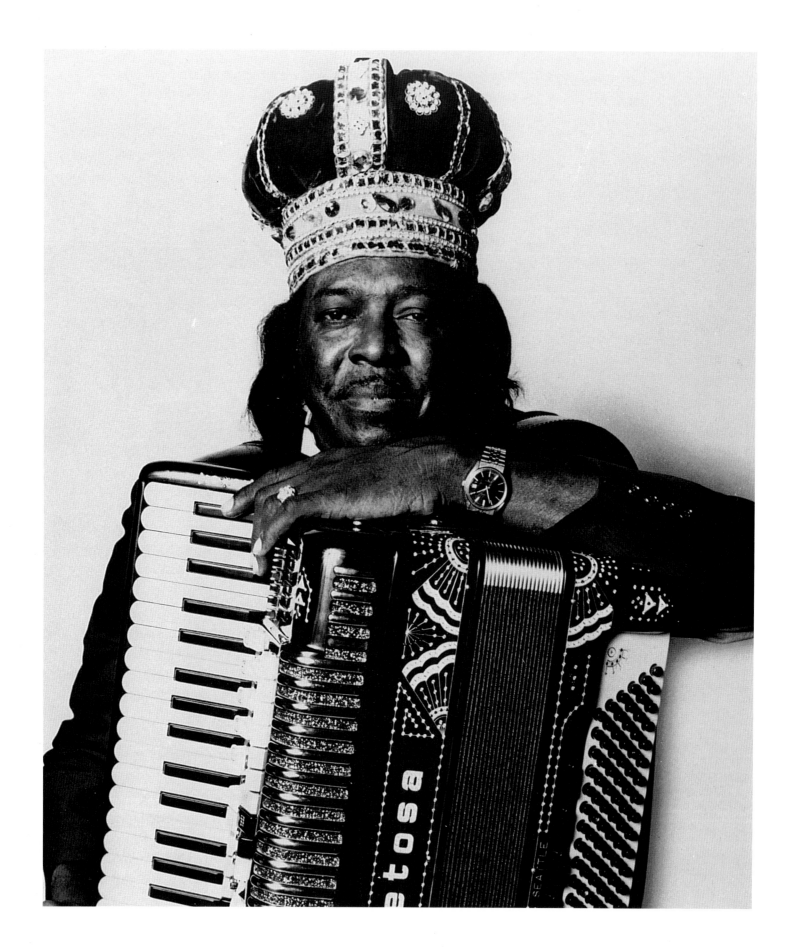

easy to define, "*folk* music" has always been a difficult and controversial term. Abstract theories, of course, are never adequate to the living experience, but when we hear someone like National Heritage Fellow Clifton Chenier, the late Creole zydeco accordionist from Lafayette, Louisiana, we get a flash of insight about what really makes folk music folk. Usually, we think of folk music as old, but age itself it not an adequate criterion—Chenier was one of the innovators of a new kind of folk music, zydeco, in the twentieth century, building as he did on earlier African-Caribbean, Cajun, and Creole tunes, and blues style. Nor can folk music be defined as always involving acoustic instruments—Chenier played an accordion backed up by electric guitars. It is not even simple popularity among the "people" (the "folk"—i.e., us) that is definitive, or rock and roll would have to be considered folk music, too.

Clifton Chenier, zydeco musician

What seems most central is that a particular community responds to the music by saying, collectively, "This is our soul." Today, between St. Martin's Parish in rural South Louisiana and Houston, Texas, people from Black Creole communities jam bars, juke joints, and dance halls to hear *their* music, zydeco, and to dance to it. There can be no doubt that zydeco is the soul of these communities; Chenier may have had a key role in locally popularizing its new form, but it really belongs to the community that nurtured him.

Zydeco grew out of the Black Creole experience in Louisiana and, like it, is a combination of many cultures: African, French, Spanish, and Caribbean, in native, urban, and pop variations.[40] When Chenier sang lines like "I'm a hog for you, baby/I'm gonna root around your door," he was clearly in the rural, Southern blues idiom, even if he was playing an accordion instead of guitar. Many of his faster dance pieces, however, sound a lot like Cajun two-steps in a kind of Afro-Caribbean rhythmic framework. All in all, the zydeco mix of traditional styles, instruments, and popular music is not easy to analyze. Chenier was clearly "a creator of a genre of folk music in his own time, a true innovator,"[41] but he always worked in fulfillment of tradition rather than as a departure from it.

When a person sings, he can forget about how hard his life is.[42]

Canray Fontenot

Other musicians, like National Heritage Fellows Alphonse "Bois Sec" ("Dry Wood") Ardoin and Canray Fontenot, have also contributed greatly to zydeco.[43] Their music, like Chenier's, is clearly of the community. Performing mainly in their home territory (southwest Louisiana), these musicians often play at informal social gatherings, without a stage or even a raised platform. Thus, there is only a minimal distance, both literally and figuratively, between the performers and the audience. The audience comes to dance, not to watch, and the music belongs to no one and to everyone. Children are everywhere, and there is much food and joking. The music starts unceremoniously because it needs no introduction—it is like being at home.

Alphonse "Bois Sec" Ardoin,
Black Creole accordionist

Canray Fontenot,
Black Creole fiddler

The rhythm of zydeco music—and of all living folk music—is the pulse of community life, and the musician is the community's heart.

Both Bois Sec Ardoin and Canray Fontenot were born into families of notable local musicians. Their fathers, Amédé Ardoin and Adam Fontenot, were Black Creole innovators who also influenced Cajun accordion style early in this century. But both Bois Sec and Canray had to struggle, in surroundings of great poverty, in order just to begin to play. Canray, born in 1918 in l'Anse des Rougeaux, Louisiana, describes how he made his first violin from an old wooden cigar box. He used wire from a screen door for the strings, a switch for the bow, and threads for the hair of the bow. Rosin came directly from a pine cone. Fontenot says, "That's how I got started."[44] He played the cigar box fiddle for two years before he had a fiddle of his own.

Alphonse "Bois Sec" Ardoin, who has played with Fontenot for more than forty years, had no easier a time.[45] His father died when he was two years old. His older brother had an accordion, but would not allow Bois Sec to play it. While the older brother was away at work, Bois Sec would take the accordion and climb to the top of the barn to play; that way, he could see his brother coming home and return the accordion to its place in time. What he did not realize was that up on the barn he was broadcasting his music across the fields. One day, the brother returned and demanded that Bois Sec play the tune he had just been playing. Bois Sec knew he had no choice. But his brother—who could not play well—was impressed and generous: "From this

day on, go ahead and play. You know that I haven't been able to learn. Since you seem to be able to play, then play."[47]

The difficulties facing Fontenot and Ardoin were enormous, but both had an equally enormous advantage in growing up near Mamou, the unofficial capital of rural Cajun country. The families of both men had already produced great musicians, and local music was part of their daily experience. As folklore scholar Barry Jean Ancelet writes, "The Fontenot household was a center for the musical and cultural life of the community. Life was hard, but full, and especially full of music and the warmth of human contact."[48]

Folklorist Alan Lomax wrote of Fontenot and Ardoin, "Both are virtuosi performers; both are great spirits. When playing together, they are utterly irresistible. . . . They are also country folks; modest, quiet, gentle, and enduring."[49] The two proved to be as capable on the festival stage as in their own country communities, and their list of major appearances is impressive.[50] Though they have also toured Europe, their music continues to be shaped by the response of their French, African-American community in southern Louisiana.

Zydeco music gives contemporary, innovative expression to age-old emotions. Clifton Chenier's beautiful song "I'm Coming Home," written for his mother, echoes the words of one of Fontenot and Ardoin's songs: "It's time to go home/And I know that my heart hurts." The concept of home can speak to groups as well as to individuals. Both French and Black culture in Louisiana began with an exile from home, and history for Cajuns and Creoles has been the effort to create a new home.

Black history is recorded and interpreted in many ways: in song, oral narrative, poetry, and dance, and in material culture as well. National Heritage Fellow Elijah Pierce, for instance, told stories through his woodcarving, his "sermons in wood."[51] One of his themes was the manifold humiliations of slavery, remembered in the painted relief *Slavery Times*. As the son of a former slave, Pierce had heard accounts of slavery firsthand; his own narrow escape from being lynched in Mississippi is recorded in the carving entitled *Mob*. Of those times, he says, "Any man with manhood couldn't take it."[52]

Like many African-American artists, Pierce found his great inspiration in the Bible. Throughout their history, African-Americans have strongly identified with the Jewish people enslaved in Egypt, but other stories have sparked their creativity as well. Certain figures, like Moses, Elijah, and Saint Peter, appear in African-American folklore, articulating wry and heroic aspects of the Black experience in America. There is an unending wealth of artistic elaborations—in song, through the spiritual and gospel tradition; in story, through sermons and folktales; and in painting and sculpture, through the works of many untrained, but profoundly expressive, visionary artists.

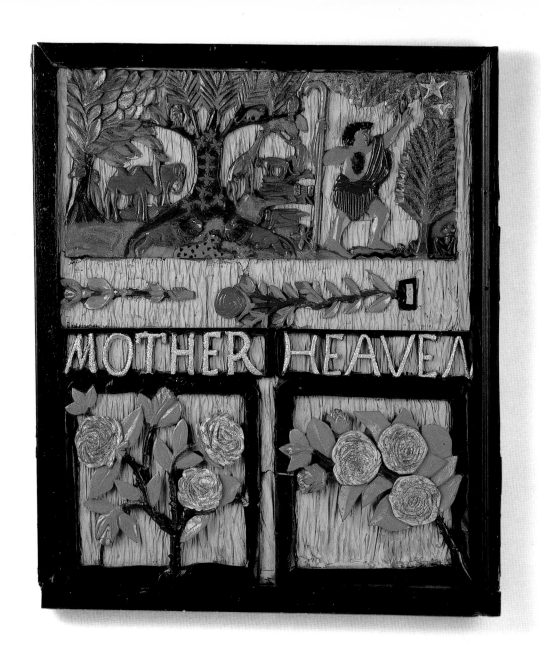

Saint John in the Wilderness.
By Elijah Pierce,
Columbus, Ohio.
Carved and painted wood panel,
32" high, c. 1960

Hippogator.
By Elijah Pierce,
Columbus, Ohio.
Carved and painted wood,
rhinestone eyes,
38" long, 1979

Elijah Pierce,
African-American carver,
painter

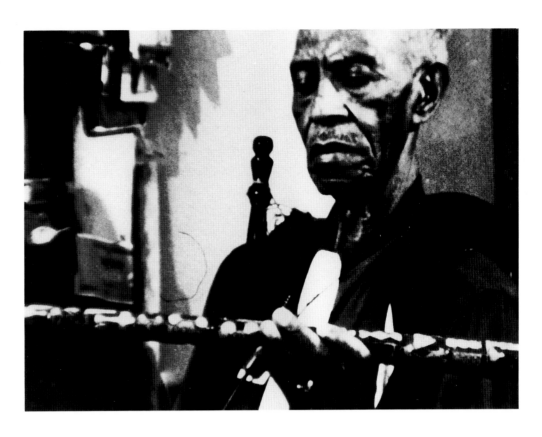

God talks with me. In a natural voice that I can understand.
He calls me by name, Elijah.[53]

Elijah Pierce

Pierce's *Book of Wood*, for instance, portrays scenes from the life of Jesus, narrating the sacred story in the same way the frescoes of medieval and Renaissance churches did: "If a picture don't tell a story, it just don't seem right to me. . . . A lot of little children look at some of my work, and see what it's trying to tell. They see it and they know it's telling a story. They can get something."[54]

Pierce was born near Baldwyn, Mississippi, in 1892 and died in Columbus, Ohio, in 1984. While his occupation was barbering, his calling was preaching and art. Thus, Pierce's barbershop in Columbus became an art gallery depicting spiritual and social struggle. It also was a showcase for the display of his sheer delight in God's creation: Pierce's carvings for a Noah's ark were only the first of his many colorful, imaginative, and whimsical depictions of animals. These humorous three-dimensional creatures stand on their own as sculpture and could easily romp with Maurice Sendak's "wild things" or with the fantastic beasts of Juan Alindato's carnival masks.

Elijah Pierce's wood carving relates his own personal history as well as that of his people. In his mid-sixties, he began to engrave the story of his life into what would become an elaborate walking stick. The project, which took twenty years, "combines family history, biblical references, and life cycle events and images from everyday life—the tools of his trades (a comb, a barber's chair, a cross and bible), the funny story a customer once told him—all rescued from miscellany and uniquely combined into a statement that stands for his life."[55] Pierce called upon this focused essence of a lifetime for knowledge, eloquence, and inspiration: "Sometimes when I was asked to say something in church, I would turn this cane over and over until I found a story or message I wanted to use."[56] Thus, he named it his "preaching stick."

What made Elijah Pierce an innovator within the tradition was not the carving of a walking stick. The carving of staffs and canes has clear precedent in West Africa and strong continuity in African-American society, particularly in the South, where Pierce was born.[57] What was original was his utilization of a traditional medium and symbols to review his own life and arrive at its significance. In doing this, he extended the staff/walking-stick tradition and deepened its inherent meaning, as a symbol of power and authority. Unique yet traditional, specific but accessible to others, articulate and interpretable—Pierce's "preaching stick" materializes an artistic code.

Could this particular artistic code be somehow linked to the human genetic code, to a genetically transmitted clock that runs in the bodies of all humans, independent of race, independent even of culture? Many people become artists late in life, or return to art forms they practiced in their youth, seeking to define through art the shape and structure, color and themes, continuities and breaks of their own lives. Some do this through their stories, but "autobiographies and memoirs are not always found in books. . . . They

138

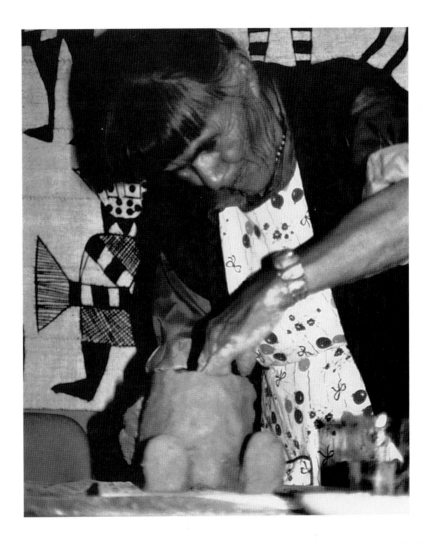

Helen Cordero,
Cochiti Pueblo potter

emerge on canvas and in wood; on fabric and in stone. . . . Telling one's story seems an essential part of being an elder, and culture provides an array of expressive forms for putting one's story forth."[58]

Though they often use traditional media, such older artists are usually innovative within those media. They even sometimes create new traditions out of old ones, as did National Heritage Fellow Helen Cordero, Pueblo potter and inventor of the evocative storyteller doll. Although Mrs. Cordero has had more impact on the Pueblo pottery tradition (and arguably all of Southwestern traditional art) than anyone else in this century, she did not learn to make pottery until she was forty-five.

Helen Cordero was born at Cochiti Pueblo, New Mexico, in 1915.[59] Hers was a culture that had had more than two thousand years of experience in making pottery, of shaping "the flesh of Mother Earth into useful, playful, and ceremonial forms."[60] In the late 1800s, this tradition developed a somewhat satirical character, and the resulting cowboys, two-headed beings, opera singers, and other clay figures provide a fascinating Native perspective on the Anglo culture of that era. But about the time Helen Cordero was

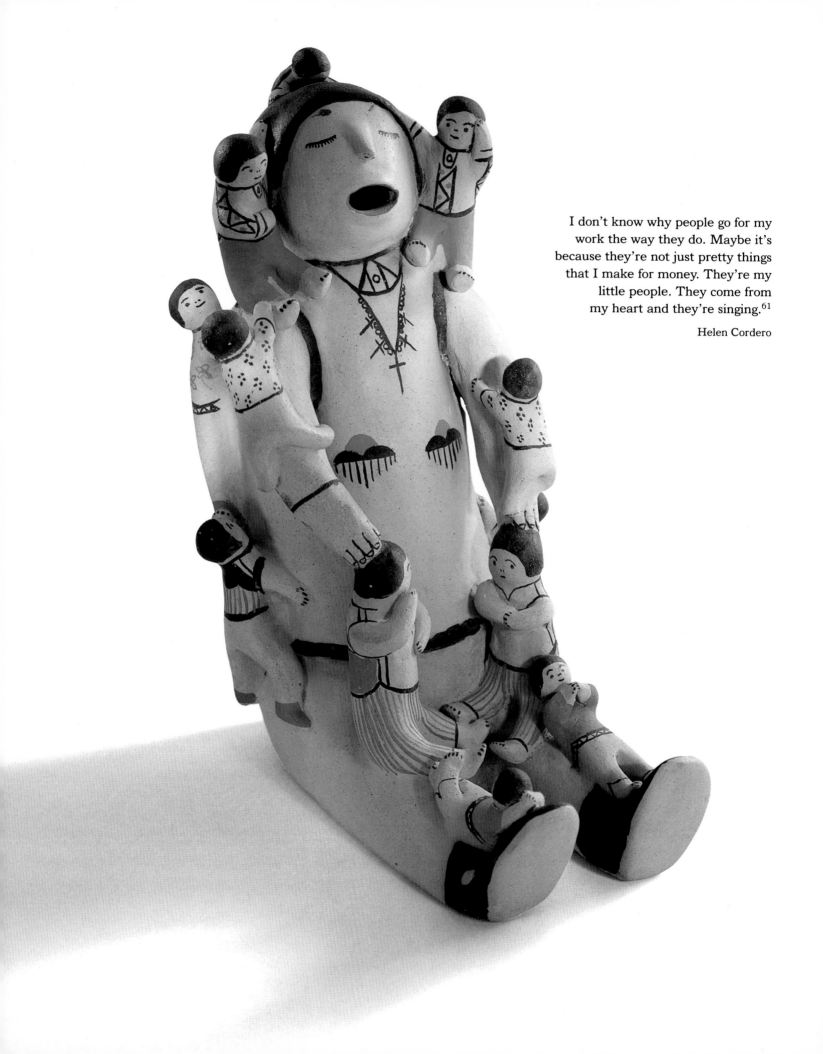

I don't know why people go for my
work the way they do. Maybe it's
because they're not just pretty things
that I make for money. They're my
little people. They come from
my heart and they're singing.[61]

Helen Cordero

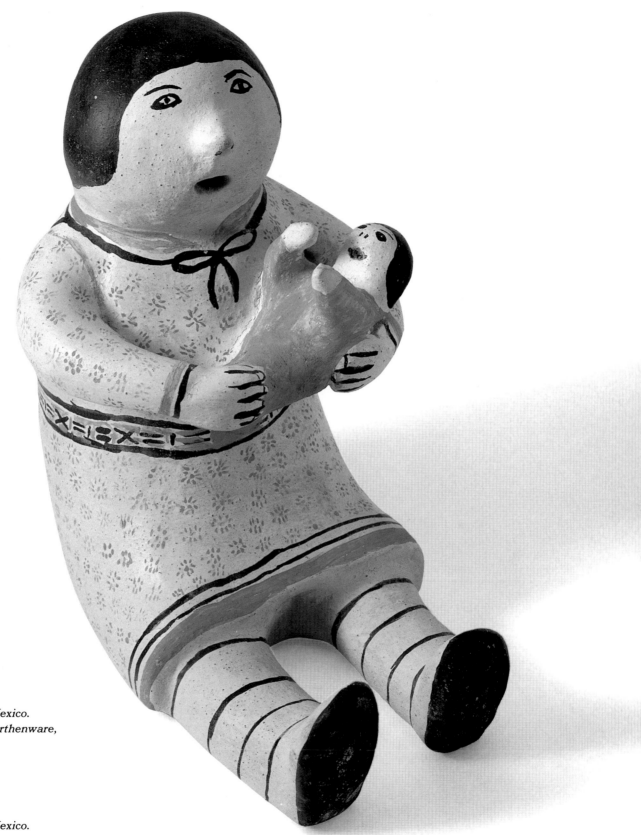

Opposite:

Storyteller.
By Helen Cordero,
Cochiti Pueblo, New Mexico.
Slipped and painted earthenware,
14" high, 1985

This page:

Singing mother.
By Helen Cordero,
Cochiti Pueblo, New Mexico.
Slipped and painted earthenware,
6½" high, 1968

born, the Pueblo figurative pottery tradition seems to have become dormant: "'. . . for a long time pottery was silent in the pueblo.'"[62]

That silence was not to last, because, in the words of anthropologist and folklorist Barbara A. Babcock, "in the late 1950s . . . Helen Cordero and her husband's cousin, Juanita Arquero, 'started up again,' making pottery as an alternative to leather and beadwork."[63] Juanita was experienced with pottery, but "Helen's bowls and jars 'never looked right.' Juanita suggested that she try figures instead, and 'it was like a flower blooming'—countless tiny birds, animals, amphibians, and eventually people came to life."[64]

Only rarely can we identify the moment a new tradition is created, but Helen Cordero's storytellers allow us to to observe both the process of creativity within an individual and the relationship of creativity to tradition. Her example is particularly important because of its far-reaching consequences: "When Helen Cordero shaped the first Storyteller doll in 1964, she made one of the oldest forms of Native American self-portraiture her own, reinvented a longstanding but moribund Cochiti tradition of figurative pottery, and engendered a revolution in Pueblo ceramics."[65]

The stimulus to make storytellers had come from Alexander Girard, a famous international collector of folk art who lived in nearby Santa Fe and who had commissioned a 250-piece nativity scene from Mrs. Cordero.[66] One of the specific items Girard requested was based on something he had already seen her make, a "singing mother"—a mother holding a baby in her arms and singing to it with her mouth open. Girard wanted a larger figure with children. According to Babcock, "In Helen's mind, his suggestion became an image of her grandfather, Santiago Quintana, a gifted storyteller who was always surrounded by children."[67]

Perhaps the most innovative aspect of Cordero's storyteller was that the attached children were not realistic in number or bodily proportions. The first storyteller had five children (representing Santiago Quintana's five grandchildren, Helen included), but those that followed had dozens, crawling all over the open-mouthed narrators.[68] These perching children—some more engaged in games with each other than intent on the story, others asleep on the storyteller's lap—displayed stubby arms and short, thick legs. They evoked enormous affection. There were soon dozens of other Pueblo storyteller makers and a flourishing local industry.

That a folk art collector should stimulate innovation in a tradition may seem inauthentic. It is certainly unpredictable and unexpected, but so are the innovative forces in all art. The most successful innovator within a tradition takes from unlikely sources and reshapes what is "not ours" into symbols of "us." With Helen Cordero, we see this process in detail and clarity.

The often unlikely sources of innovation were acknowledged by George-ann Robinson, an Osage ribbonworker from Oklahoma who received a

National Heritage Fellowship for her beautiful appliqué work on shirts, skirts, and fancy dance items. At the 1982 National Heritage Fellowship concert, Robinson said, "I want to thank the French Revolution" for the creation of Native-American ribbonwork, a wonderfully absurd-sounding statement that her research had fully substantiated.[69] In the wake of the Revolution, silk ribbon and other aristocratic items carried negative connotations in France. French merchants, with large stockpiles of ribbon, exported it wherever they could, especially to the colonies of the New World. Native Americans, in turn, found a new use for silk ribbon, making ribbon shirts and other items of clothing that have since become deeply felt expressions of their identity. As with Helen Cordero's storytellers, the source of the stimulus seems unlikely, perhaps even trivial, but the marvelous outcome is simultaneously original and congruent with tradition.

*Georgeann Robinson,
Osage ribbonworker*

French silk ribbon first arrived in America almost two hundred years ago, but its imaginative reinterpretation continues with vitality today; Helen Cordero made her first storyteller in 1964, and the influence of her innovation is still spreading. Among Cordero's many professional distinctions are a major retrospective exhibition of her work at the Wheelwright Museum in Santa Fe in 1981–82 and the Governor's Award, the highest artistic honor in the state of New Mexico.[70] Photographs of her storytellers have appeared on UNICEF cards, the cover of *National Geographic* magazine,[71] calendars, posters, and programs; there is even a gallery in Santa Fe called The Storyteller.

Some three hundred potters in more than a dozen pueblos now make storytellers; there are bear and turtle storytellers covered with tiny bears and turtles. The mudheads of the Hopis have become storytellers, too, as have numerous other figures. Clearly, such dynamic diversity indicates a strong, growing tradition. As in any commercially successful tradition, there are many degrees of quality. Mrs. Cordero herself continues to make each storyteller by hand, from the clays of the region, and paints them with mineral and vegetal paints. She makes her grandfather again and again; the children are still there, the story is still told.

Art forms have their stories, too. When we are lucky, those stories are told not just by historians and critics but by the artists themselves. The story of tap dance is told, "with juice and life,"[72] by National Heritage Fellow LaVaughn Robinson every time he dances.

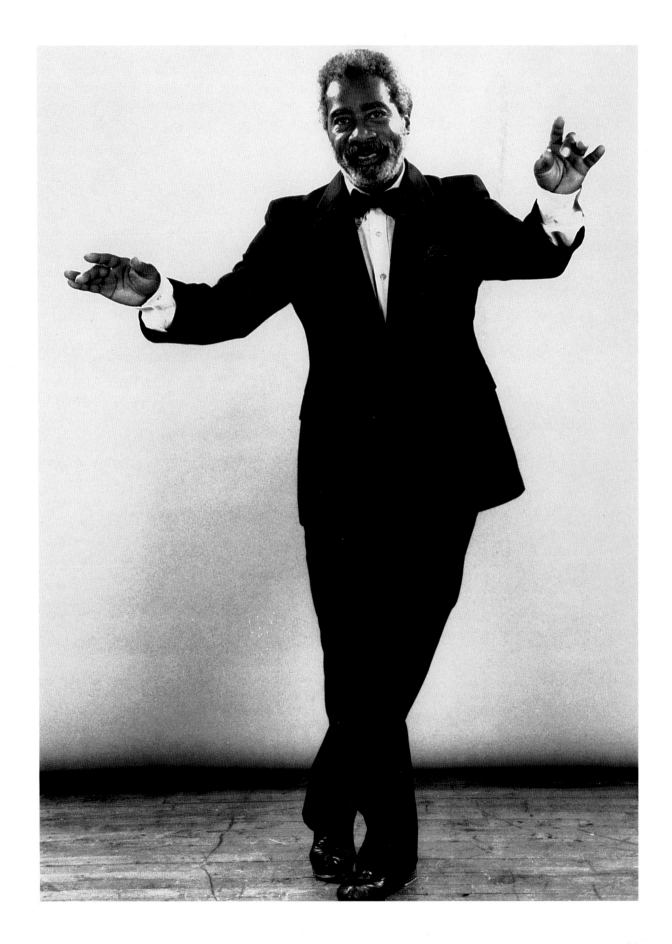

Tap is an indigenous American art form, with roots "as diverse as the jig, clog dances, hornpipes, Morris and other English step dances, Irish step dances, and the steps and clogs of Afro-American ancestry."[73] Yet both the fine art and folk art worlds have undervalued it. The fine art tradition, based on European sensibilities, has always favored ballet and modern dance, while many folklorists have regarded tap as too close to vaudeville and the stage to be considered community-based and folk. Moreover, since tap was temporarily scorned by Black militants during the 1960s, it suffered a loss of reputation even within its own community. If not for the endurance of a few masters like Honi Coles, the Nicholas Brothers, Howard "Sandman" Sims, and LaVaughn Robinson, tap dance would surely have been lost forever. As dance critic Sally R. Sommer writes, "These tap masters took other jobs to support themselves financially, but kept tapping to support themselves spiritually."[74]

LaVaughn began to learn his first tap steps from his mother at the age of seven. From there he had only to go down to the streets of South Philadelphia: "You could walk down South Street and meet up with the best dancers in the city. As a youngster I put my steps to good use performing for change on the streets of downtown and South Philadelphia."[75] Performers like Bill Bailey would bring LaVaughn and other kid tap dancers inside the nightclubs to let them watch their shows: "We used to sit in his dressing room while he talked to us about being 'good.' His father was a reverend, you know, and Bill thought tap dancing was very spiritual. He believed you had to be 'right' to dance. He was a big influence on my dancing."[76] Robinson shared the stage with the best professionals, too—Cab Calloway, Billie Holiday, Tommy Dorsey, Maynard Ferguson, Ella Fitzgerald, and Charlie Parker.

LaVaughn received the National Heritage Fellowship in 1989, at the age of sixty-two. That night, he could have been eighteen, as he danced with all the energy, vitality, and originality of youth. As one critic said: "He lays down his percussions in a cascade of sound, sheets of dense fast rhythms hail down on the floor, one phrase builds into another, and each new percussive statement tops the one that went before. It sounds and looks tough, vigorous, and because he often works a capella, Mr. Robinson weaves his own musical tapestry of sound."[77] Robinson has shown audiences the purely aesthetic thrill of tap at the National Festival of Dance and Film in France, at the Smithsonian's Festival of American Folklife (1984), and at International House's Folklife Center in Philadelphia, to mention only a few.[78]

Robinson has contributed to the national heritage as a dance teacher as well. Since 1980, he has taught tap dance at the University of the Performing Arts in Philadelphia and has also been the master teacher in apprenticeship grants from the Pennsylvania Council on the Arts. As folklorist Glenn Hinson

LaVaughn E. Robinson, African-American tap dancer

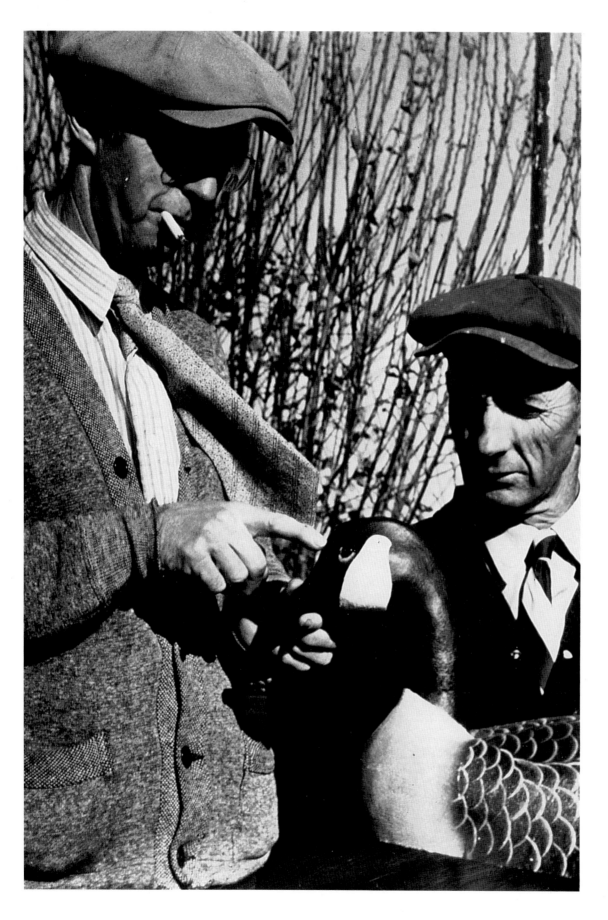

*Lem Ward (right),
decoy carver, painter,
with his brother Steve*

How does a bluebill swim? How does a vaulting pintail grab for air? How does a twisty-necked goose preen? Lem first noticed, then captured them all in his highly detailed working blocks and other art pieces.[79]

Journalist Mike Beno

Pintail Drake decoy.
By Lem Ward,
Crisfield, Maryland.
Carved and painted wood,
8 x 15", 1937

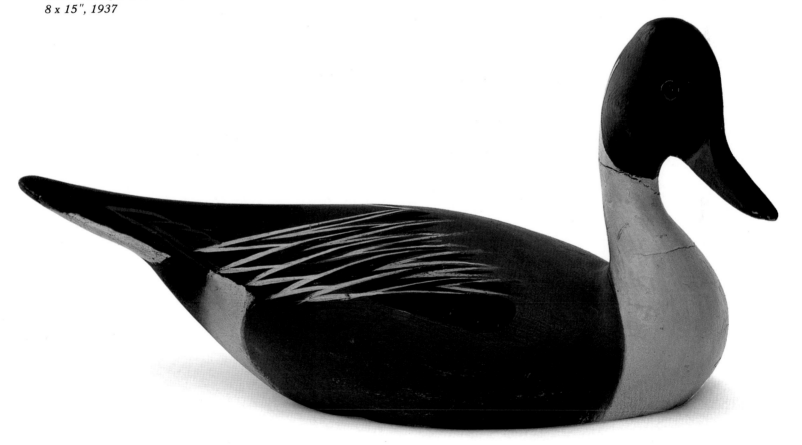

writes: "One of the central criteria for determining an artist's 'significance' to his/her tradition should be the artist's contribution to maintaining that tradition's vitality. In the world of vernacular dance, this 'maintenance' translates into teaching. And in the world of tap, LaVaughn Robinson stands as a master teacher."[80] Teaching dance requires something beyond sound pedagogy: only Robinson's soul-satisfying dancing could inspire students to strive for such impossibly complex and fine artistry. His apprentices and students offer a living testimony that complements his own joyful mastery of tap.

It's a far cry from Robinson's syncopated, percussive grace to Lem Ward's still and silent ducks. But each man came to an art form when it was in crisis and conserved it through well-grounded innovations. National Heritage Fellow Lem Ward has carved both decoys used by hunters and those displayed by collectors, yet he calls each "counterfeit": "Every artist today is a counterfeiter. They're counterfeiting God. All of 'em—and no one will ever do it right. I was trying for perfection, and I couldn't reach it. . . . No matter how hard I tried I couldn't paint what God put on 'em."[81] This desire for realism, which characterizes American decoy carving in the twentieth century, may be particular to a certain time and place, but the larger impulse toward perfection characterizes all artists at their best everywhere and in every era. When Lem Ward wrote poetry about his experience as a folk artist, it sounded little different from the sentiments voiced by so many other twentieth-century artists: "To Be an Artist/Is to hurt in silence to hear/The harsh words from loose/Toungs to feel the pangs of hunger/The aches for understanding and/To sit in the long lonsom hours/When evening comes."[82]

Lem and his brother Steve were born in one of the great places in the world for duck hunting and decoy carving, the Chesapeake Bay area. In the town of Crisfield, Maryland, the two brothers formed a team—both in their occupation as barbers and in their avocation and love, decoy carving. Steve was usually the carver and Lem the painter. Ducks and decoys fulfilled many aspects of the Wards' lives, from the basic necessity for food to the need to create, the "necessity beyond necessity."[83] When their father died in a boating accident in 1918, the family was left practically destitute; carving decoys and hunting game put food on the table. Perhaps not by accident, these brothers—who really experienced the spirit-crushing grind of poverty—were among the most artistically innovative of decoy carvers and are widely credited with playing a central role in the transition from decoy carving to decorative carving, beginning in the 1920s: "Their decoys were more lifelike than the typical decoy of the period. Each bird had its own expression on its face. The paint patterns and details were much more extensive than [those of] the average bird carving of the time."[84]

With Lem as the leader, the brothers formed "L. T. Ward and Bro. Wildfowl Counterfeiters."[85] As the years passed, their carvings came to be

appreciated as works of art and to be bought by museums, private collectors, and even presidents of the United States. In the wake of the important innovation from decoy to decorative carving, a way was made for thousands of other expressive artists. As a result, there are many fewer working decoys carved today as compared to the enormous number of decorative decoys produced in garage studios and other workshops all over the country. What is important to bear in mind, though, is the sensitivity to community that shaped Lem Ward's art form as it grew out of tradition: Lem grew up along inland waterways and marshes, he floated his decoys, he hunted, and he shared all these activities in common with his neighbors. All this knowing and feeling informs even the decorative birds he and his brother invented from tradition. For duck hunters and decoy carvers, though, the greatest accomplishments of the Ward brothers lie in the many real decoys they made.

Lem Ward received the National Heritage Fellowship in 1983. Steve, his brother and life-long artistic collaborator and business partner, had died in 1976 at the age of eighty. If he had lived, it is likely they would have received fellowships together since "the boundaries between Steve and Lem became indistinct," especially in their ducks.[86] Lem's final years were plagued with difficulties, yet also marked by some of his best work. Born with only one completely functional hand, he lost that temporarily in 1972, when a major stroke paralyzed his entire left side. Soon afterward, he developed cataracts that greatly reduced his sight. In his last years, he sat in a wheelchair and wrote poetry and sketched birds with a pencil, the last medium left to him, still seeking perfection: "I sit there and draw all day long. Never made a perfect bird in my life, and nobody else is gonna make one either."[88]

> If with pleasure you are viewing
> Any work a man is doing
> If you like him or you love him
> Tell him now,
> Don't withhold your approbation
> With the parson's fine oration
> When he lies with snowy lilies
> O'er his brow.
> For no matter how you shout it—
> He won't care a thing about it
> He won't know how many
> Teardrops you have shed.
> If you think some praise is due him,
> Now's the time to slip it to him,
> For he cannot read his tombstone
> when he's dead.[87]
>
> Lem Ward

In the world of tradition, especially in the Old World, it is not unusual for a craft to be the product of a family effort. This is certainly true of Juan Alindato's mask-making enterprise, of Mike Manteo's puppet theater, and, to a certain extent, of Lem and Steve Ward. Folk art is not always identified with the individual artist as is fine art, and perhaps most of us, as products of Western civilization, have a hard time *not* identifying the work of art with an individual ego. The National Heritage Fellowships awarded to Emilio and Senaida Romero in 1987 are therefore instructive, in that they marked the first time the award had been given to a couple, a team, rather than to individuals. (Other multiple Fellowships have been subsequently awarded: in 1989, to the Fairfield Four, a Black gospel-singing group, and in 1990, to Giuseppe and Raffaela DeFranco, two Italian-American

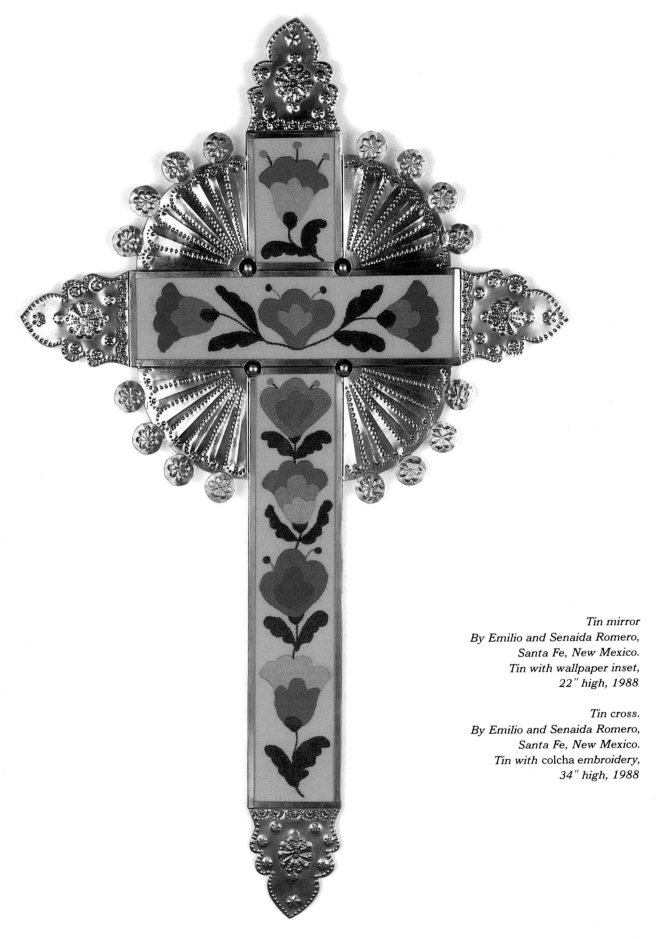

Tin mirror
By Emilio and Senaida Romero,
Santa Fe, New Mexico.
Tin with wallpaper inset,
22" high, 1988

Tin cross.
By Emilio and Senaida Romero,
Santa Fe, New Mexico.
Tin with colcha embroidery,
34" high, 1988

151

musicians and dancers.) The Romeros' work was so closely knit that one could not say where Senaida's ended and Emilio's began. Their artistic collaboration started from the time of their wedding, in 1930, and continues today not only in their own work but also through their children, who have become traditional New Mexican *artesanos*.[89]

The Romeros' art consists of reshaping "poor man's silver"—as tin has been called—and sometimes decorating it with *colcha*, a kind of coverlet embroidery. Combining these two traditions, the Romeros make church and devotional objects like tin crosses and *nichos* (niches) for carved wooden

Emilio and Senaida Romero, Hispanic tin and embroidery workers

santos as well as functional items like mirrors, frames, wall socket plates, and wastebaskets. Their complicated patterns are achieved by "cutting, bending, crimping, scoring, piercing, and punching the tin."[90] The Romeros' work is treasured by the surrounding communities, and many Southwestern homes, churches, and businesses are graced by their art.

Although the tin-working tradition is an ancient one worldwide, it has its own special history in the Southwest. The material had not been readily available in the area until the mid-nineteenth century, when the United States Army arrived with quantities of newly invented tin cans used to store and transport bulk supplies. The five-gallon containers were sold when empty, to be salvaged by the first generation of New Mexican tinsmiths. These earliest craftsmen created designs that are still in the repertoire of

today's tinsmiths. As in the making of many other folk-art objects—like quilts, rural mailboxes, and rag rugs—recycling was a theme in tinsmithing long before it became a popular contemporary concept.

Emilio Romero's grandfather had been a tinsmith who sold his wares in exchange for food throughout the villages of northern New Mexico. During the Depression, Emilio picked up the art of tinworking in the camps of the Civilian Conservation Corps. He became a sheetmetal worker during World War II and acquired skills that proved useful in his experiments with tin, even creating his own tools for working tin by adapting those of the sheet-metal trade. Romero's goal as an innovator, however, has always been to intensify the tradition by developing its inherent qualities, and he has spent a good deal of time trying to duplicate museum pieces as the basis for his own patterns. After his retirement from sheetmetal work, tinwork became his full-time occupation.

Tinwork was traditional in Mrs. Romero's family as well, and she also gradually became adept at the various jobs it involves. It was Mrs. Romero who practiced the sewing of *colcha* embroidery, a local tradition from the Rio Grande Valley, where it is used to decorate bedspreads and altar cloths. And it was her innovative idea to combine her *colcha* pieces with tin. Stretching the *colcha* over cardboard, she placed it into panels of tin with channeled grooves, then covered the panel with glass. This unusual, yet tradition-based, combining of metal and thread was first used by Mrs. Romero to make altar pieces and saints' portraits; now, many others have imitated and varied the idea until her innovation itself has become traditional.

Although the Romeros may be modest, their work has not gone unnoticed in the art world. Not only have their crafts-conscious northern New Mexico neighbors paid them the compliment of imitating their work, they have also received many significant awards. They have been invited participants in Santa Fe's Spanish Market, were honored artists of the Feria Artesana of Albuquerque, and have received purchase awards from the Museum of International Folk Art in Santa Fe, the Taylor Museum in Colorado Springs, Colorado, the Albuquerque Museum, and the Smithsonian Institution, among others.

The Romeros' tin and embroidery art, while highly prized, is still house-hold art, assembled at the large table that dominates their kitchen. The winding Santa Fe side street where they live is the same street Mr. Romero grew up on, and his childhood house is just across the way. In their old neighborhood, practicing the old neighborhood art, the Romeros can be found working on any given morning, the door of their adobe house open to visitors. Their culturally informed innovations have recovered a tradition's vitality.

As National Heritage Fellow Philip Simmons, the African-American blacksmith, was quoted as saying at the beginning of this chapter, "You've got

It gives me a very good feeling. I could work day and night on it.[91]

Senaida Romero

Metalwork— that's what I am. I love it.[92]

Emilio Romero

153

to change to stay alive."[93] National Heritage Fellow and blues guitarist John Cephas put it another way: "Nothing stays the same."[94] Cephas's and Simmons's words sound as if they could be blues lyrics themselves, and blues, indeed, provide the best broad example of the importance of innovation in American folk expression. John Cephas also has observed that "the blues is the only American music that has affected every other American music."[95]

Maybe part of the melancholy of the blues stems from the fact that everything has to change—even tradition. Perhaps it is the tension between older forms and original impulses that makes the art of the blues innovator so dynamic and poignant. But what makes these and other folk innovators different from those in other arts is their lived and experienced grounding in tradition; thus, they employ the stuff of tradition itself, not abstraction, as their vocabulary of innovation.

National Heritage Fellow Alex Moore, Sr., a blues pianist from Dallas, Texas, is as fine an example of one who innovates *with* tradition as one could ever have met. It has been said that his "piano stylings combine the blues, ragtime, barrelhouse and boogie-woogie sounds commonly heard in clubs and bars in the southwest."[97] His musical education was classically American folk: "He never had formal lessons, but taught himself by watching, and practicing when he got a chance. Most of the musicians he heard were not professionals and were never recorded; they played for fun and occasional tips. . . . usually in someone's home, and seldom was there a hired piano player. Instead, local musicians took turns at a battered, mistuned piano while patrons drank, danced, and sometimes sang."[98]

In his long lifetime of interaction with other musicians, Moore saw and heard such traditional masters as Blind Lemon Jefferson, Mary Wright, Blind Bernie, the Allen family, "Squatlow" Washington, the Maloney brothers, and Lovie Bookman. He knew well the recordings of Pete Johnson, Albert Ammons, Pinetop Smith, Meade Lux Lewis, Earl Hines, Fats Waller, Oscar Peterson, and Art Tatum. Thus, when he played, all this spirit-felt knowledge of tradition combined with his own talent to come forth as unending musical innovation and originality. Blues scholar Paul Oliver said of Moore: "He is a true original, a folk blues singer of the city who can sit at the piano and improvise endlessly piano themes and blues verses that are sometimes startling, sometimes comic, sometimes grim, and very often are pure poetry."[99]

At the same time that Alex Moore was "improvising endlessly," he was also conserving a tradition, for the style, sound, and musical phrases he conjured up and wove together at his piano were like a great, living concordance to the history of the blues. An innovator so conversant with a tradition has, in another sense, conserved it, giving not just the sounds, but the musical spirits, of the great African-American pianists to audiences once again.

My fingers know what I'm doing, I don't.[96]

Alex Moore, Sr.

Alex Moore, Sr.,
blues pianist

Chapter Four

CONSERVERS

"If you have a culture and you let it slip by, please wake up and preserve it."

A baby turns a colorful toy over in her hands. What is she thinking? Her expression is intent, yet peaceful, and her delight is clear. What is she learning, what does she see? Any baby would be fascinated by this object of blue beads and red quills, but this is a Native American baby, and the object in her hands is one of many that will help her identify with her people. The lullaby her mother sings is ancient and in a language she will learn only as fragments—but she will remember the melody. The first piece of porcupine quillwork she felt was on the surface of her cradleboard, that initial step in her transformation from the womb. The first quillwork she saw contained her umbilical cord and hung suspended from the cradleboard shade as a bright bauble to attract her hands and eyes and to focus her mind. A visiting stranger looks at her and thinks, "You are a happy baby."

National Heritage Fellow Alice New Holy Blue Legs from South Dakota is descended from generations of porcupine quillworkers. She is Lakota, a people for whom the quillwork tradition was once strong—as it was for other Native American groups such as the Bannock and Shoshone in Idaho, Woodland tribes like the Ojibwe in Michigan and Wisconsin, and even the Micmacs to the far northeast in Nova Scotia. Centuries earlier, when Europeans brought glass beads to North America, these groups found an easier way to achieve colorful designs than through their traditional quillwork. Much that had been discovered through quillwork was adapted to beads: geometric and floral patterns were replicated and beads were used, as quills had been, to cover seams. A difficult process gave way to one that was

relatively easy and quick and, at the same time, allowed for much innovation. Quillworkers became fewer and fewer over the centuries, until by the time of Alice New Holy Blue Legs, practically no one was doing quillwork any longer.

Alice then made her singular decision to use all her efforts to conserve traditional Lakota quillwork. She is notable because her work is excellent, because she sought out older masters as teachers, and because she has taught the skill to her five daughters, her granddaughters, and others as well. She stands for the impulse to conserve heritage by becoming its practitioner. And, by furthering her own Lakota people's porcupine quill decoration tradition, she has nurtured the quillwork tradition of other Native Americans as well.

Irene Preacher, for instance, is not a National Heritage Fellow, but she is one of the few Shoshone-Bannocks who knows how to do porcupine quillwork. She is reluctant to teach and very careful about whom she will accept as an apprentice. "The porcupine is a very sacred little animal," she says. She worries about the creature, which is vulnerable to man. She is concerned that greedy, lazy boys, who do not recognize the sacred nature of the world, will kill a porcupine for a few choice quills. She describes the patient, slow ways to remove the quills, which let the animal live: throw an old hat over the porcupine and then remove the hat (punctured with quills like a pincushion), or follow behind the porcupine as it scurries along and tap the animal with a board, collecting an assortment of quills in the board (and leaving the porcupine plenty to defend himself).[1]

Irene Preacher also worries about what will happen to the families of those who kill porcupines needlessly and disrespectfully, and tells stories about boys whose grandmothers died shortly after they tormented porcupines. "Grandmother," perhaps, means not only their specific grandmothers, but our Grandmother Earth, source of life. Taking life needlessly, one damages the source of life.

Alice New Holy Blue Legs and Irene Preacher exemplify one of the main impulses of traditional folk artists—the desire to conserve a valued tradition, even when it is no longer broadly popular. This effort implies a kind of "double sight": though such artists may appear to be looking only into the past, they are, in fact, also looking farther into the future than their contemporaries. They see beyond immediate trends and recognize that a time will come when the old forms will be precious once again—if they are not lost. And so, often at great personal effort and cost, these far-sighted artists become the guardians of a tradition at its most perilous passage.

Sometimes, such a person becomes the sole bearer of a tradition between the reservoir of the past and the hoped-for repository of the future. Sometimes, even that single thread of preservation fails, and a tradition is lost. National Heritage Fellow Vanessa Paukeigope Morgan, who consciously chose to pass up a career as an innovative "modern" artist to preserve her

Alice New Holy Blue Legs,
Lakota quill artist

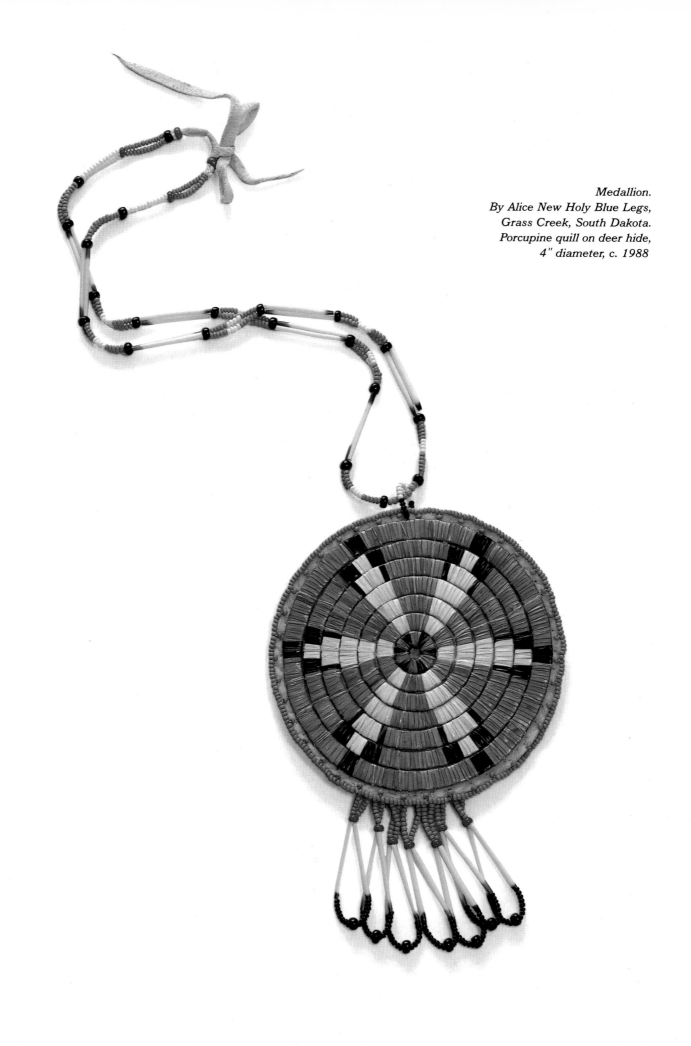

Medallion.
By Alice New Holy Blue Legs,
Grass Creek, South Dakota.
Porcupine quill on deer hide,
4" diameter, c. 1988

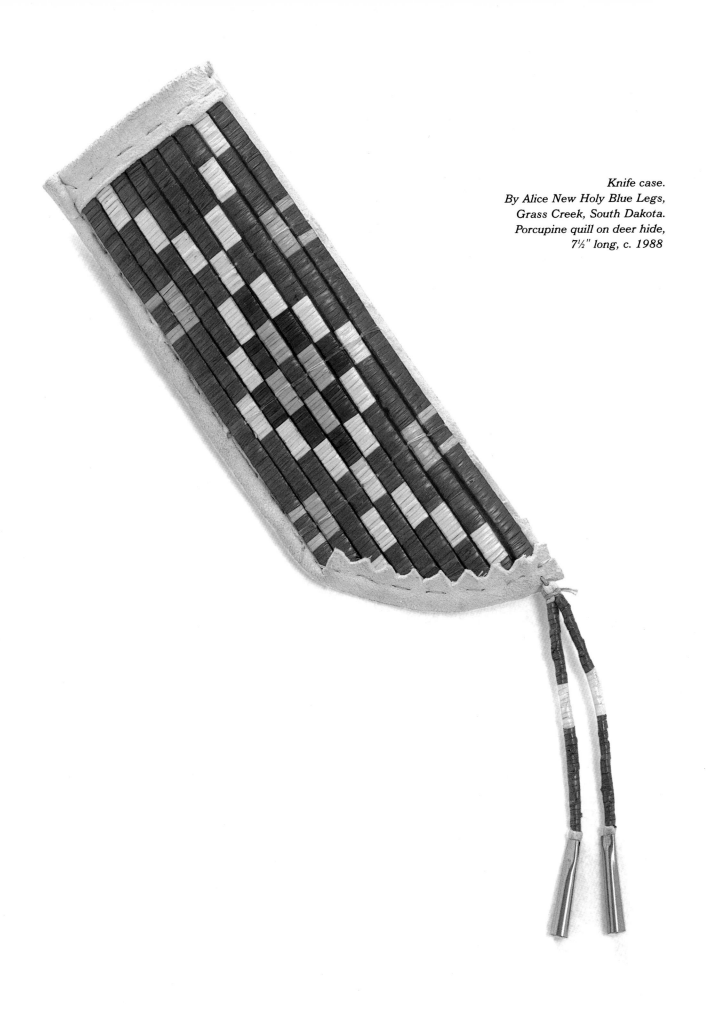

Knife case.
By Alice New Holy Blue Legs,
Grass Creek, South Dakota.
Porcupine quill on deer hide,
7½" long, c. 1988

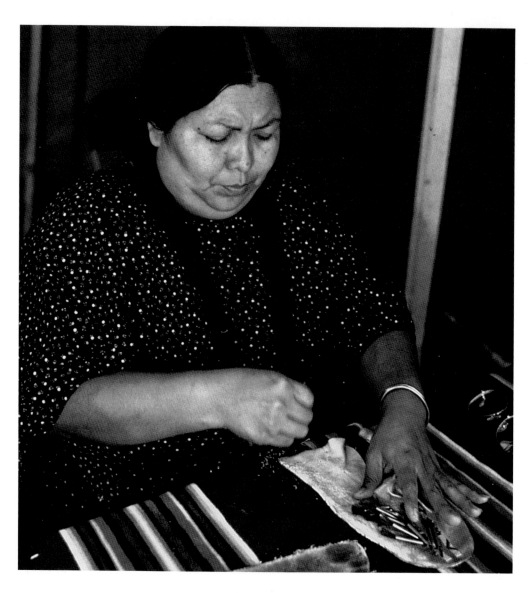

people's traditional art, speaks of such a situation: "I am a Kiowa woman. My work is traditional Kiowa work. As far as I know there are: 8 dressmakers, 25 moccasin and leggings makers, 1 bowmaker, 3 arrowmakers. There are no active cradleboard makers, saddlemakers or bowcase and quiver makers. I am the only one. It frightens me that our Kiowa heritage that was so powerful and beautiful has almost disappeared. It is more important that I continue my traditional work . . . more than to take artistic liberties at this time."[2]

There are few voices today that encourage artists to submit their talent to their communities' needs. Yet, today's communities, like the Kiowa, need their artists more than ever. They need them not only as inheritors and innovators, but also as conservers of tradition. The courageous, selfless, and wise choice Vanessa Morgan made is itself grounded in tradition: "My abilities as a traditional woman are because of my grandparents. The way that my family and I live is because of their love and effort. I know of no

other way to show the love and respect that I have for Stephen Mopoe and Jeanette Berry, my grandparents, than to continue to do the work that I am presently doing. My work is not an end to itself. Nor is it something meant to bring me fame or riches. It is simply a perpetuation of the Kiowa people for the generations after me."[3]

There are performers of ethnic music who also aim to perpetuate their heritage, and nowhere are they more numerous than in Louisiana. Folklorist and author Nicholas Spitzer writes that "Cajun music has also come to represent the survival and re-awakening of Cajun culture."[4] Over two hundred years ago, in 1755, French settlers in Acadia were deported from their colony after it was taken over by the British and renamed Nova Scotia. Many of these "Acadians" (thus, eventually, "Cajuns") settled in southern Louisiana in *le grand derangement*, as the exodus was called. Folklorist Barry Jean Ancelet, a French-speaking Louisianian himself, writes that "within a generation these exiles had so firmly reestablished themselves as a people that they became the dominant culture in South Louisiana, absorbing other ethnic groups around them."[5] Acadian musicians had brought a French musical tradition with them, but they also borrowed and created new styles through contact with African and other European groups. They incorporated blues, percussive techniques, and improvisational singing from African-American and African-Caribbean people, new fiddle tunes from Anglo Americans, and new instruments from Hispanic Americans. When German immigrants brought the diatonic accordion to the region late in the nineteenth century, it was used to play the original French fiddle tunes and became one of the most Cajun of instruments. No equation can possibly describe how these diverse elements made the distinctive, new/old creolized sound, but there is no mistaking Cajun music for any other. Cajuns today recognize their music—along with their food—as the most powerful, unifying statement of who they are.

Dewey Balfa, the gifted Cajun fiddler and National Heritage Fellow from Basile, Louisiana, understood this early on. Because music speaks directly to the soul, its power to create community and organize ethnicity is such that even enormous obstacles—like mass culture and the modern state—can, miraculously it seems, be overcome. Performing at the New-port Folk Festival in 1964, Balfa was rewarded with huge crowds that wanted him to go on

> When things stop changing, they die. The culture and the music have to breathe and grow, but they have to stay within certain guidelines to be true. And those guidelines are pureness and sincerity.[6]
>
> Dewey Balfa

Dewey Balfa, Cajun fiddler

161

playing forever. Ancelet writes that "Dewey Balfa was so moved that he returned to Louisiana determined to bring the message home."[7] Through music, he worked hard to preserve the language and other elements of Cajun culture. He helped to organize traditional music concerts and contests and in 1974 to launch a major Tribute to Cajun Music festival, which became an annual event, conserving Cajun heritage by creating opportunities for new, young musicians as well as bringing renewed attention to older performers. Dewey Balfa must have been thinking about all this when, upon receiving the National Heritage Fellowship in 1982, he said, "I bring this back, but not for Dewey Balfa . . . for everybody."[8]

This community-serving role is accentuated among those folk artists who are trying to preserve an inheritance that many of their own people have abandoned. There is a paradox about this combination of selflessness and self-expression that folklorist John Vlach captures in writing about National Heritage Fellow Philip Simmons. Vlach's words apply equally well to Balfa and many other folk artists: "His creativity remains vibrant and impressive, but it is channeled into forms that satisfy a conservative public demand; it is targeted at communal interests."[9] The reward for those who turn their artistic energies to serving their own people is not only to gain recognition for themselves, but also to see their communities strengthened through their efforts. For Dewey Balfa, receiving the National Heritage Fellowship was clearly such a reward. The community he called "everybody" that night stretched back over two hundred years in southern Louisiana.

Another musician, the accordionist Jimmy Jausoro, has played a parallel role in the Basque community in Boise, Idaho, and the surrounding Basque-settled region of southern Idaho, eastern Oregon, Nevada, and California.[10]

American Basques come originally from a region straddling the border between France and Spain. The Basque Country is not an independent political entity, but is one of the oldest ethnic regions in Europe, settled perhaps as early as 10,000 B.C. Unfortunately, the history of the Basques has been one of oppression by national states that have tried, since Roman times, to destroy their independence, language, and culture. Basques first came to Idaho in the 1890s, during the period of mass migrations from southern and eastern Europe, and quickly became known as the most reliable sheepherders in the Intermountain West. Today, they are active in all walks of life and contribute greatly to the character of the region.

Jimmy Jausoro grew up in a Basque boardinghouse in Nampa, Idaho, in the 1920s and 1930s. The Spanish Hotel, as his parents called their establishment, was a place for relaxation, recreation, and festive occasions for the Basque sheepherders of southwest Idaho. As a small boy, Jim would listen to the sheepherders play traditional tunes on their harmonicas and button accordions, and he soon learned to play both instruments himself. His first

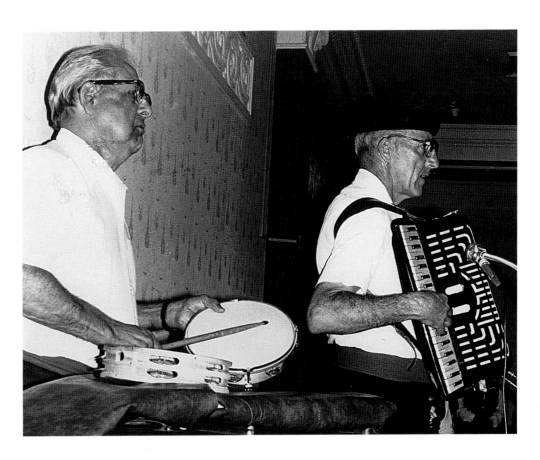

job earned him enough money to buy a large, piano-style Hohner accordion, on which he played both American and Basque popular tunes as well as traditional Basque folk songs. Jausoro took an accordion with him when he joined the Navy in World War II and, upon his return to Boise after the war, formed a dance band. His repertoire was still mainly popular music.

Also in Boise during the postwar era was Juanita "Jay" Hormaechea, who kept traditional Basque dance alive through her dance classes. As the years went by, however, Basque immigration dropped off and the Basque language and Old World culture began to fade in Boise. It was not until 1960 that the thin thread of Basque culture represented by Jausoro and Hormaechea was to broaden into a full and colorful fabric.

In that year, seven Basque teenagers from Boise, including some of Jay Hormaechea's students, visited the Basque country and met a dance group named Oinkari ("one who does with his feet," that is, a dancer). Granted permission to use the name Oinkari, the excited and inspired young people formed their own Oinkari Basque Dancers in Boise and asked Jimmy Jausoro to provide the music. The troupe's public debut occurred later that year, at the Sheepherders' Christmas Ball; their first major regional performance was at the Seattle World's Fair in 1962. In 1964, they performed at the New York World's Fair and have since been to Wolf Trap and other festivals of national stature.

In 1985, for the twenty-fifth anniversary of their founding, nearly sixty Oinkari dancers toured their ancestral homeland, performing in all seven Basque provinces in Spain and France. As Patty Miller, then president of the Oinkari dancers, said before she left, "We'll be so proud to be dancing in the country our grandfathers came from."[12]

The Oinkari usually perform in a troupe of at least twelve dancers, all wearing costumes deriving from traditional dress. Of the five different costumes, one for men consists of white trousers, shirt, and shoes, a broad red sash around the waist, and a black beret. A woman dancer might be dressed in a red skirt decorated with three black stripes at the base, a black vest over a white blouse, a white scarf covering the hair, and leather shoes.

Some dances, like the men's slow and stately *Erreberenzia*, are intended to be performed before an honored guest. The Oinkari dancers performed the *Erreberenzia* in the Caucus Room of the U.S. Senate to honor their teacher, Jimmy Jausoro, on the occasion of his National Heritage Fellowship; they ended in a gesture of respect as they bowed and removed their berets. On the same occasion, the men also performed the flashing, high-kicking Sword Dance (in which one dancer, standing atop interlocking wooden swords, is hoisted above the others' heads), and the women presented the Small Stick Dance, in which they intricately maneuvered from position to position to create new formations.

Basque dances usually communicate vitality and dignity. Several recreate mock combats, while one involves each dancer executing steps around a wine glass, mounting it and leaping free without knocking it over. Oinkari performances are not only public and secular, however; some dances are literally prayers. The *Banakoa*, for instance, is performed around the altar of Saint John's Cathedral in Boise on the feast day of San Ignacio, the patron saint of the Basque Country. The Oinkari's leaping dancers and ringing castanets fill the church with joy and energy.

The performing dance group has grown since 1960 from a half-dozen members to about seventy. Jausoro's Basque repertoire has expanded as well, as the Oinkari and his orchestra have become inseparable. It is the live music, based on traditions and symbolizing community, that raises the level of this revival far above the ordinary.

Jimmy Jausoro exemplifies the way in which an artistic tradition, personified and conserved by an individual folk artist, can become the dynamic expression that binds a community together. Basque people speak with pride about the Oinkari dancers and Jausoro's orchestra. It was his music and dedication, they say, that allowed the Oinkari to develop. The Oinkari and Jimmy Jausoro have become the emblem and the creative center of the present-day community. Besides playing for the dancers, Jimmy is busy every summer performing at Basque picnics, weddings, and festival celebrations all over

southwest Idaho and northern Nevada. He plays at fund-raisers for churches and has taught music and performed at Basque music camps. He once said that, like the first generation of Basque musicians in America, he plays music for "summer picnics and winter dances."[13]

Only an hour west of Boise, the Snake River forms Idaho's border with Oregon. This political boundary is not significant geographically or culturally, and many of the inhabitants of eastern Oregon are oriented toward Idaho, generally, and Boise, in particular. This is true not only of the Basques, but of another group that traces its roots to the Iberian peninsula—Mexican Americans. The small town of Nyssa, Oregon (population 2,862), sits on the banks of the Snake River, in an irrigated agricultural region that spans both sides of the border. Here the crops include not only "famous potatoes" (and it is said that as many "Idaho" potatoes are grown in eastern Oregon as in Idaho), but also onions, sugar beets, other root crops, alfalfa hay, and heady fields of mint. Mexican-American families have lived in Nyssa since the turn of the century, and the pull of family and work continues to draw immigrants, who bring both old and new traditions. Nyssa, for instance, boasts a traditional bakery where you can buy *pan dulce* ("sweet bread"), and Nampa, Idaho, is sung about with longing in a traditional Mexican American ballad.[14]

Far from the nation's centers of Hispanic culture and institutions, and lacking cultural support systems, this area marks the northern frontier of Mexican migration and settlement in the Intermountain West. Mexican Americans are a small minority in the region, and the pressure to assimilate is great. Thus, community events often gain an importance here, at the periphery of Mexican-American settlement, that they do not even have at its core, for they become ways for a dispersed community to reach for unity and confidence.

National Heritage Fellow Genoveva Castellanoz, or Eva, as she is usually known, is well aware of the spiritual and sociological difficulties her people face in Nyssa.[15] Through her church, she does social work among the young people of her community, and her art is a less formal part of the same loving impulse. But while her social work is local, her art reaches Mexican-American communities throughout southern Idaho and eastern Oregon.

Eva makes *coronas* (crowns) and bouquets of artificial flowers, created with paper, wire, wax, and dye, as well as a variety of additional ornaments. This tradition, widespread in Mexico but rarely found in the United States, is important to the *quinceañera* ceremony, a rite of passage that introduces a young woman to the community of adults and reminds her of her responsibilities. Like the blossoming flowers of the *corona* worn by the *quinceañera* girl, the young woman is beginning to blossom and take her place in society.

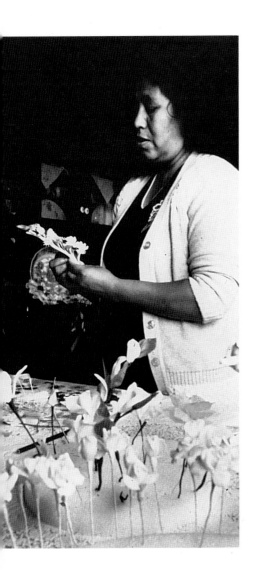

Genoveva Castellanoz, Mexican-American corona *maker*

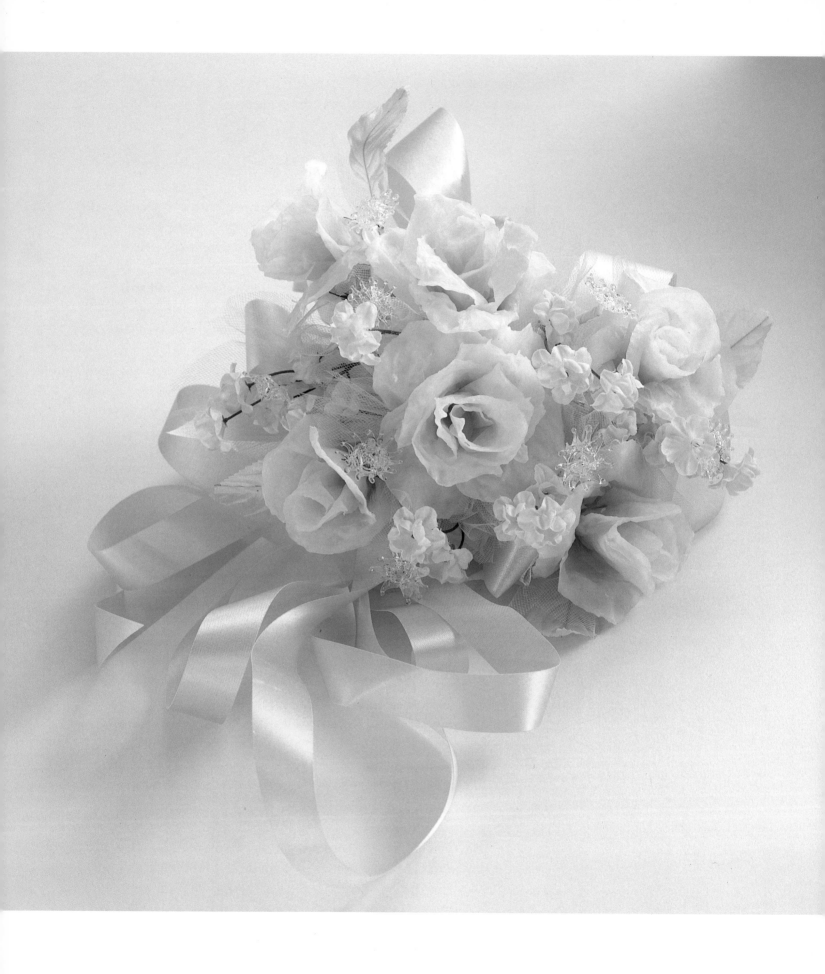

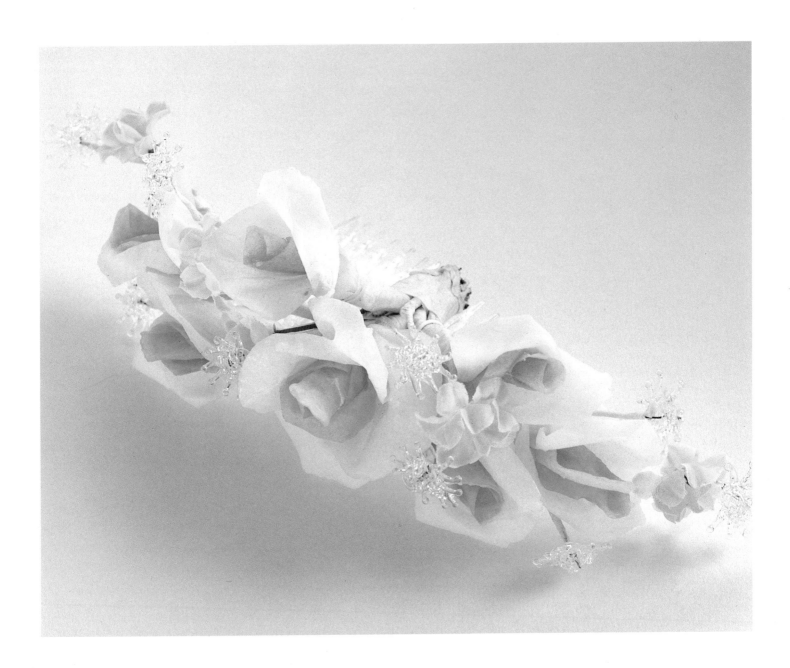

Opposite:

Wax bouquet.
By Genoveva Castellanoz,
Nyssa, Oregon.
Tissue paper dipped in wax,
9" wide, 1988

Above:

Corona, *wax-flower crown.*
By Genoveva Castellanoz,
Nyssa, Oregon.
Tissue paper dipped in wax,
3" high, 1988

Although the event celebrates one person's achievement, the *quinceañera* festivities are a family and community affair. Traditionally, each relative contributes one of the items for the girl's outfit, such as the dress, a pillow for kneeling, or the *corona*. The *quinceañera* girl is instructed in the meaning of each object, and all the items are blessed by a priest during a ceremony and special Mass. The girl is dressed in white, and wears a white *corona* to symbolize purity and innocence. In Idaho and eastern Oregon, the *corona* is likely to be one of Eva's, since she is the only person in this huge region who makes *coronas*. Thus, almost all *quinceañeras* and many Mexican-American brides in the area depend on Eva. (Flowers are an important part of the Mexican wedding trousseau, for which Eva makes boutonniers, bridesmaids' bouquets, *azahares*—orange-blossom bouquets—and bridal *coronas*.)

The *quinceañera* girl may be accompanied by fourteen other girls, one for each year of her life: a one-year-old, a two-year-old, and so on, up to the *quinceañera* herself, who makes fifteen. After the religious ceremony, there is an evening of traditional Mexican dancing. To start the dance, the young men and women form an arch through which the *quinceañera* girl passes with her father; she later dances her first dance with him.

Events like the *quinceañera* demonstrate how traditional art, music, and dance can unite and focus a community. And, as the "crown," the *corona* is central to the aesthetics of the ceremony—as necessary as the ring in a wedding. Yet, it is more than a beautiful accessory. Once, when Eva demonstrated her art at an elementary school in Nampa, children asked her to put on a *corona* she had made. She declined, explaining that only unmarried girls wear the *quinceañera corona*. For Eva Castellanoz, this object of wax and paper has special meaning, governed by the values of her community. It achieves that meaning through its symbolism and its artistry, but also by being set aside for one special use only.

Since the artificial flowers of the *corona* do not fade or wither, they can become important keepsakes to remind women of key transitions in their lives. Their meaning is thus personal as well as social, permanent as well as fleeting. The ritual is ephemeral, but it marks effects that are lasting. The *corona*, like other ritual objects, is an unchanging, tangible reminder of the physical and social changes in a woman's life which the *quinceañera* ritual has acknowledged. It serves "not only as a reminder but also as a stimulus, focus, affirmation, guide, and resource."[17] Eva's *coronas* are made to be worn and then kept, and they are often displayed in a careful arrangement.

Since 1982, when the Idaho Commission on the Arts first learned of Eva Castellanoz's work, she has taken part in a variety of educational efforts, both within her Mexican-American community and for the general public. She has taught in schools, lent her work to traveling exhibitions,[18] given workshops for teachers, and demonstrated her skills at festivals and conferences.

I spend a lot of time making flowers. . . . I believe that the flowers also have their own personality, even though a lot of people don't. For me they do because I work with them, and I see that some flowers let their little petals bend. But others don't. . . . So I think that they have their own mind, and I respect each one. No two are exactly alike. A rose is a rose. . . . And it won't look like a carnation because it's not.

Eva Castellanoz[16]

Viewers of Eva's work are always surprised to learn that these beautiful flowers are made of mere paper, wax, wire, and dye. When they attempt to make the flowers themselves at one of Eva's demonstrations, they discover that the skill is elusive. Eva sometimes begins such a demonstration by simply saying, "I love flowers." As she works, it becomes clear that she has seriously studied flowers themselves as well as her people's artistic tradition of making them. If artists are those who transform the ordinary into the extraordinary, who teach us to find beauty and to see freshly, Eva Castellanoz is surely one of the most successful.

The eastern Oregon and southern Idaho region that Eva Castellanoz serves is part of the larger Great Basin and Intermountain West, an area sometimes called the "pastoral West"—because of the large tracts of land used mainly for the grazing of stock—or the "hydraulic West"—because of its dependence on irrigation for agriculture.[19] It is home to a number of different, but interlocking, ethnic, occupational, and religious groups: not only Mexican Americans and Basques, but also Mormons, Native Americans, and cowboys. For over a hundred years, the cowboy occupation has drawn men—and sometimes women—from all these groups and from all over the country to this region.

Glenn Ohrlin, cowboy singer, storyteller, illustrator

National Heritage Fellow Glenn Ohrlin, one such cowboy, calls the Owyhee Desert country of northern Nevada, southeast Oregon, and southwest Idaho "buckaroo country" and says it's "mostly outdoors!" He should know. Born in Minneapolis, he came to Nevada via California to become a buckaroo in 1942, at the age of sixteen. He has since become well known as a masterful storyteller, an entertaining singer familiar on the folk-festival circuit since the early days of the folk-music revival, and the author and illustrator of a classic cowboy songbook. Even with all this recognition, he still works with cattle on his own ranch in Arkansas.

169

Ohrlin has never been far from cattle and horses, having worked for ranches throughout the West and on the rodeo circuit from 1943 to 1965. Like other cowboy poets, he learned a lot of poems and songs behind the chutes, in bars, motel rooms, and other places where rodeo cowboys meet.

Well, you can't expect a cowboy to agitate his shanks
In the etiquettish fashion in aristocratic ranks,
When he's always been accustomed to shake the heel and toe,
At the rattling ranchers' dances where much etiquette don't go.
You can bet I set them laughing in an astonished sort of way,
A-giving of their squinters an excited sort of play,
When I happened into Denver and was asked to take a prance
In the smooth and easy measures of a high-toned dance.[20]

From "The High-toned Dance,"
as sung by Glenn Ohrlin

He describes the situations in which cowboy music and poetry are traditionally performed: "One of the first things folks ask is 'Did you sing that song around the campfire?' Well, I have sat around a campfire, in fact worked for one outfit that had no buildings so we camped out all the time 'till our beds turned green.' Many days, however, there are long nights at home on the ranch to sing, or songs heard at a dance or party. Or maybe some guy in a bar knows one real good song or recitation and someone encourages him to 'cut loose.' Also traveling down the road from one rodeo to another, it helped the miles go by to sing and it was a good time to remember the long songs (nowadays it's long drives to folk festivals and concerts)."[21]

From Wally McCrae of Montana (named a National Heritage Fellow in 1990), Ohrlin learned McCrae's classic cowboy poem "Reincarnation," and from Powder River Jack in Arizona in 1944, he picked up "Windy Bill," one of the most popular cowboy songs and poems. "The Wild Buckaroo," the title song of one of Ohrlin's albums, a real treasure of authentic cowboy songs, is a composition by one of the greatest cowboy poets, Curley Fletcher. Representing the widespread bawdy tradition in cowboy music and poetry, the song is not usually performed in public. The liner notes transcribe four stanzas, then read, "second part of song nontranscribable."[22]

Ohrlin confirms the American cowboy's indebtedness to the *vaquero* through the Mexican part of his repertoire. He says, "Now my favorite group ain't 'The Rolling Stones' or 'Red Sovine and his Louisiana Syrup Soppers,' but 'Los Alegres de Terán,' 'Los Tremendos Gavilanes y Salomón Prado,' and 'Santiago Jiménez, Jr. y su Conjunto'. . . . my friend Santiago puts more guts and fun and happiness in his music than anyone I ever saw or heard."[23] Sometimes Ohrlin sings "*Mi Caballo Bayo*" (My Buckskin Horse), a song about the bond between a cowboy and a good horse, one of the most central of cowboy themes.

As a performer, Glenn Ohrlin is master of the deadpan face, the pregnant pause, suspense-heightening delay, perfect timing, and the small gestures that release laughter. He tells tall tales in a way that sneaks up and catches listeners unawares. Folklorist Archie Green writes of "Glenn's unadorned laconic vocal style and his simple rhythmic guitar technique, which generally serves to color the narrative thread in his songs. Glenn's departure from instrumental simplicity is seen in his pleasure in flamenco."[24]

But perhaps what makes Glenn Ohrlin such a beloved performer is the unobtrusive way he imparts his enormous knowledge of cowboy ways. He lets audiences in on the culture rather than making them feel like the outsiders they, of course, are. He makes material that is based on special knowledge completely intelligible to urban and suburban audiences. He speaks through the laugh to the heart.

Ohrlin's book, *The Hell-Bound Train: A Cowboy Songbook*, is both a highly accessible collection of the most authentic songs of the tradition (with lyrics and music) and a fundamental scholarly work on the history, music, and culture of working cowboys. The classic songs, one hundred of them, are here—among them, "Zebra Dun," "The Gol-Darned Wheel," "The Sierry Petes," "The Strawberry Roan"—but so are introductions that describe Ohrlin's personal acquaintance with each song as well as its individual history. A biblio-discography supplies references, including recordings, for every song. All in all, *The Hell-Bound Train* is a major contribution to the study of occupational folk music.

Sketching, another traditional cowboy art, also plays a part in Glenn's work, which is often illustrated with his drawings of cowboy life. Over the years, he has painted signs and pictures of bucking horses, bulls, and cowboys on storefront windows and also braided rawhide, made saddles, and even built his own stone house.[25] His artistic skills do not stop at any known border.

Nor does his humanity. Glenn Ohrlin seems to burst through any attempt to categorize and stereotype. A traditional folk artist, he is, in many ways, a folklorist, too. He has made records and written a book, two fundamental acts of cultural conservation. Not content to be just a performer, Ohrlin is also a conserver of tradition; he has collected the songs he sings and has deposited the field recordings he has made in the Archives of Traditional Music at Indiana University, home of one of the major folklore programs in the world. He is at once a scholar and the subject of scholarship, a man who works not only with cattle but also with images, music, and words. To quote Ohrlin himself, "Like the philosopher said, 'You can't tell how far a frog will jump by looking at it.'"[26]

Glenn's songs make his audiences laugh, wonder, and sometimes cry. For National Heritage Fellow Hugh McGraw, music is fundamentally a religious and spiritual experience. His description of becoming aware of the beauty of his musical heritage parallels stories of religious conversion: "The McGraw family has been involved in Sacred Harp music for well over a hundred years. But I didn't get involved in it until I was 25 years old. I'd go to a singing, with my father and mother, but I thought it was more important to stay outside and play in the spring and run around the house than it was to learn this tradition. Until I walked into a singing—after I was done married and had a family. And I heard this music, and something just—petrified me.

Hugh McGraw,
shape-note singer

Says now you gotta do your thing. So I began studying, and teaching, composing, and singing this music all over the country."[27]

For Hugh McGraw, music and religion and community are different faces of the same heritage; working to conserve one is working to conserve the other. "A lot of people don't sing this old music because it's 'old fogey.' You know 'old fogey' means a caretaker. A caretaker preserving something that's worth preserving. And that's what we're trying to do in preserving this music, our national heritage."[28]

Sacred Harp is sometimes described as "four shape music" because of the shaped notes (triangle, square, oval, and diamond) used to designate the four tones of the scale (fa, sol, la, and mi) that comprise its arrangements. Although Sacred Harp singing has been identified with the South since the mid-nineteenth century, it is thought to have come to America with the Pilgrims and first developed in eighteenth-century New England singing schools.[29] This haunting music lived as oral tradition until it was transcribed into several songbooks in the South between 1810 and 1860. Soon after the standard songbook, *The Sacred Harp*, was published in 1844, the tradition of singing conventions began, with all their attendant strengthening of ties and enhancement of community life. These gatherings continue today in Georgia, Alabama, Mississippi, Florida, Tennessee, and Texas.

Hugh McGraw has become the great conserver of the Sacred Harp tradition in this century. Like Glenn Ohrlin, he combines aspects of the performer and scholar. An enthusiastic singer and principal song leader, he has taught singing schools in many Southern communities. He has brought the tradition back into areas where it once languished and also introduced it to other parts of the country. He has assisted a number of scholars in making recordings and publishing books on the Sacred Harp.

Equally beautiful, and closely related to Hugh McGraw's heritage, is the African-American Sacred Harp tradition in southeast Alabama. The singers there have the same songbook as those in the Anglo tradition: *The Sacred Harp*, whose enormous repertoire of more than five hundred songs is expanded by the seventy-seven in *The Colored Sacred Harp*, the only published collection of Black Sacred Harp compositions. Although the two traditions share the same technique as well as songbook, they sound totally different, style being the differentiating factor. In the African-American tradition, religious fervor is expressed by various ways of extending a song: repeating verses, shouting "Oh, Jesus," "Yes, Lord," or "Amen," or adding melodic and rhythmic ornamentation. Spontaneous interjection and expression are encouraged. As Doris Dyen, a scholar of the tradition, writes, "Blacks allow and encourage more outward evidencing of religious fervor during a sing than do [their] white counterparts, even though blacks and whites both see Sacred Harp sings as partly religious, partly social occasions."[30]

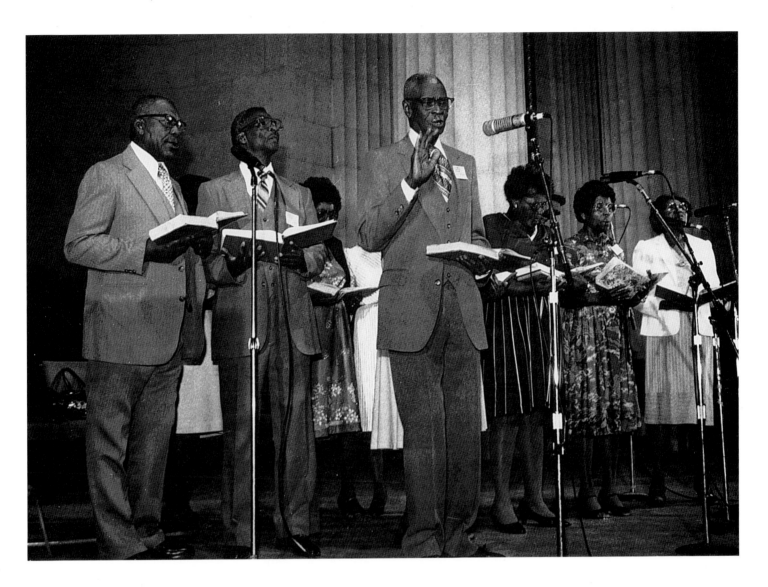

Dewey Williams, shape-note singer

Alabama folklorist Henry Willett describes the singing: "During a typical sing, the participants arrange themselves in a square according to voice part, the basses facing the trebles, and the tenors facing the altos. A song leader stands in the middle of the square leading the singers first through the notes to the songs and then through the lyrics, a practice emanating from the traditional singing school classes where singers are taught to sing the notes (musical syllables) and then the words."[31]

The master performer, conserver, and promoter of African-American Sacred Harp singing in this century is Dewey Williams of Ozark, Alabama, who was named a National Heritage Fellow in 1983.[32] Mr. Williams was born to sharecropper parents in 1898 in rural Haw Ridge, Alabama. His grandparents were ex-slaves who had been singing Sacred Harp since before the Civil War, and they introduced the music to their grandson. Mr. Williams, a sharecropper like his parents, studied Sacred Harp with two singing-school masters, Webster Woods and Judge Jackson. (Jackson was the author and

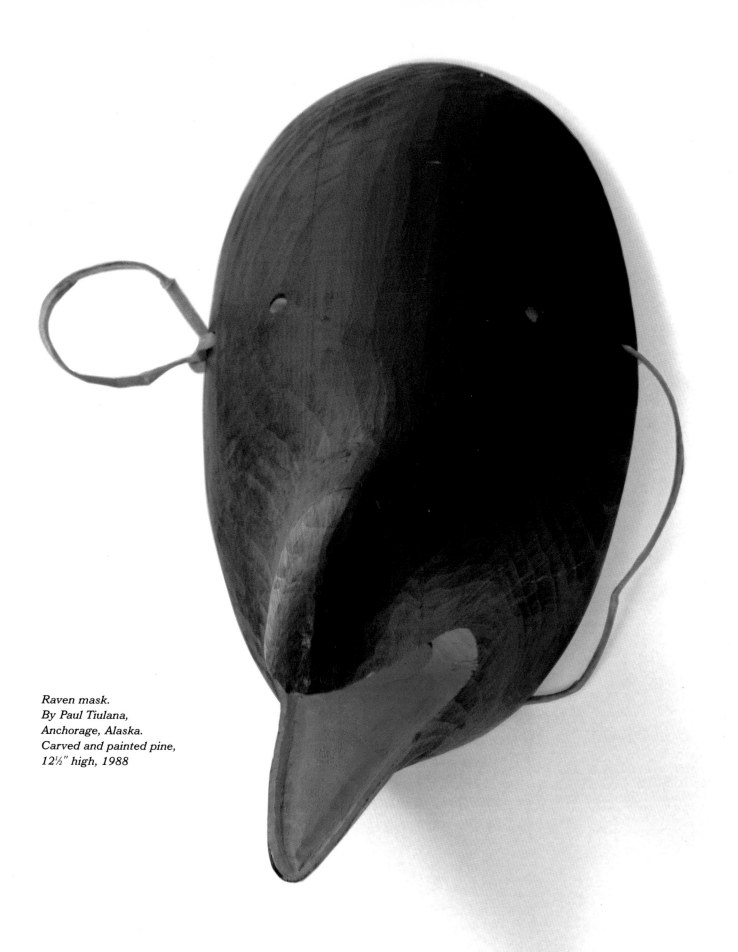

Raven mask.
By Paul Tiulana,
Anchorage, Alaska.
Carved and painted pine,
12½" high, 1988

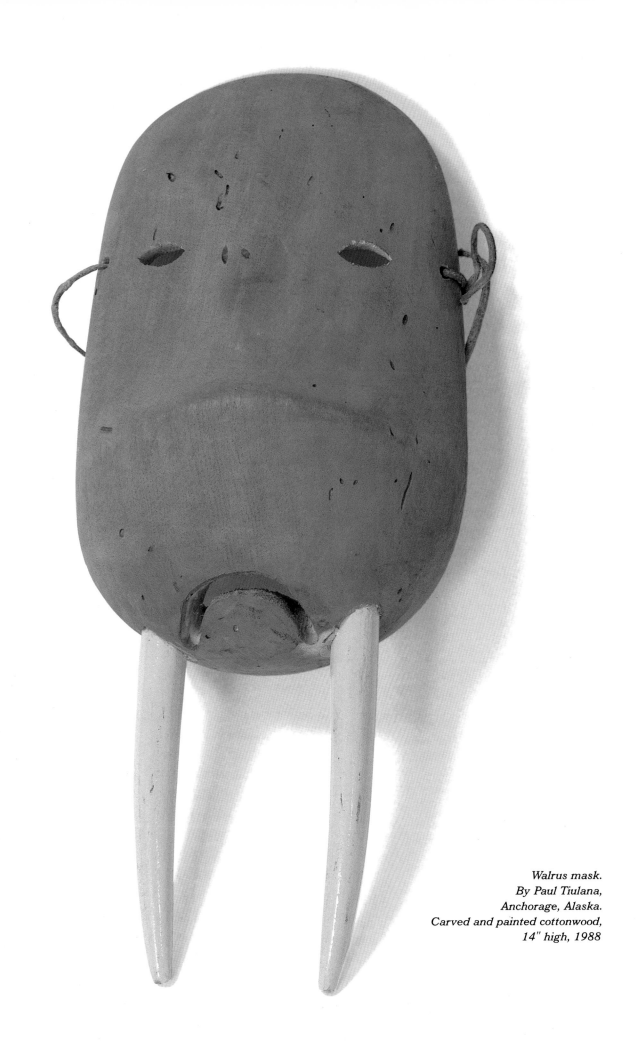

Walrus mask.
By Paul Tiulana,
Anchorage, Alaska.
Carved and painted cottonwood,
14" high, 1988

editor of the original *Colored Sacred Harp* [1934], which Williams helped to bring back into print in 1973.) By the time he was forty, Williams was teaching singing schools, too. Through these classes, in which he has taught hundreds of students, he has conserved the tradition in southeast Alabama, the only place in the South where the African-American Sacred Harp is still vital.

In addition to his singing, teaching, and publishing efforts, Williams has formed the Wiregrass Sacred Harp singers, a special performing group that plays on radio and television and at festivals in the United States and Canada. Every year on his birthday—for over forty years, now—he runs the annual Dewey P. Williams sing, the kind of family singing event that is traditional in parts of the Black community.

Dewey Williams has been called "the active patriarch" of the African-American Sacred Harp. It has been said that "Black Sacred Harp Singing . . . would more than likely be headed toward extinction were it not for the tireless efforts of singing master Dewey Williams."[33] Furthermore, "it is rare when a single individual can be credited as being the major factor in preserving a tradition, but Dewey Williams must be so credited. Almost single-handedly Dewey Williams has seen to it that a 150 year old tradition of black Sacred Harp singing has maintained itself."[34]

National Heritage Fellow Paul Tiulana, born in 1921 on King Island in the Bering Straits—the far north of Alaska—has also been a major force within a community striving to maintain and conserve its cultural traditions.[35] In addition to the twentieth-century influences that have had a corrosive effect on traditional arts everywhere, his Inupiaq Eskimo community suffered a catastrophe very few ever recover from—the loss of place. They were forced to leave King Island in the 1950s to be resettled in Nome, Anchorage, and other places in Alaska. If history is, as Martin Heidegger wrote, "the chronicle of man's concern for place," then the odds against the King Islanders maintaining a sense of their own history were great indeed.[36]

Among this group of exiles was Tiulana, a young man who exemplified the traditional qualities important in Inupiaq culture. Only in his thirties, and already an accomplished ivory carver, mask maker, singer, dancer, and drummer, he had mastered many of his people's traditional art forms. And as the years passed, his achievements as an artist only grew. Equally important, however, have been Tiulana's efforts to conserve the cultural heritage of his community. He has taught carving classes and workshops. He has been a member of the King Island Dancers for more than forty years and its leader since 1956. Working closely with folklorist Suzi Jones of the Traditional Native Arts Program at the Alaska State Council on the Arts, he helped revive the ceremonial Wolf Dance, which had not been performed in over fifty years. Although the King Island Dancers had been presenting their

direct and expressive dances to audiences all over the United States for many years, the return of the Wolf Dance, in 1982, was for the Inupiaqs alone. For them, it evoked the trading and socializing of the winter festivals that had been celebrated by the Bering Sea people from time immemorial.[37]

Another of Paul Tiulana's projects was to build a traditional skin boat, an *umiak*, which he completed in 1982. Many Inupiaqs in northwest Alaska still build *umiaks*; what is significant about Tiulana's is that it was made in Anchorage, more than six hundred miles from the Inupiaq homeland, so that Inupiaq oldtimers living in that city would have an aesthetically proper and satisfying way to go on outings and literally reimmerse themselves in their ethnicity.

Tiulana understands well the relationship between art and community, and in pursuing his own artistic excellence, he has always sought to strengthen the bonds uniting his people. In organizing ex–King Islanders for artistic projects, he has both maintained and revived traditional arts. He was quick to recognize that what were once survival crafts in the Arctic lands of the Inupiaq are now just as vital to the perpetuation of Inupiaq identity, morale, dignity—and, thus, in a new way, to life itself. It thus made good sense, although it was unusual, for the Alaska Federation of Natives to name Tiulana Citizen of the Year in 1983. Such civic awards are rarely given to practicing artists, but his work in using his art to promote cultural heritage has been exceptional.

Paul Tiulana met the difficult challenge of organizing the teaching of traditional arts to his fellow King Islanders after their relocation from their native home. National Heritage Fellow Eppie Archuleta found herself serving

I have been taking a walk in the past.[38]

Paul Tiulana, referring to his building of an *umiak*

Paul Tiulana, Eskimo mask maker, dancer, singer

a parallel function in the San Luis Valley of south central Colorado.[39] Although she was born in the oldest area of European settlement in the United States—in northern New Mexico, in the town of Santa Cruz—she has lived much of her life in the extension of that area into Colorado. Pressured by a changing economy, her family—like those of many of her neighbors—moved to the San Luis Valley in the 1940s to work the lettuce and potato fields.

Eppie Archuleta spent practically all her early years near a loom. As a child, she slept underneath it, and as soon as she was big enough to work it, her weaving career began. Since she started out in this way, weaving came to

Eppie Archuleta (center), Hispanic weaver, with daughter Norma Medina and grandchildren

be part of her spirit. Even when she worked in the fields during the day and cooked for her family in the evening, she would weave at the loom at night, while the others slept.[40]

Weaving had always been a strong tradition in Mrs. Archuleta's family—going back at least to her great-grandparents. For generations, members of her family had raised their own sheep, carded, spun, and dyed the wool, and woven the yarn into rugs and blankets. Her own mother, Agueda Martinez, had won a New Mexico Governor's award for the elegance and skill of her weaving.

Thus, it was natural for Eppie to continue the family heritage and to pass it on to her daughters and granddaughters. They all weave, and her sons construct looms. But the equation has changed in the Southwest, as in Alaska and so many other places in the twentieth century. What was once a widespread tradition diffused throughout an ethnic population has been

Chimayo-style weaving.
By Eppie Archuleta,
Alamosa, Colorado.
Aniline-dyed commercial wool,
75 x 29", c. 1987

restricted to fewer and fewer practitioners. In this new situation, Eppie Archuleta's skill and knowledge as a master traditional weaver became one of the main links connecting an older tradition with a contemporary resurgence of interest in the art she practices: "There is general agreement that her work as an artist and as an educator played a seminal role in the recent revival of local interest in traditional weaving and other fibre arts throughout the Hispanic communities of southern Colorado."[41]

In fact, it is sometimes hard to find Eppie Archuleta's weavings in her own studio because the walls and tables contain so many examples of work by her family, friends, and students. This is not for lack of organization; just the opposite—there is meaning in it. As a folk artist, Eppie does not separate herself from her community; as a teacher and conserver, she has eyes more for the continuity of tradition than for her own role in it, central as it may be. Her energy, enthusiasm, and sincere interest in her students are immeasurable in themselves, but they are equally important as forces in the continuity of a tradition.

Eppie Archuleta has contributed to the preservation of Hispanic weaving by teaching in the San Luis vocational schools and the Artes del Valle Craft Cooperative. Her own work is both conservative and dynamic, as all living folk art must be. She produces work that reflects both the old southwestern Rio Grande style, which makes great technical demands, as well as the more recent eclectic Chimayo style, which draws on pan-Southwest designs.[42]

Eppie Archuleta's faithfulness to a tradition has preserved it, and she, like National Heritage Fellow Jennie Thlunaut, the Chilkat blanket weaver, compares well with Penelope in the *Odyssey*, who kept her household together through weaving and unraveling, through faithfulness and clever thought. Perhaps Penelope provides us with an archetype for the conserver of culture: just as the long absence of Odysseus to fight in the Trojan War meant the integrity of his household in Ithaca was threatened, so traditional societies often lose part of their authority to the intrusion of outside forces (when, for instance, their men leave to seek work). Penelope was an artist who relied on her traditional form of expression, weaving, to hold the society of her home together. But in a new and threatening situation, she wove somewhat differently. With Odysseus absent for nearly twenty years and increasingly assumed to be dead, Penelope kept her suitors at bay by promising to marry one of them when she finished weaving her tapestry. Thus she wove each day, but unraveled her work each night. Her persistence in weaving was what preserved the whole society until Odysseus's return; his heroic deeds when he came home would have been meaningless without Penelope's perseverance. In a sense, Jennie Thlunaut and Eppie Archuleta, these two busy, quiet weavers—and other contemporary conservers of culture—are patiently waiting for the rest of us to return.

Just as the *Odyssey* is the account of an adventure of wide wandering, disguise, and survival, so is the story of 1986 National Heritage Fellow Peou Khatna, Cambodian court dancer and choreographer.[43] Khmer court dance is more than twelve hundred years old and flourished during one of the most glorious periods of Cambodian history, that of the Angkor Empire; images from the dance are engraved on the magnificent temples of Angkor Wat. Although the tradition had periods of decline, it was revived by the royal court in the

Peou Khatna,
Cambodian-American
court dancer, choreographer

nineteenth century. Mrs. Khatna's dance training began at the age of seven with the Royal Ballet. She later became a choreographer, costumer, and dance instructor with the troupe, and traveled with it all over the world, including the United States.

In the mid-1970s, under the barbarous rule of the Khmer Rouge—in which one third of all Cambodians were murdered by their own leaders— anyone associated with the previous regime was a target. The artists of the Royal Ballet were among the victims, and knowledge of the court dances was, by itself, reason enough for execution. Disguising themselves as peasants, Mrs. Khatna and members of her family survived four years of working in rice paddies as members of communal work units. Eventually, they fled to a makeshift refugee camp on the border of Thailand, and there the Royal Ballet was reborn.

As in other holocausts, when all else had been taken away, the capacity for artistic expression still remained. Peou Khatna began by teaching the children in the camps. She assembled a group of twenty-five former dancers, singers, and musicians, as well as a mask maker, and they began to perform and to teach others. Their performances raised the ravaged spirits of thousands. In these camps on the edge of disaster, a remnant of the Royal Ballet became the Khmer Classical Dance Troupe. Here Peou Khatna preserved her nation's art and her people—for her, there was no difference between the two.

In 1980 and 1981, these Cambodian dancers and musicians came to the United States with the help of the State Department, the Cambodian Crisis Committee, and the National Council on the Traditional Arts; they settled in Silver Spring, Maryland. Since then, Khatna Peou has led them in performances throughout the country. The award-winning film *Dance of Tears: The Dance Lives*—produced in 1982 by the National Council on the Traditional Arts—tells their story.

Although the tradition that Peou Khatna has worked to preserve is courtly, and not folk dance in the Western sense, it is one of the most powerful symbols of Cambodian identity. In the United States, Khmer dance functions to conserve Cambodians' sense of self in the same way that folk culture does for many other ethnic Americans. And there is a special irony to the present situation. In Cambodia, the Royal Ballet had performed only at court, and common people were not allowed to attend. Thus, more Cambodians may have seen their national ballet in the United States than in Cambodia.

Today Mrs. Khatna continues to work for the preservation of Cambodian dance with her daughter, Ms. Sin Ny, and twenty other dancers from the troupe. Her granddaughter is one of her students, in a class of young girls mercifully too young to remember the horrors of the past. Peou Khatna works to instill in them all the grace of a deep tradition.

It is my duty to preserve the tradition.[44]

Peou Khatna

One evocative way of indicating that a group is still vital is to say of them that "they're still dancing," as dancer Vanessa Brown and folklorist Barre Toelken once wrote of Native Americans.[45] Similarly, Mrs. Peou Khatna understood how central dance was to Cambodian identity, especially during a time of crisis and dispersion. In another culture, that of Hawaii, the hula—long considered the most serious and profound of traditions—has also found its champions in a troubled time. Like Khmer dance, it too has been threatened with extinction—in this instance, from popularization and stereotypical portrayal in the mass media. In 1970, a study of the state of Hawaiian culture published by the Bishop Museum in Honolulu identified only five people—all of them women—as masters of the traditional hula. Ten years later, only one of the five was still active: National Heritage Fellow Emily "Aunty Kau'i" Zuttermeister, who is recognized worldwide for her dedicated work in preserving the traditional hula.[46]

Emily Zuttermeister was raised in a traditional culture that drew heavily on the oft-noted natural harmony between grandparents and grandchildren.

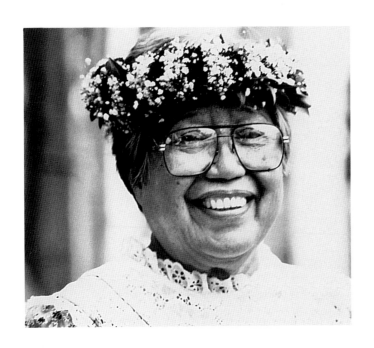

Emily Kau'i Zuttermeister,
hula master

In accordance with Hawaiian child-rearing practices, her granduncle and grandaunt became her adoptive parents, taking her at birth and raising her as their own. This practice is a particularly effective way to conserve a society's tradition: the grandparents teach the older ways—patiently—to the grandchildren. Thus, Emily grew up surrounded by Hawaiian customs, traditions, values, and experiences that were older, perhaps, than those her parents would have taught her.

Another relative also played a key role. For most of his life, Sam Pua Ha'aheo, an uncle, had guarded a profound knowledge of the hula and ancient chants. In 1933, when he was an old man, he decided to pass on what he knew and opened a *hula halau* (hula house) next to his fishing shack. Emily, who was twenty-six then, realized the intense requirements of learning hula—three years of study and practice five nights a week—and thus was reluctant to become involved. But she had married a mainlander (of German descent, thus Zuttermeister) who was fascinated by all things Hawaiian. Almost completely because of her husband's eagerness, Emily Zuttermeister became a student. In only three years, Aunty Kau'i had started her own *hula halau* and had begun a career that would last for more than fifty years and in which she would educate hundreds of students in the classic form. Among her students have been her own children, most especially her daughter Noe Noe, and others, like Tom Hiona, who have become well-known hula masters in their own right.

Most Americans today think of dance mainly as a recreational activity or as an elegant art form to be watched and appreciated. The idea that dance can be the most important form of expression for a whole society is unfamiliar to many of us, yet hula was clearly that central to traditional Hawaiian culture and identity. One reason hula has always been so important is probably because it tells stories. As dance expert Edith McKinzie writes, "The body movements of the *hula* are visual embellishments of the poetry of a chant or *mele*. A *hula* is made up of a combination of foot, hip and hand movements. The artistry and creativity in choreography by a *kumu hula* [master] are

Mealii Kalama, Hawaiian quilter

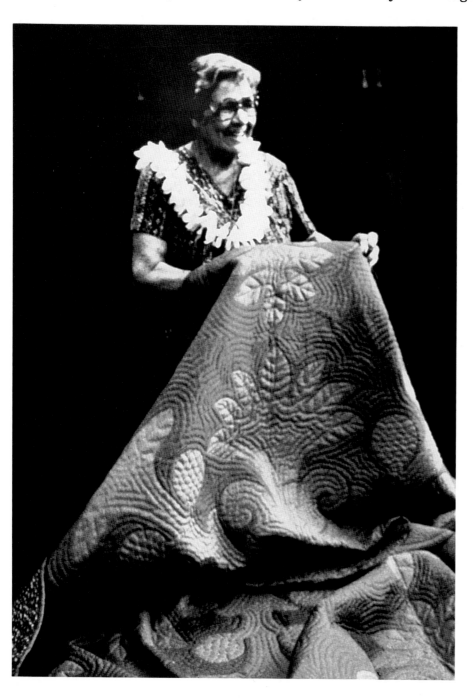

expressed in the unique way he or she combines these movements to depict the chant."[47] Hand movements draw on a conventional "vocabulary" to depict objects in nature (flowers, cliffs, waves, or softly falling rain) or even emotions and sensations (love or the scent of a flower).[48] Among the varieties of hula are the sacred dances (*hula pahu*) that Aunty Kau'i learned from her uncle. Since then, she has been one of the few vessels for their conservation and communication to a new generation.

National Heritage Fellow Mealii Kalama has been as instrumental in the preservation of Hawaii's distinctive quilting heritage as Emily Zuttermeister has been in the preservation of hula.[49] She, too, was raised by the older generation, her grandparents, and thus was surrounded by tradition—in her case, quilting. Though the hula is at the core of ancient native Hawaiian tradition and the quilt is obviously not indigenous, in modern times quilts have become just as Hawaiian a symbol as the hula.

In her work, Mealii Kalama represents generations of Hawaiian women who—like the ancestors of

African-American National Heritage Fellows Lucinda Toomer and Janie Hunter—successfully adopted an item of Anglo material culture and demonstrated the capacity of traditional aesthetics to incorporate and reinterpret it. Traditional artists are not always overwhelmed by a new object; often, they set to work and make it their own, as the story of the Hawaiian quilt demonstrates.

Hawaiian men and women were already skilled at sewing before the first missionaries brought quilts to the islands in the 1820s: they used whalebone needles and thread made from coconut and other natural fibers to sew sails and coverlets made of *tapa* (bark cloth). They also had a long tradition of making clothing from draped panels of *tapa* cloth adorned with dramatic, imprinted designs. In the piecework quilts of the New England missionary women, however, the islanders encountered a new sewing tradition.

Using their sewing skills and combining the two traditions, Hawaiians created something utterly new—a quilt with one bold, large, central design. They replaced the small, geometric blocks of Anglo-American quilting with their traditional *tapa* designs, whose organic, flowing shapes brought a fresh touch of nature to their work. Hawaiian quilts typically utilize two colors—the central motif branches out against a background of a contrasting shade. The technique is appliqué, and the stitching that attaches the pieces is intricate and tight, requiring enormous amounts of time, patience, and precision.

Hawaiian quilting today is a vibrant tradition, thanks in no small part to Mrs. Kalama. She has preserved this native expression by teaching hundreds of quilters over the years. As a child, she often played beneath the quilting frame—an experience she shares with Anglo- and African-American quilters on the mainland. Hearing the older ladies talk and seeing the sunlight filter through the colors of the quilt, she gained a precious knowledge that cannot be learned any other way. As an adult conserver of the tradition, she has garnered publicity and respect for Hawaiian quilting through individual commissions (including one for the governor's mansion) and through a spectacular exhibition of thirty of her quilts for the Maunakea Hotel on the Big Island of Hawaii. She produced these pieces—each was eight feet square and had more than two million stitches—in a year and a half of constant work. One of Mrs. Kalama's best-known designs continues to be the breadfruit quilt, based on one of the traditional staples of Hawaiian agriculture, which she sewed for the first time at the age of thirteen at her grandmother's urging.

Many traditional artists—among them Mealii Kalama—express strong personal ideas about the effects of emotion on their work. The *corona* maker Eva Castellanoz, for instance, says that "if I am not feeling pretty, I can't work. . . . Things will not turn out how I want to see them. And my roses are

> All nature acknowledges its Creator. And all designs must show that flowing gracefulness of nature. All must acknowledge the breeze and the air. All must display *ulu*, "growth."[50]
>
> Mealii Kalama

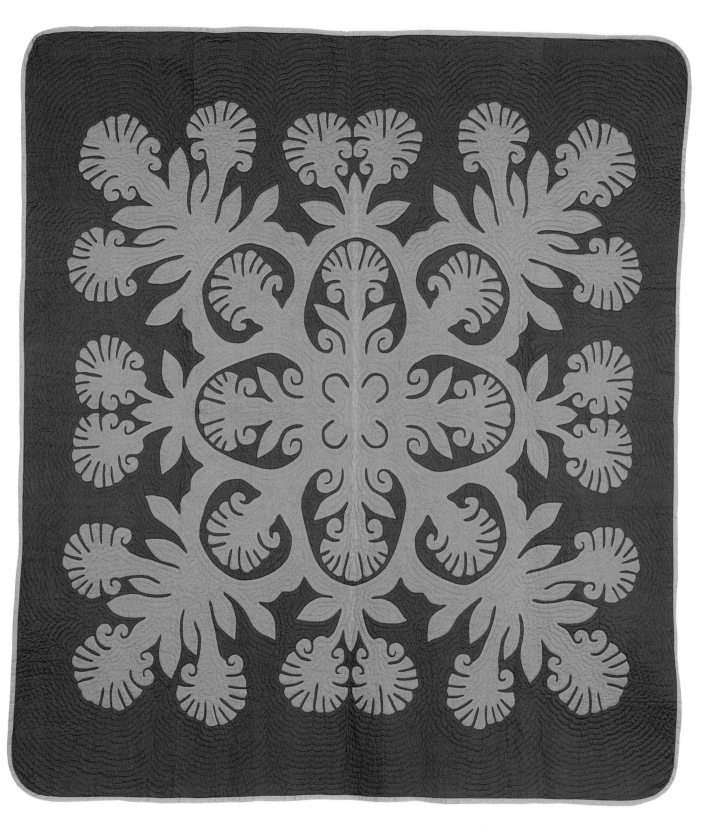

Flower Garden quilt.
By Mealii Kalama,
Honolulu, Hawaii.
Cotton appliqué, 89 x 81", c. 1988

angry because that's how I am."[51] Mealii Kalama puts it this way: "I cannot quilt when I am troubled or under stress. I make mistakes and must undo the work. I make quilts with loving thoughts of the persons who will receive and use the quilts. Quilting requires clean thoughts as well as clean hands. You would not want a quilt that was soiled by dirty hands and you would not want a quilt which was not made with love."[52]

Such thoughts are not superstition; rather, they express an understanding of the traditional, essential relationship between maker, object, and user. With such an understanding, Mealii Kalama preserves community in a way that goes beyond even the threads of her lovely and powerful quilts. The invisible level, the level of meaning, is the most important—the level (so classically Hawaiian) of love, sharing, and concern for nature.

That same invisible level—the meaning an art form expresses for a community—emerges between the quiet, delicate notes of a fragile musical tradition, that of the Native American courting flute. This music has been preserved largely through the efforts of one person, National Heritage Fellow Doc Tate Nevaquaya. It is generally agreed that without Nevaquaya's love and persistence, this music would have been completely lost.[53]

Native American courting music is played on a carved wooden flute, and its sound is haunting, tender, gentle, and wistful. The tradition was once widespread, "an integral part of plains, plateau, woodland, eastern, and southwestern tribal cultures and served important sociological functions that were connected with courtship, love, magic, and entertainment."[54] But as traditional ways changed, the flute came to be played only rarely. And fewer and fewer were made, although some Sioux and Utes continued to carve them.[55]

Then, Doc Tate Nevaquaya, a Comanche from Apache, Oklahoma, became interested in the courting flute. Listen to Nevaquaya talk about his quest to learn about the instrument: "When I was a little boy, about seven years old, was the first time I heard an Indian flute, and from that time it stuck with me. . . . Unfortunately no one knew anybody that made or even played it, so through the forties I began to inquire about it. . . . I went to the elders of my tribe. . . . While I was just in high school, I had a flute I found in an old pawn shop. . . . [I went] from reservation to reservation . . . inquiring and asking about the flute, and as time went along I began to find people I knew that knew a little bit about the flute, and from there on I began to research the flute at the Smithsonian . . . , the Library of Congress, the Historical Society of Oklahoma City, and this little museum in Saint Frances, South Dakota. . . . One thing led to another."[56]

Researching both construction and playing techniques, Nevaquaya realized that he could preserve the flute tradition both by composing new music based on the old and by giving it fresh contexts. Thus, he adapted

Joyce Doc Tate Nevaquaya,
Comanche flutist

Native American vocal music, including social dance songs and wind songs—even Comanche Christian hymns—to the voice of the flute. And he created two new genres for the flute: one called the "modern courting flute song," and the other centered around a deep appreciation of nature.[57] Along with these innovations, Doc has also revived the old tunes and, with his son, Edmond, has taught others the carving of flutes.

Thanks to Nevaquaya's efforts, the contexts for the performance of the once-intimate solo courting flute have changed spectacularly. Nevaquaya has played at the John F. Kennedy Center for the Performing Arts (1982), in England on a tour sponsored by the Smithsonian Institution, in the Far East, and on all the major television networks. More important, his frequent performances at Native American events throughout Oklahoma have inspired the revival of flute-playing in the region in which it once reached its highest artistic development. Nevaquaya was also the first musician to make a commercial record presenting only Indian flute music—*Indian Flute Songs from Comanche Land* (1976), released by Native American Music. As Edward Wapp, a courting flute player and scholar, said in the letter of nomination for his own master teacher, "I consider his knowledge of the courting flute and his achievements in performing and composing for

Albert Fahlbusch, hammered-dulcimer maker, musician

the instrument to be the main catalyst in preserving this musical art and bringing about its renaissance."[58] Though much of the old repertoire is gone forever—and that is a painful loss—the beauty of the flute can still be heard through players like Doc Tate Nevaquaya and the new generation he has inspired.

A cement-truck driver in Scottsbluff, Nebraska, has given another Plains musical tradition a chance to go on. National Heritage Fellow Albert Fahlbusch both makes and plays the hammered dulcimer and thus, like many conservers of tradition, combines the material and performing impulses in his work. The hammered dulcimer consists of a large, trapezoid-shaped wooden frame, strung with wire strings, and is played with a pair of soft hammers.[59] A member of the zither family, it is known in many cultures, but was brought to the upper Midwest by German-Russian immigrants. This area is also the heart of polka country, and in the German-Russian communities of Nebraska, polka bands play the "Dutch Hop" style, which incorporates the instrument.

Albert Fahlbusch learned to play the hammered dulcimer by "going to the German wedding dances as a boy and watching."[60] This was the only way to learn, for there is no written music for the instrument. He learned to build

Hammered dulcimer.
By Albert Fahlbusch,
Scottsbluff, Nebraska.
Wood, metal, plastic,
21 x 45", 1988

dulcimers by buying one from a former neighbor and studying its parts. Although no one taught Fahlbusch, he has made it easier for those who are following. His son, as well as five other apprentices, have studied both the construction and the playing of dulcimers with him. One of his students, who had moved to Kansas City, received a hand-built scale model from Fahlbusch in the mail, which helped to show the student what Fahlbusch had been trying to explain by telephone—conserving a tradition often requires as creative an imagination as inventing one.

Conservers of folk art and folk performance such as Fahlbusch are, at heart, conservers of community. Among German-Russians, "the hammered dulcimer is central to the people who play, dance, and enjoy Dutch Hop polka music. The dulcimer also plays an important part in the customs of German-Russian weddings. The music is continuous throughout the wedding and has always been at the heart of the lively Dutch Hop dancing.

In the days when German-Russian weddings could go on for three days or more, the members of the band not only had to be fine musicians, but also had to have a great deal of endurance.

It is customary for the bride and bridegroom to dance every dance. Money is often pinned to the couple's clothing in exchange for a dance. In this way, the couple is assured a good start in life. Money is also slipped under the strings of the hammered dulcimer and in this way, the band's payment is assured by the guests of the wedding. In some cases, special 'money holes' are built into the structure of the dulcimer."[61] Unfortunately, the German-Russian wedding dances are in decline today, and "some of the younger generation do not want them played."[62]

If there is a future for the hammered dulcimer among German-Russians, much of it will be due to Albert Fahlbusch. Nebraska folklorist Roger Welsch offers his own testimony: "Albert is a quiet man who loves skill but never announces it. He is a national treasure whose first joy (understandably) is that his son Roger has followed his father in the building and playing of the ancient instrument."[63]

The conservers we have noted—from Albert Fahlbusch back to Alice New Holy Blue Legs—leave us with a sensation of the paradoxical fragility and tenacity of tradition. They bring us to inevitable questions concerning the future of tradition.

Chapter Five

THE FUTURE OF TRADITION

"Do all your work as though you had a thousand years to live and as if you will die tomorrow."

What is the future of the past? Will a day come when there is no one to nominate for a National Heritage Fellowship? Our everyday experience tells us that there is truth to the sensation that tradition is rapidly being lost all around us.

There is a Jewish story about this feeling of loss. When the great Rabbi Israel Baal Shem Tov saw misfortune threatening the Jews, it was his custom to go to a certain part of the forest to meditate. There he would light a fire, say a special prayer, and a miracle would be accomplished and the misfortune averted. Later, when his disciple, the celebrated Magid of Mezritch, had occasion, for the same reason, to intercede with heaven, he would go to the same place in the forest and say, "Master of the Universe, listen! I do not know how to light the fire, but I am still able to say the prayer." And again a miracle would be accomplished.

Still later, Rabbi Moshe-Leib of Sasov, in order to save his people once more, would go into the forest and say: "I do not know how to light the fire, I do not know the prayer, but I know the place and this must be sufficient." It was sufficient and a miracle was accomplished. Finally, it fell to Rabbi Israel of Rizhyn to overcome misfortune. Sitting in his armchair, his head in his hands, he spoke to God: "Lord of the Universe," he prayed. "Look at us now. We have forgotten the prayer. The fire is out. We can't find our way back to the place in the forest. We can only remember that once there was a fire, a prayer, a place in the forest. So, Lord, now that must be sufficient."[1]

Today we wonder if memory alone is sufficient. What happens in the next generation? If all we inherit is a memory of something that once had

substance, what do we leave our children—a memory of a memory? Soon there will be nothing. Hawaiian National Heritage Fellow Clyde "Kindy" Sproat uses a line from one of his songs to describe the same feeling of loss: "I will never in my eyes see the things my father and my grandfather have seen; and my kids, my grandkids, will never see the time that I saw."[2] In one sense, what Sproat describes is always bound to be true—the world is always changing. Yet he is speaking about a pervasive kind of loss that haunts our particular era.

There are those like Alan Lomax, who fear the future of America will be a nightmare of homogeneity, a plastic, seamless, streamlined future unrelieved by the indigenous and the local: "A grey-out is in progress which, if it continues unchecked, will fill our human skies with a smog of the phoney and cut the families of men off from a vision of their own cultural constellations. A mismanaged, over-centralized electronic communication system is imposing a few standardized, mass-produced and cheapened cultures everywhere."[3] Writer Andrei Codrescu evokes the same danger when he writes about "the million minute murders of specifics going on in the world."[4] This concern cannot be denied, and it is part of the philosophical basis for programs like the National Heritage Fellowships.

There are others who say that although traditions die, tradition itself never dies. These people believe that—like life itself—as one kind of vernacular expression fades, another comes into being. They argue that although new technologies may doom long-lived skills, these very technologies become the basis for new kinds of art, which, in essence, carry on older ideas. The invention of the metal blade thousands of years ago did not end woodcarving, though it did replace the stone blade; in our own age, the gasoline-engine-powered chainsaw has given traditional woodcarving new impetus and lively contemporary expression. Thus, the Japanese folklorist Kunio Yanagita viewed folklore as that part of the expressive culture we continue to bring with us, not the part we leave behind.[5]

Although individuals and groups may argue over whether tradition is in fact fragile or tenacious, both opinions can be present in the same person and often are—revealing, perhaps, our profound concern and uncertainty. Nevertheless, those who argue for the irrepressible continuity of tradition have observed other encouraging phenomena. It has been claimed repeatedly that the only people around who know how to tell particular stories, carve chains, sing certain songs, or perform old rituals are all old themselves—and that when they are gone, no one will be left who will be able to do these things. But actually, it may be possible that much of the knowledge possessed by young people is latent until late in life. An old Indian woman once told folklorist Barre Toelken that, in every tribe, "when the last basket maker dies, well, then, someone else becomes the last basket maker." Toelken adds

*Earnest Bennett,
Anglo-American whittler*

that this phenomenon is common among Native-American artists, partly because of the deference paid to the elderly in their culture and partly because some of their art forms are not undertaken until a person is older.[6]

Henry Glassie discusses a similar situation he witnessed in Ireland. To read folklore books written over the past 150 years, he says, one would think that "generation after generation contains the last basket weaver and the last ballad singer. When they were young, Hugh Nolan and Michael Boyle were not noted storytellers. They would not have performed for a visiting folklorist. Their elders, George Armstrong and Hugh McGiveney, would have told the tales, while the folklorist foretold the demise of the art and young Hugh and Mick cut turf and hay. But now they are the tellers. As never before, young men are wrenched out of the community, and drawn to jobs and films, but some still come to ceilis [informal social gatherings in homes]. They sit quietly after work, unable to tell tales, but they are listening, and some day they will."[7] Glassie also describes how each of five folklorists, collecting Irish tales and writing about them from 1845 to 1945, predicted that the traditional stories would die with the old people.[8] Yet he encountered the same stories about which these folklorists had spoken—in the 1970s.

Folklorist Simon Bronner also noticed this phenomenon in relation to material folk art. He recognized a biographical pattern among men who carved supple, linked chains from solid chunks of wood: they learned to carve in their youth, stopped in the middle part of their lives, when they were busy earning a living, and then returned to carving again in retirement, oftentimes in response to bereavement or other loss.[9] Earnest Bennett, the 1986 National Heritage Fellow from Indianapolis, Indiana, was one such example.

In the carving tradition Bennett practiced, whittled chains and other tricky puzzles like pliers with movable parts tease the eye and mind with a visual riddle. You see and hold the wooden chain or pliers and are told that it was carved from a single piece of wood—with no gluing or other construction of parts, the only allowable technique being the removal of wood by cutting it away with a knife. How can this be done? That is the riddle. And, as with rawhide braiding, the answer is not given—it has to be earned. Bronner describes how Bennett gained his chain-carving skills: "A man with the unusual name of Bacon Godberry got Earnest started on chain carving. Godberry was an old man, a neighbor, with a joker's personality. He showed the chain to the boy and dared him to figure out the puzzle. Figuring it became as important as making it. A boy's mind rises to such a challenge, Earnest felt, because it tests mechanical skills, problem-solving, and craftiness. Once he had it figured out, Earnest showed the chain to friends. They recognized the chain as a trophy, for it embodied symbols of prestige—woodworking and adaptability—prized in the community."[10]

Growing up in rural Kentucky hill country, Bennett absorbed cultural values and a sense of community that would serve him well throughout his life, even in radically different surroundings. Like so many people from Kentucky, Tennessee, and West Virginia, Bennett moved to an industrial northern city to find work. He settled on a fifty-acre farm near Indianapolis, but as the city expanded, his land was surrounded by urban development and eventually zoned for business. Bennett said, "It was a sad day for me when I had to move away from this wonderful land."[11] After this second uprooting, he and his wife settled in a residential area north of Indianapolis, and Bennett built a workshop for his carving behind the house.

Bronner writes that, in these circumstances, "chain carving literally became [Bennett's] 'links' to the past."[12] It was a symbol of country values and a connection with his rural background, and, as with other practitioners of the craft, the act of carving seemed to provide some relief from personal grief. Paradoxically, chain carving also helped to integrate Bennett into urban life, for woodcarving clubs provided one venue for performance and camaraderie; the Children's Museum of Indianapolis proved to be another. Bronner writes, "Cities do not necessarily destroy such older traditional skills, but they certainly recast them. In the city, the public face of carving becomes more unusual, specialized, and celebratory, compacted into shows, festivals, and other special occasions."[13] Perhaps the excitement for the puzzle shown by young visitors to Bennett's demonstrations at the Children's Museum was not all that different from Bennett's in his first encounter with Bacon Godberry some seventy years ago.

Bennett's story appears not only in Bronner's book *Chain Carvers*, but also in *The Grand Generation: Memory, Mastery, Legacy*, which examines the reappearance of folk art in the lives of the elderly.[14] Several other National Heritage Fellows—including Helen Cordero, Mike Manteo, Genevieve Nahra Mougin, Elijah Pierce, Duff Severe, Alex Stewart, and Margaret Tafoya— also appear in *The Grand Generation*, a remarkable book that reveals how artistic expression, as an important part of healthy aging, often increases among the elderly. This notion leads to an interesting prospect for the future of tradition. If the elderly have always preserved traditional art, and if increased life expectancy in this century means that many more of us can expect to live longer, might there not be more traditional art in the future than ever before? Are we entering the golden age of tradition rather than leaving it?

Either extreme is a dramatic simplification of the future of tradition; neither its disappearance nor its strengthening is automatic or inevitable. Thus, we cannot control the future of tradition, but neither are we free from trying to protect it. Not knowing whether we can make a difference, we have to act as if we can.

Carved chain.
By Earnest Bennett,
Indianapolis, Indiana.
Carved from single piece of wood,
56½" long, 1988

I guess I started whittling when I was three years old.
My father was hired to take some men for witnesses for a trial
twenty-eight miles away in a two-horse surrey. Dad was gone
several days and when he came home he brought me a knife.
I suppose I started cutting everything out including my fingers.[15]

Earnest Bennett

The National Heritage Fellowships and grants programs of the Folk Arts Program at the National Endowment for the Arts, the American Folklife Center in the Library of Congress, the Folklife Office of the Smithsonian Institution, and the National Council on the Traditional Arts—the nation's major programs for conserving folk tradition—represent a significant public commitment to the ongoing diversity of American life. These programs are the outcome of a gradually evolving local and national concern about heritage. But they are not, nor would they claim to be, the determining forces for the future of tradition. They reflect more than create, and they are charged to assist rather than initiate. Nor are the academic institutions for the study of folklore and folklife going to "save" tradition. Not even the state programs for the conservation and public presentation of traditional culture—which are housed in state arts agencies, state historical societies, and other institutions—can guarantee that tradition will be conserved.

In the end, the continuity of traditional arts depends upon ordinary people. Will *we* recognize that our neighbors are artists? Will *we* care for what our parents and elders have given us? Will *we* acknowledge the masters of tradition in our midst? What will *we* expect as national, state, and local policy toward cultural heritage? What will *we* do?

The National Heritage Fellows and the many other traditional artists they represent have the knowledge to guide us in nurturing the traditional arts. In many ways, they are the experts; they've done it. The inheritors, innovators, and conservers of tradition are themselves resources we as a nation have usually overlooked—even though they are often recognized within their own communities for their wisdom as well as their artistry. They have not only thought about tradition and change, they have danced, carved, quilted, and sung it. What is their advice?

For one thing, many of the National Heritage Fellows speak reverently about their masters, the teachers they learned from or imitated. They stress the importance of the learning experience, and more particularly, of apprenticeship, in which techniques and values are taught together because they have never been separated. The message is clear—without the opportunity to learn directly from skilled traditional masters, tradition has little chance.

For instance, National Heritage Fellow Newton Washburn, a fourth-generation brown-ash-splint basket maker from Stowe, Vermont, described his master's teaching technique in this way: "Mother started me out with a flat bottom. Then we went to round baskets. Each one you had to do 'til it was right.' The first one you did was right because if it wasn't you took it apart and started over again. There was never nothing said about how many you made. . . . It was quality, not quantity. She'd tell me, 'Make it right, or make it over.'"[16]

For most of the National Heritage Fellows, tradition was conserved and passed on through the close personal association between master and student. Kiowa artist Vanessa Paukeigope Morgan once said, "My abilities as a traditional woman are because of my grandparents."[17] Martin Mulvihill, the great Irish-American fiddler and a National Heritage Fellow in 1984, insisted that in spite of musical training from a classical violinist and all the fine, traditional music he heard in Ireland, his mother's style remained his primary influence.[18] Alex Stewart, a cooper and woodworker from Sneedville, Tennessee, said, "My grandfather, I learned this from him. He made everything—wheels, anything that could be thought about, he made it."[19] Stewart taught his grandfather's skills to his grandson, Rick Stewart, and to an apprentice, Bill Henry.[20]

The experience of saddlemaker and rawhide braider Duff Severe helps us focus on formal apprenticeship programs today. After World War II, Severe learned to be a saddlemaker through a four-year apprenticeship program in a historic saddlemaking shop named Hamley's, in Pendleton, Oregon. As the Severe Brothers Saddle Company grew, Duff and his brother Bill tried to repay their masters and replenish the tradition by taking on apprentices. Both of Bill's sons, Randy and Robin, apprenticed in the shop—Robin through the GI bill and Randy through a State of Oregon apprenticeship program. Yet, in the 1980s, Oregon decided that relatives could not apprentice to relatives with state funding. On the other hand, Duff says that today he would accept only a relative as an apprentice, for the investment—emotional as well as financial—is so enormous that he has to be fairly certain the apprentice will remain as an employee.

Duff's is not an isolated case: state and federal guidelines regularly prohibit apprenticeships between relatives, yet relatives often make the most successful apprentices. Why does government thus fight the current of the river of tradition? Why not ride with it? Folk artists and folklorists both agree that family is often a powerful ally in the conservation of a craft, but recently we have been modifying our laws to discourage family participation. Today—because of rules like the one disallowing family members—apprenticeships that used to be supported by federal and state governments are less likely to happen. What folk artists themselves recommend as the most effective way to communicate tradition has been deprived of assistance.

Fortunately, the National Endowment for the Arts Folk Arts Program does offer apprenticeship bloc grants to state and local agencies, which in turn make individual apprenticeship grants according to criteria decided upon by their own panels. Since these bloc grants were initiated only a few years ago, it is too early to know what their long-term impact will be. If we listen seriously to the National Heritage Fellows, we will encourage a multiplicity of apprenticeship programs through many sources, in addition to the NEA.

Besides the dearth of apprenticeships, there are other barriers to passing on traditions. In at least two cases—the whittling of carved chains and the braiding of rawhide—obstacles to learning are actually an integral part of tradition itself. The would-be carver or braider apprentice has to "puzzle it out" for himself. Duff Severe reveals that he did not want to teach anyone for a long time, both because he was possessive of his skill and because he had had bad luck with apprentices. Some people, as Duff says, do not have the aptitude for rawhide work; others begin and then give up. After a few such bad experiences, Duff says, you get disgusted and don't want to try to teach any more. Receiving the National Heritage Fellowship changed Duff's feelings, however, and made him realize how important it is to pass on the skills. In 1986, Duff began to teach rawhide braiding to his nephew Robin, an already accomplished saddlemaker. Robin's brother, Randy, confirms the simple efficiency of the apprenticeship method: "By telling me things that he had learned, he was saving me fifty years of trial and error. And, of course, he had the same things passed on to him by the old-timers he learned from. That's a lot of experience."[21]

What else can we learn about charting the future of tradition from the National Heritage Fellows? From Allison "Totie" Montana, costume designer and dancer, we can come to realize that conservation does not necessarily require preservation and that the sources of tradition are sometimes unexpected and even incongruous. Montana, a 1987 National Heritage Fellow, is Big Chief of the Yellow Pocahontas Tribe, a "Black Indian" of New Orleans.

The phrase "Black Indians" sounds at first like a contradiction, combining two cultures that are radically different. The main cultural display of the Black Indians—the costumed dancing-and-singing processions of Mardi Gras—seems to be mainly African-American, but these people have, in fact, adapted materials from a wide variety of seemingly unharmonious sources. In doing so, they have created both an art form and a social identity that defies conventional categories—thus, their seemingly contradictory name is appropriate. As folklorist Michael P. Smith writes, "The cultural expressions of the Mardi Gras Indians have an authentic quality, depth, dignity, purity, and power which can only be achieved within the context of a living, non-commercial, traditional culture."[22] Moreover, the Black Indians have their own language and stories (even their own history), most of which relates to Mardi Gras.

The phrase "Yellow Pocahontas Tribe" may also seem confusing, if not outrageous, to anyone not from New Orleans. (There are several other tribes with similar names which compete with each other through costume and dance during Mardi Gras.) Allison Montana's great uncle, Chief Becate (said to have been part African American and part American Indian), founded the Yellow Pocahontas Tribe in 1880. There seems to have been a concrete

historical connection, both cultural and racial, between the African Americans and Native Americans (probably Natchez Indians) of the region, although much of the Black Indians' Mardi Gras costuming has been borrowed from popular sources.[23] Every year, that historical interaction manifests itself again in the multifaceted artistic expression that is Mardi Gras among the Black Indians of New Orleans.[24] Allison Montana, who inherited his title from his father, has been the group's artistic director for more than forty years. He is the senior Chief of all the tribes and "the most respected overall leader within this important submerged community."[25]

Montana and the other Black Indians design and sew Mardi Gras costumes made of "thousands of stones, beads, plumes, and feathers" that look like "auras of a rainbow."[26] They have been called "living works of art"[27]—works of art that dance and sing through the streets of New Orleans. For each Mardi Gras, all their art forms are created anew, as if a world were being born again: "The Black Indians destroy or dismantle their costumes each year and new costumes are created the following year. These are ordinary working people who make great sacrifices to maintain their cultural heritage. It is a potent heritage, one that gives life, beauty, and sustenance to the resilient spirit of the people of New Orleans."[28]

Why would anyone put so much effort into making something beautiful only to destroy it? Why wouldn't they save one year's work for the following year's celebration? Their custom finds striking parallels in West African aesthetics, as described by the Nigerian novelist Chinua Achebe: "The purposeful neglect of the painstakingly and devoutly accomplished *mbari* houses with all the art objects in them as soon as the primary mandate of their creation has been served, provides a significant insight into the Igbo aesthetic value as *process* rather than *product*. Process is motion while product is rest. When the product is preserved or venerated, the impulse to repeat the process is compromised. Therefore the Igbo choose to eliminate the product and retain the process so that every occasion and every generation will receive its own impulse and experience of creation."[29] Similarly, "Totie" Montana conserves his tradition by intentionally not preserving the costumes. In a process quite different from the static preservation that museums practice, conservation is achieved through the dynamism of activity. Montana strikingly demonstrates that creativity is not the monopoly of contemporary high art or of the ancient, primitive past: his traditional art is wildly new every year.

Montana's work also sheds light on the mystery of the historical origins of art—an issue that has long puzzled anthropologists, archeologists, classicists, art historians, and historians of religion. One popular cultural theory at the turn of the century held that myth, drama, and perhaps all forms of art evolved from the seasonal rituals of ancient peoples.[30] Although later

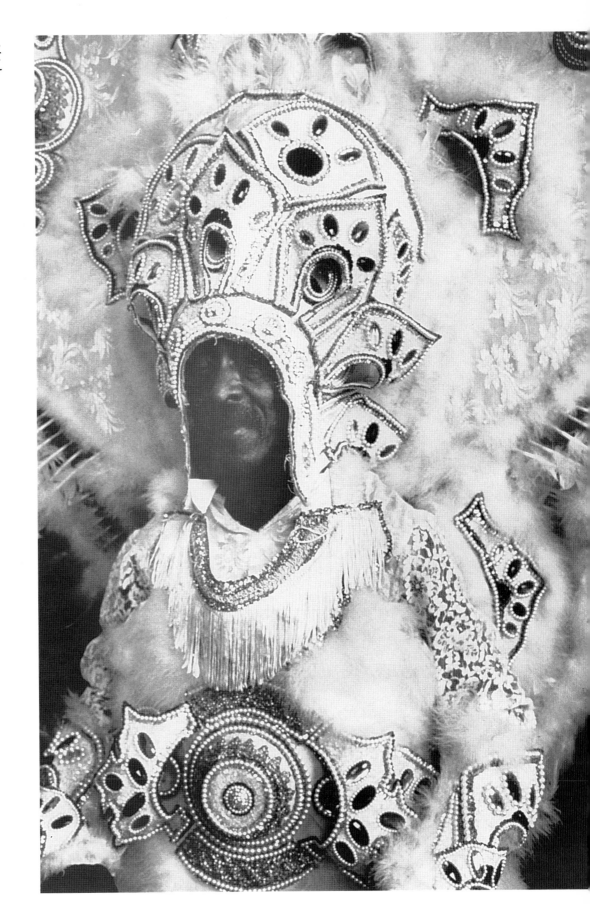

Allison "Totie" Montana,
Mardi Gras Big Chief,
costume maker

scholarship has cast doubt on this myth-ritual theory, we can see from "Totie" Montana and the Black Indians of New Orleans that seasonal changes and the festivities accompanying them can be great moments for artistic expression. It seems that myth and drama were not born only once, long ago; they are born again, from ritual, every year, as the still significant seasonal festivals return. Many of our own annual holidays, which are connected with nature's rhythms, imply the cyclical character of time, in apparent opposition to linear, mechanical time. Thus, in regularly returning us to tradition and creativity, festivals offer us another perspective on the future of tradition.

Finally, the phenomenon of the Black Indians of New Orleans provides a fascinating perspective on the process of traditionalizing material from non-traditional sources. For such a group, the original sources of costume, ritual, story, and even names are not all-important: the traditionalizing process itself has reshaped materials of diverse provenance so that they have come to speak artistically and authentically for the group. This new, expressive tradition has been conserved and shaped by the dynamism of artists like Allison "Totie" Montana. Through his costumes, dancing, singing, and leadership, he has done much to preserve this inheritance and, perhaps most important, has acted as an inspiring role model for a new generation of Black children.[31]

So has National Heritage Fellow John Cephas, a blues guitarist, who is also an expert on tradition well worth consulting. He is an articulate and active authority on the blues tradition and works to conserve it by playing, teaching, and serving as president of the Blues Society of Washington, D.C. In one way, Cephas brought a unique perspective to the National Heritage Fellowship concert when he received the award in 1989: Lisner Auditorium, the theater on the George Washington University campus where the ceremony was held, is located near his old neighborhood, Foggy Bottom. For every Fellow, part of the honor of the award has always been to be acknowledged in the nation's capital; for Cephas, there was the additional dimension of the site's being his birthplace.

This coincidence was a powerful reminder that all places—even the capital itself, the symbol of the entire nation—are really local. Though Cephas spent part of his formative years in Bowling Green, Virginia, and eventually settled there, his exposure to traditional music—both blues guitar and religious singing—came at least as much from Washington. The night Cephas accepted his award, many of his local fans came to see the Fellow they felt represented them. In a city inhabited by transient professionals, Cephas represented the persistence of local heritage.

Yet, being grounded in the local led, for John Cephas, to a global rather than a provincial awareness: "It doesn't just stop here. We have another charge. We must try to interest some younger people. . . . I am dedicated to

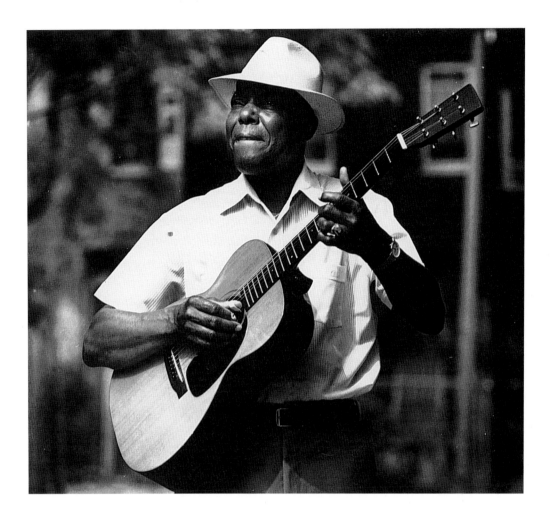

perpetuating the Blues as long as I have life. . . . I like to think that the traditional arts hold the world together."[32]

John Cephas has traveled around the world, playing Piedmont blues guitar for audiences in Europe, Africa, Central and South America, and elsewhere, so his work to "hold the world together" is not just rhetoric. As modern communications technology and travel make the world smaller, the local is often in danger of being squeezed into nothingness. Faced with that threat, Cephas has used those same powers of communication tirelessly, to share his local heritage with the entire world.

Bertha Cook did not travel as far as John Cephas, and she was a craftsperson rather than a musician, but, like Cephas, she allows us to recognize the role of nontraditional settings and new audiences in charting the future of tradition. A knotted-bedspread maker from Sands, North Carolina, Mrs. Cook was named a National Heritage Fellow in 1984 and died in 1990. Like Cephas, she often displayed her skills to the public, performing at occasions ranging from country fairs to world's fairs over the last forty years.[33] She was the vital connecting link for a threatened artistic skill within her family, learning from her grandmother and teaching her granddaughter.

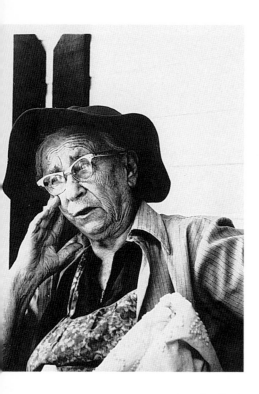

*Bertha Cook,
knotted-bedspread maker*

I was 18 years old. . . .
My grandmother, my aunts,
and my mother, they all did it.
I never did want to tie it,
but I did. . . . One day,
Momma said, "Now big
as you are, if you don't
learn to tie fringe
I'm gonna whip you."
So I didn't want to be
whipped and I learned.
Now I've been
tyin' ever since.[38]

Bertha Cook

Folklorist Thomas McGowan described Bertha Cook at work: "She pulls fourteen strands of white thread, doubled in her needle through a ball of beeswax and then begins to twist and pull a quick line of colonial knots through blue dots on a large sheet of muslin. Knots pop up in neat rows. She occasionally stops to snip off unacceptable knots with scissors. Rows of knots meet to form patterns. They trace the windings and leaf shapes of a grape vine. Around a central wreath of the grape vine design is a rectangle of small knots. Close up, the knots appear like little flowers, the crossed threads of the knotting making a deft, tight cluster."[34]

In Mrs. Cook's Blue Ridge Mountains, the subtlety of white on white—white cotton thread on unbleached or whitened muslin—constitutes much of the beauty in these bedspreads, and she maintained this essential element of the tradition even in the face of suggestions from outsiders. When a viewer once offered the opinion that her Grape Wreath spread would be prettier if she added green to the leaves and made the grapes purple, Mrs. Cook, slightly miffed, disagreed.[35]

Yet Bertha Cook did innovate within the tradition, within the unspoken rules as she understood them. The Grape Wreath spread, for instance, is her own design. And instead of knotting her bedspreads on a broom handle suspended from two chairs, as she first saw it done, she used a frame. Public demonstrations were so much a part of her effort that she even had a small transportable frame for use in demonstrations away from home.

The knotted bedspread is a family tradition within the Blue Ridge region of North Carolina. But one reason it has remained viable in Bertha Cook's family is because many others besides family members want to bring the quiet beauty of "colonial knotting" to their bedrooms. Mrs. Cook made and sold her first knotted bedspread in 1912; by the publication in 1975 of the National Geographic Society's book *The Craftsman in America*, in which she was featured, she had made over a thousand spreads.[36] After 1950, she demonstrated her skill at a wide variety of sites and was also the subject of numerous newspaper articles as well as a videotape.[37] In 1960, she was honored with a life membership in the Southern Highland Handicraft Guild, and in 1973 she received the Brown-Hudson Award, the highest award given by the North Carolina Folklore Society.

Such honors, media coverage, and demonstration appearances call attention to the increasingly important role of nontraditional institutions and events in creating the future of tradition. The expansion of an audience for Bertha Cook's work beyond the traditional one of family and neighbors was clearly important to the continuation of her art. So was her personal character; she was independent and self-reliant. As McGowan wrote: "In the early 1900s knotting was a popular craft and practiced mainly in the mountains of Western North Carolina. After the depression, many of the

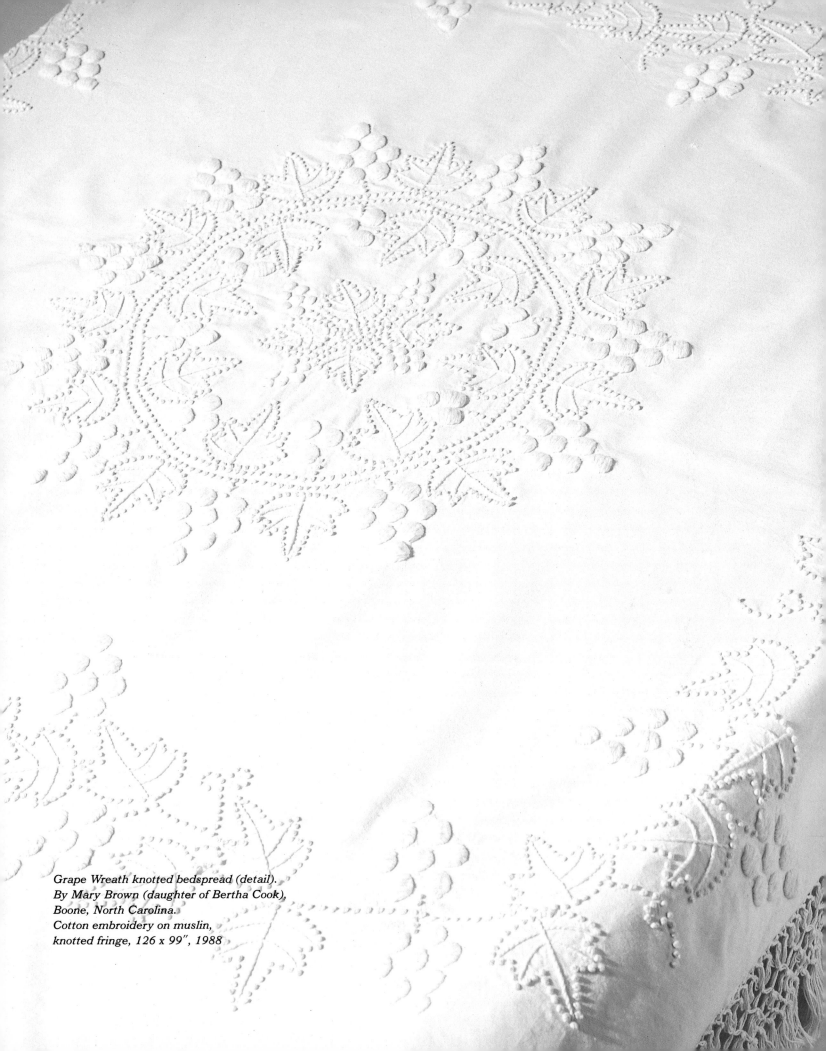

Grape Wreath knotted bedspread (detail).
By Mary Brown (daughter of Bertha Cook),
Boone, North Carolina.
Cotton embroidery on muslin,
knotted fringe, 126 x 99", 1988

women ceased to work at this craft, but not Mrs. Cook. She kept alive a beautiful and traditional craft and has left us a beautiful heritage to enjoy."[39]

It may be that these two elements—the strength of character of a gifted artist and the opening up of new audiences—more than any others, provide the conditions for traditional arts to remain lively. The opportunities afforded by public demonstrations meant that Bertha and one of her daughters, Mary Brown, were able to work together, and the skill was thus reinforced in the following generation. Patterns with lovely names—Bird in the Tree, Rose of Sharon, Bowknot and Thistle, Napoleon Wreath, and Sunflower—continue to be composed anew not in spite of, but because of, the wider attention that public programs have brought to this quiet, local tradition. We have to ask, then: can other folk traditions, in performance and craft, also find new audiences? Is that desirable? How do new audiences affect old traditions?

Fiddling is one of the best examples of a traditional art that developed its own new audiences and, in the process, changed itself. Fiddle music was deeply ingrained in early American experience; the fiddle's musical adaptability, small size, and portability made it "the pre-eminent musical instrument of the American frontier."[40] As Alan Lomax puts it, "The fiddle rode west in all the wagons and rode north in the saddlebags of all the cowboys."[41] When the Mormon leader Brigham Young sent out carefully selected groups from Salt Lake City to colonize remote areas of the Intermountain West, he sent not only masons and carpenters, but a fiddler, too.[42] Everywhere the fiddle went, local styles developed—from French Canadian to Texas longbow. The fiddle usually was the lead instrument in the small bands that commonly provided dance music, and when that function began to wane in many places in the early twentieth century, fiddling developed new contexts, like fiddling contests, old-time fiddling organizations, and the competitions and festivals that are now widespread throughout the country. When fiddling changed from providing dance music to being performed on a raised stage, to being watched and listened to from the fixed seats of an auditorium, a new kind of fiddler—the contest fiddler—emerged. Yet, as Barre Toelken points out, judges still grade contestants in part on the danceability of their tunes, so even though dancing is no longer the primary context, contest fiddling requires the maintenance of dance knowledge.[43] Today, all varieties of traditional and contest fiddlers flourish in almost every part of the United States, from the Deep South to Weiser, Idaho, and among groups as originally alien to the fiddle tradition as the Athapascan Indians of Canada and Alaska.

Thus, in many ways, fiddling has taken care of itself. So far there are nine fiddlers and violinists among the National Heritage Fellows, each representing a distinctive tradition: Howard Armstrong (African-American), Dewey Balfa (Cajun), Joseph Cormier (Cape Breton), Canray Fontenot

(Black Creole), Tommy Jarrell (Appalachian), Simon St. Pierre (French-American), Kenny Sidle (Anglo-American), and Chesley Goseyun Wilson (Apache).[44] And there are many more local traditions yet to be recognized. Clearly, fiddling is a relatively healthy tradition in America today—as is blues guitar, another American traditional form. The diversity and number of fiddlers and blues guitarists constitute dramatic examples of success in conserving and encouraging traditions.

There has not been as much success, however, in bringing the objects made by American folk artists to new audiences. Even the popularity of Bertha Cook's knotted bedspreads is a rather slender thread for an entire tradition to depend upon. Perhaps because today we purchase most consumer objects from a few, massive outlets, lack of marketing presents problems for the material folk tradition.[45] Getting authentic, contemporary folk arts and crafts to market is quite different from finding audiences for folk music.

The coiled-grass baskets made and sold by African Americans in Mount Pleasant and Charleston, South Carolina, provide us with a good example of a craft tradition that has struggled successfully to survive in the modern world, yet still remains threatened. It is an example that also demonstrates many of the problems facing the future of material traditions as well as the need for stronger public policies in support of tradition.

Mary Jane Manigault, the National Heritage Fellow seagrass basket maker from Mount Pleasant, has been recognized for her artistic excellence and traditional authority, but it is important to recall that she is one of hundreds of seagrass basket makers in the area. Also, though the African-American art of making coiled baskets once extended along the coast from North Carolina to Florida, its territory has been reduced today to Mount Pleasant and Charleston. Even with this reduced market, "the same pressures that have caused the disappearance of coiled basketmaking else-where have been increasingly felt in the Mt. Pleasant community."[46] Yet, the craft has maintained its economic viability by replacing its traditional uses and users with a new audience of consumers—tourists looking for items of authenticity, quality, and local significance. The basket makers, in turn, benefit the tourist industry and local economy by adding to the distinct character that draws visitors to Charleston.

But commercial development, of which tourism is an important part in this area, also threatens the future of seagrass basketry by making it difficult to obtain the raw materials themselves: "All basketmakers depend in large part on naturally growing wild plants to produce their baskets. Coiled basket-makers use parts of black rush, sweetgrass, cabbage palm and longleaf pine. The rapid development expanding from Charleston in the past twenty years is largely taking place across lands previously underdeveloped.

Basket with lid.
By Ada Thomas,
Charenton, Louisiana.
Swamp cane, plaited in double weave,
11″ high, 1980

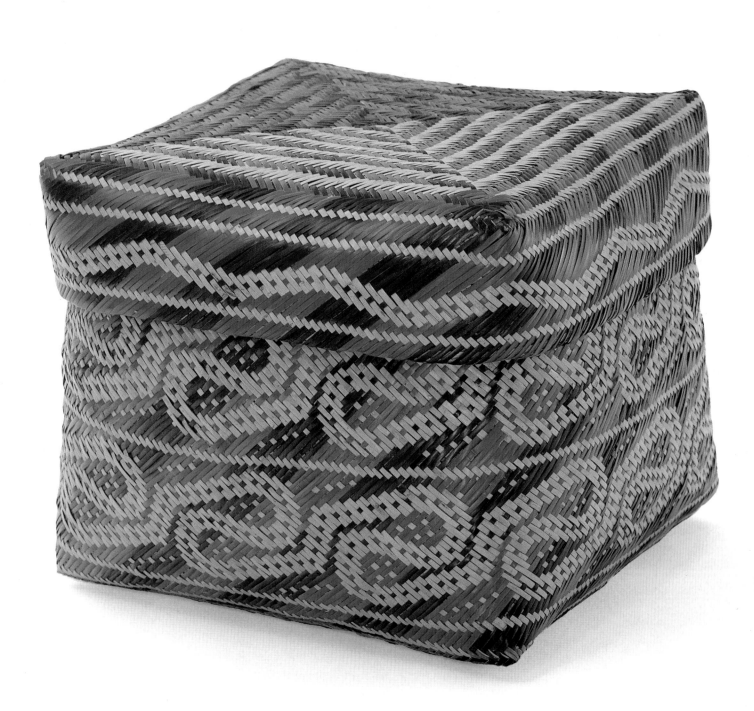

Development has removed from public access areas where grass, palm, and rush continue to exist, while in other building sites the native plants have been covered by asphalt parking lots, golf courses, and buildings. Designation of the lands as wildlife preserves, or State and National forest lands also limits the ability of men to harvest grasses, palm, or pine needles."[47] (The elegant and intricately patterned doubleweave baskets of National Heritage Fellow Ada Thomas are also becoming increasingly rare because of a similar destruction and changing designation of natural habitat in Louisiana. Mrs. Thomas is a Chitimacha Indian and lives on the 265-acre reservation at Charenton, Louisiana.[48])

Moreover, there is a growing problem of access to markets. In addition to the basket makers who sell their wares in the open-air Market Square in Charleston, many others set up wooden stands along Highway 17 in Mount Pleasant. Neither owning the frontages nor paying rent, they have been given easements or made informal agreements allowing them to sell from their stands. In recent years, however, commercial development in the outlying areas of the town has increasingly challenged these easements and informal arrangements.[49]

Given this situation, it may seem surprising that coiled basketry continues to thrive in Mount Pleasant. That it does so is due, undoubtedly, to efforts being made by many parties.[50] And now, even with all this good will and effort, the effects of a hurricane must be dealt with as well. On September 21, 1989, Hurricane Hugo struck its hardest just north of Charleston, in Mount Pleasant and other coastal communities: "The heaviest concentration of basketmaking families resided in the area affected by Hugo's tidal surge, which inundated the land under as much as fourteen feet of sea water. . . . In addition to the structural damage to their homes, the basketmakers esti-mate the loss of baskets and materials at $1.3 million."[51] Hugo also damaged the raw materials of the craft, destroying palmetto used in sewing as well as two types of sweetgrass; little was harvested the year of the hurricane or the year after (1989–90). Since the basket makers' personal supplies were also destroyed, the tradition faced serious immediate trouble.

An even more grave long-term problem resulted from the hurricane:

> Highway 17 . . . has historically been the area where hundreds of basketmaking families have sold their wares from wooden roadside stands. Few of these flimsy structures withstood the hurricane. In the general cleanup of debris along the highway almost all of the destroyed stands have been removed. Most of these stands stood on private land on which easement had been orally granted to the basketmakers. The custom of use was a powerful factor for the persistence of these stands. The pressures of development had already resulted in the removal of stands closer to Mt. Pleasant proper. . . . After the storm, approximately fifteen stands have

been rebuilt and are currently operating. These are in yards that belong to basketmaking families. Those who have lost stands on property that does not belong to them may very well find that their accustomed easement will be lost if they are not able to replenish their stock of baskets and rebuild their stands in the next season.[52]

We may be tempted to see a metaphor in a natural force like Hugo that destroys the built environment and dramatizes the fragility of all that humanity constructs—nature sometimes sweeps culture off the map. But we should be wary about overplaying the role of such forces in the loss of traditional culture. The need to fortify the basketry tradition was clear before Hugo, and in fact, the storm's best purpose may have been to make us realize that our long-term neglect of tradition can be more destructive than a hurricane.

Some will take the metaphor of the hurricane a step further and see nature at work in the forces of the marketplace. They will claim that it is futile to try to save tradition, arguing, "If it can't make it on its own, it shouldn't be maintained artificially." But the dikes that hold back hurricane surges are artificial, as are radar, scouting planes, and all the other means of tracking hurricanes. They are cost-effective only in terms of their benefit to large numbers of people. We developed them to protect lives and property, but what have we done for our heritage, particularly in its intangible aspects? Americans gave generously to restore art treasures damaged by the floods in Florence and Venice in 1967, but we sometimes forget that our country has living artistic treasures, "things of intrinsic worth," that are similarly threatened.[53]

We really have to decide what kind of culture we as a nation want in the future, and not leave the outcome to the marketplace alone. We don't leave our airports or our highways to the marketplace; they are paid for by everybody's taxes. If we ran airports and highways for profit, most of us couldn't afford to use them, and all of us would suffer. Is our national heritage any less important? We need it at least as much as we need airports and highways; we cannot be healthy without it. The question is not whether these traditions deserve to live; it is whether we have the wisdom and will to stop throwing "hurricanes" in their paths.

After having surveyed the National Heritage Fellows—these unexpected, mainly locally known master artists—we may be a bit surprised by the wealth of aesthetic tradition we still have. Nearly 150 traditional American artists have been designated as National Heritage Fellows since the inception of the program. Think of these people, now that you have read about some of them: they are a group that reflects not only American, but global, diversity. They share the highest standards of artistic excellence. Native speakers of different tongues, they still speak a common language—an aesthetic language

conceived differently by individual communities, but ultimately accessible to all humans. They epitomize the best of everyday life, for they have conserved art that, until recently, had no institutions to maintain it. What they bring forward has withstood the toughest tests of time. Their reach extends beyond their own cultures and their own times as well. They are the diversity we fear the world may be losing.

What else is it we see *in* the National Heritage Fellows, and what do we see *through* them? Is it the past or the future? Is it something almost dead or something vital?

If we go back to those two cowboys—Richard Wetherill and Charlie Mason—who brought the greatest monument of North American archeology to the world's attention, we may see their experience as a metaphor in another way. That "magnificent city," as they described the Cliff Palace— is it glowing with activity? Or is it a golden illusion, a dying shadow of an earlier glory? Mason and Wetherill saw life in Mesa Verde, as if its inhabitants had just left yesterday. They had the imagination to perceive something alive in something apparently dead, and their vision has persisted and come down to us. One hundred years later, we still see Mesa Verde as they saw it—a place of life.

Their discovery leads us to the creative cultural treasures in our midst today. Native American traditional artists, the descendants of the inhabitants of Mesa Verde, live in the pueblos and cities to the south and west. Other Native American singers, storytellers, dancers, and makers of endlessly beautiful objects live throughout the United States. Everyone else is either an immigrant or the descendant of immigrants: traditional music, story, craft, art, and dance from many cultures have been transformed and transfigured through centuries, or even only decades, of experience in America. They, the National Heritage Fellows past and future, are the Mesa Verdes, Yosemites, and Yellowstones of our traditional artistic heritage.

Like Mason and Wetherill, we, too, are poised on the canyon rim, and what we need is vision. The National Heritage Fellows give us that vision. Through their skill and enthusiasm, we see a future with a human face, art with human dimensions. We see the curve of the maker's hand in things lovingly shaped. The voice of the singer is nearby and need not strain. We beg the storyteller not to stop, even if we fall asleep.

NOTES

Much of the information drawn on for the text may be found in the files of the National Endowment for the Arts Folk Arts Program in Washington, D.C., filed under the general category of National Heritage Fellowships and specifically under the name of each artist (the "NHF files"). The following abbreviations have been used throughout these Notes: NEA (National Endowment for the Arts) and NHF (National Heritage Fellowships).

Introduction

1. This text makes use of notes from the various NHF programs since 1982 as well as the catalogue prepared for *Living National Treasures of Japan,* published in connection with the appearance of that exhibition at the Boston Museum of Fine Arts in 1983. The cavalier use of the terms "I" and "we" encompasses many individuals who contributed greatly to the entire program: Daniel Sheehy, Sally Yerkovich, Robert Teske, Barry Bergey, Rose Morgan, and Ana Steele of the NEA; J. C. Dickinson and Theodore Bikel of the National Council on the Arts; Joe Wilson, Richard Kennedy, and Meg Glaser of the National Council for the Traditional Arts; and Barre Toelken and Roger Welsch of the Folk Arts advisory panels, among many others.
2. *The National Heritage Fellowships 1985* (Washington, D.C.: NEA Folk Arts Program).

Chapter One

The opening quotation is from Alex Stewart, a National Heritage Fellow and master cooper, recalling his grandfather and teacher. In *The National Heritage Fellowships 1983* (Washington, D.C.: NEA, Smithsonian Institution, and Continental Telecom Inc.).

1. Wetherill, his brothers, and Mason were well aware of, and interested in, ancient Indian ruins in the area, but they had not seen anything on the scale or magnificence of Cliff Palace. For the history of their discoveries, as well as the history of the park, see Duane A. Smith, *Mesa Verde National Park: Shadows of the Centuries* (Lawrence: University of Kansas Press, 1988).
2. In fact, even though the Wetherill family wrote to the Smithsonian Institution several times from 1888 to 1890, a lack of funds prevented any purchases or assistance in excavation on the part of the Smithsonian. The Wetherills undertook exploration, collection, and promotion themselves. See Smith, pp. 22–23.
3. Comments, NHF concert, Washington, D.C., 1982, NHF files.
4. Comments, NHF dinner, Washington, D.C., 1986, NHF files.
5. Ibid.
6. See Alan Dundes, "Thinking Ahead: A Folkloristic Reflection on the Future Orientation in American Worldview," *Anthropological Quarterly* 42 (1969): 53–72.
7. See Roger D. Abrahams, ed., *A Singer and Her Songs: Almeda Riddle's Book of Ballads* (Baton Rouge: Louisiana State University Press, 1970).
8. As quoted in material in the NHF files.
9. The word "star" has come to bear an association of crassness and commercialism, but the metaphor is fundamentally rich. Folklorist Henry Glassie uses it throughout his masterful work *Passing the Time in Ballymenone: Culture and History of an Ulster Community* (Philadelphia: University of Pennsylvania Press, 1982).
10. *The National Heritage Fellowships 1985* (Washington, D.C.: NEA Folk Arts Program).

11. As quoted in *National Heritage Fellowships 1985.*
12. Margot McMillen Roberson, letter of nomination, Sept. 29, 1986, NHF files.
13. As cited in Bess Lomax Hawes, "The National Heritage Fellowships Program," in *1982 Festival of American Folklife Book* (Washington, D.C.: Smithsonian Institution), p. 9.
14. As cited in *The National Heritage Fellowships 1988* (Washington, D.C.: NEA Folk Arts Program). Information on Watson comes from this source as well as Bill Ivey, letter of nomination, Dec. 8, 1981, NHF files; and Marilyn Kochman, ed., *The Big Book of Bluegrass Music* (New York: Morrow, 1984), pp. 130–35.
15. *The National Heritage Fellowships 1988.*
16. Henry Glassie, "Artifact and Culture, Architecture and Society," in Simon Bronner, ed., *American Material Culture and Folklife: A Prologue and Dialogue* (Ann Arbor, Mich.: UMI Research Press, 1985), p. 53.
17. *The National Heritage Fellowships 1984* (Washington, D.C.: NEA Folk Arts Program).
18. As quoted in "Talk of the Town," *The New Yorker,* Oct. 1, 1984, p. 30.
19. Ibid.

Chapter Two

The opening quotation is from National Heritage Fellow Stanley Hicks. In *The National Heritage Fellowships 1983* (Washington, D.C.: NEA, Smithsonian Institution, and Continental Telecom Inc.).

1. Speaking in *Fixin' to Tell about Jack* (Elizabeth Barret, Director), 16mm film and videotape (Whitesburg, Ky.: Appalshop, 1974).
2. Gwen Kinkead, "An Overgrown Jack," *The New Yorker,* July 18, 1988, p. 33.
3. Speaking in *Fixin' to Tell about Jack.*
4. Ibid.

5. Ibid.

6. Michael Moloney, "Joe Heaney: Cultural Ambassador," *New York Folklore Newsletter* 5:2 (July 1984): 2. (This article appeared originally in Dublin's *The Sunday Tribune*, May 13, 1984.)

7. As quoted in Kinkead, p. 34.

8. As quoted in *The National Heritage Fellowships 1983*.

9. As quoted in Kinkead, p. 38.

10. A recent book which argues for the determining impact of English culture on America is David Hackett Fischer's *Albion's Seed: Four British Folkways in America* (Oxford: Oxford University Press, 1989).

11. *The National Heritage Fellowships 1984* (Washington, D.C.: NEA Folk Arts Program).

12. John Michael Vlach, *The Afro-American Tradition in Decorative Arts* (Cleveland: Cleveland Museum of Art, 1978), p. 7.

13. Ibid., p. 8. The preceding brief discussion of African and African-American agriculture and basketry is based on Vlach, *Afro-American Tradition*, pp. 7–10.

14. *The National Heritage Fellowships 1984*.

15. Vlach, *Afro-American Tradition*, p. 19.

16. As quoted in Dale Rosengarten, *Row upon Row: Sea Grass Baskets of the South Carolina Lowcountry* (Columbia: McKissick Museum of the University of South Carolina, 1987), rev. ed., p. 39.

17. Native Americans, "Indians," were, of course, really the first people to live in North America. I am speaking about a later (post-1492), "modern" migration with dynamics of its own. *Albion's Seed*, mentioned above, is the most recent argument for the lasting impact of Anglo cultures in America. The idea that the first settlers have a major cultural impact out of proportion to their numbers is known as the Doctrine of First Effective Settlement. See Wilbur Zelinsky, *The Cultural Geography of the United States* (Englewood Cliffs, N.J.: Prentice-Hall, 1973), pp. 13–14.

18. For a magnificent history and appraisal of the powerful creativity of African-American culture in spite of indescribably demoralizing conditions, see Lawrence W. Levine, *Black Culture and Black Consciousness: Afro-American Folk Thought from Slavery to Freedom* (Oxford: Oxford University Press, 1977).

19. Zelinsky, p. 23.

20. Unpublished poem by Ed Edmo, Jr., as recalled by Barre Toelken, Dec. 1990.

21. Barbara Kirshenblatt-Gimblett, "Studying Immigrant and Ethnic Folklore," in Richard M. Dorson, ed., *Handbook of American Folklore* (Bloomington: Indiana University Press, 1983), pp. 39–47.

22. Gilbert Shapiro and Bernard Rosenberg, "Marginality and Jewish Humor," *Midstream* 4 (1958): 74.

23. Anna Lomax Chairetakis, NEA site report, Mar. 3, 1983.

24. The discussion of Miguel Manteo and the *opera dei pupi* is based on the following sources: Denise DiCarlo, "The Manteo Family Saga," paper delivered at the Annual Meeting of the American Italian Historical Association, San Francisco, 1989; Donna Lauren Gold, "Plucky Puppets Are the Stars in One Family's Saga," *Smithsonian*, Aug. 1983, pp. 68–73; David Grogan, "Chivalry Lives as Mike Manteo Revives Knights to Remember," *People Magazine*, June 1, 1987, pp. 52–54; Mary Hufford, Marjorie Hunt, and Steven Zeitlin, *The Grand Generation: Memory, Mastery, Legacy* (Seattle: University of Washington Press, 1987), p. 93; Susan Kalcik, "Gifts to America," in *Festival of American Folklife Program Book* (Washington, D.C.: Smithsonian Institution, 1976); and Barbara Kirshenblatt-Gimblett, "Manteo Sicilian Marionette Theatre," *New York Folklore Newsletter* 3:2 (1982): 1,10.

25. Stewart Culin, "Italian Marionette Theatre in Brooklyn, N.Y.," *Journal of American Folklore* 3 (1890): 155–57.

26. D. H. Lawrence, "Sea and Sardinia," in *D. H. Lawrence and Italy* (New York: Viking Penguin, 1972 [1921]), p. 200.

27. Grogan, p. 53.

28. Lois Adler, *The Drama Review* 20 (1976): 29, as cited in Barbara Kirshenblatt-Gimblett, "Manteo Sicilian Marionette Theatre," p. 10.

29. Gold, p. 70.

30. Ibid.

31. As quoted in Kalcik, pp. 12–13, cited by Hufford, Hunt, and Zeitlin, p. 93.

32. As quoted in *The National Heritage Fellowships 1983*.

33. Mike "Papa" Manteo, as quoted in Gold, pp. 71–72.

34. The discussion of Dave Tarras and klezmer music is based on Henry Sapoznik, "Klezmer Music," in *Der Yidisher Caravan* (program notes to a national tour of Yiddish culture), n.d., pp. 8–9; Mark Slobin, "The Neo-*Klezmer* Movement and Euro-American Musical Revivalism," *Journal of American Folklore* 97 (1984): 98–104; *The National Heritage Fellowships 1984*; and *Dave Tarras* (New York: Global Village Music, 1989), audio-cassette C105.

35. Sapoznik, p. 9.

36. *1980 Census of Population. Ancestry of the Population by State: 1980. Supplementary Report* [PC80-S1-10] (Washington, D.C.: U.S. Department of Commerce, Bureau of the Census, 1983), p. 1.

37. Moloney, p. 2.

38. As quoted in Moloney, p. 2.

39. Moloney, p. 2.

40. Ibid.

41. Marjorie Hunt, personal communication, Mar. 1990.

42. Comments, NHF concert, Washington, D.C., 1982, NHF files.

43. Ibid.

44. Marion J. Nelson, "The Material Culture and Folk Arts of the Norwegians in America," in Ian M. G. Quimby and Scott T. Swank, eds., *Perspectives on American Folk Art* (New York: Norton, 1980), p. 133.

45. Debora Kodish, "Ethnic Arts," in Suzi Jones, ed., *Webfoots and Bunchgrassers: Folk Art of the Oregon Country* (Salem: Oregon Arts Commission, 1980), p. 110.

46. Marion J. Nelson, "Material Culture and Folk Arts," p. 129.

47. Philip Martin, "The Heritage of Rosemaling in the Upper Midwest," NHF files.

48. Janet C. Gilmore, letter of nomination, NHF files.

49. The discussion of Ethel Kvalheim is based on *From Hardanger to Harleys: A Survey of Wisconsin Folk*

Art (Sheboygan, Wis.: Kohler Arts Center, 1987); Philip Martin, "The Heritage of Rosemaling"; *The National Heritage Fellowships 1989* (Washington, D.C.: NEA Folk Arts Program), pp. 9–10; and letters of nomination from Janet C. Gilmore, Richard March, Philip Martin, Marion J. Nelson, and Robert T. Teske in the NHF files.

50. Philip Martin, "The Heritage of Rosemaling," p. 4.

51. Marion J. Nelson, "Norwegian-American Woodcarving: Historic and Aesthetic Context," in Darrell D. Henning, Marion J. Nelson, and Roger L. Welsch, eds., *Norwegian-American Woodcarving of the Upper Midwest* (Decorah, Iowa: Norwegian-American Museum, 1978), p. 13.

52. Henning, Nelson, and Welsch, *Norwegian-American Woodcarving of the Upper Midwest*.

53. Henry Glassie, *The Spirit of Folk Art: The Girard Collection at the Museum of International Folk Art* (New York: Abrams, 1989), p. 101.

54. For examples of behavioral and narrative folklore among college students, see, for instance, Barre Toelken, "The Folklore of Academe," in Jan Brunvand, *The Study of American Folklore: An Introduction* (New York: Norton, 1986 [1968]), pp. 502–28.

55. Glassie, pp. 96, 101.

56. Nelson, "Material Culture and Folk Arts," pp. 127–28.

57. Nelson, "Norwegian-American Woodcarving," p. 17.

58. Ibid., p. 18.

59. As quoted in *The National Heritage Fellowships 1985* (Washington, D.C.: NEA Folk Arts Program).

60. The discussion of José Dolores López and George López is based mainly on Charles L. Briggs, "The Role of *Mexicano* Artists and the Anglo Elite in the Emergence of a Contemporary Folk Art Form," in John Michael Vlach and Simon Bronner, eds., *Folk Art and Art Worlds* (Ann Arbor, Mich.: UMI Research Press, 1986), pp. 195–224, and Jim Maldanado, "Cordova Keeps Knife Carving," *The Santa Fe New Mexican*, Dec. 28, 1969.

61. Briggs, p. 215.

62. Glassie, pp. 96–99.

63. Elliott Oring, "Ethnic Groups and Ethnic Folklore," in Elliott Oring, ed., *Folk Groups and Folklore Genres* (Logan: Utah State University Press, 1986), p. 28.

64. Robert J. Smith, "Festivals and Celebrations," in Richard M. Dorson, ed., *Folklore and Folklife: An Introduction* (Chicago and London: University of Chicago Press, 1972), p. 168.

65. The discussion of Juan Alindato is based mainly on materials in the NHF files.

66. They are Narciso Martínez (1983), Valerio Longoria (1986), and Pedro Ayala (1988). Lydia Mendoza received the National Heritage Fellowship with the first group of Fellows, in 1982.

67. The discussion of José Gutiérrez is based mainly on materials in the NHF files.

68. Daniel E. Sheehy, "Traditional Music of the Mexican Mestizos," in *1978 Festival of American Folklife Book* (Washington, D.C.: Smithsonian Institution), pp. 14–15.

69. *The National Heritage Fellowships 1989*.

70. Robert McCarl, "Occupational Folklore," in Oring, *Folk Groups*, p. 77.

71. Ibid., pp. 71–89.

72. For artistry in work technique, see Robert S. McCarl, "The Production Welder: Product, Process and the Industrial Craftsman," *New York Folklore Quarterly* 30 (1974), pp. 243–53. For mining songs, see Archie Green, *Only a Miner* (Urbana: University of Illinois Press, 1972). For occupational narrative, see Robert S. McCarl, *The District of Columbia Fire Fighters' Project: A Case Study in Occupational Folklife* (Washington, D.C.: Smithsonian Institution, 1985), and Jack Santino, "Characteristics of Occupational Narrative," *Western Folklore* 37 (1978), pp. 57–70, and *Miles of Smiles, Years of Struggle: Stories of Black Pullman Porters* (Urbana: University of Illinois Press, 1989).

73. This line is from one of the best-loved and most often recited cowboy poems, "The Sierry Petes" by Gail Gardner. For a full text, as well as other examples of "classic" and contemporary traditional cowboy poetry, see Hal Cannon, ed., *Cowboy Poetry: A Gathering* (Salt Lake City: Peregrine Smith, 1985), pp. 3–5.

74. The exhibit, entitled *Western Folk Art*, was a traveling version of *"We Came to Where We Were Supposed to Be": Folk Art of Idaho*, curated by Steve Siporin and sponsored by the United States Information Agency.

75. See, for example, Suzi Jones, ed., *Webfoots and Bunchgrassers*; Hufford, Hunt, and Zeitlin, *The Grand Generation*; and the accompanying exhibitions by the same titles.

76. For Bob Severe, see the videotape or slide-tape program *"I've Got a Soft Spot for Some Old Horse": Bob Severe, Master Saddlemaker*, Barbara Rahm, producer (Boise: Idaho Commission on the Arts, 1981). Also see Steve Siporin, ed., *"We Came to Where We Were Supposed to Be": Folk Art of Idaho* (Boise: Idaho Commission on the Arts, 1984), p. 42.

77. Comments, NHF concert, Washington, D.C., 1982, NHF files.

78. Ibid.

79. As quoted in Hufford, Hunt, and Zeitlin, p. 79.

80. Ibid., p. 82.

81. The discussion of Clyde Sproat and *paniolo* traditions is based mainly on Lynn J. Martin, ed., *Na Paniolo o Hawai'i* (Honolulu: Honolulu Academy of Arts, 1987); Ricardo D. Trimillos, ed., *Na Mele o Paniolo: Songs of Hawaiian Cowboys*, double-cassette tape and essay (Honolulu: State Foundation on Culture and the Arts, 1987); Jill Widner, "Kindy Sproat: Backporch Purist," *Honolulu: The Paradise of the Pacific* (Dec. 1988), pp. 76–77, 98–107; and materials in the NHF files.

82. NHF files.

83. Ibid.

84. Ricardo D. Trimillos, "Having Fun: The *Paniolo* Heritage in Hawaiian Music," in Lynn J. Martin, ed., *Na Paniolo o Hawai'i*, p. 95.

85. As quoted in Widner, p. 99.

86. NHF files.

87. Ibid.

88. The discussion of Raymond Kane is

based mainly on materials in the NHF files.

89. As quoted in Mike Gordon, "The Guitar Man," *Honolulu Star-Bulletin*, Aug. 17, 1987, pp. B1, B3.

90. As quoted in Gordon, p. B1.

91. Gordon, p. B3.

92. Ricardo D. Trimillos, letter of nomination, NHF files.

93. Bess Lomax Hawes, "The National Heritage Fellowships Program," in *1982 Festival of American Folklife Book* (Washington, D.C.: Smithsonian Institution), p. 8.

94. The discussion of Bessie Jones is based mainly upon Bessie Jones and Bess Lomax Hawes, *Step It Down: Games, Plays, Songs, and Stories from the Afro-American Heritage* (New York: Harper and Row, 1972).

95. Bessie Jones, comments, NHF concert, Washington, D.C., 1982, NHF files.

96. Jones and Hawes, p. 7.

97. For a summary of this rich scholarship, see Charles Joyner, "Afro-American Folklife Scholarship: A Case Study of the Sea Islands," in *1988 Festival of American Folklife Book* (Washington, D.C.: Smithsonian Institution), pp. 53–56. For a masterful interpretation of African-American culture that draws upon the Sea Island materials, see Lawrence Levine, *Black Culture and Black Consciousness: Afro-American Folk Thought from Slavery to Freedom* (Oxford: Oxford University Press, 1977). For some of the best of recent scholarship, including reprints of still significant earlier work, see (in chronological order) *Slave Songs of the United States* (1867); Mary Granger, ed., *Drums and Shadows: Survival Studies among the Georgia Coastal Negroes* (Athens: University of Georgia Press, 1986 [1940]); Guy and Candy Carawan, *Ain't You Got a Right to the Tree of Life? The People of Johns Island, South Carolina* (Athens: University of Georgia Press, 1988 [1966]); Charles Joyner, *Down by the Riverside: A South Carolina Slave Community* (Urbana: University of Illinois Press, 1984); Patricia Jones-Jackson, *When Roots Die: Endangered Traditions on the Sea Islands* (Athens: University of

Georgia Press, 1987).

98. For background on the Georgia Sea Island Singers, see Lydia Parrish, *Slave Songs of the Georgia Sea Islands* (Hatboro, Pa.: Folklore Associates, 1965 [1942]).

99. Jones and Hawes, p. xvi.

100. Ibid., pp. 4–6.

101. The discussion of Janie Hunter is based mainly on *The National Heritage Fellowships 1984*.

102. Ibid.

103. Levine, pp. 81–135.

104. The discussion of Cleofes Vigil is based mainly on *The National Heritage Fellowships 1984* and *Cleofes Vigil, Storyteller* (Elizabeth Dear, Director), videotape (Santa Fe: Museum of New Mexico), work in progress.

105. As recounted in *Cleofes Vigil, Storyteller*.

106. *The National Heritage Fellowships 1984*.

107. Tale Type 1626 in Antti Aarne and Stith Thompson, *The Types of the Folktale: A Classification and Bibliography* (Helsinki: Folklore Fellows Communications, 1961).

108. Dov Noy, ed., *Folktales of Israel* (Chicago: University of Chicago Press, 1963), pp. 108–9.

109. Marta Weigle and Thomas R. Lyons, "Brothers and Neighbors: The Celebration of Community in Penitente Villages," in Victor Turner, ed., *Celebration: Studies in Festivity and Ritual* (Washington, D.C.: Smithsonian Institution, 1982), p. 231.

110. Ibid., p. 232.

111. *The National Heritage Fellowships 1984*.

112. Ducks are generally shot in the air, not in the water; but if a hunter thinks he has only wounded a duck and it has landed in the water, he will shoot it quickly to end its misery.

113. Quoted in David S. Cohen, letter of nomination, Sept. 21, 1983, NHF files. The discussion of Harry Shourds is based mainly on materials in the same files.

114. John Michael Vlach, "American Folk Art: Questions and Quandaries," *Winterthur Portfolio* 15 (1980), p. 351. Decoy carver Frank Werner, of Moscow, Idaho, explains that Styrofoam may work earlier in the

season but not after several weeks, when there are fewer—and smarter—ducks remaining.

115. Frank Werner, personal communication, Feb. 12, 1991.

116. The title of a pathbreaking work on folk art. See Kenneth L. Ames, *Beyond Necessity: Art in the Folk Tradition* (Winterthur, Del.: Winterthur Museum, 1977).

117. As quoted in David S. Cohen, letter of nomination.

118. Comments, NHF concert, Washington, D.C., 1989.

119. Rick Dillingham, Richard W. Lang, and Rain Parrish, *The Red and the Black: Santa Clara Pottery by Margaret Tafoya: A Retrospective Exhibition at the Wheelwright Museum of the American Indian* (Santa Fe: Wheelwright Museum of the American Indian, 1983), p. 2. The discussion of Margaret Tafoya is based mainly on this exhibition catalogue and other materials in the NHF files.

120. Dillingham, Lang, and Parrish, p. 4.

121. As quoted in Dillingham, Lang, and Parrish, p. 2.

122. Ibid., p. 10.

123. Dillingham, Lang, and Parrish, p. 6.

124. Ibid., pp. 7–8.

125. James Deetz, *In Small Things Forgotten: The Archeology of Early American Life* (Garden City, N.Y.: Doubleday, 1977), p. 47.

126. Ibid., pp. 48–49.

127. See Charles G. Zug, III, *Turners and Burners: The Folk Potters of North Carolina* (Chapel Hill and London: University of North Carolina Press, 1986), pp. 435–46.

128. Ibid., pp. 446–47.

129. John A. Burrison, *Brothers in Clay: The Story of Georgia Folk Pottery* (Athens: University of Georgia Press, 1983), pp. 309–21.

130. Ibid., pp. 120–21.

131. *The National Heritage Fellowships 1983*.

132. As quoted in *The National Heritage Fellowships 1983*.

133. John A. Burrison, letter of nomination, Sept. 18, 1982, NHF files. Also see Ralph Rinzler and Robert Sayers, *The Meaders Family: North Georgia Potters* (Washington, D.C.: Smithsonian Institution, 1980).

134. Vlach, *Afro-American Tradition*, pp.

76–96. There is some controversy about the Anglo contribution since antecedents seem to exist in both Africa and Europe. See Glassie, p. 45; John A. Burrison, "Afro-American Folk Pottery," *Southern Folklore Quarterly* 42 (1978): 186–87; and Zug, *Turners and Burners*, pp. 381–82.

135. Glassie, p. 45.

136. Charles G. Zug, III, "Southern Pottery Tradition in a Changing Economic Environment," p. 74. In Thomas Vennum, Jr., ed., *1986 Festival of American Folklife Program Book* (Washington, D.C.: Smithsonian Institution).

137. Glassie, p. 45.

138. Roger D. Abrahams, Foreword to Elizabeth Mathias and Richard Raspa, eds., *Italian Folktales in America: The Verbal Art of an Immigrant Woman* (Detroit: Wayne State University Press, 1985), p. xi.

139. Chilkat refers to a territorial subgroup of the larger Tlingit people.

140. Folklorist Suzi Jones cites Austin Hammond as saying this in the film *Haa Shagoon*, in her letter of nomination, Oct. 1, 1984, NHF files.

141. The discussion of Jennie Thlunaut is based on Rosita Worl and Charles Smythe, "Jennie Thlunaut: Master Chilkat Blanket Artist," in Suzi Jones, ed., *The Artists behind the Work: Life Histories of Nick Charles, Sr., Frances Demientieff, Lena Sours, and Jennie Thlunaut* (Fairbanks: University of Alaska Museum, 1986), and other materials available in the NHF files.

142. Worl and Smythe, p. 127.

143. Ibid., p. 135.

144. As quoted in *The National Heritage Fellowships 1986* (Washington, D.C.: NEA Folk Arts Program), p. 14.

145. The discussion of Genevieve Nahra Mougin is based mainly on Steven Ohrn, ed., *Passing Time and Traditions: Contemporary Iowa Folk Artists* (Ames: Iowa State University Press, 1984), and Ohrn's letter of nomination in the NHF files.

146. Winnie Lambrecht and Carolyn Shapiro, *Blue Hmong Loom and Weaving: Yang Fang Nhu*, pamphlet, NHF files.

147. As quoted in Hufford, Hunt, and Zeitlin, p. 14.

148. As quoted in materials in the NHF files.

149. Bill Henry, "Alex Stewart: A Personal Reminiscence," typescript, NHF files.

150. As quoted in *The National Heritage Fellowships 1983*.

151. See, for instance, "Alex Stewart: Cooper and Churnmaker," in *Foxfire Magazine*; the film *Alex Stewart: Cooper*, distributed by Instructional Media Center, East Tennessee State University, Johnson City, Tenn.; and the cover of the book *The Craftsman in America* (Washington, D.C.: National Geographic Society, 1975).

152. As quoted in *The National Heritage Fellowships 1983*.

Chapter Three

The opening quotation is from Philip Simmons, African-American blacksmith and National Heritage Fellow, cited in John Vlach, *The Afro-American Tradition in Decorative Arts* (Cleveland: Cleveland Museum of Art, 1978), p. 4.

1. John Vlach, *Charleston Blacksmith, The Work of Philip Simmons* (Athens: University of Georgia Press, 1981), p. 131.

2. As quoted in Vlach, *Charleston Blacksmith*, p. 131.

3. The discussion of Philip Simmons is based mainly on Vlach, *Charleston Blacksmith* and *Afro-American Tradition*.

4. Vlach, *Charleston Blacksmith*, p. 14.

5. As quoted in Vlach, *Charleston Blacksmith*, p. 31.

6. Vlach, *Charleston Blacksmith*, p. 31.

7. Vlach, *Afro-American Tradition*, p. 81.

8. As quoted in Vlach, *Charleston Blacksmith,* p. 131.

9. Harry Gammerdinger, Gary Stanton, and Steve Siporin, "Working the Land," in Steve Siporin, ed., *"We Came to Where We Were Supposed to Be": Folk Art of Idaho* (Boise: Idaho Commission on the Arts, 1984), p. 36.

10. The discussion of Luis Ortega is based on Luis Ortega, "El Mecate: The Hair Rope," *Western Horseman* (Apr. 1955), pp. 24, 55–56; Jill Scopinich, "Luis Ortega: The Artist, the Vaquero, and the Man," *Pacific Coast Journal* (May 1985),

pp. 44–46; and my own interview with him in Paradise, Cal., on Nov. 14, 1985.

11. As quoted by Scopinich, p. 45.

12. Personal interview, Paradise, Cal., Nov. 14, 1985.

13. Ibid.

14. Siporin, ed., *"We Came to Where We Were Supposed to Be,"* p. 45.

15. Personal interview with Duff Severe, Pendleton, Oreg., Sept. 26, 1985.

16. "Claude Joseph Johnson," p. 1. This typescript and other materials used in the discussion of Dr. Johnson can be found in the NHF files.

17. Brett Sutton, letter of nomination, Sept. 24, 1985, NHF files.

18. The discussion of Dr. C. J. Johnson depends mainly on these documents in the NHF files: William and Janice Dargan, "Toward a Critical Biography of the Life and Ministry of C. J. Johnson (1913–): Preliminary Considerations," typescript, and letter of nomination, Sept. 30, 1985; "Claude Joseph Johnson," typescript; and Brett Sutton, letter of nomination. Also utilized was *The National Heritage Fellowships 1987* (Washington, D.C.: NEA Folk Arts Program), pp. 8–9.

19. As quoted in Dargan, p. 12.

20. Dargan, p. 10.

21. "Claude Joseph Johnson," p. 1.

22. *The National Heritage Fellowships 1987*, pp. 8–9.

23. Dargan, p. 23.

24. Ibid.

25. As quoted in Dargan, p. 23.

26. Sutton, letter of nomination.

27. As quoted in *Georgia Folklife: Program Update* 1:2 (1990):1.

28. *Geometry in Motion: Afro-American Quiltmakers* was an exhibition of African-American quilts from Pinal County, Arizona, curated by Jim Griffith and sponsored by the Southwest Folklore Center, University of Arizona, Tucson. It toured the Western states from 1981 to 1986.

29. John Michael Vlach, *Afro-American Tradition*, p. 67.

30. Sanders "Sonny Terry" Terrill, comments, NHF concert, Washington, D.C., 1982, NHF files.

31. Ibid.

32. Lyrics sung by Brownie McGhee, NHF concert, Washington, D.C.,

1982, NHF files.

33. As quoted in *The National Heritage Fellowships 1985* (Washington, D.C.: NEA Folk Arts Program).

34. As quoted in *The National Heritage Fellowships 1985*.

35. The discussion of Horace "Spoons" Williams is based on the work of Glenn Hinson, who was Williams's advocate and friend over the last years of his life. Hinson nominated Spoons for the National Heritage Fellowship and accompanied him to the ceremony. Spoons died shortly afterward, in the glow of recognition and achievement.

36. Glenn Hinson, letter of nomination, Oct. 17, 1984, NHF files.

37. Horace "Spoons" Williams, as quoted in "Spoon Tunes," *The Philadelphia Inquirer*, Jan. 28, 1983, p. C-1. Folklorist Glenn Hinson, in personal correspondence, notes that "the fact that hooded whites were hanging not only blacks, but also their own . . . for fraternizing (and, presumably, cooperating) with African Americans . . . left Spoons with a deep sense of racism's mindlessness and absurdity."

38. Glenn Hinson, letter of nomination, Nov. 13, 1984, NHF files.

39. William Cran, letter of support, Feb. 27, 1985, NHF files.

40. The discussion of Clifton Chenier is based on Les Blank's film *Hot Pepper: The Life and Music of Clifton Chenier* (El Cerrito, Calif.: Flower Films, 1973) and *The National Heritage Fellowships 1984* (Washington, D.C.: NEA Folk Arts Program).

41. Margot Albert, comments, National Heritage Fellowship concert, Washington, D.C., 1984, NHF files.

42. As quoted in Barry Jean Ancelet and Elemore Morgan, Jr., *The Makers of Cajun Music: Musiciens Cadiens et Créoles* (Austin: University of Texas Press, 1984), p. 81.

43. The discussion of Ardoin and Fontenot is based on Les Blank's film *Dry Wood* (El Cerrito, Calif.: Flower Films, 1973); Ancelet and Morgan; and materials in the NHF files. Ardoin is also documented in Nick Spitzer's film *Zydeco: Creole Music and Culture in Rural Louisiana* (New Orleans: Center for Gulf South History and Culture, 1984).

44. Speaking in *Dry Wood*.

45. Ardoin got his nickname, "Bois Sec," because, when he was a child, he was supposedly the first to leave work in the fields and make it to the shelter of the barn when a rainstorm hit. *The National Heritage Fellowships 1986* (Washington, D.C.: NEA Folk Arts Program).

46. As quoted in Ancelet and Morgan, p. 79.

47. Ardoin, as quoted in Ancelet and Morgan, p. 82.

48. Ancelet and Morgan, p. 77.

49. Alan Lomax, letter of nomination, Oct. 11, 1983, NHF files.

50. Over the years, the two have appeared at the Newport Folk Festival, the National Folk Festival, the Mariposa Folk Festival, the Smithsonian Festival of American Folklife, the Frontier Folklife Festival in Saint Louis, the New Orleans Jazz and Heritage Festival, and the Tribute to Cajun Music Festival. Barry Jean Ancelet, letter of nomination, Oct. 10, 1983, NHF files.

51. See the film on Elijah Pierce and his work, *Sermons in Wood*, produced by Carolyn Jones Allport and Raymond Kook (Memphis, Tenn.: Center for Southern Folklore, 1976).

52. Speaking in *Sermons in Wood*.

53. Ibid.

54. Ibid.

55. Mary Hufford, Marjorie Hunt, and Steven Zeitlin, *The Grand Generation: Memory, Mastery, Legacy* (Seattle: University of Washington Press, 1987), p. 42. In an endnote, the authors acknowledge John Moe's research on Elijah Pierce. See John Moe, *Elijah Pierce: The Life of an Afro-American Woodcarver* (Athens: University of Georgia Press, forthcoming).

56. Hufford, Hunt, and Zeitlin, p. 42.

57. Vlach, *Afro-American Tradition*, pp. 27–43.

58. Hufford, Hunt, and Zeitlin, p. 41.

59. The section on Helen Cordero is based, directly and indirectly, on the work of Barbara A. Babcock. See, for instance, *The Pueblo Storyteller: Development of a Figurative Ceramic Tradition* (Tucson: University of Arizona Press, 1986), with Guy and Doris Monthan; and "Clay Voices: Invoking, Mocking, Celebrating," in Victor Turner, ed., *Celebration: Studies in Festivity and Ritual* (Washington, D.C.: Smithsonian Institution, 1982), pp. 58–76.

60. Babcock, "Clay Voices," p. 58.

61. As quoted in Barbara A. Babcock, letter of nomination, Oct. 2, 1984, NHF files.

62. Helen Cordero, as quoted in Babcock, "Clay Voices," p. 63.

63. Babcock, "Clay Voices," p. 63.

64. Ibid.

65. Babcock, letter of nomination.

66. The Girard Collection is the world's largest cross-cultural collection of folk art, consisting of more than one hundred thousand objects collected from over one hundred countries. See Henry Glassie, *The Spirit of Folk Art: The Girard Collection at the International Museum of Folk Art* (New York: Abrams, 1989).

67. Babcock, "Clay Voices," p. 64.

68. Ibid. Babcock also notes the significance of the change in gender from female singer to male storyteller. The storyteller *is* Cordero's grandfather. Only men are storytellers in the Cochiti Pueblo tradition.

69. Comments, NHF ceremony, Washington, D.C., 1982, NHF files.

70. Marsha Bol, letter of nomination, Sept. 25, 1984, NHF files.

71. *National Geographic* 162 (1982), illustrating article by David Arnold, "Pueblo Pottery," pp. 593–606.

72. Sally R. Sommer, letter of nomination, Nov. 3, 1988, NHF files. The discussion of LaVaughn Robinson is based on materials found in the same file.

73. Publicity sheet entitled "Apprenticeship in Afro-American Tap Dance," NHF files.

74. Sommer, letter of nomination.

75. LaVaughn Robinson, as quoted in *Works-in-Progress: Newsletter of the Philadelphia Folklore Project* 2:3 (1989): 7.

76. Ibid.

77. Sommer, letter of nomination.

78. Carole Boughter, letter of nomination, Oct. 25, 1988, NHF files.

79. As quoted in Mike Beno, "A Poet,

A Painter, A Whittler of Wood," p. 31, article in the NHF files. The discussion of Lem Ward is based on materials in this file.

80. Glenn D. Hinson, letter of nomination, Feb. 18, 1989, NHF files.

81. Beno, p. 31.

82. Beno, p. 29. I have left Lem Ward's nonstandard spellings intact.

83. The idea comes from William A. Wilson's article, "The Deeper Necessity: Folklore and the Humanities," *Journal of American Folklore* 101 (1988), pp. 156–67.

84. Typescript, NHF files.

85. Beno, p. 30.

86. Barry Robert Berkey, Velma Berkey, and Richard Eric Berkey, *Pioneer Decoy Carvers: A Biography of Lemuel and Stephen Ward* (Cambridge, Md.: Tidewater Publishers, 1977), p. 121.

87. Typescript, NHF files.

88. Lem Ward, as quoted in Beno, p. 32.

89. The discussion of Emilio and Senaida Romero is based on materials in the NHF files, including an unpublished report by Teresa Sanchez entitled "The Romero Family," dated 1985; newspaper and magazine articles, among them Susan Hazen-Hammond, "Art from Poor Man's Silver," *New Mexico Magazine*, Dec. 1984, pp. 56–61, and Laura Hinton Lyon, "The Tinsmiths," *SFR Voices* (Summer 1979); and letters of nomination.

90. Hazen-Hammond, p. 57.

91. Senaida Romero, as quoted in Lyon, p. 3B.

92. Emilio Romero, as quoted in Lyon, p. 3B.

93. As cited in Vlach, *Afro-American Tradition*, p. 4.

94. Comments, meeting of the NHF Advisory Panel, NEA Folk Arts Program, Washington, D.C., Mar. 15, 1990.

95. Ibid.

96. As quoted in James Megar, "Alex Moore—Blues Piano." Program notes, Traditional Texas Music series, Amon Carter Museum Theater, Oct. 29, 1978, NHF files.

97. *The National Heritage Fellowships 1987*, p. 13.

98. Megar.

99. Paul Oliver, liner notes to *Alex Moore*, LP album, Arhoolie 1008.

Chapter Four

The opening quotation is from remarks made by Dewey Balfa at the NHF concert, Washington, D.C., 1982, NHF files.

1. Such attitudes are not limited to Native Americans. Some traditional New Englanders say that porcupines must not be needlessly taken because they are so slow and awkward that they are one of the few animals that can be killed for food by a person lost in the woods. (Bess Lomax Hawes, personal communication, 1990)

2. Vanessa Paukeigope Morgan, "Biographical Information," p. 4, NHF files.

3. Ibid.

4. Nicholas R. Spitzer, "South Louisiana: Unity and Diversity in a Folk Region," in *Louisiana Folklore: A Guide to the State* (Baton Rouge: Louisiana Folklife Program, 1985), p. 82.

5. Barry Jean Ancelet, "Cajun Music: A Louisiana French Tradition," in *1983 Festival of American Folklife Book* (Washington, D.C.: Smithsonian Institution), p. 40. The discussion of Dewey Balfa and Cajun music is based largely on this article and on Spitzer, "South Louisiana."

6. As quoted in Ancelet, "Cajun Music," p. 42.

7. Ancelet, "Cajun Music," p. 41.

8. Comments, NHF concert, Washington, D.C., 1982, NHF files.

9. John Michael Vlach, "The Concept of Community and Folklife Study," in Simon J. Bronner, ed., *American Material Culture and Folklife: A Prologue and Dialogue* (Ann Arbor, Mich.: UMI Research Press, 1985), p. 70.

10. The discussion of Jimmy Jausoro is based on my fieldwork with him and Domingo Ansotegui and a number of newspaper articles from *The* (Boise) *Idaho Statesman* in 1985.

11. Tape-recorded interview with Jimmy and Isabel Jausoro by Steve Siporin, Boise, Idaho, Aug. 12, 1982.

12. As quoted in *The* (Boise) *Idaho Statesman*, May 5, 1985, p. 1D.

13. Tape-recorded interview, Boise, Idaho, Aug. 12, 1982.

14. For the ballad, "Nampa, Idaho," and other examples of Mexican-American music from this region, see *Soy Mexicano: Mexican-American Music from Southern Idaho*, LP album (Boise: Idaho Commission on the Arts, 1982).

15. In writing about Genoveva Castellanoz, I have relied upon my own fieldwork and that of Alicia Gonzalez and Robert S. McCarl.

16. As quoted in Alicia Gonzalez, *Eva Castellanoz: Corona Maker: Mexican-American Ceremonial Traditions*, slide-tape program and videotape (Boise: Idaho Commission on the Arts, 1987).

17. Though these words describe the Torah binder, the token of an infant Jewish male ceremony, they apply equally well to the *corona*, the token of an adolescent Hispanic/Catholic female ceremony. See Barbara Kirshenblatt-Gimblett, "The Cut That Binds: The Western Ashkenazic Torah Binder as Nexus between Circumcision and Torah," in Victor Turner, ed., *Celebration: Studies in Festivity and Ritual* (Washington, D.C.: Smithsonian Institution Press, 1982), p. 145.

18. The exhibition *"We Came to Where We Were Supposed to Be": Folk Art of Idaho* toured Idaho from 1984 to 1986 and was circulated overseas in Pakistan and several North African countries by the United States Information Agency from 1987 to 1988. Eva's work appears in the accompanying catalogue of the same name (Boise: Idaho Commission on the Arts, 1984), Steve Siporin, ed. A description and illustrations of her work may be found in the essay "Chicano Culture: Everyday Life in the Pacific Northwest," by Tomás Ybarra-Frausto, in the exhibition catalogue *Chicano and Latino Artists in the Pacific Northwest*, edited by Lauro Flores and Cecilia Alvarez, pp. 12–17.

19. See, for instance, Donald Worster, "New West, True West: Interpreting the Region's History," *The Western Historical Quarterly* (1987): 141–56. See also Barre Toelken, "The Folklore of Water in the Mormon

West," *Northwest Folklore* 7 (1989): 3–26.

20. First stanza of "The High-Toned Dance," composed by James Burton Adams and sung by Glenn Ohrlin on *The Wild Buckaroo*.

21. Liner notes, *The Wild Buckaroo*, LP album (Somerville, Mass.: Rounder Records, 1983).

22. Glenn Ohrlin, liner notes, *The Wild Buckaroo*.

23. Ibid.

24. Archie Green, Foreword to Glenn Ohrlin, *The Hell-Bound Train: A Cowboy Songbook* (Urbana: The University of Illinois Press, 1973), p. xv. Green was the first to bring Ohrlin to the public's attention, through a concert at the University of Illinois in 1963 and the release of his first LP album, *The Hell-Bound Train*, in 1964.

25. Ibid., pp. xv–xvi.

26. Liner notes, *The Wild Buckaroo*.

27. Comments, NHF ceremony, Washington, D.C., 1982, NHF files.

28. Ibid.

29. The discussion of Hugh McGraw and Sacred Harp singing is based on Daniel W. Patterson's letter of nomination, Apr. 2, 1981, NHF files.

30. Doris Dyen, "Song Notes," in *Wiregrass Notes: Black Sacred Harp Singing from Southeast Alabama*, booklet accompanying LP record album (Montgomery: Alabama Traditions, 1982), p. 12.

31. Henry Willett, in *Wiregrass Notes*, p. 3.

32. The discussion of Dewey P. Williams is based mainly on materials in the NHF files.

33. Typescript, NHF files.

34. Ibid.

35. The discussion of Paul Tiulana is based mainly on *The National Heritage Fellowships 1984* (Washington, D.C.: NEA Folk Arts Program).

36. Martin Heidegger, "An Ontological Consideration of Place," in *The Question of Being* (New York: Twayne Publishers, 1958), p. 24, as quoted in Mary Hufford, Marjorie Hunt, and Steven Zeitlin, eds., *The Grand Generation: Memory, Mastery, Legacy* (Seattle: University of Washington Press, 1987).

37. William W. Fitzhugh and Susan A. Kaplan, eds. *Inua: Spirit World of the Bering Sea Eskimos* (Washington, D.C.: Smithsonian Institution Press, 1982).

38. As quoted in *The National Heritage Fellowships 1984*.

39. The discussion of Eppie Archuleta is based mainly on *The National Heritage Fellowships 1985* (Washington D.C.: NEA Folk Arts Program).

40. Studs Terkel, comments, NHF concert, Washington, D.C., 1985, NHF files.

41. *The National Heritage Fellowships 1985*.

42. Charlene Cerny and Christine Mather, "Textile Production in Twentieth Century New Mexico," pp. 272–73. In Sarah Nestor, ed., *Spanish Textile Traditions of New Mexico and Colorado* (Santa Fe: Museum of New Mexico Press, 1979).

43. The discussion of Peou Khatna is based on *The National Heritage Fellowships 1986* (Washington, D.C.: NEA Folk Arts Program) and materials in the NHF files.

44. As quoted in Richard Kennedy, letter of nomination, Oct. 31, 1983, NHF files.

45. Vanessa Brown and Barre Toelken, "American Indian Powwow," in Alan Jabbour and James Hardin, eds., *Folklife Annual 1987* (Washington, D.C.: Library of Congress, 1988), p. 68.

46. The discussion of Kau'i Zuttermeister is based on *The National Heritage Fellowships 1984* and materials in the NHF files.

47. Edith McKinzie, "Hawaiian Performing Arts Traditions," in Lynn J. Martin, ed., *Folklife Hawai'i* (Honolulu: State Foundations on the Culture and the Arts, 1990), p. 13.

48. Ibid., p. 14.

49. The discussion of Mealii Kalama is based on *The National Heritage Fellowships 1985* and materials in the NHF files. For more on Polynesian quilting traditions, see Joyce D. Hammond, *Tifaifai and Quilts of Polynesia* (Honolulu: University of Hawaii Press, 1986).

50. As quoted in materials in the NHF files.

51. As quoted in Gonzalez.

52. As quoted in materials in the NHF files. The idea is widespread. Teola Hall, a young Shoshone-Paiute woman from the Duck Valley Reservation on the Idaho-Nevada border, once told me that you should not do beadwork when you are angry. She says that the anger will remain in the work and bring the wearer misfortune. See Siporin, *"We Came to Where We Were Supposed to Be,"* p. 101.

53. Edward Wapp, Jr., as cited by Studs Terkel, comments, NHF concert, Washington, D.C., 1986, NHF files.

54. Edward Wapp, Jr., "The American Indian Courting Flute: Revitalization and Change," article in the NHF files, p. 49. The discussion of Doc Tate Nevaquaya is based mainly on this article and other materials also available in the same file.

55. Barre Toelken, personal communication, 1990.

56. Comments, NHF dinner, National Press Club, Washington, D.C., 1986, NHF files.

57. Wapp, "The American Indian Courting Flute," pp. 49–58.

58. Edward Wapp, Jr., letter of nomination, Feb. 14, 1984, NHF files.

59. The discussion of Albert Fahlbusch is based mainly on materials from the NHF files.

60. Albert Fahlbusch, as quoted by Geoff Gephart, interview, Jan. 31, 1979, NHF files.

61. "Hammered Dulcimer Making: Albert Fahlbusch," typescript, NHF files.

62. Gephart, interview.

63. Letter of nomination, Aug. 12, 1980, NHF files.

Chapter Five
The opening quotation is a Shaker saying, as spoken in *The Shakers* (Ken Burns, Director), 16mm film and videotape (Northampton, Mass.: Florentine Films, 1983).

1. A traditional tale which I have retold by combining two sources: Elie Wiesel, *Souls on Fire: Portraits and Legends of Hasidic Masters* (New York: Random House, 1973), pp. 167–68, and Barbara Myerhoff, *Number Our Days* (New York: Simon and Schuster, 1980 [1978]), p. 112.

2. As quoted in Jill Widner, "Kindy Sproat: Backporch Purist," *Honolulu: The Paradise of the*

Pacific (Dec. 1988), p. 104.

3. Alan Lomax, "Appeal for Cultural Equity," *Journal of Communication* 27 (1977), pp. 125–26.

4. Andrei Codrescu, *A Craving for Swan* (Columbus: Ohio State University Press, 1986), p. 281.

5. J. V. Koschmann, Oiwa Keibo, and Yamashita Shinji, eds., *International Perspectives on Yanagita Kunio and Japanese Folklore Studies*, Cornell University East Asia Papers, no. 37 (Ithaca, N.Y.: Cornell University Press, 1985).

6. Barre Toelken, personal communication, Dec. 1990.

7. Henry Glassie, *Passing the Time in Ballymenone: Culture and History of an Ulster Community* (Philadelphia: University of Pennsylvania Press, 1982), p. 63.

8. Ibid., pp. 742–43, n. 18.

9. Simon Bronner, *Chain Carvers: Old Men Crafting Meaning* (Lexington: University Press of Kentucky, 1985). The discussion of Earnest Bennett is based mainly on this source.

10. Bronner, pp. 61–62.

11. As quoted in Bronner, p. 65.

12. Bronner, p. 65.

13. Ibid., p. 66.

14. Mary Hufford, Marjorie Hunt, and Steven Zeitlin, eds., *The Grand Generation: Memory, Mastery, Legacy* (Seattle: University of Washington Press, 1987), pp. 26, 51, 111, 121.

15. As quoted in Bronner, p. 59.

16. As quoted by Jane Beck, "Newton Washburn: Traditional Basket Maker," in Charles Camp, ed., *Traditional Craftsmanship in America* (Washington, D.C.: National Council on the Traditional Arts, 1983), p. 72.

17. As quoted in materials in NHF files.

18. *The National Heritage Fellowships 1984* (Washington, D.C.: NEA Folk Arts Program).

19. As quoted in *The National Heritage Fellowships 1983* (Washington, D.C.: NEA, Smithsonian Institution, and Continental Telecom Inc.).

20. NHF files.

21. As quoted in Hufford, Hunt, and Zeitlin, p. 82.

22. Michael P. Smith, letter of nomination, Nov. 1, 1983, NHF files.

23. Maurice M. Martínez, Jr., "Two Islands: The Black Indians of Haiti and New Orleans," in Michael P. Smith, ed., *Spirit World: Pattern in the Expressive Folk Culture of Afro-American New Orleans* (New Orleans: New Orleans Museum of Art, 1984), p. 5.

24. Martínez, "Two Islands," pp. 5–18.

25. Smith, letter of nomination.

26. Maurice M. Martínez, Jr., "Delight in Repetition: The Black Indians," *Wavelength* (Feb. 1982).

27. Ibid.

28. Martínez, "Two Islands," p. 18.

29. Chinua Achebe, Foreword to Herbert M. Cole and Chike C. Aniakor, *Igbo Arts: Community and Cosmos* (Los Angeles: UCLA Museum of Cultural History, 1984), p. ix, as quoted in Suzi Jones, "Art by Fiat, and Other Dilemmas of Cross-Cultural Collecting," in John Michael Vlach and Simon J. Bronner, eds., *Folk Art and Art Worlds* (Ann Arbor, Mich.: UMI Research Press, 1986), pp. 246–47.

30. See, for example, Theodor H. Gaster, *Thespis: Ritual, Myth, and Drama in the Ancient Near East* (New York: Norton, 1961).

31. Maurice M. Martínez, Jr., letter of nomination, Mar. 29, 1983, NHF files.

32. Comments, NHF concert, Washington, D.C., 1989.

33. The discussion of Bertha Cook is based mainly on Thomas McGowan, "Bertha Cook, Blue Ridge National Heritage Fellow," pp. 153–60, and other materials in the NHF files.

34. McGowan, "Bertha Cook," p. 153.

35. Thomas McGowan, typescript, NHF files.

36. Clay Anderson, Andy Leon Harney, et al., *The Craftsman in America* (Washington, D.C.: National Geographic Society, 1975), p. 99.

37. McGowan, Thomas A., "Bertha Cook, Maker of Knotted Bedspreads," videotape (Boone, N.C.: Appalachian State University, 1979).

38. As quoted by McGowan, "Bertha Cook," p. 159.

39. McGowan, typescript.

40. "Kenny Sidle," *The National Heritage Fellowships 1988* (Washington, D.C.: NEA Folk Arts Program).

41. Comments, NHF concert, Washington, D.C., 1982, NHF files.

42. Wallace Stegner, *Mormon Country* (Lincoln: University of Nebraska Press, 1981 [1942]), p. 64.

43. Personal communication, Dec. 1990.

44. The single-string Apache fiddle is indigenous and has no direct relationship to European fiddles.

45. For samples of folklorists' thoughts on this subject, see *Marketing Folk Art*, a special issue of *New York Folklore* (1986 [12]).

46. NEA Grant Application from the South Carolina Sea Grant Consortium, Charleston, S.C., submitted Mar. 8, 1990, p. 1.

47. NEA Grant Application, South Carolina Sea Grant Consortium, pp. 1–2.

48. *The National Heritage Fellowships 1983.*

49. NEA Grant Application, South Carolina Sea Grant Consortium, p. 1.

50. These parties include the USDA Soil Conservation Service, the Mount Pleasant Sweetgrass Basketmakers' Association, the South Carolina Sea Grant Consortium, the Coastal Research and Education Center, Clemson University Cooperative Extension Service, the 1890 Extension Program, South Carolina Coastal Council, the Citadel, South Carolina Wildlife and Marine Resources Department, U.S. Fish and Wildlife Service, the Charleston Soil and Water Conservation District, Tom Yawkey Wildlife Refuge, the U.S. Forest Service, Belle W. Baruch Institute, the McKissick Museum of the University of South Carolina, and the National Endowment for the Arts Folk Arts Program.

51. NEA Grant Application, South Carolina Sea Grant Consortium, p. 5.

52. Ibid., pp. 5–6.

53. "Things of Intrinsic Worth" is the title of a poem by Wallace McRae, a rancher and cowboy poet from Forsyth, Mont., who received a National Heritage Fellowship in 1990. For this and other poems by McRae, see Hal Cannon, ed., *New Cowboy Poetry: A Contemporary Gathering* (Layton, Utah: Gibbs Smith, 1990), pp. 46–54.

DIRECTORY

National Heritage Fellows—1982–1991
Compiled by Judith Chiba Smith

Included in this Directory are selected bibliographic, discographic, and/or filmographic references for each of the National Heritage Fellows through 1990, as well as biographical summaries for those Fellows not fully discussed in the text. A listing of 1991 Fellows is also provided. Unless otherwise noted, the information on the Fellows was obtained from National Heritage Awards Ceremonies programs published by the National Council for the Traditional Arts on behalf of the National Endowment for the Arts, Folk Arts Program. The discographic information is the result of research by Craig Miller and Kip Lornell.

Juan Alindato
Puerto Rican carnival-mask maker
Ponce, Puerto Rico
1987 Fellow

BIBLIOGRAPHY: Hunt, Marjorie, and Boris Weintraub. "Masters of Traditional Arts." *National Geographic* 179:1 (Jan. 1991). Vidal, Teodoro. *Las Caretas de Cartón del Carnaval de Ponce.* San Juan, P.R.: Ediciones Alba, 1983.

Eppie Archuleta
Hispanic weaver
Alamosa, Colorado
1985 Fellow

BIBLIOGRAPHY: Everts, Dana. "Folklife Festival to Showcase the Authentic Folklore of the San Luis Valley." *State of the Arts* 2:4 (Apr. 1984).
————. *Tradiciones del Valle: Folklore Collected in the San Luis Valley.* Alamosa, Colo.: Rio Grande Arts Center, 1986.
Hunt, Marjorie, and Boris Weintraub. "Masters of Traditional Arts." *National Geographic* 179:1 (Jan. 1991).

Alphonse "Bois Sec" Ardoin
Black Creole accordionist
Eunice, Louisiana
1986 Fellow

BIBLIOGRAPHY: Ancelet, Barry Jean, and Elemore Morgan, Jr. *The Makers of Cajun Music: Musiciens Cadiens et Créoles.* Austin: University of Texas Press, 1984.

DISCOGRAPHY: Ardoin, Alphonse, Adam and Cyprien Landreneau, et al. *Louisiana Cajun French Music from the Southwest Prairies, Vol. 2* (c. 1966). Rounder 6002 (LP/C/CD)
Ardoin, Alphonse, Canray Fontenot, et al. *"Boisec" Ardoin: La Musique Créole* (c. 1973). Arhoolie 1070 (LP/C)
Ardoin, Alphonse, et al. *Voices of the Americas Series: Cajun and Creole Music* (1987). World Music Institute T110 (C)

FILMOGRAPHY: *Dry Wood.* 16mm, videotape; color, 37 mins. By Les Blank, with Maureen Gosling. Distributor: Flower Films, El Cerrito, Calif.
Hot Pepper. 16mm, videotape; color, 54 mins. By Les Blank, with Maureen Gosling. Distributor: Flower Films, El Cerrito, Calif.
J'ai Eté au Bal. 16mm, videotape; color, 84 mins. By Les Blank, with Chris Strachwitz and Maureen Gosling. Distributor: Flower Films, El Cerrito, Calif.
Zydeco: Creole Music and Culture in Rural Louisiana. Videotape, color, 57 mins. Producer: Nicholas R. Spitzer. New Orleans: Center for Gulf South History and Culture.

Howard Armstrong
African-American string-band musician
Detroit, Michigan
1990 Fellow

Howard Armstrong, born in 1909 in Dayton, Tennessee, learned to play the mandolin from his father, a steelworker and musician, and by the age of fifteen had become a professional in the string-band tradition. After performing in Tennessee for some time with his three younger brothers, he teamed up with fellow musicians Carl Martin and Ted Bogan and toured throughout the eastern United States. As a result of playing for diverse ethnic audiences of steelworkers and miners, Armstrong's blues and popular music repertoire gradually acquired Spanish, German, and Italian songs. He eventually moved to Detroit to work in the automobile industry, and in 1972 joined Martin and Bogan once again, touring extensively in the United States and Central and South America.

DISCOGRAPHY: Armstrong, Howard, et al. *Barnyard Dance* (c. 1973). Rounder 2003
————. *Let's Have a Party* (1976). Flying Fish 27003
————. *Louie Bluie* (1987). Arhoolie 1095
————. *That Old Gang of Mine* (1979). Flying Fish 27056

Pedro Ayala
Mexican-American accordionist
Donna, Texas
1988 Fellow

"*El Monarca del Acordeón*," Pedro Ayala played *conjunto* music—a lively blend of German and Mexican forms—for over sixty-one years. Developed by the Mexican population along the southern Texas border in the late 1800s, the *conjunto* style combines button accordion with Spanish guitar, and has become increasingly popular since the 1920s. Ayala, an innovator within this musical style, was the first to add a *toloche* (stand-up bass) to the basic *conjunto* ensemble.

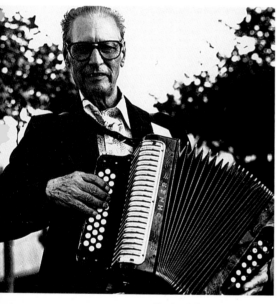

BIBLIOGRAPHY: Peña, Manuel H. *The Texas-Mexican Conjunto: History of a Working Class Music*. Mexican-American Monograph, no. 9. Austin: University of Texas Press, 1985.

DISCOGRAPHY: Ayala, Pedro, et al. *Texas-Mexican Border Music, Vol. 13; Norteño Accordion Music, Part 3: South Texas and Monterrey*. Arhoolie 9020.
———. *Texas-Mexican Border Music, Vol. 21; The Texas-Mexican Conjunto*. Arhoolie 9049. Notes by Manuel H. Peña

Dewey Balfa
Cajun fiddler
Basile, Louisiana
1982 Fellow

BIBLIOGRAPHY: Ancelet, Barry Jean, and Elemore Morgan, Jr. "Dewey Balfa: Cajun Music Ambassador." *Louisiana Life*, Sept./Oct. 1981.
———. *The Makers of Cajun Music: Musiciens Cadiens et Créoles*. Austin: University of Texas Press, 1984.
Hunt, Marjorie, and Boris Weintraub. "Masters of Traditional Arts." *National Geographic* 179:1 (Jan. 1991).
Wilson, Charles Reagan, and William Ferris, eds. *Encyclopedia of Southern Culture*. Chapel Hill and London: The University of North Carolina Press, 1989.

DISCOGRAPHY: Balfa, Dewey. *The Balfa Brothers Play More Traditional Cajun Music* (1970). Swallow 6019 (LP/C/CD)
———. *The Balfa Brothers Play Traditional Cajun Music* (1967). Swallow 6011 (LP/C)
———. *Cajun Days*. Sonet 813
———. *Handmade* (c. 1988). Swallow 6063
———. *The New York Concerts*. Swallow 6037 (LP/C/CD)
———. *Souvenirs*. Swallow 6056 (LP/C/CD)
Balfa, Dewey, Mark Savoy, and D. L. Menard. *Louisiana Cajun Music: "Underneath the Green Oak Tree"* (c. 1980). Arhoolie 5019 (LP/C), 312 (CD)
Balfa, Dewey, and Tracy Schwartz. *Traditional Cajun Fiddle: Cajun Fiddle Old and New* (1976, 1977). Folkways 8361, 8362

FILMOGRAPHY: *Blues des Balfas*. 16mm, videotape; color, 28 mins. Producer: Yashia Aginsky. Distributor: Flower Films, El Cerrito, Calif.
J'ai Eté au Bal. 16mm, videotape; color, 84 mins. By Les Blank, with Chris Strachwitz and Maureen Gosling. Distributor: Flower Films, El Cerrito, Calif.
Spend It All. 16mm, videotape; color, 41 mins. By Les Blank, with Skip Gerson. Distributor: Flower Films, El Cerrito, Calif.

Sister Mildred Barker
Shaker singer
Poland Springs, Maine
1983 Fellow

Sister Mildred Barker, a spiritual leader and trustee of the Shaker Village at Sabbathday Lake in Maine, was known for her remarkable musical abilities. She was instrumental in preserving Shaker spirituals, including the art of pantomiming Shaker hymns. A fellow Shaker has been quoted as saying: "Sister Mildred always said the vim and vigor was in music and that's what attracted her to Shakerism." Barker was also a poet and the author of four books.

BIBLIOGRAPHY: Patterson, Daniel. *The Shaker Spiritual*. Princeton: Princeton University Press, 1979.

DISCOGRAPHY: Barker, Mildred. *Early Shaker Spirituals* (c. 1973). Rounder 0078 (LP/C). Sung by Mildred Barker and other members of the United Society of Shakers

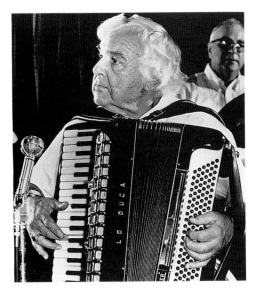

Louis Bashell

Slovenian-American accordionist,
polka master
Greenfield, Wisconsin
1987 Fellow

Louis Bashell was born in 1914 to a
family that had recently emigrated
from Slovenia to Wisconsin. Like his
father, he is a master of the diatonic
button accordion. Bashell has played
at countless weddings and social
occasions throughout his life, and has
been a lively inspiration to many
other polka musicians.

DISCOGRAPHY: Bashell, Louie, and
His Silk Umbrella Orchestra. *Polka
Special*, *Silk Umbrella Polkas*.
Cassettes available through Louis
Bashell, 4939 S. 65th Court,
Greenfield, WI 53220

Kepka Belton

Czech-American egg painter
Ellsworth, Kansas
1988 Fellow

Traditional Czech crafts, such as
needlework and egg decorating, were
taught to Kepka Belton as a child by
her maternal grandmother. Belton's
mastery of *kraslice* (Czech decorated

eggs) has not only gained her
recognition as a skillful artist but has
also guided her in learning about her
heritage. "Sometimes I think I'm
tired of doing the eggs, but I revive
myself by believing that in this
way I tell other people about
Czechoslovakia, my heritage, and
maybe even their own roots. You
can't go into the future if you don't
know your past," she reflects. A
schoolteacher who is known in her
community as "the egg lady," Belton
has introduced many enthusiasts to
the delicate art of decorating eggs
through the batik method, a wax-and-
dye process.

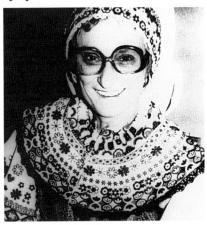

BIBLIOGRAPHY: Burkhead, Jeff. "Egg
Lady." In *Czech Festival '83*. Wilson,
Kans.: *The Wilson World*.
Szeremet, Mike. "Mrs. Belton to
Display Art." *The Wilson World*.
Wilson, Kans., July 29, 1976.

Earnest Bennett

Anglo-American whittler
Indianapolis, Indiana
1986 Fellow

BIBLIOGRAPHY: Bronner, Simon.
*Chain Carvers: Old Men Crafting
Meaning*. Lexington: University
Press of Kentucky, 1985.
Hufford, Mary, Marjorie Hunt, and
Steven Zeitlin. *The Grand
Generation: Memory, Mastery,
Legacy*. Seattle: University of
Washington Press, 1987.

Em Bun

Cambodian-American silk weaver
Harrisburg, Pennsylvania
1990 Fellow

In her native Cambodian village, Em
Bun was a respected merchant and
weaver of iridescent silk cloth for
wedding and ceremonial costumes.
After emigrating to the United States
with her family in 1980, she was able
to continue practicing her craft with
the help of friends who provided a
loom and a plentiful supply of leftover
silk thread from a men's tie factory.
Today, Em Bun has established a
successful business operation and is
passing on to her four daughters and
other Cambodian women in her
community the tradition she learned
from her mother.

Natividad Cano

Mexican-American mariachi musician
Monterey Park, California
1990 Fellow

The Mexican state of Jalisco and its
capital, Guadalajara, where Natividad
Cano was born in 1933, are renowned
centers of mariachi music, an
ensemble tradition which features the
guitarrón (bass guitar), the *vihuela* (a
small rhythm guitar), violins, and
trumpets. Cano learned mariachi
music from his father, with whom he
played until he moved to the border
town of Mexicali to join Mariachi
Chapala in 1950. Ten years later he
emigrated to Los Angeles, where he
joined Mariachi Aguila; he eventually
became the leader of this group and
renamed it Los Camperos. Today,
Cano continues to teach, perform,
and influence the growth of mariachi
music throughout California and the
Southwest.

DISCOGRAPHY: Cano, Natividad, and
Los Camperos. *El Super Mariachi:
Los Camperos en La Fonda* (1972).
Discos Latin International DLIS 2003

Genoveva Castellanoz

Mexican-American *corona* maker
Nyssa, Oregon
1987 Fellow

BIBLIOGRAPHY: Siporin, Steve, ed. *"We Came to Where We Were Supposed to Be": Folk Art of Idaho*. Boise: Idaho Commission on the Arts, 1984.

FILMOGRAPHY: *Eva Castellanoz, Corona Maker: Mexican-American Ceremonial Traditions* (1987). Slide-tape program, videotape; 15 mins. Producers: Alicia González, Steve Siporin, Robert McCarl. Boise: Idaho Commission on the Arts.

Rafael Cepeda

Puerto Rican *bomba* and *plena* musician, dancer
Santurce, Puerto Rico
1983 Fellow

Rafael Cepeda has devoted his life to two important Puerto Rican musical traditions: the *bomba*, characterized by improvisational dancing, drumming, and spontaneous rhyming texts with group refrains, and the *plena*, a more structured combination of singing and one-step dancing. "*La Familia Cepeda*," comprised of Don Rafael, his wife, three daughters, eight sons, and their families, has toured extensively, bringing *bomba* and *plena* to audiences around the world.

DISCOGRAPHY: Cepeda, Rafael. *Don Rafael Cepeda: "Patriarca de la Bomba."* Discos Cangrejo #1. Available through Familia Cepeda, Inc., Calle Progreso núm. 332, Villa Palmeras, Santurce, PR 00905

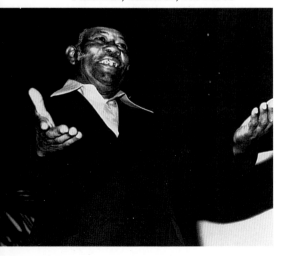

John Cephas

Blues musician
Bowling Green, Virginia
1989 Fellow

BIBLIOGRAPHY: Pearson, Barry Lee. *Virginia Piedmont Blues: The Lives and Art of Two Virginia Bluesmen*. Philadelphia: University of Pennsylvania Press, 1990.

DISCOGRAPHY: Cephas, John, et al. *Non-Blues Secular Black Music in Virginia* (1977). BRI001*
———. *Tidewater Blues* (1980). BRI006*
———. *Voices of the Americas Series: The Blues* (1987). World Music Institute WMI001 (C)
Cephas, John, and Phil Wiggins. *Bowling Green John Cephas and Harmonica Phil Wiggins: Dog Days of August* (1986). Flying Fish Records FF394 (LP), FF90394 (C)
———. *Guitar Man*. Flying Fish Records FF470 (LP/C/CD)
———. *Living Country Blues USA, Vol. 1; Bowling Green John Cephas and Harmonica Phil Wiggins from Virginia*. L&R Label (Germany) LR42.031**
———. *Sweet Bitter Blues* (1983). L&R Label (Germany) LR42.054**
*Available through BRI, Ferrum College, Ferrum, Va.
**Available at import stores

Clifton Chenier

Zydeco musician
Lafayette, Louisiana
1984 Fellow

BIBLIOGRAPHY: Ancelet, Barry Jean, and Elemore Morgan, Jr. *The Makers of Cajun Music: Musiciens Cadiens et Créoles*. Austin: University of Texas Press, 1984.
Savoy, Ann Allen. *Cajun Music: A Reflection of a People*. Vol. 1. Eunice, La.: Bluebird Press, 1985.
Wilson, Charles Reagan, and William

Ferris, eds. *Encyclopedia of Southern Culture*. Chapel Hill and London: The University of North Carolina Press, 1989.

DISCOGRAPHY: Chenier, Clifton. *Bon Ton Roulet!* (c. 1968). Arhoolie 1031 (LP/C)
———. *Classic Clifton* (c. 1978). Arhoolie 1082 (LP/C)
———. *Clifton Chenier and His Red Hot Louisiana Band* (c. 1976). Arhoolie 1078 (LP/C)
———. *The King of Zydeco*. Arhoolie 1086 (LP/C)
———. *The King of Zydeco Sings the Blues* (1987). Arhoolie AR1097 (LP/C)
———. *Live at a French-Creole Dance*. Arhoolie 1059 (LP/C)
———. *Live at the San Francisco Blues Festival* (1982). Arhoolie 1093 (LP/C)
———. *60 Minutes with the King of Zydeco*. Arhoolie 301 (CD)

FILMOGRAPHY: *Clifton Chenier and His Red Hot Louisiana Band* (1977). Videotape ¾" and ½", color, 58 mins. New York: Phoenix Films.
Clifton Chenier: The King of Zydeco. 16mm, videotape; color, 55 mins. Producer: Chris Strachwitz. Distributor: Flower Films, El Cerrito, Calif.
Dry Wood. 16mm, videotape; color, 37 mins. By Les Blank, with Maureen Gosling. Distributor: Flower Films, El Cerrito, Calif.
Hot Pepper. 16mm, videotape; color, 54 mins. By Les Blank, with Maureen Gosling. Distributor: Flower Films, El Cerrito, Calif.
J'ai Eté au Bal. 16mm, videotape; color, 84 mins. By Les Blank, with Chris Strachwitz and Maureen Gosling. Distributor: Flower Films, El Cerrito, Calif.

Bertha Cook

Knotted-bedspread maker
Boone, North Carolina
1984 Fellow

BIBLIOGRAPHY: Abrams, W. Amos. "Bertha Hodges Cook." *North Carolina Folklore Journal* 22:2 (May 1974).

McGowan, Thomas A. "Bertha Cook, Maker of Knotted Bedspreads." *Appalachian Arts* 3:1 (Fall 1980).

FILMOGRAPHY: *Bertha Cook, Maker of Knotted Bedspreads* (1979). Videotape. Director: Thomas A. McGowan. Boone, N.C.: Appalachian State University.

Helen Cordero

Cochiti Pueblo potter
Cochiti Pueblo, New Mexico
1986 Fellow

BIBLIOGRAPHY: Babcock, Barbara A. *The Pueblo Storyteller: Development of a Figurative Ceramic Tradition*. Tucson: University of Arizona Press, 1986.
———. "Clay Voices: Invoking, Mocking, Celebrating." In *Celebration: Studies in Festivity and Ritual*, edited by Victor Turner, 58–76. Washington, D.C.: Smithsonian Institution Press, 1982.
Glassie, Henry. *The Spirit of Folk Art: The Girard Collection at the Museum of International Folk Art*. New York: Harry N. Abrams, Inc., 1989.
Hufford, Mary, Marjorie Hunt, and Steven Zeitlin. *The Grand Generation: Memory, Mastery, Legacy*. Seattle: University of Washington Press, 1987.

Joseph Cormier

Cape Breton violinist
Waltham, Massachusetts
1984 Fellow

Joseph Cormier was born in 1927 in an Acadian fishing community in Nova Scotia that had a strong Scottish violin tradition. He mastered the full Cape Breton repertoire in his youth, working with noted musician Winston "Scotty" Fitzgerald. Cormier later moved to Maine, where he was sought out by the French-American Victory Club of Waltham, Massachusetts, to play at its quadrilles. Although Cormier considers himself to be mainly a "dance fiddler," his mastery and skill have helped preserve the Cape Breton musical tradition. A member of his community wrote of him: "While we are proud to be United States citizens, we have worked hard to keep our traditions alive for ourselves and our children. . . . It is a real pleasure for us to see the recognition given Joe and his music . . . because in some small way we all share in it."

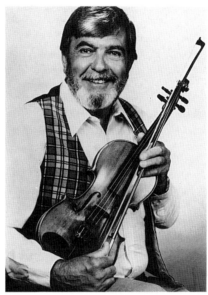

DISCOGRAPHY: Cormier, Joseph. *Cheticamp Connection*. Cassette available through Joseph Cormier, 21 Leonard St., Waltham, MA 02154
———. *Dances from Down Home* (1977). Rounder 7004 (LP/C)
———. *Scottish Violin Music from Cape Breton Island* (1975). Rounder 7001 (LP/C)

FILMOGRAPHY: *New England Fiddles*. 16mm, color, 30 mins. Watertown, Maine: Documentary Educational Resources.

Elizabeth Cotten

African-American singer, songwriter
Washington, D.C.
1984 Fellow

Made-up songs for family gatherings were the beginning of Elizabeth Cotten's musical career. At the age of twelve, while playing with her brother, she composed "Freight Train," one of her most notable songs. Born in 1893 in North Carolina, Cotten taught herself at an early age how to pick a guitar one string at a time, and by her early teens she had composed a large repertoire of tunes. However, Cotten then gave up "worldly" music for almost fifty years. It was while working for performers Mike and Peggy Seeger that she again began to play the guitar, touring with the Seegers around the country.

BIBLIOGRAPHY: Seeger, Mike. "A 'Freight Train' Picker." *Festival of American Folklife* (program). Washington, D.C.: Smithsonian Institution, 1970.

DISCOGRAPHY: Cotten, Elizabeth. *Elizabeth Cotten: Live*. Arhoolie 1089
———. *Freight Train and Other North Carolina Folk Songs and Tunes* (1958). Rounder SF 40002 (LP/C/CD)
———. *Shake Sugaree*, Vol. 2 (1967). Folkways 31003
Cotten, Elizabeth, et al. *Newport Folk Festival Recordings: 1964 Blues II* (1964). Vanguard 79181

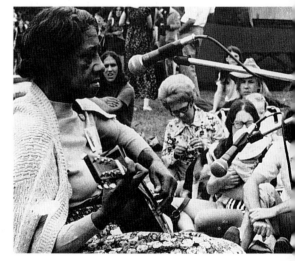

FILMOGRAPHY: *Elizabeth Cotten*. 16mm, black and white, 25 mins. Seattle: Seattle Folklore Society. *Me and Stella* (1977). 16mm, videotape; color, 24 mins. New York: Phoenix Films.

Burlon Craig
Potter
Vale, North Carolina
1984 Fellow

BIBLIOGRAPHY: Burrison, John A. *Brothers in Clay: The Story of Georgia Folk Pottery*. Athens: University of Georgia Press, 1983. Glassie, Henry. *The Spirit of Folk Art: The Girard Collection at the Museum of International Folk Art*. New York: Harry N. Abrams, Inc., 1989. Zug, Charles G., III. *Turners and Burners: The Folk Potters of North Carolina*. Chapel Hill and London: The University of North Carolina Press, 1986.

Giuseppe and Raffaela DeFranco
Italian-American musicians
and dancers
Belleville, New Jersey
1990 Fellows

The DeFrancos left Calabria, the southernmost region of continental Italy, for the United States in 1968. Giuseppe DeFranco, a master of the *organetto* (a small button accordion), also plays the *ciaramella* (a wooden oboe), the *zampogna* (bagpipes), and the *chitarra battente* (rhythm guitar), an instrument he learned in his youth while working as a shepherd. Raffaela DeFranco accompanies her husband with a wide range of songs, including serenades, tarantella verses, religious melodies, and lullabies. She sings both in the high-pitched style typical of Calabria and in the region's choral style, the *villanella*. The DeFrancos frequently perform with their son Faust—who plays the accordion, the tambourine, and the *triccaballacca*, a wooden percussive instrument—and with longtime friend Franco Cofone, a tambourine player and singer.

DISCOGRAPHY: DeFranco, Giuseppe and Raffaela. *The DeFranco Family— and Franco Cofone* (1990). Cassette available through Faust DeFranco, 134 Bee Street, Belleville, NJ 07109 DeFranco, Giuseppe and Raffaela, et al. *Calabria Bella—Italian Music in New York, New Jersey, and Rhode Island, Vol. 2* (1979). Smithsonian/Folkways 34042. Recorded and edited by Anna Lomax Chairetakis

Amber Densmore
Quilter
Chelsea, Vermont
1988 Fellow

The tradition of needlework, common among farm women throughout America, encompasses many skills, such as tatting, hooking, and quilting; often the socializing which accompanies needlework is important not only to catch up on community events but also to teach and pass on such skills. Amber Densmore, like many other women, learned needlework as a child, from family members and friends. Folklorist Jane Beck described Densmore thus: "Her work is truly exceptional. She personifies the term folk artist in its most complete sense. She is a visual spokeswoman for a tradition that is endangered in Vermont—the farm wife who works beside her husband and yet manages to find time for those quiet moments of artistic pleasure so necessary to create and produce beauty of leftovers and scraps and the well-worn traditions of every day."

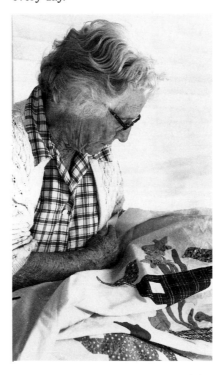

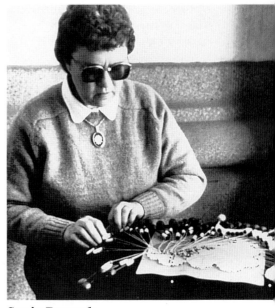

Sonia Domsch
Czech-American bobbin-lace maker
Atwood, Kansas
1986 Fellow

When Mary Dostal Beck emigrated to America from Czechoslovakia in 1894 with her three children and younger brother, her skills as a bobbin-lace maker enabled her to support her family. She eventually taught the delicate art of lacework to her daughter Ann, who years later would teach Sonia Domsch, her grand-niece. Among Domsch's most cherished possessions are the bobbins she inherited from her great-grandmother Mary. Today, however, Domsch's husband, Don, makes all her bobbins, as well as the pillows she uses. Domsch has taught her daughter the skill of bobbin-lace making and has participated in numerous workshops and demonstrations.

Albert Fahlbusch
Hammered-dulcimer maker, musician
Scottsbluff, Nebraska
1984 Fellow

DISCOGRAPHY: Fahlbusch, Albert, et al. *Dutch Hop Polka Music and Old German Songs, Vol. 1* (1972), *Vol. 2* (1974), *Vol. 3* (1976), *Vol. 4* (1978),

Vol. 5 (1980). Cassettes available through Albert Fahlbusch, 1807 Eleventh Avenue, Scottsbluff, NE 69361

The Fairfield Four

African-American a capella gospel singers
Nashville, Tennessee
1989 Fellows

Named after the Fairfield Baptist Church in Nashville, this gospel group was organized in the early 1920s and has kept its original name despite several changes in membership over the years. During the 1940s and 1950s, the group performed on radio and toured the South and Midwest. A special reunion concert held in Birmingham, Alabama, in 1980 brought together all the surviving Fairfield Four singers, including Samuel McCrary, who was a member from the late 1930s until his duties as a pastor restricted his involvement. The Fairfield Four continues to perform today, ensuring the vitality of a superb gospel harmony singing tradition.

The Fairfield Four. From left: the Rev. Sam McCrary, Elder Willie Richardson, Robert Hamlett, Wilson Waters, Isaac Freeman, and James Hill

BIBLIOGRAPHY: *Gospel Arts Day, Nashville* (program). Nashville: Nashville Gospel Ministries, June 19, 1988.

DISCOGRAPHY: Fairfield Four et al. *Voices of the Americas Series: Gospel* (1986). World Music Institute WMI002 (C)

Michael Flatley

Irish-American step dancer
Palos Park, Illinois
1988 Fellow

BIBLIOGRAPHY: Hunt, Marjorie, and Boris Weintraub. "Masters of Traditional Arts." *National Geographic* 179:1 (Jan. 1991).

Canray Fontenot

Black Creole fiddler
Welsch, Louisiana
1986 Fellow

BIBLIOGRAPHY: Ancelet, Barry Jean, and Elemore Morgan, Jr. *The Makers of Cajun Music: Musiciens Cadiens et Créoles*. Austin: The University of Texas Press, 1984.
Savoy, Ann Allen. *Cajun Music: A Reflection of a People*. Vol. 1. Eunice, La.: Bluebird Press, 1985.

DISCOGRAPHY: Fontenot, Canray, and Alphonse Ardoin. *Les Blues du Bayou* (1966). Melodeon 7330
Fontenot, Canray, Alphonse Ardoin, et al. *"Boisec" Ardoin: La Musique Créole* (c. 1970). Arhoolie 1070 (LP/C)
Fontenot, Canray, et al. *Voices of the Americas Series: Cajun and Creole Music* (1987). World Music Institute T110 (C)

FILMOGRAPHY: *Dry Wood*. 16mm, videotape; color, 37 mins. By Les Blank, with Maureen Gosling. Distributor: Flower Films, El Cerrito, Calif.
Hot Pepper. 16mm, videotape; color, 54 mins. By Les Blank, with Maureen Gosling. Distributor: Flower Films, El Cerrito, Calif.
J'ai Eté au Bal. 16mm, videotape; color, 84 mins. By Les Blank, with Chris Strachwitz and Maureen Gosling. Distributor: Flower Films, El Cerrito, Calif.

Thomas Edison "Brownie" Ford

Anglo-Comanche cowboy singer, storyteller
Herbert, Louisiana
1987 Fellow

The skills of cowboy "Brownie" Ford extend far beyond the range: he has worked as a rodeo rider, ranch-hand, horse trainer, construction worker, oil-field roughneck, and truck driver. Born in 1904 at Gum Springs in the Oklahoma Territory, Ford is half-Comanche by ancestry. Today, he lives in northeastern Louisiana, where he is well known for his singing and storytelling gifts. His extensive repertoire includes cowboy songs, frontier ballads, and stories of his early days in the Oklahoma Territory and in Wild West shows.

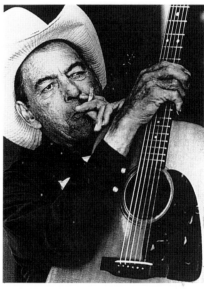

DISCOGRAPHY: Ford, Thomas Edison "Brownie," et al. *Cowboy Tour* (1983). Cassette available through National Council for the Traditional Arts, 806 15th St. N.W. #400, Washington, D.C. 20005

Kansuma Fujima

Japanese-American Kabuki dancer
Los Angeles, California
1987 Fellow

With commitment and perseverance, Kansuma Fujima has dedicated her life to the practice and teaching of the Kabuki tradition in California.

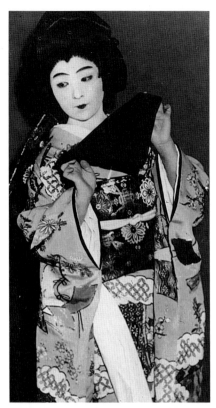

Kabuki drama is characterized by elaborate costuming, rhythmic dialogue, and stylized acting, music, and dancing. At the age of nine, Kansuma Fujima began dance training which later led her to study in Japan with well-known Kabuki master Kikugoro Onnoe VI. She taught dance in the Los Angeles area until the outbreak of World War II. During the war, in various "relocation centers" for Japanese-Americans, she performed Kabuki dances for fellow detainees. Upon returning to Los Angeles she continued to teach, and has since participated in numerous Japanese cultural events.

José Gutiérrez

Mexican-American *jarocho* musician
Norwalk, California
1989 Fellow

DISCOGRAPHY: Gutiérrez, José. *Music of Veracruz: The Sones Jarochos of Los Pregoneros del Puerto* (1990). Rounder 5048

Sister Rosalia Haberl

German-American bobbin-lace maker
Hankinson, North Dakota
1988 Fellow

Born in 1897 in a small town in Bavaria, Germany, Sister Rosalia Haberl was an accomplished lace maker by the age of fourteen. Like many young women her age, she attended a folk-craft school after regular school hours. At the Royal Bobbin Lace School she would take three-hour lessons five afternoons a week. In 1917 she entered the Franciscan Order, and in 1928 was transferred to Hankinson, North Dakota, where she has remained ever since. Upon her retirement from convent responsibilities, Sr. Rosalia again began to practice lace making, and she can still deftly handle projects which require the manipulation of up to 100 bobbins. She has assisted in preserving this tradition by teaching an apprentice through the North Dakota Traditional Arts Apprenticeship program.

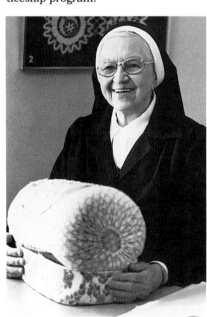

Richard Hagopian

Armenian-American oud musician
Visalia, California
1989 Fellow

Richard Hagopian's musical talents were already evident in his youth, and among the instruments he

mastered early on was the oud, a type of lute that has been referred to as "the queen of Near Eastern music." Hagopian's interest in the oud is not limited to playing, however; of Armenian descent, he has gathered information from older Armenians about how and when the music was performed in the Old Country and how the instruments were made. He has also researched how this musical tradition has changed in the United States.

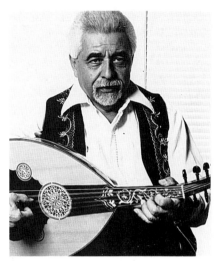

DISCOGRAPHY: Hagopian, Richard, and ensemble. *Kef Time Detroit* (1971). SaHa Recording Co. SH1004 (LP/C)*
———. *Kef Time Fresno* (1969). SaHa Recording Co. SH1002 (LP/C)*
———. *Kef Time Hartford* (1972). SaHa Recording Co. SH1005 (LP/C)*
———. *Kef Time Las Vegas* (1968). SaHa Recording Co. SH1001 (LP/C)*
*Available through Hagopian's Delicatessen, 409 N. Willis, Visalia, CA 93291

Periklis Halkias

Greek-American clarinettist
Astoria, New York
1985 Fellow

Born in the Epirote region of northern Greece, Periklis Halkias began playing the clarinet when he

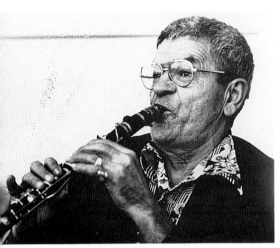

was ten. His musical ability eventually led him to Athens, where he became well known for his ornate, elaborate renditions of ancient Greek melodies. When he moved to the United States in 1964, Halkias immediately achieved popularity in New York City's Greek nightclubs. His homeland has not forgotten him, though; whenever he returns, enthusiastic audiences still throng his performances.

BIBLIOGRAPHY: "Dancing to the Ethnic Beat." *The New York Times*, June 9, 1978.
"European Roots." *The Village Voice*, Dec. 1980.

DISCOGRAPHY: Halkias, Periklis. *Epirotika with Periklis Halkias: Greek Folk Music and Dance from Northern Epirus, Vol. 1*. Folkways 34024
————. *Epirotika with Periklis Halkias: Greek Folk Music and Dance, Vol. 2*. Folkways 34025
————. *Fragile Traditions: The Art of Periklis Halkias**
Halkias, Periklis, and Halkias Family Orchestra. *Songs and Dances of Epiros*. BA US 1003 (C). Radio documentary*
*Available through Ethnic Folk Arts Center, 131 Varick St. #907, New York, NY 10013

Joe Heaney

Irish-American singer
Brooklyn, New York
1982 Fellow

BIBLIOGRAPHY: Moloney, Michael. "Joe Heaney: Cultural Ambassador." *New York Folklore Newsletter* 5:2 (July 1984).

DISCOGRAPHY: Heaney, Joe. *Come All Ye Gallant Irishmen*. Philo PH–2004. Available through Rounder
————. *Irish Traditional Songs in Gaelic and English*. Topic 12T 91
————. *O Mo Dhuchas*. Gael-linn CEF 051. In Gaelic
————. *Seosamh OhEanai*. Gael-linn CEF 028. In Gaelic
Heaney, Joe, and Gabe O'Sullivan. *Joe and Gabe*. Green Linnet 1018. Mostly in English, some Gaelic

Christy Hengel

German-American concertina maker
New Ulm, Minnesota
1989 Fellow

Growing up in the agricultural community of New Ulm, Minnesota, Christy Hengel was surrounded by German-American musical traditions, and by the age of seventeen he had bought his first concertina. However, it was the art of creating a concertina that fascinated him most, and in 1955 he purchased the Patek concertina factory. Today, Hengel concertinas are widely revered for the quality of the hand tuning, easier lever action, and lesser overall weight, improvements originated by Hengel himself.

BIBLIOGRAPHY: Hunt, Marjorie, and Boris Weintraub. "Masters of Traditional Arts." *National Geographic* 179:1 (Jan. 1991).

DISCOGRAPHY: Hengel, Christy. *Six Fat Dutchmen*. Reissue of 1951–52 recordings. Cassette available through Christy Hengel, 403 N. Minnesota, New Ulm, MN 56073

Ray Hicks

Appalachian storyteller
Banner Elk, North Carolina
1983 Fellow

BIBLIOGRAPHY: Hunt, Marjorie, and Boris Weintraub. "Masters of Traditional Arts." *National Geographic* 179:1 (Jan. 1991).
Kinkead, Gwen. "An Overgrown Jack." *The New Yorker*, July 18, 1988.
Wilson, Charles Reagan, and William Ferris, eds. *Encyclopedia of Southern Culture*. Chapel Hill and London: The University of North Carolina Press, 1989.

DISCOGRAPHY: Hicks, Ray. *Jack Alive*. June Appal Recordings JA0052 (LP/C/CD)

FILMOGRAPHY: *"Fixin' to Tell about Jack"* (1974). 16mm, videotape; color, 25 mins. Director: Elizabeth Barret. Whitesburg, Ky.: Appalshop.

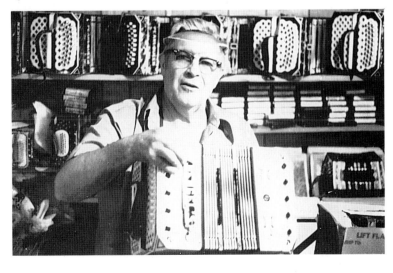

Stanley Hicks
Appalachian instrument maker,
musician, storyteller
Vilas, North Carolina
1983 Fellow

BIBLIOGRAPHY: Wigginton, Eliot, ed.
Foxfire 3. Garden City, N.Y.:
Doubleday, Anchor Press, 1975.
————. *Foxfire 4.* Garden City, N.Y.:
Doubleday, Anchor Press, 1977.
————. *Foxfire 6.* Garden City, N.Y.:
Doubleday, Anchor Press, 1980.
————. *Foxfire 8.* Garden City, N.Y.:
Doubleday, Anchor Press, 1984.

DISCOGRAPHY: Hicks, Stanley. *It Still
Lives* (1980). Foxfire Records

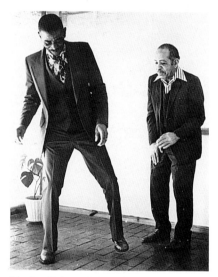

John Dee Holeman (left), with Quentin Holloway

John Dee Holeman
African-American dancer,
musician, singer
Durham, North Carolina
1988 Fellow

A master performer, John Dee
Holeman aptly demonstrates the
diversity of African-American musical
traditions in the southern Piedmont
area. Typical entertainment at
community gatherings in this region
includes singing, instrumental music,
and dancing. Informal, competitive
solo dancing often incorporates flat-
foot, tap, or "buck-dancing," along
with clapping and "patting" various
sections of the body to produce

different rhythmic tones. With friend
and fellow performer Quentin "Fris"
Holloway, Holeman has traveled
throughout the South and abroad.

DISCOGRAPHY: Holeman, John, et al.
*Voices of the Americas Series: The
Blues* (1987). World Music Institute
WMI001 (C)

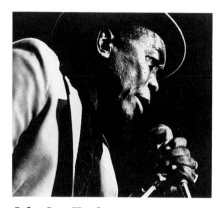

John Lee Hooker
Blues guitarist, singer
San Carlos, California
1983 Fellow

Born in Clarksdale, Mississippi, in
1917, John Lee Hooker has played
an important role in the evolution
and popularity of the blues tradition.
Having learned the guitar from his
father, he performed with Delta blues
musicians until he left home at the
age of fourteen. In the post–World
War II period, Hooker lived in Detroit,
where he developed an enthusiastic
following. Known for his individual-
istic style, the "King of the Boogie"
has inspired many rock-and-roll
musicians.

BIBLIOGRAPHY: Wilson, Charles
Reagan, and William Ferris, eds.
Encyclopedia of Southern Culture.
Chapel Hill and London: The Univer-
sity of North Carolina Press, 1989.

DISCOGRAPHY: Hooker, John Lee.
Alone (1948–51). Specialty 14027*
————. *The Cream* (1977). Tomato
269609–2 (CD)*
————. *Detroit* (1948–52). United
Artists UAS–127. Three-record set
————. *House of the Blues.* Chess
CHD9258 (CD)*
————. *16 Selections Every One a
Pearl.* King 727*

*Available through Down Home
Music, Inc., El Cerrito, Calif.

FILMOGRAPHY: *John Lee Hooker.*
16mm, black and white, 25 mins.
Seattle: Seattle Folklore Society.

Janie Hunter
African-American singer, storyteller
Johns Island, South Carolina
1984 Fellow

DISCOGRAPHY: Hunter, Janie, the
Moving Star Hall Singers, and Alan
Lomax. *Been in the Storm So Long.*
Smithsonian Folkways SF 40031
(C/CD). Editors: Guy and Candie
Carawan. Seventy-two-minute
compilation of Folkways FS3841 and
the out-of-print FS3842, including
spirituals, folk tales, and children's
games from Johns Island, S.C.

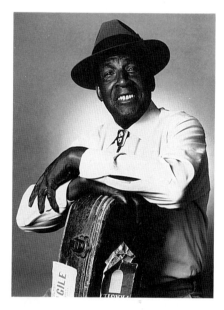

John Jackson
African-American singer, guitarist
Fairfax Station, Virginia
1986 Fellow

In Virginia's rural Rappahannock
County, John Jackson grew up attend-
ing social events such as dances, house
parties, and church meetings. Music
was an important part of his life, as
both his mother and father sang and
played the guitar and several other

instruments for their family of four-teen children. Jackson taught himself how to play the guitar and soon memorized the songs he heard in his community, on the radio, and on 78 r.p.m. records. He has performed both in the United States and internationally, delighting audiences with his extensive repertoire of blues, gospel, ragtime, and country-style songs.

DISCOGRAPHY: Jackson, John. *Blues and Country Dance Tunes from Virginia* (c. 1965). Arhoolie 1025 (LP), 221 (C)
———. *Blues and Country Dance Tunes from Virginia, Vol. 2* (c. 1967). Arhoolie 1035 (LP), 221 (C)
———. *Deep in the Bottom* (1982). Rounder 2032 (LP/C)
———. *John Jackson In Europe* (1969). Arhoolie 1047
———. *Step It Up and Go* (1978). Rounder 2019
Jackson, John, et al. *Country Blues Live* (1988). Document–DLP525. Available through Document Records, Eipeldauerstr. 23/43/5, A–1220, Vienna, Austria
———. *National Down Home Blues Festival, Vol. 2* (1987). Southland Records SLP–23. Available through Southland Records, 3008 Wadsworth Mill Place, Decatur, GA 30032
———. *Voices of the Americas Series: The Blues* (1987). World Music Institute WMI001 (C)

Tommy Jarrell
Appalachian fiddler
Mount Airy, North Carolina
1982 Fellow

Tommy Jarrell's home was often filled with young musicians hoping to learn from this master, whose father was also a well-known fiddler. After his retirement as a heavy equipment operator, Jarrell resumed playing the fiddle and the Blue Ridge mountain tunes he had learned as a boy. In the late 1960s he began to perform at folk festivals and to make recordings, as interest in his music increased. Regarding the young musicians who sought him out, Jarrell once

commented: "They'll carry it on after I'm gone. . . . I've left a little something behind, I reckon."

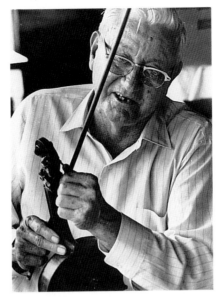

BIBLIOGRAPHY: Rich, Alan. "Pickin' on Tommy's Porch." *Newsweek*, Sept. 17, 1984.

DISCOGRAPHY: Jarrell, Tommy. *Back Home in the Blue Ridge*. Country 713
———. *Come and Go with Me*. Country 748
———. *Down at the Cider Mill*. Country 723
———. *Rainbow Sign* (1984). Country 791
———. *Sail Away Ladies*
———. *Stay All Night*. Country 741
Jarrell, Tommy, Frank Bode, et al. *Frank Bode: Been Riding with Old Mosby* (1986). Folkways FTS 31109

FILMOGRAPHY: *Homemade American Music*. 16mm, videotape; 42 mins. or 30 mins. Mendocino, Calif.: Lawren Productions.
Sprout Wings and Fly. 16mm, videotape; color, 30 mins. By Les Blank, with Cece Conway and Alice Gerrard. Distributor: Flower Films, El Cerrito, Calif.
Tommy Jarrell. Videotape, black and white, 32 mins. Director: Margaret McClellan. Johnson City, Tenn.: Southern Appalachian Video Ethnography Series.

Jimmy Jausoro
Basque-American accordionist
Boise, Idaho
1985 Fellow

BIBLIOGRAPHY: Siporin, Steve. "Summer Picnics and Winter Dances . . . An Edited Interview with Jimmy and Isabel Jausoro." *Sun Valley Festival Booklet*. Sun Valley, Idaho, Aug. 1982.

Claude Joseph "C. J." Johnson
African-American religious singer, orator
Atlanta, Georgia
1987 Fellow

DISCOGRAPHY: Johnson, Claude Joseph. *Babylon City Is Falling Down* (1974). Savoy 14338 A*
———. *Go On. There's Something Telling Me to Go On* (1978). Savoy 14460*
———. *Hold My Hand While I Run This Race* (1988). No. 1350. Available through Meltone Records, P.O. Box 310600, Atlanta, GA 30331
———. *I Heard the Voice of Jesus Say* (1982). Savoy SL14617*
———. *I'm Going to Wait Till My Jesus Comes* (1980). Savoy 14531*
———. *I Want to Go Where Jesus Is* (1965). Savoy MG–14135*
———. *Low Down, Chariot, Let Me Ride* (1985). Savoy 14273*
———. *You Can't Do Wrong and Get By*. Savoy G14288*
*Available through Malaco Records, P.O. Box 9287, Jackson, MS 39206

Bessie Jones
African-American singer, storyteller
Brunswick, Georgia
1982 Fellow

BIBLIOGRAPHY: "In Retrospect: Bessie Jones." *The Black Perspective in Music* 13:1 (Spring 1985).
Jones, Bessie, and Bess Lomax Hawes. *Step It Down: Games, Plays, Songs and Stories from the Afro-American Heritage*. New York: Harper and Row, 1972.

DISCOGRAPHY: Jones, Bessie. *So Glad I'm Here*. Rounder 2015 (LP/C)

———. *Step It Down: Games for Children*. Rounder 8004 (LP/C)
Jones, Bessie, and the Sea Island Singers. *Georgia Sea Island Songs*. New World Records. Notes by Alan Lomax
Jones, Bessie, et al. *American Folk Songs For Children* (1959). Atlantic SD–1350. Anthology of field recordings by Alan Lomax

FILMOGRAPHY: *American Folklife Company, Part 1* (1971). Videotape, 30 mins. Lincoln, Nebr.: NETCHE. *Yonder Come Day* (1976). 16mm, color, 26 mins. Washington, D.C.: Films for Anthropological Teaching, American Anthropological Association.

Mealii Kalama
Hawaiian quilter
Honolulu, Hawaii
1985 Fellow

BIBLIOGRAPHY: Nogelmeier, Puakea. "Hawaiian Crafts." *Folklife Hawai'i* (festival program). Honolulu: The State Foundation on Culture and the Arts, 1990.

FILMOGRAPHY: *Mealii Kalama, Hawaiian Quilter*. Producer: Tip Davis. Available for viewing at the Hawaii State Library Film Unit.

Raymond Kane
Hawaiian slack-key guitarist, singer
Wai'anae, Hawaii
1987 Fellow

BIBLIOGRAPHY: Gordon, Mike. "The Guitar Man." *Honolulu Star-Bulletin*. Aug. 17, 1987.

DISCOGRAPHY: Kane, Raymond. *Kane Kapila, Vol. 1* (1989). DC–3022 (C/CD)*
———. *Kane Kapila, Vol. 2* (1990). DC–3023 (C/CD)*
———. *Manakulis Raymond Kane* (1976). TS–1130 (LP/C). Available through Tradewinds-Recording, P.O. Box D, Alameda, CA 94501
———. *Master of the Slack Key Guitar* (1988). Rounder 6020 (LP/C)
Kane, Raymond, et al. *Hawaiian Rainbow*. Rounder 6018 (LP/C)
*Available through Dancing Cat Records, Box 639, Santa Cruz, CA 95061

Maude Kegg
Ojibwe craftswoman, storyteller
Onamie, Minnesota
1990 Fellow

Scholar Ralph Coe has written of Maude Kegg: "As an influence upon and teacher of the young, as an example to follow and emulate, as both preserver and extender of the correct interpretation of the Ojibwe way, [she] has made a major contribution to Great Lakes Native culture." A tradition bearer of the Ojibwe people, Kegg was born near Portage Lake, Minnesota. Her maternal grandmother, who raised her, taught her the Ojibwe language, customs, and traditions. Although she may be best known as a master craftswoman of Ojibwe floral designs and geometric loom beadwork techniques, Kegg has also written three books, assisted Ojibwe language scholars, and demonstrated agricultural traditions such as maple sugaring and wild-rice harvesting and processing.

BIBLIOGRAPHY: Kegg, Maude. *Gabekanaansing* (*At the End of the Trail: Memories of Chippewa Childhood in Minnesota*; with texts in Ojibwe and English). New York: Nichols Publishing, 1978.
———. *Gii-ikwezensiwiyaan* (*When I Was a Little Girl: Memories of Indian Childhood in Minnesota*). 1973.
———. *Nookomis gaa-inaajimotawid* (*What My Grandmother Told Me*; with texts in Ojibwe and English). Bemidji, Minn.: Indian Publishing, Bemidji University, 1983.

Ilias Kementzides
Pontic Greek–American *lyra* musician
Norwalk, Connecticut
1989 Fellow

Ilias Kementzides was born in the Caucasus in 1929, and eleven years later emigrated with his family to Greece. Of his youth, Kementzides recalls: "In Russia, every weekend the whole neighborhood would gather

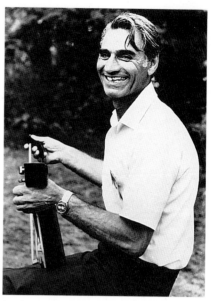

in the courtyard. . . . If someone heard an instrument starting up, everyone would come running. It was joyous. That's how it was in Greece too. Not a blade of grass could grow in our courtyard, there was so much dancing." Surrounded by strong communal and family musical traditions, Kementzides mastered the *lyra*—a bottle-shaped violin with three strings. When he moved to the Pontic community of Norwalk in 1974, he discovered to his delight ". . . that there was a place for the *lyra* here. Not only that, I was able to give a gift, in a sense, to pass on an ancient tradition."

Peou Khatna
Cambodian-American court dancer, choreographer
Silver Spring, Maryland
1986 Fellow

FILMOGRAPHY: *Dance of Tears: The Dance Lives. The Story of the Khmer Classic Dance Troupe* (1982). 16mm, color. Washington, D.C.: National Council for the Traditional Arts.

Ethel Kvalheim
Norwegian-American rosemaler
Stoughton, Wisconsin
1989 Fellow

BIBLIOGRAPHY: Martin, Philip. *Rosemaling in the Upper Midwest*. Mount Horeb: Wisconsin Folk Museum, 1989.

Teske, Robert T., James P. Leary, and Janet C. Gilmore, eds. *From Hardanger to Harleys: A Survey of Wisconsin Folk Art*. Sheboygan, Wis.: John Michael Kohler Arts Center, 1987.

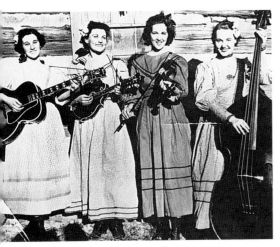

The Coon Creek Girls. From left: Rosie Ledford, Esther "Violet" Koehler, Lily May Ledford, Evelyn "Daisy" Lange

Lily May Ledford
Appalachian musician, singer
Lexington, Kentucky
1985 Fellow

In the early 1930s, together with her brother and sister, Lily May Ledford started a string band they called the Red River Ramblers. Shortly afterward a talent scout, impressed with her skillful playing of the claw-neck banjo, invited Ledford to Chicago to perform on a radio broadcast series. In 1936 she, her sister Rosie, and two other young women organized the "Coon Creek Girls." An all-woman string band was a novelty at this time, and the group toured the country, even giving a concert for President Franklin D. Roosevelt at the White House.

BIBLIOGRAPHY: Wolfe, Charles K. *Kentucky Country: Folk and Country Music of Kentucky*. Lexington: The University Press of Kentucky, 1982.

DISCOGRAPHY: Ledford, Lily May. *Banjo Pickin' Girl*. Greenhays Records GR0712
Ledford, Lily May, and the Coon Creek Girls. *Coon Creek Girls: Early Radio Favorites* (c. 1940). CS–142

(LP/C). Available through Old Homestead, Brighton, Mich.

FILMOGRAPHY: *Homemade American Music*. 16mm, videotape; 42 mins. or 30 mins. Mendocino, Calif.: Lawren Productions.

Kevin Locke
Lakota flute musician, dancer, storyteller
Mobridge, South Dakota
1990 Fellow

Kevin Locke learned the Lakota language and traditions from an elderly uncle with whom he lived as a boy. His specialty is the Lakota courting flute, an end-blown flute usually made of wood and traditionally played only by men. An articulate artist, Locke has toured extensively throughout the world, lecturing, performing, and occasionally demonstrating the Plains hoop dance.

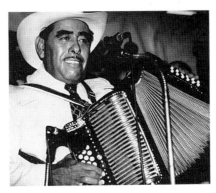

Valerio Longoria
Mexican-American accordionist
San Antonio, Texas
1986 Fellow

In 1982, Valerio Longoria was inducted into the *Conjunto* Music Hall of Fame in San Antonio for his contributions to the development and advancement of this genre, which combines northern Mexican and German elements. Longoria's innovations have included combining singing with accordion playing and incorporating other instruments to the basic *conjunto* ensemble. Through his compositions and distinctive style, he

has also helped to introduce *boleros* and *canciones corridas* in *conjunto* music. Longoria, now master accordion instructor for the Guadalupe Cultural Arts Center in San Antonio, continues to perform with his sons and grandsons.

BIBLIOGRAPHY: Cicchetti, Stephen J. "Stand Up and Play It Right." *San Antonio Monthly*, Sept. 1984.
Peña, Manuel. *The Texas-Mexican Conjunto: History of a Working Class Music*. Mexican-American Monograph, no. 9. Austin: University of Texas Press, 1985.
Reyna, José R. "Tejano Music as an Expression of Cultural Nationalism." *Tonantzin* 6:2 (May 1989).

DISCOGRAPHY: Longoria, Valerio. *A Través del Tiempo* (1987). HAC7050 (C)*
———. *Besos Callejeros* (1989). HAC7104 (C)*
———. *Ella Me Dijo Que No* (1989). HAC7131 (C)*
———. *Quisiera Llorar* (1989). HAC7083 (C)*
Longoria, Valerio, and Freddy Fender. *Amor Chiquitito with Freddy Fender* (1989). HAC7137 (C)*
Longoria, Valerio, et al. *Texas-Mexican Border Music, Vol. 24; The Texas-Mexican Conjunto*. Arhoolie 9049
*Available through Hacienda Records, 1236 S. Staples, Corpus Christi, TX 78404

George López
Hispanic woodcarver
Córdova, New Mexico
1982 Fellow

BIBLIOGRAPHY: Briggs, Charles L. "The Role of *Mexicano* Artists and the Anglo Elite in the Emergence of a Contemporary Folk Art Form." In *Folk Art and Art Worlds*, edited by John Michael Vlach and Simon Bronner, 195–224. Ann Arbor, Mich.: UMI Research Press, 1986.
———. *The Woodcarvers of Córdova, New Mexico*. Knoxville: University of Tennessee Press, 1980.
Glassie, Henry. *The Spirit of Folk Art: The Girard Collection at the*

Museum of International Folk Art. New York: Harry N. Abrams, Inc., 1989.
Hunt, Marjorie, and Boris Weintraub. "Masters of Traditional Arts." *National Geographic* 179:1 (Jan. 1991).

Albert "Sunnyland Slim" Luandrew

Blues pianist, singer
Chicago, Illinois
1988 Fellow

Born in Mississippi, Albert Luandrew grew up listening to local blues musicians and taught himself to play the piano and organ. His career as a musician began in a movie theater; he later moved to Memphis, Tennessee, where he worked with notable blues performers. An offer to cut a record led Luandrew—by then already known as "Sunnyland Slim"—to Chicago, where he established himself as a major blues artist. A friend and neighbor, Studs Terkel, once said: "Slim is one of the last of the breed of country blues singers who in their youth moved north. An old colleague of Big Bill Broonzy, he, like Bill, has been gallantly and eloquently carrying on in the tradition . . . he is a living piece of our folk history."

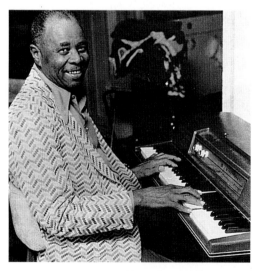

DISCOGRAPHY: Luandrew, Albert "Sunnyland Slim." *After Hours Blues* (c. 1948). BLP. Available through

Biograph Records, 16 River St., Chatham, NY 12010
————. *Blues Jam* (c. 1965). Storyville 245. Available through Down Home Music, Inc., El Cerrito, Calif.
————. *Blues Piano Orgy* (c. 1970). DMK 626*
————. *Blues World of Little Walter* (c. 1953). DMK 648*
————. *Chicago Ain't Nothin' But a Blues Band*. DMK 624*
————. *Cryin' in the Morning*. MUS 5212. Available through Muse Records, 160 W. 71st St., New York, NY 10023
————. *Rare Blues*. ST–72781. Available through Tacoma Records, c/o Allegiance Ltd., 7525 Fountain Ave., Hollywood, CA 90046
————. *Slim's Shout*. PRS 7723. Available through Prestige Records, c/o Fantasy Inc., 10th & Parker, Berkeley, CA 94710
*Available through Delmark Records, 4243 N. Lincoln Ave., Chicago, IL 60618

Marie McDonald

Hawaiian lei maker
Kamuela, Hawaii
1990 Fellow

A descendant of the Mahoe line of Hawaiian chiefs on her maternal side and of the Adams family of New England on her paternal side, Marie McDonald has become one of the best known lei makers in Hawaii. She speaks of leis as exemplifying "arms entwined about another person's neck—mother and child, lover and beloved, friend and friend." After having taught art and Hawaiian studies in public schools for several years, McDonald established Honopua Flower Growers in the city of Waimea. She has also conducted research and fieldwork on lei traditions associated with Hawaiian ranching, and has experimented with raising plants and flowers formerly used in lei making.

BIBLIOGRAPHY: McDonald, Marie A. *Ka Lei: The Leis of Hawaii*. Honolulu: Topgallant, 1985.

Brownie McGhee

Blues guitarist
Oakland, California
1982 Fellow

BIBLIOGRAPHY: Stambler, Irwin, and Grelun Landon. *Encyclopedia of Folk, Country, and Western Music*. New York: St. Martin's Press, 1969.
Traum, Happy. "Brownie McGhee." *Festival of American Folklife* (program). Washington, D.C.: Smithsonian Institution, 1971.

DISCOGRAPHY: McGhee, Brownie. *Brownie Speaks* (1981). Paris-Album 28513.*
————. *Sings the Blues* (1959). Folkways 3557
————. *Traditional Blues, Vol. I* (1960). Folkways 2421
————. *Traditional Blues, Vol. II* (1960). Folkways 2422
McGhee, Brownie, and Sonny Terry. *Brownie McGhee and Sonny Terry Sing*. Smithsonian/Folkways 40011 (LP/C/CD)
————. *Coffee House Blues*. Vee-Jay (Japan) CD1067 (CD)*
————. *I Couldn't Believe* (1969). See For Miles SEE 92*
*Available through Down Home Music, Inc., El Cerrito, Calif.

FILMOGRAPHY: *Dimensions of Black*. Videotape, 59 mins. Producer: KPBS, San Diego, Calif. Distributor: PBS Video.
Sonny Terry and Brownie McGhee. 16mm, black and white, 25 mins. Seattle: Seattle Folklore Society.
Walter Brownie McGhee (1976). 16mm, black and white, 25 mins. Seattle: Seattle Folklore Society.

Hugh McGraw

Shape-note singer
Bremen, Georgia
1982 Fellow

BIBLIOGRAPHY: Boyd, Joe Dan. "The Sacred Harpers and Their Singing." *Festival of American Folklife* (program). Washington, D.C.: Smithsonian Institution, 1970.

DISCOGRAPHY: McGraw, Hugh. *How to Sing Sacred Harp.* Cassette available through Sacred Harp Publishing Company, Inc., Box 185, Bremen, GA 30110

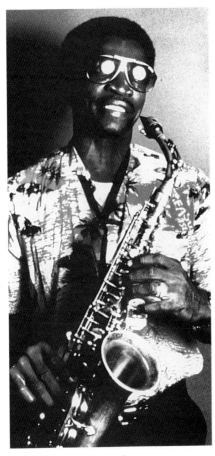

Sylvester McIntosh
Crucian singer, bandleader, wind instrumentalist
Saint Croix, Virgin Islands
1987 Fellow

The popularity of Sylvester McIntosh's music stems from his extensive repertoire of traditional Crucian songs, many of which he learned from his mother. His father was a prominent saxophonist, and the young McIntosh was playing guitar in his band by age fifteen. He later joined a carnival masquerade troupe, and eventually became lead saxophonist of Saint Croix's best-known quadrille band. He has since formed several bands himself: the "Pond Bush Hot Shots," the "Clefs," and, currently, "Blinky and the Roadmasters"—a name derived from his occupation, heavy equipment operator.

DISCOGRAPHY: McIntosh, Sylvester. *Blinky and the Roadmasters* (c. 1989). Rounder 5047 (LP/C/CD)

Wallace McRae
Cowboy poet
Forsyth, Montana
1990 Fellow

Wallace McRae's family has raised sheep and cattle in the Rosebud Creek area of southeastern Montana since 1885. McRae, born in 1936, is a working rancher and cowboy himself, and a practitioner of cowboy poetry. This genre, derived from the narrative poetry of nineteenth-century settlers and ranchers, is still a vital tradition and has its own festival, the Cowboy Poetry Gathering held annually in Elko, Nevada. McRae has written over one hundred poems and three books, on topics ranging from the often humorous concerns of the cowboy to issues such as strip mining in Montana.

BIBLIOGRAPHY: Cannon, Hal, ed. *Cowboy Poetry: A Gathering.* Layton, Utah: Gibbs Smith, 1985.
———. *New Cowboy Poetry: A Contemporary Gathering.* Layton, Utah: Gibbs Smith, 1990.
McRae, Wallace. *Things of Intrinsic Worth.* Edited by Jeri D. Walton. Montana: Outlaw Publishing, 1985.
———. *It's Just Grass and Water.* The Oxalis Group, 1986.
McRae, Wallace, and Jeri D. Walton. *Up North Is Down the Crick.* Montana: Outlaw Publishing, 1985.

DISCOGRAPHY: Cannon, Hal, ed. *Favorite Cowboy Recitations: Cowboy Poets and Their Poems* (1985). Cassette available through Utah Folklife Center, Salt Lake City

FILMOGRAPHY: *Cowboy Poets* (1987). Videotape, color. Producer: Kim Shelton. Elko, Nev.: Western Folklife Center.

Wade Mainer
Appalachian banjo picker, singer
Flint, Michigan
1987 Fellow

Wade Mainer's music has its roots in the Appalachian tradition, but shows the influences of radio and phonographic records. While working in a cotton mill in Concord, North Carolina, Mainer and his brother formed a string band to play at local gatherings. They were soon invited to a popular radio program, Crazy Water Crystal Barn Dance. The success of this broadcast, coupled with Mainer's unique two-finger banjo picking style and his repertoire of traditional tunes, led to further radio performances and numerous recording sessions. In 1953 Mainer left the music business and moved to Flint, Michigan, where he worked for General Motors until his retirement. He returned to banjo music in the 1970s and now plays with his wife, Julia.

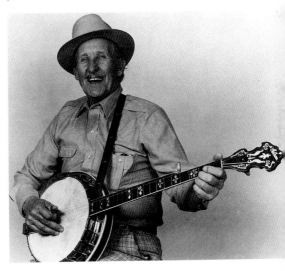

BIBLIOGRAPHY: Malone, Bill C. *Country Music, U.S.A.* Austin: University of Texas Press, 1968.

DISCOGRAPHY: Mainer, Wade. *Early Radio, Vol. I* (recorded c. 1940; 1979 reissue). Old Homestead OHCS124
———. *First Time in Stereo* (1971). Old Homestead 90002 (LP/C)
———. *Mountain Sacred Songs* (c. 1973). Old Homestead 90016
———. *Old Time Banjo Tunes* (1984). Old Homestead 90168

———. *Old Time Songs* (1980). Old Homestead 90123

———. *Sacred Songs of Mother and Home.* Old Homestead OHCS135

———. *Old Time Sacred Songs.* Old Homestead 700665

Mary Jane Manigault

African-American basket maker
Mount Pleasant, South Carolina
1984 Fellow

BIBLIOGRAPHY: Ferris, William. *Afro-American Folk Art and Crafts.* Boston: G. K. Hall, 1983.
Rosengarten, Dale. *Row Upon Row: Sea Grass Baskets of the South Carolina Low Country.* Rev. ed. Columbia: McKissick Museum of the University of South Carolina, 1987.

Mike Manteo

Sicilian-American marionettist
Staten Island, New York
1983 Fellow

BIBLIOGRAPHY: Gold, Donna Lauren. "Plucky Puppets Are the Stars in One Family's Saga." *Smithsonian*, Aug. 1983.
Grogan, David. "Chivalry Lives as Mike Manteo Revives Knights to Remember." *People*, June 1, 1987.
Hufford, Mary, Marjorie Hunt, and Steven Zeitlin. *The Grand Generation: Memory, Mastery, Legacy.* Seattle: University of Washington Press, 1987.
Kalcik, Susan. "Gifts to America." *Festival of American Folklife* (program). Washington, D.C.: Smithsonian Institution, 1976.
Kirshenblatt-Gimblett, Barbara. "Manteo Sicilian Marionette Theater." *New York Folklore Newsletter* 3:2 (1982): 1, 10.

Narciso Martínez

Texas-Mexican *conjunto* accordionist, composer
San Benito, Texas
1983 Fellow

Narciso Martínez, considered one of the fathers of *conjunto* music, is highly regarded for his original compositions and lively accordion style. He is known as *"El Huracán del Valle,"* but his popularity has spread far beyond the Rio Grande Valley. In the 1930s, developing Spanish-language radio stations were eager to play his recordings, which helped launch his career. In 1982 Martínez was honored as a charter member of the *Conjunto* Music Hall of Fame.

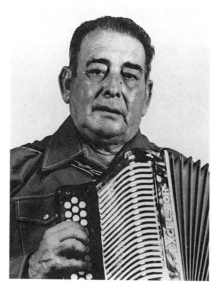

BIBLIOGRAPHY: Reyna, José R. "Tejano Music as an Expression of Cultural Nationalism." *Tonantzin* 6:2 (May 1989).

DISCOGRAPHY: Martínez, Narciso. *The Father of Tex-Mex Conjunto* (1989). Folklyric 9055
———. *Texas-Mexican Border Music, Vol. 10; Narciso Martínez, "El Huracán del Valle," Part 1: His First Recordings, 1936–1937.* Arhoolie 9017
Martínez, Narciso, et al. *Texas-Mexican Border Music, Vol. 4; Norteño Accordion Music, Part 1: The First Recordings.* Arhoolie 9006 (LP), 218 (C)

FILMOGRAPHY: *Chulas Fronteras.* 16mm, videotape; color, 58 mins. By Chris Strachwitz and Les Blank. Distributor: Flower Films, El Cerrito, Calif.

Lanier Meaders

Potter
Cleveland, Georgia
1983 Fellow

BIBLIOGRAPHY: Burrison, John A. *Brothers in Clay: The Story of Georgia Folk Pottery.* Athens: University of Georgia Press, 1983.
Ferris, William. *Afro-American Folk Art and Crafts.* Chapel Hill and London: The University of North Carolina Press, 1983.
Glassie, Henry. *The Spirit of Folk Art: The Girard Collection at the Museum of International Folk Art.* New York: Harry N. Abrams, Inc., 1989.
Rinzler, Ralph, and Robert Sayers. *The Meaders Family: North Georgia Potters.* Smithsonian Folklife Studies, no. 1. Washington, D.C.: Smithsonian Institution Press, 1980.
Wadsworth, Anna. *Missing Pieces: Georgia Folk Art, 1770–1976* (exhibition catalogue). Tucker: Georgia Council for the Arts and Humanities, 1976.

FILMOGRAPHY: *The Meaders Family: North Georgia Potters.* 16mm, color, 30 mins. Smithsonian Folklife Studies. Washington, D.C.: Smithsonian Institution.
Missing Pieces: Georgia Folk Art, 1770–1976 (1976). 16mm, color, 28 mins. By Steve Heiser. Tucker: Georgia Council for the Arts and Humanities.

Leif Melgaard

Norwegian-American woodcarver
Minneapolis, Minnesota
1985 Fellow

BIBLIOGRAPHY: Henning, Darrell D., Marion J. Nelson, and Roger L. Welsch, eds. *Norwegian-American Wood Carving of the Upper Midwest.* Decorah, Iowa: The Norwegian-American Museum, 1978.

Lydia Mendoza

Mexican-American singer
Houston, Texas
1982 Fellow

Lydia Mendoza, *"La Alondra de la Frontera"* (the lark of the border), began performing at age ten with her family's musical group, which toured small towns in the lower Rio Grande valley. Accompanying herself on a twelve-string guitar, Mendoza sang the popular melodies of working-class Mexican Americans living along the Mexico-Texas border. She has traveled extensively throughout the Southwest and recorded many albums.

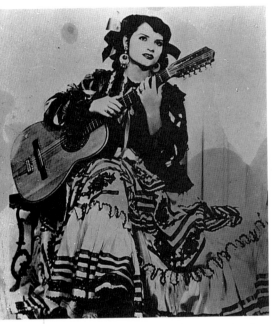

BIBLIOGRAPHY: Gil, Carlos B. "Lydia Mendoza: Houstonian and First Lady of Mexican-American Song." *Houston Review*, Summer 1981.
Peña, Manuel H. *The Texas-Mexican Conjunto: History of a Working Class Music.* Mexican-American Monograph, no. 9. Austin: University of Texas Press, 1985.
Wilson, Charles Reagan, and William Ferris, eds. *Encyclopedia of Southern Culture.* Chapel Hill and London: The University of North Carolina Press, 1989.

DISCOGRAPHY: Mendoza, Lydia. *La Gloria de Texas.* Arhoolie 3012
———. *Lydia Mendoza, La Alondra de la Frontera.* Norteño Records N809*
———. *Lydia Mendoza y Su Guitarra de Oro.* Norteño Records N812*
———. *Texas-Mexican Border Music, Vol. 15; Lydia Mendoza, Part 1: First Recordings 1928–1938.* Arhoolie 9023 (LP), 219 (C)
———. *Texas-Mexican Border Music, Vol. 16; Lydia Mendoza, Part 2: Early Recordings from the 1930s.* Arhoolie 9024 (LP), 219 (C)
Mendoza, Lydia, and Rita Vidaurrie. *20 Exitos de Siempre.* Norteño Records NRC204*
*Available through Norteño Records, 2606 Ruiz St., San Antonio, TX 78228

FILMOGRAPHY: *Chulas Fronteras.* 16mm, videotape; color, 58 mins. By Chris Strachwitz and Les Blank. Distributor: Flower Films, El Cerrito, Calif.

Arthur Moilanen

Finnish-American accordionist
Mass City, Michigan
1990 Fellow

The son of Finnish immigrants to the western Great Lakes region, Arthur Moilanen grew up near Mass City, Michigan. During his youth he learned first the harmonica, then the button accordion, and finally the piano accordion, which he plays today; the Finnish music he heard from neighbors and on recordings laid the foundation for his classically Finnish repertoire. After serving in the Air Force during World War II, Moilanen returned to Michigan and formed his own logging crew. He retired in 1965 and opened a tavern; he retired again when he turned sixty, but later purchased a bar and a motel. Today, on his third attempt at retirement, Moilanen continues to play and teach the accordion.

DISCOGRAPHY: Moilanen, Arthur, et al. *Accordions in the Cutover: Field Recordings of Ethnic Music from Superior's South Shore* (1984). Inland Sea Records. Available through The Wisconsin Folk Museum, 100 South Second Street, Mount Horeb, WI 53572

Bill Monroe

Bluegrass musician
Nashville, Tennessee
1982 Fellow

BIBLIOGRAPHY: Malone, Bill C. *Country Music, U.S.A.* Austin and London: University of Texas Press, 1968.
Shostack, Melvin. *The Country Music Encyclopedia.* New York: Thomas Y. Crowell Co., 1974.
Stambler, Irwin, and Grelun Landon. *Encyclopedia of Folk, Country, and Western Music.* New York: St. Martin's Press, 1969.
Wolfe, Charles K. *Kentucky Country: Folk and Country Music of Kentucky.* Lexington: The University Press of Kentucky, 1982.

DISCOGRAPHY: Monroe, Bill. *Bean Blossom.* MCA Records MCA2–8002
———. *Best of Bill Monroe* (c. 1953). MCA Records MCAC2–4090 (C)
———. *Bill Monroe: Bluegrass 1950–1958.* Bear Family Records BCD 15423 (CD). With 65-page booklet
———. *Columbia Historical Edition* (c. 1946). Columbia Records FCT–38904 (C), CK–38904 (CD)
———. *I Saw the Light.* MCA Records MCA–527 (LP), MCAC–527 (C)
Monroe, Bill, and the Bluegrass Boys. *Southern Flavor.* MCA Records MCA–42133 (LP), MCAC–42133 (C), MCAD–42133 (CD)
Monroe, Bill, et al. *Bill Monroe and Friends.* MCA Records MCAC–949 (C)
———. *MCA Records, 30 Years of Hits, 1958–1988.* MCA Records MCA2–8025 (2LP), MCAC2–8025 (2C), MCAD2–8025 (CD)
Monroe, Bill, Lester Flatt, and Earl Scruggs. *The Original Bluegrass Band* (c. 1946). Rounder SS–06 (LP/C)

FILMOGRAPHY: *Discovering Country and Western Music*. 16mm, videotape; color, 24 mins. Producer: Bernard Wilets. Distributor: BFA Educational Media, Santa Monica, Calif.
The High Lonesome Sound: Kentucky Mountain Music. 16mm, black and white, 30 mins. Stillwater: Oklahoma State University Audio-Visual Center.

Allison "Totie" Montana
Mardi Gras Big Chief, costume maker
New Orleans, Louisiana
1987 Fellow

BIBLIOGRAPHY: Hunt, Marjorie, and Boris Weintraub. "Masters of Traditional Arts." *National Geographic* 179:1 (Jan. 1991). Martínez, Maurice M., Jr. "Delight in Repetition: The Black Indians." *Wavelength*, Feb. 1982.

FILMOGRAPHY: *The Black Indians of New Orleans*. 16mm, videotape; color, 30 mins. Producer: Maurice Martínez. Distributor: Bayou Films, c/o Transit Media, Franklin Lakes, N.J.

Alex Moore, Sr.
Blues pianist
Dallas, Texas
1987 Fellow

BIBLIOGRAPHY: Megar, James. "Alex Moore—Blues Piano" (program notes). Traditional Texas Music Series. Amon Carter Museum Theater, Oct. 29, 1978.

DISCOGRAPHY: Moore, Alex. *Alex Moore* (c. 1964). Arhoolie 1008
―――. *In Europe* (c. 1969). Arhoolie 1048
―――. *Wiggle Tail* (c. 1980). Rounder 2091 (LP/C), 11559 (CD) Moore, Alex, et al. *Texas Blues, Vol. II* (c. 1937). Arhoolie 1017

Vanessa Paukeigope Morgan
Kiowa regalia maker
Anadarko, Oklahoma
1989 Fellow

BIBLIOGRAPHY: Mayeux, Lucie. "Carrying on a Kiowa Tradition." *The New Mexican*. Santa Fe, Aug. 20, 1989.

Genevieve Nahra Mougin
Lebanese-American lace maker
Bettendorf, Iowa
1984 Fellow

BIBLIOGRAPHY: Hufford, Mary, Marjorie Hunt, and Steven Zeitlin. *The Grand Generation: Memory, Mastery, Legacy*. Seattle: University of Washington Press, 1987.
Ohrn, Steve, ed. *Passing Time and Traditions: Contemporary Iowa Folk Artists*. Ames: Iowa State University Press, 1984.

Bua Xoa Mua
Hmong musician
Portland, Oregon
1985 Fellow

BIBLIOGRAPHY: "Fighting to Keep Their Faith." *The Oregonian*. Portland, Feb. 27, 1985.
"Little Bua and Tall Jan." *The Oregonian*. Portland, Aug. 1984.

DISCOGRAPHY: Mua, Bua Xoa, et al. *Folk Arts in the Classroom*. Cassette available through Oregon Folk Arts Program, Lewis and Clark College, 615 S.W. Palatine Hill Rd., Portland, OR 97219

Martin Mulvihill
Irish-American fiddler
Bronx, New York
1984 Fellow

Martin Mulvihill was born in 1923 in Ballygoughlin, West Limerick, Ireland, a region with strong musical traditions. He learned to fiddle from his mother and later added the piano and button accordion to his repertoire. In 1971 Mulvihill and his family moved to New York City, where he established the Martin

Mulvihill School in the Bronx. He has also taught the music of his native country in Irish communities throughout New Jersey, Connecticut, and Pennsylvania.

DISCOGRAPHY: Mulvihill, Martin. *Traditional Irish Fiddling*. Green Linnet 1012 (C)
Mulvihill, Martin, et al. *Irish Traditional Instrumental Music from the East Coast of America, Vol. 1*. Rounder 6005

Mabel Murphy
Anglo-American quilter
Fulton, Missouri
1989 Fellow

In 1915—at the age of eight—Mabel Murphy made her first quilt, and she has not stopped quilting since, creating gifts for friends and family occasions. For her sister's wedding she made a Lover's Link quilt, and each grandchild who graduates from college receives a Rainbow quilt. In the 1950s and 1960s, when quilting declined, Murphy tried to stimulate interest by speaking to various groups and clubs. As enthusiasm revived, she began to invite other quilters to her home on Thursdays, a practice she continues today. Amazed by the current popularity of quilting, she comments: "If anyone had told me there'd be a day when so many

people would quilt, I wouldn't have believed them."

BIBLIOGRAPHY: Hunt, Marjorie, and Boris Weintraub. "Masters of Traditional Arts." *National Geographic* 179:1 (Jan. 1991). Roberson, Margot. "The Meetin' Place." *Quilter's Newsletter Magazine*, Jan. 1985.

Julio Negrón Rivera

Puerto Rican instrument maker
Morovis, Puerto Rico
1985 Fellow

For generations, religious activities dedicated to *la Virgen del Carmen*—including music and songs—have played an important role in the community life of Morovis. As part of this musical tradition, Julio Negrón Rivera learned and mastered the skills required to make the *cuatro*, a ten-string guitar. Similar in shape to the lute and the Spanish guitar, the *cuatro* originally had four strings—hence its name; in the late nineteenth century, however, it became customary to make it with ten strings.

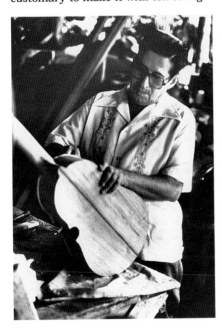

Joyce Doc Tate Nevaquaya

Comanche flutist
Apache, Oklahoma
1986 Fellow

DISCOGRAPHY: Nevaquaya, Joyce Doc Tate. *Comanche Flute Music.* Available through Ethnic Folkways Records
————. *Indian Flute Songs from Comanche Land* (1976). Native American Music NAM401C

Alice New Holy Blue Legs

Lakota quill artist
Grass Creek, South Dakota
1985 Fellow

FILMOGRAPHY: *Lakota Quillwork: Art and Legend.* 16mm, videotape; color, 28 mins. Producer: H. Jane Nauman. Distributor: Onewest Media, Santa Fe

Yang Fang Nhu

Hmong weaver, embroiderer
Detroit, Michigan
1988 Fellow

Yang Fang Nhu grew up in a small Hmong village in northern Laos and was taught weaving by her mother. In 1978 she and her husband left Laos for France, and in 1984 they moved to the United States to live with their youngest son in Providence, Rhode Island. Yang Fang Nhu's interest in passing on her weaving and embroidery skills led her to participate in a Rhode Island State Council on the Arts project to build a loom and demonstrate Hmong dyeing and weaving techniques. Her dedication is best described by Hmong Loom Project Coordinator Carolyn Shapiro: "For Fang Nhu, weaving is not just making cloth. She is weaving a social fabric. Her care for her craft is the care and nurturing of her people. It is the thread that links them to their ancestors and to each other."

BIBLIOGRAPHY: Lambrecht, Winnie, and Carolyn Shapiro. *Blue Hmong Loom and Weaving* (pamphlet). Providence: Rhode Island State Council on the Arts.

Glenn Ohrlin

Cowboy singer, storyteller, illustrator
Mountain View, Arkansas
1985 Fellow

BIBLIOGRAPHY: Ohrlin, Glenn. *The Hell-Bound Train: A Cowboy Song Book.* Urbana: The University of Illinois Press, 1973.

DISCOGRAPHY: Ohrlin, Glenn. *The Hell-Bound Train.* University of Illinois Campus Folksong Club CFC301
————. *1986 Cowboy Poetry Gathering: Funny Situations.* CP2–039 (C)*
————. *1986 Cowboy Poetry Gathering: Plains States Poets.* CP2–004 (C)*
————. *1987 Cowboy Poetry Gathering: Modern Cowboy Songs.* CP3–309 (C)*
————. *1989 Cowboy Poetry Gathering: Spanish Is the Loving Tongue.* CP5–543 (C)*
————. *Stone Country Singing.* Shoestring Tape SGB–1
————. *The Wild Buckaroo.* Rounder 0158
Ohrlin, Glenn, et al. *Cowboy Tour* (1983). Cassette available through National Council for the Traditional Arts, 806 15th St. N.W. #400, Washington, D.C. 20005
*Available through Worldwide Communications, 320 Stewart St., Reno, NV 89502

Luis Ortega

Hispanic rawhide worker
Paradise, California
1986 Fellow

BIBLIOGRAPHY: Ortega, Luis B. "The California Falsarienda." *Western Horseman*, Dec. 1953.
————. "California Hackamore Tips." *Western Horseman*, Feb. 1954.
————. "The Headstrong Horse." *Western Horseman*, June 1951.

———. "El Mecate: The Hair Rope." *Western Horseman*, Apr. 1955.

———. "An Old Ranch Custom." *Western Horseman*, Feb. 1951.

———. "Tying the Mecate." *Western Horseman*, Oct. 1954.

Scopinich, Jill. "Luis Ortega: The Artist, the Vaquero, and the Man." *Pacific Coast Journal*, May 1985.

Elijah Pierce
African-American carver, painter
Columbus, Ohio
1982 Fellow

BIBLIOGRAPHY: Horwitz, Elinor Lander. *Contemporary American Folk Artists*. Philadelphia and New York: J. B. Lippincott Company, 1975.

Hufford, Mary, Marjorie Hunt, and Steven Zeitlin. *The Grand Generation: Memory, Mastery, Legacy*. Seattle: University of Washington Press, 1987.

Moe, John. *Elijah Pierce: The Life of an Afro-American Woodcarver*. Athens: University of Georgia Press, forthcoming.

Wadsworth, Anna. *Missing Pieces: Georgia Folk Art, 1770–1976* (exhibition catalogue). Tucker: Georgia Council for the Arts and Humanities, 1976.

FILMOGRAPHY: *Elijah Pierce, Woodcarver* (1974). 16mm, color, 20 mins. Producer: Carolyn Jones. Columbus: Ohio State University. *Sermons in Wood* (1976). 16mm, videotape; color, 27 mins. Producers: Carolyn Jones Allport, Raymond L. Kook. Memphis: Center for Southern Folklore.

Adam Popovich
Serbian-American tamburitza musician
Dolton, Illinois
1982 Fellow

As director and musical arranger of the Sloboda Choir in Chicago, head of the city's Tambura Ensemble, and member of the Popovich Brothers tamburitza orchestra, Adam Popovich is a widely respected leader of the Serbian- and Croatian-American tamburitza musical tradition. Speaking of him, folklorist Margy McClain states: "Adam's life and work truly show how community and art are inseparable." Born in Colorado in 1909, Popovich learned Serbian traditions from his immigrant parents. While still a youngster he began taking tamburitza lessons with two of his brothers, and they soon formed their own touring orchestra. After settling in South Chicago, Popovich began his close and lasting involvement with the area's Serbian- and Croatian-American communities.

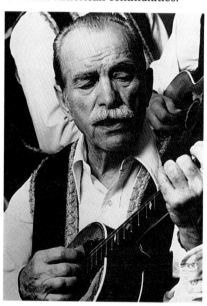

BIBLIOGRAPHY: Raim-Zinser, Ethel, and Martin Koenig. "Tamburashi Tradition." *Festival of American Folklife* (program). Washington, D.C.: Smithsonian Institution, 1973.

DISCOGRAPHY: Popovich, Adam. *Sing with Teddy and the Popovich Brothers, Vol. 1, Vol. 2, Vol. 3, Vol. 4, Vol. 5, Vol. 6, Vol. 7, Vol. 8*. Cassettes available through Festival Records, 2773 West Pico Blvd., Los Angeles, CA 90006

FILMOGRAPHY: *Ziveli: Medicine for the Heart*. 16mm, videotape; color, 51 mins. By Andre Simic and Les Blank. Distributor: Flower Films, El Cerrito, Calif.

Ola Belle Reed
Appalachian banjo picker, singer
Rising Sun, Maryland
1986 Fellow

At the time Ola Belle Campbell's father moved his family of thirteen children to northeastern Maryland during the Depression, his ancestors had lived in the New River Valley area of western North Carolina since the 1760s. Thus, the Campbells brought to their new home a long and rich history of Appalachian traditions. Ola Belle grew up listening to the music of her father and grandfather, and to her mother's and grandmother's ballads and songs. She herself learned to play the banjo and sing traditional Appalachian tunes, and in 1949 organized the "New River Boys" band with her husband, Bud Reed, and her brother Alex. She still performs with her husband and her son David at festivals across the country.

BIBLIOGRAPHY: Camp, Charles, and David E. Whisnant. "A Voice from Home." *Southern Exposure* 5:2,3 (1977).

DISCOGRAPHY: Reed, Ola Belle, Alex Campbell, and New River Boys. *Travel On*. Starday Records SLP–342*

Reed, Ola Belle, Bud Reed, and David Reed. *My Epitaph*. Folkways FA2493

———. *Ola Belle Reed and Family* (1972). Rounder 0077

Reed, Ola Belle, Bud Reed, David Reed, and John Miller. *Ola Belle Reed* (1972). Rounder 0021
Reed, Ola Belle, et al. *All in One Evening* (1978). Folkways FA2329
———. *Ola Belle and Alex*. Starday Records, SLP–214*
———. *Women of Old Time Music: Brandywine Mountain Music Convention 1980* (1980). Heritage XXXVI**
Reed, Ola Belle, New River Boys, et al. *Early Country Radio: Brandywine Mountain Music Convention 1979* (1979). Heritage XXX**
*Available through Starday Records, Box 115, Madison, TN 37115
**Available through Heritage Records, Rt. 3, Box 278, Galax, VA 24333

FILMOGRAPHY: *Calling Me Home: Music from the Maryland-Pennsylvania Border*. 16mm, color, 22 mins. University Park: Pennsylvania State University Audio-Visual Services.
The Folk Way. Videotape, 60 mins. Owing Mills: Maryland Center for Public Broadcasting.
Ola Belle Reed: Memories. 16mm, color, 14 mins. Director: Gei Zantzinger. University Park: Pennsylvania State University.

Almeda Riddle
Ballad singer
Greers Ferry, Arkansas
1983 Fellow

Born in 1898, Almeda Riddle—or "Granny," as she preferred to be called—was raised in the Ozark ballad traditions of Arkansas. Although her father played a key role in her musical training, her solo singing style was her own. Riddle's importance as a tradition-bearer is most aptly described by folklorist Roger Abrahams: "She is not only a singer, but also a lifelong collector of ballads and a writer and rewriter of songs—in fact, a person who has virtually lived her life in songs and whose values are reflected in the choice of songs she will sing."

BIBLIOGRAPHY: Abrahams, Roger D. *A Singer and Her Songs: Almeda Riddle's Book of Ballads*. Baton Rouge: Louisiana State University Press, 1970.

DISCOGRAPHY: Riddle, Almeda James. *Ballads and Hymns from the Ozarks* (1972). Rounder 0017
———. *How Firm a Foundation: Favorite Religious Songs of Almeda Riddle of Greers Ferry* (1984). Arkansas Traditions 003. Cassette available through Arkansas Traditions, Rt. 73, Box 166, Mountain View, AR 72560
———. *More Ballads and Hymns from the Ozarks* (c. 1976). Rounder 0083

Georgeann Robinson
Osage ribbonworker
Bartlesville, Oklahoma
1982 Fellow

FILMOGRAPHY: *Ribbons of the Osage: The Art and Life of Georgeann Robinson*. Videotape, color, 28 mins. Distributor: Full Circle Communications, Tulsa, Okla.

LaVaughn E. Robinson
African-American tap dancer
Philadelphia, Pennsylvania
1989 Fellow

BIBLIOGRAPHY: *Works-in-Progress: Newsletter of the Philadelphia Folklore Project* 2:3 (1989).

Emilio and Senaida Romero
Hispanic tin and embroidery workers
Santa Fe, New Mexico
1987 Fellows

BIBLIOGRAPHY: Alba, Victoria. "The Romeros Transform Tin into Gold." *New Mexican, Pasatiempo*, Oct. 23, 1987.
Hazen-Hammond, Suzanne. "Art from Poor Man's Silver." *New Mexico Magazine*, Dec. 1984.
Lyon, Laura Hinton. "The Tinsmiths." *Santa Fe Reporter*, Summer 1979.

Emilio Rosado
Puerto Rican woodcarver
Utuado, Puerto Rico
1990 Fellow

According to the folklore of his hometown, the moment Emilio Rosado was born in 1911, "all the neighborhood roosters began to crow, and they crowed on and on until they became hoarse, honoring the infant who was to become the greatest bird carver in Puerto Rican history." Rosado, who raises roosters and is knowledgeable about them, was born into a family tradition of woodcarving: his grandfather's brother carved oxen yokes, machete handles, and walking sticks, and his father carved all his tool handles. Although he makes other items as well, Rosado prefers to carve roosters; he likes to use a single piece of cedar, which he says "is a special wood with a special story. When you cut down a cedar tree there is always a small hollow inside; that is where the Blessed Virgin hid on the flight to Egypt. That is why cedar smells so wonderfully good."

Simon St. Pierre
French-American fiddler
Smyrna Mills, Maine
1983 Fellow

Born in Quebec, Canada, Simon St. Pierre learned to play the fiddle from his father, grandfather, and other

241

family members. Like many other young men in his community, he took up work in logging camps, where he entertained fellow lumberjacks with his music and heard other eastern Canadian tunes. In the 1950s St. Pierre moved to Smyrna Mills, Maine, where he continues to work as a lumberjack and to play the fiddle, often treating his audiences to intricate foot clogging (*frapper du pied*) while he performs.

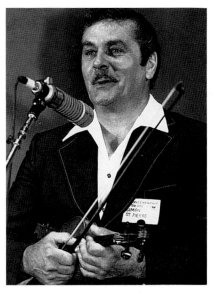

DISCOGRAPHY: St. Pierre, Simon. *Fiddler from Maine.* Renovah Records
———. *The Joys of Quebec.* Renovah Records 915
———. *The Woods of Maine.* Renovah Records
St. Pierre, Simon, and the Balfa Brothers, et al. *Music of French America.* Rounder 6010

Earl Scruggs
Bluegrass banjo player
Madison, Tennessee
1989 Fellow

BIBLIOGRAPHY: Malone, Bill C. *Country Music, U.S.A.* Austin and London: University of Texas Press, 1968.
Wilson, Charles Reagan, and William Ferris, eds. *Encyclopedia of Southern Culture.* Chapel Hill and London: The University of North Carolina Press, 1989.

DISCOGRAPHY: Scruggs, Earl, and Lester Flatt. *Columbia Historic Edition* (c. 1948). Columbia PCT–37469 (C), CK–37469 (CD)
———. *Don't Get above Your Raisin'* (c. 1948). Rounder SS–08 (LP/C)
———. *The Golden Era* (c. 1949). Rounder SS–05 (LP/C)
———. *Golden Hits of Lester Flatt and Earl Scruggs* (c. 1953). Gusto Records 6297
———. *Hear the Whistles Blow.* Gusto Records 4001 (LP), GT5–4001 (C)
———. *Preachin', Prayin', Singin'.* Starday, c/o Gusto Records 303 (LP), GT5–303 (C)
Scruggs, Earl, et al. *Folk Classics (Roots of American Folk Music).* Columbia FTC–45026 (C), CK–45026 (CD)
———. *Mercury Records: 40 Years of Country Music, Vol. 1 (1948–1959).* Mercury Records 836523–4 (C)

Duff Severe
Saddlemaker and rawhide worker
Pendleton, Oregon
1982 Fellow

BIBLIOGRAPHY: Hufford, Mary, Marjorie Hunt, and Steven Zeitlin. *The Grand Generation: Memory, Mastery, Legacy.* Seattle: University of Washington Press, 1987.
Hunt, Marjorie, and Boris Weintraub. "Masters of Traditional Arts." *National Geographic* 179:1 (Jan. 1991).
Jones, Suzi, ed. *Webfoots and Bunchgrassers: Folk Art of the Oregon Country.* Salem: Oregon Arts Commission, 1980.

Joe Shannon
Irish-American piper
Chicago, Illinois
1983 Fellow

Born in Ireland in 1920, Joe Shannon emigrated to Chicago with his family six years later. During his early teens he became interested in the *uilleann* pipes, Ireland's distinctive bagpipes. An uncle, Ed Mullaney, then one of

the last remaining players of the *uilleann* in Chicago, taught him the fundamentals of this complex, elaborately ornamental style of music. Shannon then turned to early recordings by Patsy Tuohey and Tom Ennis, two of the best known Irish-American *uilleann* pipers, to learn the articulation, phrasing, and drive characteristic of early-twentieth-century Irish piping in America.

DISCOGRAPHY: Shannon, Joe, and Johnny McGreevy. *Joe Shannon and Johnny McGreevy.* Green Linnet 1023 (LP/C)
Shannon, Joe, et al. *Irish Traditional Instrumental Music from Chicago, Vol. 2.* Rounder 6006

Harry V. Shourds II
Wildfowl-decoy carver
Seaville, New Jersey
1989 Fellow

BIBLIOGRAPHY: MacKey, William F., Jr. *American Bird Decoys.* New York: Dutton, 1965.

Kenny Sidle
Anglo-American fiddler
Newark, Ohio
1988 Fellow

Given a fiddle as a boy, Kenny Sidle learned to play from his father and grandfather. He has since become a legendary master fiddler, earning a

reputation as one of the finest not only in his home state of Ohio, where he was born in 1931, but throughout the nation as well. An avid contest fiddler, he has repeatedly placed in the top ten spots of the Grand Masters Fiddle Championships in Nashville, Tennessee. Sidle's repertoire reflects the Texan and French-Canadian influences that enrich the fiddling tradition in Ohio.

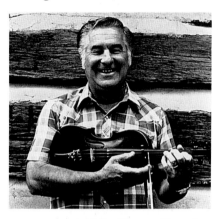

DISCOGRAPHY: Sidle, Kenny. *Favorite Fiddle Tunes* (1977). JRC81043 (LP/C)*
————. *Fiddle Memories* (1989). Starr–SPL–72589 (C)*
Sidle, Kenny, et al. *Seems Like Romance to Me* (1985). GFS–901. Available through Gambier Folklore Society, Kenyon College, Gambier, OH 43022
*Available through Rome Recording Co., 1414 E. Broad St., Columbus, OH 43025

Philip Simmons

African-American blacksmith, ornamental ironworker
Charleston, South Carolina
1982 Fellow

BIBLIOGRAPHY: Ferris, William. *Afro-American Folk Art and Crafts*. Boston: G. K. Hall, 1983.
Vlach, John Michael. *The Afro-American Tradition in Decorative Arts*. Cleveland: Cleveland Museum of Art, 1978.
————. *Charleston Blacksmith: The Work of Philip Simmons*. Athens: University of Georgia Press, 1981.

FILMOGRAPHY: *Philip Simmons* (1988). Videotape. Producer: Herman Rich. Columbia: South Carolina State Museum.

Howard "Sandman" Sims

African-American tap dancer
New York, New York
1984 Fellow

BIBLIOGRAPHY: "Talk of the Town." *The New Yorker*, Oct. 1, 1984.

FILMOGRAPHY: *Julie Andrews's Invitation to the Dance, with Rudolf Nureyev* (1981). Videotape, color, 60 mins. Athens: University of Georgia, Peabody Recording Center.
No Maps on My Taps (1978). 16mm, videotape; color, 58 mins. Producer, director: George T. Nierenberg. Distributor: Direct Cinema, Ltd., Los Angeles.
Tap (1989). 16mm, color, 110 mins. Director: Nick Castle. Producers: Gary Adelson, Richard Vane. Chicago: Tri-Star Pictures.

Willie Mae Ford Smith

African-American gospel singer
St. Louis, Missouri
1988 Fellow

To Willie Mae Ford Smith, "the gospel song is the Christian blues. I'm like the blues singer; when something's rubbing me wrong, I sing out my soul to settle me down." Smith was born in 1906 in the Central Mississippi Delta, into a devout Baptist family, and her gospel-singing career began with three of her sisters at the First Baptist Convention of 1922. She helped create the National Convention of Gospel Choirs and Choruses, an organization she directed for many years.

DISCOGRAPHY: Smith, Willie Mae Ford. *I'm Bound for Canaan Land* (c. 1955). Savoy Records 14739 (LP), SC–14739 (C)
Smith, Willie Mae Ford, et al. *Say Amen, Somebody* (c. 1980). SB2L–12584 (2LP), SBLC–12584 (C), CDSBL–12584 (CD). Available through DRG Records, 130 W. 57th St. #5B, New York, NY 10019

FILMOGRAPHY: *Say Amen, Somebody* (1982). 16mm, videotape. Producer: George T. Nierenberg. Distributor: MGM/UA, New York.

Robert Spicer

Flatfoot dancer
Dickson, Tennessee
1990 Fellow

Flatfoot dancing, an improvisational solo form also known as buck dancing, is a blend of African and Celtic foot-stepping traditions with a long history in communities throughout Tennessee. Robert Spicer, who has lived in Dickson County since his birth in 1921, was seven years old when he first saw a flatfoot dancer in Charlotte and vowed to learn the steps. Today, Spicer is an accomplished flatfoot dancer, teacher, and professional square dance caller and organizer in his native state.

Clyde "Kindy" Sproat

Hawaiian cowboy singer, ukulele musician
Kapa'au, Hawaii
1988 Fellow

BIBLIOGRAPHY: Martin, Lynn J., ed. *Na Paniolo o Hawai'i*. Honolulu: Honolulu Academy of Arts, 1987.

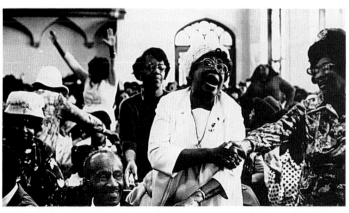

Widner, Jill. "Kindy Sproat: Backporch Purist." *Honolulu: The Paradise of the Pacific*, Dec. 1988.

DISCOGRAPHY: Sproat, Clyde "Kindy." *Na Mele O Paniolo: Songs of Hawaiian Cowboys* (1987). Cassette available through Hawaii State Foundation on Culture and the Arts, 335 Merchant St., Rm. 202, Honolulu, HI 96813
Sproat, Clyde "Kindy," et al. *1989 Cowboy Poetry Gathering: Yodeling Workshop*. Available through Worldwide Communications, 320 Stewart St., Reno, NV 89502

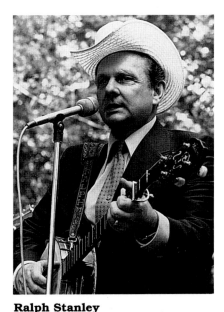

Ralph Stanley
Appalachian banjo player, singer
Coeburn, Virginia
1984 Fellow

Ralph Stanley and his brother Carter grew up in the Clinch Mountain area of southwestern Virginia. They learned to play the banjo from their mother, who also taught them an extensive repertoire of old English ballads and religious a capella songs. The Stanley Brothers soon began performing on local radio stations and eventually on Tennessee's WCYB, which broadcasts to a five-state region. After Carter Stanley's death in the mid-1960s, his brother remained active professionally, performing and recording on his own. An admirer has written: "He has

continued in his unswerving ways, the creator of a sound so traditional that he is considered by many to be the epitome of 'mountain soul,' the musician who is the best exemplar of the 'high lonesome sound' so important in Appalachian music."

BIBLIOGRAPHY: Malone, Bill C. *Country Music, U.S.A.* Austin and London: University of Texas Press, 1968.

DISCOGRAPHY: Stanley, Ralph. *Down Where the River Bends.* Rebel 1579*
Stanley, Ralph, and Carter Stanley. *Bluegrass in Concert.* King K864
————. *Everybody's Country Favorites.* King K690
————. *The Stanley Brothers: Sacred Songs from the Hills.* Starday 122*
————. *The Stanley Brothers: Stanley Series Volume 2, Number 3* (1986). Copper Creek CCSS–V2N3 (LP/C)
Stanley, Ralph, Carter Stanley, and the Clinch Mountain Boys. *Country Pickin' and Singin'* (1958). Stetson Hat 3125 (LP/C)
————. *Hymns and Sacred Songs.* King K645
Stanley, Ralph, and Larry Sparks and the Country Gentlemen. *Christmas Time Back Home.* Appalshop RB1600 (LP/C)
*Available through Down Home Music, Inc., El Cerrito, Calif.

Alex Stewart
Cooper, woodworker
Sneedville, Tennessee
1983 Fellow

BIBLIOGRAPHY: Anderson, Clay, Andy Leon Harney, et al. *The Craftsman in America.* Washington, D.C.: National Geographic Society, 1975.
Hufford, Mary, Marjorie Hunt, and Steven Zeitlin. *The Grand Generation: Memory, Mastery, Legacy.* Seattle: University of Washington Press, 1987.
Wigginton, Eliot, ed. *Foxfire 3.* Garden City, N.Y.: Doubleday, Anchor Press, 1975.

FILMOGRAPHY: *Alex Stewart: Cooper* (1973). 16mm, color, 13 mins. Producers: Tom Burton, Jack Schrader. Distributor: Instructional Media Center, East Tennessee State University, Johnson City.

Margaret Tafoya
Santa Clara Pueblo potter
Santa Clara Pueblo, New Mexico
1984 Fellow

BIBLIOGRAPHY: Dillingham, Rick, Richard W. Lang, and Rain Parrish. *The Red and the Black: Santa Clara Pottery by Margaret Tafoya; A Retrospective Exhibition at the Wheelwright Museum of the American Indian.* Santa Fe: Wheelwright Museum of the American Indian, 1983.
Hufford, Mary, Marjorie Hunt, and Steven Zeitlin. *The Grand Generation: Memory, Mastery, Legacy.* Seattle: University of Washington Press, 1987.
Hunt, Marjorie, and Boris Weintraub. "Masters of Traditional Arts." *National Geographic* 179:1 (Jan. 1991).

David Tarras
Klezmer clarinettist
Brooklyn, New York
1984 Fellow

BIBLIOGRAPHY: Ferraro, Susan. "The Clamor for Klezmer." *American Way*, July 1983.
Slobin, Mark. "The Neo-*Klezmer* Movement and Euro-American Musical Revivalism." *Journal of American Folklore* 97 (1984).

DISCOGRAPHY: Tarras, David, et al. *Dave Tarras, Vol. 1* (1989). Global Village 105 (C)*
————. *Dave Tarras, Vol. 2* (1989). Global Village 106 (C)*
————. *Master of the Jewish Clarinet.* BA US 1002 (C). Available through Ethnic Folk Arts Center, 131 Varick St. #907, New York, NY 10013
*Available through Global Village Music, P.O. Box 2051, Cathedral Station, New York, NY 10025

Sanders "Sonny Terry" Terrill
Blues musician
Holliswood, New York
1982 Fellow

DISCOGRAPHY: Terrill, Sanders "Sonny Terry." *Gotta Move Your Baby*. Prestige P7831
————. *On the Road* (1959). Folkways 2369
————. *Sonny Is King* (c. 1962). Bluesville c/o Fantasy Records OBC–521
————. *Whoopin'* (c. 1977). ALG4734. Available through Alligator Records, P.O. Box 60234, Chicago, IL 60660
Terrill, Sanders "Sonny Terry," and Brownie McGhee. *Brownie McGhee and Sonny Terry* (1958). Smithsonian/Folkways 40011 (LP/C/CD)
————. *Coffee House Blues*. Vee-Jay (Japan) CD1067 (CD)*
————. *I Couldn't Believe*. (1969) See For Miles SEE 92*
Terrill, Sanders "Sonny Terry," and Buster Brown. *Toughest Terry and Baddest Brown*. Sundown 709–11*
*Available through Down Home Music, Inc., El Cerrito, Calif.

FILMOGRAPHY: *Dimensions in Black*. Videotape, 59 mins. Producer: KPBS, San Diego, Calif. Distributor: PBS Video.
Sonny Terry. 16mm, black and white, 25 mins. Seattle: Seattle Folklore Society.
Sonny Terry and Brownie McGhee. 16mm, black and white, 25 mins. Seattle: Seattle Folklore Society.

Jennie Thlunaut
Tlingit Chilkat blanket weaver
Haines, Alaska
1986 Fellow

BIBLIOGRAPHY: Worl, Rosita, and Charles Smythe. "Jennie Thlunaut: Master Chilkat Blanket Artist." In Suzi Jones, ed. *The Artists behind the Work: Life Histories of Nick Charles, Sr., Frances Demientieff, Lena Sours, and Jennie Thlunaut*. Fairbanks: University of Alaska Museum, 1986.

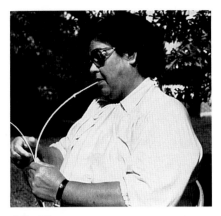

Ada Thomas
Chitimacha basket maker
Charenton, Louisiana
1983 Fellow

The Chitimacha Indians of Louisiana have long been known for their intricately patterned, double-weave, split-cane baskets. Ada Thomas learned these basketmaking skills as a child from her grandmother and aunt. After raising her own family in Florida, she moved back to Louisiana and began teaching basketry at a Charenton school. Prior to her return, only a few local women were still making baskets, and none was working in the double-weave style. Thus, Thomas's commitment to her art has helped insure the continuance of a beautiful Chitimacha tradition.

BIBLIOGRAPHY: Gregory, H. F. "Pete." "'A Promise from the Sun': The Folklife Traditions of Louisiana Indians." In Nicholas K. Spitzer, ed. *Louisiana Folklife: A Guide to the State*. Baton Rouge: Louisiana Folklife Program, 1985.
Wilby, Ruth Trowbridge. "The Weave Goes On." *Dixie*, Nov. 7, 1976.

Paul Tiulana
Eskimo mask maker, dancer, singer
Anchorage, Alaska
1984 Fellow

BIBLIOGRAPHY: Senungetuk, Vivian, and Paul Tiulana. *A Place for Winter: Paul Tiulana's Story*. Anchorage: CIRI Foundation, 1987.

Lucinda Toomer
African-American quilter
Dawson, Georgia
1983 Fellow

BIBLIOGRAPHY: Ferris, William. *Afro-American Folk Art and Crafts*. Boston, Mass.: G. K. Hall, 1983.
Vlach, John Michael. *The Afro-American Tradition in the Decorative Arts*. Cleveland: Cleveland Museum of Art, 1978.
Wadsworth, Anna. *Missing Pieces: Georgia Folk Art, 1770–1976* (exhibition catalogue). Tucker: Georgia Council for the Arts and Humanities, 1976.
Wahlman, Maude Southwell, and Ella King Torrey. *Ten Afro-American Quilters* (exhibition catalogue, University of Mississippi Center for the Study of Southern Culture). University, Miss.: The University Press of Mississippi, 1983.

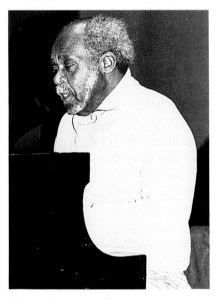

Henry Townsend
Blues musician, songwriter
Saint Louis, Missouri
1985 Fellow

Henry Townsend left his Shelby, Mississippi, home in 1918, at the age of nine; his blues career began some twelve years later in Saint Louis. Drawing on the Delta country music traditions of his youth, Townsend first learned the guitar and then the piano. By 1935 he had accompanied many

notable musicians and had achieved a distinguished reputation of his own. Like several other African-American musicians of the time, he became very popular in Europe in the 1950s. Today, Townsend continues to perform and teach the blues.

DISCOGRAPHY: Townsend, Henry. *Blues in St. Louis, No. 3* (c. 1964). Folkways 3816
Townsend, Henry, et al. *Blues Rediscoveries* (1929). Folkways RBF11. Anthology
———. *St. Louis Blues, 1929–35.* Yazoo 1030. Anthology available through Shanachie, 37 E. Clinton St., Newton, NJ 07860
———. *Things Have Changed* (1969). Catalogue no. 1012. Anthology available through Adelphi, Box 7688, Silver Spring, MD 20907

FILMOGRAPHY: *Blues Like Showers of Rain* (1986). Videotape, black and white, 31 mins. Distributor: Rhapsody Films, New York.

Cleofes Vigil
Hispanic storyteller, singer
San Cristóbal, New Mexico
1984 Fellow

DISCOGRAPHY: Vigil, Cleofes. *Buenos Días, Paloma Blanca.* Taos Recording and Publications TRP122. Available through Taos Recording and Publications, Taos, N. Mex.

FILMOGRAPHY: *Cleofes Vigil, Storyteller* (forthcoming). Videotape. Director: Elizabeth Dear. Santa Fe: Museum of New Mexico.

Douglas Wallin
Appalachian ballad singer
Marshall, North Carolina
1990 Fellow

Douglas Wallin grew up in Madison County, North Carolina, a community well known throughout Appalachia for the singing of British ballads. English-ballad collector Cecil Sharp, who visited the Sodom-Laurel section of Madison County over seventy- five years ago, described it later as "a community in which singing was as common and almost as universal as speaking." Wallin, a storyteller and fiddler, learned many of his songs from his parents, relatives, and neighbors, and prides himself on his comprehensive repertoire.

BIBLIOGRAPHY: Scherman, Tony. "A Man Who Mined Musical Goals in the Southern Hills." *Smithsonian*, Apr. 1985, 173–96.

Lem Ward
Wildfowl-decoy carver, painter
Crisfield, Maryland
1983 Fellow

BIBLIOGRAPHY: Berkey, Barry, Velma Berkey, and Richard Eric Berkey. *Pioneer Decoy Carvers: A Biography of Lemuel and Stephen Ward.* Cambridge, Mass.: Tidewater Publishers, 1977.
Lawson, Glenn. *The Story of Lem Ward: As Told by Ida Ward Linton to Glenn Lawson.* West Chester, Pa.: Schiffer Publishing Ltd., 1984.
Mackey, William F., Jr. *American Bird Decoys.* New York: Dutton, 1965.

FILMOGRAPHY: *Duck Carvers*. Videotape, 30 mins. Producer, distributor: Maryland Center for Public Broadcasting, Owing Mills.

Newton Washburn
Split-ash-basket maker
Littleton, New Hampshire
1987 Fellow

Once, an amazing variety of baskets was needed by families to carry and store personal, household, and agricultural goods. Newton Washburn is the last basket maker in the Sweetser family, originally of Vermont and well known since at least 1850 for its split-ash baskets. Washburn, who learned the family's style and techniques from his mother, has passed his skills on to more than sixty apprentices.

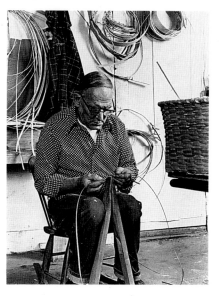

BIBLIOGRAPHY: Beck, Jane. *Always in Season: Folk Art and Traditional Culture in Vermont.* Montpelier: Vermont Council on the Arts, 1982.
Camp, Charles, ed. *Traditional Craftsmanship in America.* Washington, D.C.: National Council on the Traditional Arts, 1982.

Arthel "Doc" Watson
Appalachian guitar player, singer
Deep Gap, North Carolina
1988 Fellow

BIBLIOGRAPHY: Kochman, Marilyn, ed. *The Big Book of Bluegrass Music.* New York: William Morrow & Co., 1984.
Wilson, Charles Reagan, and William Ferris, eds. *Encyclopedia of Southern Culture.* Chapel Hill and London: The University of North Carolina Press, 1989.

DISCOGRAPHY: Watson, Doc. *Essential Doc Watson* (c. 1964). Vanguard VSD–45/46 (2LP), VCD–45/46 (2CD), CVSD–45/46 (2C)
———. *Essential Doc Watson, Vol. 2* (c. 1964). Vanguard VSD–73121 (2LP), CV–73121 (2C)
———. *Out in the Country.* Intermedia Records 5031 (LP), CQS–5031 (C). Available through Quicksilver, 8265 Sunset Blvd. #2000, Hollywood, CA 90046
———. *Red Rocking Chair* (c. 1975). Flying Fish Records 252

———. *Southbound*. Vanguard
79152 (C)
Watson, Doc, et al. *Greatest
Folksingers of the 60s* (c. 1965).
Vanguard VSD–17/18 (2LP),
VCD–17/18 (2CD), CVSD–17/18
(2C)
———. *Old Timey Concert*.
Vanguard VSD–107/8 (2LP),
CVSD–107/8 (2C)
Watson, Doc, and Merle Watson. *On
Stage*. VSD–9/10 (2LP), VCD–9/10
(CD), CVSD–9/10 (2C)

Dewey Williams
Shape-note singer
Ozark, Alabama
1983 Fellow

BIBLIOGRAPHY: Boyd, Joe Dan. "The
Sacred Harpers and Their Singing."
Festival of American Folklife
(program). Washington, D.C.:
Smithsonian Institution, 1970.
Hunt, Marjorie, and Boris Weintraub.
"Masters of Traditional Arts."
National Geographic 179:1 (Jan.
1991).

DISCOGRAPHY: Williams, Dewey.
*Wiregrass Black Sacred Harp
Singers* (1981). Alabama Traditions
no. 102 (C). Available through
Japheth Jackson, 27 Willa St., Ozark,
AL 36360

FILMOGRAPHY: *Dewey Williams*
(1980). 16mm, color, 14 mins.
Producer: Landon McCrary.
Distributor: Alabama Film Makers
Cooperative, Huntsville.

Horace "Spoons" Williams
Spoons and bones player, poet
Philadelphia, Pennsylvania
1985 Fellow

BIBLIOGRAPHY: Scheinin, Richard.
"The Rhymes and Rhythms of
Spoons Williams." *The Philadelphia
Inquirer Magazine*, Dec. 8, 1985.
"Spoon Tunes." *The Philadelphia
Inquirer*, Jan. 28, 1983.

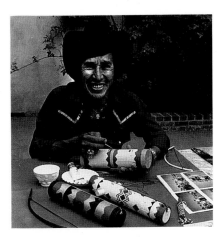

Chesley Goseyun Wilson
Apache fiddle maker
Tucson, Arizona
1989 Fellow

A Western Apache of the Eagle Clan,
Chesley Goseyun Wilson was born in
1932 on the San Carlos Reservation
in southeastern Arizona; his
grandfatherand father were both well
known among the Apache people as
musicians and violin makers. Wilson
has carried on the tradition of crafting
violins from the dried flower stalks of
the agave—or century—plant, which
are hollowed out, leaving enough stalk
at each end to support the string peg
and the tuning peg. Apache violins
have one string, traditionally of black
horsehair, like the bow; they are often
ornamented with painted and lightly
carved geometric traditional designs.
Wilson, who is also a singer, dancer,
and medicine man, is deeply
committed to the preservation of
Apache culture, and instructs young
people in the discipline of Apache
Gan dancing and singing.

Nimrod Workman
Appalachian ballad singer
Chattaroy, West Virginia
1986 Fellow

In 1910, at the age of fourteen,
Nimrod Workman took his first job in
the coal mines of his native region of
Appalachia. During the next forty-two
years, he participated in the struggle
for unionization of the miners and
experienced severe problems with
black-lung disease, all while raising a
family of eleven children; he retired
from the mines in 1952. With humor

and wit, Workman recounts the
experiences of his life through songs
and stories, a tradition into which he
feels he was born: "My race of
people, seems like they pick up
music, they can learn it, seems like
it's in 'em," he once remarked.

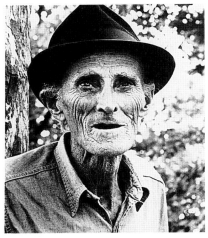

DISCOGRAPHY: Workman, Nimrod.
Mother Jones' Will. Rounder 0076
———. *Passing through the Garden*
(c. 1978). June Appal Recordings
JA0001

FILMOGRAPHY: *Dreadful Memories*.
Videotape. Johnson City, Tenn.:
Southern Appalachian Video
Ethnography Series.
Nimrod Workman. Videotape, black
and white, 48 mins. Directors: Paul
Congo, Jackie Wright. Johnson City,
Tenn.: Southern Appalachian Video
Ethnography Series.
*Nimrod Workman: To Fit My Own
Category*. 16mm, black and white,
35 mins. Directors: Scott Faulkner,
Anthony Stone. Whitesburg, Ky.:
Appalshop Films.

Emily Kau'i Zuttermeister
Hula master
Kaneohe, Hawaii
1984 Fellow

BIBLIOGRAPHY: Hunt, Marjorie, and
Boris Weintraub. "Masters of Tradi-
tional Arts." *National Geographic*
179:1 (Jan. 1991).
McKinzie, Edith. "Hawaiian Perform-
ing Arts." *Folklife Hawai'i* (festival
program). Honolulu: The State Founda-
tion on Culture and the Arts, 1990.

Etta Baker
"Piedmont blues" musician
Morganton, North Carolina

George Blake
Hupa-Yurok ceremonial regalia
and featherwork craftsman,
dugout-canoe builder
Hoopa, California

Jack Coen
Irish-American flutist
Bronx, New York

Rose Frank
Nez Perce cornhusk weaver
Sweetwater, Idaho

Eduardo Guerrero
Mexican-American singer,
guitarist, composer
Cathedral City, California

Khamvong Insixiengmai
Laotian-American singer
Fresno, California

Donald L. King
Western saddlemaker
Sheridan, Wyoming

Riley "B. B." King
African-American rhythm
and blues musician
Las Vegas, Nevada

Esther Littlefield
Tlingit beadworker, basket maker
Sitka, Alaska

Seisho "Harry" Nakasone
Sanshin (Hawaiian stringed
instrument) musician
Honolulu, Hawaii

Irvin Pérez
Isleño (Canary Island)-
American singer
Poydras, Louisiana

Morgan Sexton
Appalachian banjo musician, singer
Cornettesville, Kentucky

Nikitas Tsimouris
Tsabouna (Greek bagpipe) musician
Tarpon Springs, Florida

**Gussie Wells and
Amber Williams**
African-American quilters
Oakland, California

Melvin Wine
Appalachian fiddler
Copen, West Virginia

SELECTED BIBLIOGRAPHY

Abrahams, Roger D. *Deep Down in the Jungle: Negro Narrative Folklore from the Streets of Philadelphia*, rev. ed. Chicago: Aldine, 1970.

——. *A Singer and Her Songs: Almeda Riddle's Book of Ballads*. Baton Rouge: Louisiana State University Press, 1970.

Abrahams, Roger D., and George Foss. *Anglo-American Folksong Style*. Englewood Cliffs, N.J.: Prentice-Hall, 1968.

Ames, Kenneth L. *Beyond Necessity: Art in the Folk Tradition*. Winterthur, Del.: Winterthur Museum, 1977.

Ancelet, Barry Jean, and Elemore Morgan, Jr. *The Makers of Cajun Music: Musiciens Cadiens et Créoles*. Austin: University of Texas Press, 1984.

Anderson, Clay, Andy Leon Harney, et al. *The Craftsman in America*. Washington, D.C.: National Geographic Society, 1975.

Armstrong, Robert Plant. *The Powers of Presence: Consciousness, Myth, and the Affecting Presence*. Philadelphia: University of Pennsylvania Press, 1981.

Babcock, Barbara A. *The Pueblo Storyteller: Development of a Figurative Ceramic Tradition*. Tucson: University of Arizona Press, 1986.

Baron, Robert, and Nicholas R. Spitzer, eds. *Public Folklore*. Washington, D.C.: Smithsonian Institution Press, 1992.

Beck, Jane. *Always in Season: Folk Art and Traditional Culture in Vermont*. Montpelier: Vermont Council on the Arts, 1982.

Briggs, Charles L. *The Wood Carvers of Córdova, New Mexico: Social Dimensions of an Artistic "Revival."* Knoxville: University of Tennessee Press, 1980.

Bronner, Simon. *American Folk Art: A Guide to Sources*. New York: Garland, 1984.

——. *Chain Carvers: Old Men Crafting Meaning*. Lexington: University Press of Kentucky, 1985.

——, ed. *American Material Culture and Folklife: A Prologue and Dialogue*. Ann Arbor, Mich.: UMI Research Press, 1985.

Bronson, Bertrand. *Traditional Tunes of the Child Ballads*. 4 vols. Princeton: Princeton University Press, 1959–72.

Burrison, John A. *Brothers in Clay: The Story of Georgia Folk Pottery*. Athens: University of Georgia Press, 1983.

Cahill, Holger. *American Folk Art: The Art of the Common Man in America, 1750–1900*. New York: Museum of Modern Art, 1932.

Camp, Charles, ed. *Traditional Craftsmanship in America*. Washington, D.C.: National Council on the Traditional Arts, 1983.

Cannon, Hal. *Utah Folk Art*. Provo, Utah: Brigham Young University Press, 1980.

——, ed. *Cowboy Poetry: A Gathering*. Salt Lake City: Peregrine Smith, 1985.

Carawan, Guy and Candy. *Ain't You Got a Right to the Tree of Life? The People of Johns Island, South Carolina*. Athens: University of Georgia Press, 1988 [1966].

Cobb, Buell E., Jr. *The Sacred Harp: A Tradition and Its Music*. Athens: University of Georgia Press, 1978.

Coffin, Tristram P., and Roger deV. Renwick, eds. *The British Traditional Ballad in North America*, rev. ed. Austin: University of Texas Press, 1977.

Cohen, Norm. *Long Steel Rail: The Railroad in American Folksong*. Urbana: University of Illinois Press, 1981.

Dewhurst, C. Kurt, and Marsha McDowell. *Rainbows in the Sky: The Folk Art of Michigan in the Twentieth Century*. East Lansing: Michigan State University Press, 1978.

Ethnic Recordings in America: A Neglected Heritage. Washington, D.C.: American Folklife Center, 1982.

Evans, David. *Big Road Blues: Tradition and Creativity in the Folk Blues*. Berkeley: University of California Press, 1982.

Feintuch, Burt, ed. *The Conservation of Culture: Folklorists and the Public Sector*. Lexington: University Press of Kentucky, 1988.

Ferris, William. *Local Color: A Sense of Place in Folk Art*. New York: McGraw Hill, 1982.

——. *Afro-American Folk Art and Crafts*. Boston: G. K. Hall, 1983.

Fischer, David Hackett. *Albion's Seed: Four British Folkways in America*. Oxford: Oxford University Press, 1989.

Fitzhugh, William W., and Susan A. Kaplan. *Inua: Spirit World of the Bering Sea Eskimo*. Washington, D.C.: Smithsonian Institution Press, 1982.

Glassie, Henry. *Pattern in the Material Folk Culture of the Eastern United States*. Philadelphia: University of Pennsylvania Press, 1969.

——. "Folk Art." In Richard M. Dorson, *Folklore and Folklife: An Introduction*, pp. 253–80. Chicago: University of Chicago Press, 1972.

——. *The Spirit of Folk Art: The Girard Collection at the Museum of International Folk Art*. New York: Abrams, 1989.

Glassie, Henry, Edward D. Ives, and John F. Szwed. *Folksongs and Their Makers*. Bowling Green, Ohio: Bowling Green Popular Press, n.d.

Granger, Mary, ed. *Drums and Shadows: Survival Studies among the Georgia Coastal Negroes*. Athens: The University of Georgia Press, 1986 [1940].

Green, Archie. *Only a Miner*. Urbana: University of Illinois Press, 1972.

Griffith, James A. *Southern Arizona Folk Arts*. Tucson: University of Arizona Press, 1988.

Hammond, Joyce D. "Polynesian Women and *Tifaifai*: Fabrications of Identity." *Journal of American Folklore* 99 (1986), pp. 259–79.

———. *Tifaifai and Quilts of Polynesia*. Honolulu: University of Hawaii Press, 1986.

Hawes, Bess Lomax. "Folksongs and Function: Some Thoughts on the American Lullaby." *Journal of American Folklore* 87 (1974), pp. 140–48.

Henning, Darrell D., Marion J. Nelson, and Roger L. Welsch, eds. *Norwegian-American Woodcarving of the Upper Midwest*. Decorah, Iowa: The Norwegian-American Museum, 1978.

Hufford, Mary, Marjorie Hunt, and Steven Zeitlin. *The Grand Generation: Memory, Mastery, Legacy*. Seattle: University of Washington Press, 1987.

Jackson, Bruce. *Wake Up Dead Man: Afro-American Worksongs from Texas Prisons*. Cambridge, Mass.: Harvard University Press, 1972.

———. *Get Your Ass in the Water and Swim Like Me: Narrative Poetry from Black Oral Tradition*. Cambridge, Mass.: Harvard University Press, 1974.

Jackson, George Pullen. *White Spirituals in the Southern Uplands*. New York: Dover, 1965 [1933].

Jones, Bessie, and Bess Lomax Hawes. *Step It Down: Games, Plays, Songs, and Stories from the Afro-American Heritage*. New York: Harper and Row, 1972.

Jones, Michael Owen. *Exploring Folk Art: Twenty Years of Thought on Craft, Work, and Aesthetics*. Ann Arbor, Mich.: UMI Research Press, 1987.

Jones, Suzi. "Art by Fiat, and Other Dilemmas of Cross-Cultural Collecting." In John Michael Vlach and Simon J. Bronner, eds, *Folk Art and Art Worlds*, pp. 243–66. Ann Arbor, Mich.: UMI Research Press, 1986.

———, ed. *Webfoots and Bunch-grassers: Folk Art of the Oregon Country*. Salem: Oregon Arts Commission, 1980.

———. *The Artists behind the Work: Life Histories of Nick Charles, Sr., Frances Demientieff, Lena Sours, and Jennie Thlunaut*. Fairbanks: University of Alaska Museum, 1986.

Jones-Jackson, Patricia. *When Roots Die: Endangered Traditions on the Sea Islands*. Athens: University of Georgia Press, 1987.

Joyner, Charles. *Down by the Riverside: A South Carolina Slave Community*. Urbana: University of Illinois Press, 1984.

Keil, Charles. *Urban Blues*. Chicago: University of Chicago Press, 1966.

Laws, Malcolm G., Jr. *American Balladry from British Broadsides: A Guide for Students and Collectors of Traditional Song*. Philadelphia: American Folklore Society, 1957.

———. *Native American Balladry: A Descriptive Study and a Bibliographical Syllabus*, rev. ed. Philadelphia: American Folklore Society, 1964.

Levine, Lawrence W. *Black Culture and Black Consciousness: Afro-American Folk Thought from Slavery to Freedom*. Oxford: Oxford University Press, 1977.

Logsdon, Guy. "*The Whorehouse Bells Were Ringing,*" and Other Songs Cowboys Sing*. Urbana: University of Illinois Press, 1989.

Lomax, Alan. "Appeal for Cultural Equity." *Journal of Communication* 27 (1977), pp. 125–38.

Lomax, John A. *Cowboy Songs and Other Frontier Ballads*. New York: Sturgis and Walton, 1910.

———. *Songs of the Cattle Trail and Cow Camp*. New York: Macmillan, 1919.

Lomax, John A. and Alan. *Folk Song U.S.A.* New York: Duell, Sloan, and Pearce, 1947.

———. *Folksongs of North America*. Garden City, N.Y.: Doubleday, 1960.

Malone, Bill C. *Country Music, U.S.A.: A Fifty-Year History*. Austin: University of Texas Press, 1968.

———. *Southern Music/American Music*. Lexington: University Press of Kentucky, 1979.

Marilyn Kochman, ed. *The Big Book of Bluegrass Music*. New York: Morrow, 1984.

Martin, Lynn J., ed. *Na Paniolo o Hawai'i*. Honolulu: Honolulu Academy of Arts, 1987.

Martin, Philip. *Rosemaling in the Upper Midwest*. Mount Horeb: Wisconsin Folk Museum, 1989.

Moore, Willard B. *Circles of Tradition: Folk Arts in Minnesota*. St. Paul: University of Minnesota Art Museum and Minnesota Historical Society Press, 1989.

Nestor, Sarah, ed. *Spanish Textile Traditions of New Mexico and Colorado*. Santa Fe: Museum of New Mexico Press, 1979.

Ohrlin, Glenn. *The Hell-Bound Train: A Cowboy Songbook*. Urbana: University of Illinois Press, 1973.

Ohrn, Steven, ed. *Passing Time and Traditions: Contemporary Iowa Folk Artists*. Ames: Iowa State University Press, 1984.

Oster, Harry. *Living Country Blues*. Detroit: Folklore Associates, 1969.

Paredes, Américo. "*With His Pistol in His Hand*": A Border Ballad and Its Hero*. Austin: University of Texas Press, 1958.

———. *A Texas-Mexican Cancionero: Folksongs of the Lower Border*. Urbana: University of Illinois Press, 1976.

Parrish, Lydia. *Slave Songs of the Georgia Sea Islands*. Hatboro, Pa.: Folklore Associates, 1965 [1942].

Patterson, Daniel W. *The Shaker Spiritual*. Princeton, N.J.: Princeton University Press, 1979.

Pearson, Barry Lee. *Sounds So Good to Me: The Bluesman's Story*. Philadelphia: University of Pennsylvania Press, 1984.

———. *Virginia Piedmont Blues: The Lives and Art of Two Virginia Bluesmen*. Philadelphia: University of Pennsylvania Press, 1990.

Quimby, Ian M. G., and Scott T. Swank, eds. *Perspectives on American Folk Art*. New York: Norton, 1980.

Ramsey, Jarold, ed. *Coyote Was Going There: Indian Literature of the*

Oregon Country. Seattle: University of Washington Press, 1977.

Randolph, Vance. *Ozark Folksongs*. Ed. Norm Cohen. Urbana: University of Illinois Press, 1982.

Rinzler, Ralph, and Robert Sayers. *The Meaders Family: North Georgia Potters*. Washington, D.C.: Smithsonian Institution Press, 1980.

Rosengarten, Dale. *Row upon Row: Sea Grass Baskets of the South Carolina Lowcountry*, rev. ed. Columbia: McKissick Museum of the University of South Carolina, 1987.

Siporin, Steve, ed. *"We Came to Where We Were Supposed to Be": Folk Art of Idaho*. Boise: Idaho Commission on the Arts, 1984.

Slobin, Mark. "The Neo-*Klezmer* Movement and Euro-American Musical Revivalism." *Journal of American Folklore* 97 (1984), pp. 98–104.

Spitzer, Nicholas R. *Louisiana Folklore: A Guide to the State*. Baton Rouge: Louisiana Folklife Program, 1985.

Stearns, Marshall, and Jean Stearns. *Jazz Dance: The Story of American Vernacular Dance*. New York: Macmillan, 1968.

Steele, Thomas J. *Santos and Saints: The Religious Folk Art of Hispanic New Mexico*. Santa Fe: Ancient City Press, 1982 [1974].

Sweezy, Nancy. *Raised in Clay: The Southern Pottery Tradition*. Washington, D.C.: Smithsonian Institution Press, 1984.

Tedlock, Dennis. *The Spoken Word and the Work of Interpretation*. Philadelphia: University of Pennsylvania Press, 1983.

Teske, Robert T. "What Is Folk Art?" *El Palacio: Magazine of the Museum of New Mexico* 88 (Winter 1982–83), pp. 34–38.

———, ed. *Hmong Art: Tradition and Change*. Sheboygan, Wis.: Kohler Arts Center, 1986.

Teske, Robert T., James P. Leary, and Janet C. Gilmore, eds. *From Hardanger to Harleys: A Survey of Wisconsin Folk Art*. Sheboygan, Wis.: Kohler Arts Center, 1987.

Thompson, Robert Farris. *Flash of the Spirit: African and Afro-American Art and Philosophy*. New York: Vintage Books, 1984.

Toelken, Barre. *The Dynamics of Folklore*. Boston: Houghton Mifflin, 1979.

Toelken, Barre, and Vanessa Brown. "American Indian Powwow." In *Folklife Annual 1987*, ed. Alan Jabbour and James Hardin, pp. 46–69. Washington, D.C.: American Folklife Center, 1988.

Vidal, Teodoro. *Las Caretas de Cartó del Carnaval de Ponce*. San Juan, P.R.: Ediciones Alba, 1983.

Vlach, John Michael. *The Afro-American Tradition in Decorative Arts*. Cleveland: Cleveland Museum of Art, 1978; repr. Athens: University of Georgia Press, 1990.

———. "American Folk Art: Questions and Quandaries." *Winterthur Portfolio* 15 (1980), pp. 345–55.

———. *Charleston Blacksmith, The Work of Philip Simmons*. Athens: University of Georgia Press, 1981.

Vlach, John Michael, and Simon Bronner, eds. *Folk Art and Art Worlds*. Ann Arbor, Mich.: UMI Research Press, 1986.

White, John I. *Git Along, Little Dogies: Songs and Songmakers of the American West*. Urbana: University of Illinois Press, 1975.

Wilson, William A. "The Deeper Necessity: Folklore and the Humanities." *Journal of American Folklore* 101 (1988), pp. 156–67.

Wolfe, Charles K. *Kentucky Country: Folk and Country Music of Kentucky*. Lexington: University Press of Kentucky, 1980.

Zug, Charles G., III. *Turners and Burners: The Folk Potters of North Carolina*. Chapel Hill: University of North Carolina Press, 1986.

INDEX

255

CREDITS

All the objects depicted are from the International Folk Art Foundation Collection, Museum of International Folk Art, a unit of the Museum of New Mexico, except for those on the following pages: 2–3, Courtesy of Frank Robinson; 46–47, 100, 114–15, 136–37, Purchased with the aid of funds from the National Endowment for the Arts and the International Folk Art Foundation; 65, 140–41, Girard Foundation Collection, Museum of International Folk Art; 88, 102, 196, Museum of International Folk Art; 96, Courtesy of the National Endowment for the Arts/Folk Arts Program Collection; 97, Courtesy of the Rick Dillingham Collection; 147, Courtesy of The North American Wildfowl Art Museum of the Ward Foundation; 208, Courtesy of the U.S. Department of the Interior, Indian Arts and Crafts Board.

All color photography is the work of Michel Monteaux. The following individuals and organizations have supplied photographs of the Fellows: page 31, Jan DeWeese; 34, Country Music Foundation, Inc.; 35 above, Norman Seeff, courtesy of Columbia Records; 35 below, Barbara Batterton, courtesy of the Country Music Foundation, Inc.; 36, Courtesy of the National Council for the Traditional Arts; 38, Jeff Tinsley, courtesy of the National Council for the Traditional Arts; 41, Jack Schrader, courtesy of Dr. Thomas G. Burton; 44, Bill Boyarsky; 45, Greg Day; 49, Robert A. Haller, Staten Island Institute of Arts and Sciences; 52, Jack Mitchell, courtesy of The Ethnic Folk Arts Center; 53, Courtesy of the Office of Folklife Programs, Smithsonian Institution; 54, Lewis Koch, Wisconsin Folk Museum; 59, Philip Nusbaum, Minnesota State Arts Board; 62, Charles Briggs; 70, Jack Delano; 72, Courtesy of the National Council for the Traditional Arts; 74, © Goodwin Harding, 1979; 78, 81, Lynn Martin, The State Foundation on Culture and the Arts, Hawaii; 83, 85, Courtesy of the Office of Folklife Programs, Smithsonian Institution; 87, Dana Everts; 91, Michael Bergman, courtesy of the New Jersey State Council on the Arts; 94, Tom McCarthy; 98, Charles G. Zug, III; 103, Dr. John A. Burrison; 104, © Larry McNeil 1985; 108, © W. Lambrecht; 109, Steven Ohrn, Iowa Department of Cultural Affairs; 113, Dan Yearout, Tennessee Valley Authority; 117, Dan Smith, South Carolina State Museum; 121, Jill Scopinich; 124, Annie Archbold; 126, Dr. Maude Southwell Wahlman; 129 above and below, Agency for the Performing Arts, courtesy of the Office of Folklife Programs, Smithsonian Institution; 131, Jim Cummings, the Folklife Center of the International House of Philadelphia; 132, Arhoolie Records; 134 above, Joe Wilson; 134 below, Courtesy of the Office of Folklife Programs, Smithsonian Institution; 137, Carolyn Jones Allport, Center for Southern Folklore Archives; 139, Museum of International Folk Art; 143, Frank Robinson; 144, Patented Photos, courtesy of the National Council for the Traditional Arts; 146, The Ward Museum of Wildfowl Art, Salisbury, Md.; 152, Nancy Hunter Warren; 155, Dave Allen; 157, Dave Nauman; 160, Norman Gross, Aristocraft Photography; 161, Courtesy of the Office of Folklife Programs, Smithsonian Institution; 163, Sanford Rikoon; 165, Robert McCarl; 169, Ernie Deane, courtesy of Glenn Ohrlin; 171, Courtesy of Hugh McGraw; 173, Jeff Tinsley, courtesy of the National Council for the Traditional Arts; 177, Rose Atuk Fosdick, Institute of Alaska Native Arts; 178, Dana Everts; 181, Dexter Hodges; 183, 184, Lynn Martin, The State Foundation on Culture and the Arts, Hawaii; 188, Courtesy of Joyce Doc Tate Nevaquaya; 189, Roger Welsch; 194, Dr. Simon J. Bronner; 201, Dexter Hodges; 203, Ray Lustig, *The Washington Post*; 204, Thomas A. McGowan; 222 left, National Council for the Traditional Arts; 222 right, The United Society of Shakers, Sabbathday Lake, Maine; 223 left, *The Milwaukee Journal*; 223 center, Jeff Burkhead; 224, Luis Reyes, courtesy of the Office of Folklife Programs, Smithsonian Institution; 225 center, Jim Higgins, courtesy of the National Council for the Traditional Arts; 225 right, Courtesy of the National Council for the Traditional Arts; 226 center, Jane C. Beck, Vermont Folklife Center; 226 right, Collection of the Kansas State Historical Society; 227 left, Robert Cogswell; 227 right, Debra Reingold, *The Arizona Daily Star*; 228 left, Dexter Hodges; 228 center, Deb Wallwork; 228 right, Courtesy of the National Council for the Traditional Arts; 229 above, Martin Koenig, The Ethnic Folk Arts Center; 229 below, Philip Nusbaum, Minnesota Arts Board; 230 left, Kathy James; 230 center, © Marina Fusco, The Rosebud Agency; 230 right, Mark Regan, © 1989; 231, Blanton Owen; 232, Martin Koenig, The Ethnic Folk Arts Center; 233 left, Country Music Foundation, Inc.; 233 center, Al Rendon, Guadalupe Art Center; 234, Courtesy of Albert Luandrew; 235 left, Dexter Hodges; 235 right, Charles Tompkins; 236, Carlos Chaves, Chamisal National Monument, courtesy of the Office of Folklife Programs, Smithsonian Institution; 237, Courtesy of the Lydia Mendoza Collection, Houston Metropolitan Research Center, Houston Public Library; 238, David A. Whitman, University of Missouri Cultural Heritage Center; 239, Walter Murray Chiesa; 240 center, David Senner, The Ethnic Folk Arts Center; 240 right, 241, Carl Fleischhauer; 242 left, Courtesy of the Office of Folklife Programs, Smithsonian Institution; 242 right, Mick Maloney, courtesy of the Office of Folklife Programs, Smithsonian Institution; 243 above, Phil Samuell, courtesy of the National Council for the Traditional Arts; 243 below, George T. Nierenberg, courtesy of the Film Society of Lincoln Center; 244, Carl Fleischhauer; 245 center, Stephen M. Richmond, U.S. Department of the Interior, Indian Arts and Crafts Board; 245 right, Margot Ford McMillen, University of Missouri Cultural Heritage Center; 246, © Erik Borg; 247 center, Helen Teiwes, Arizona State Museum; 247 right, Doug Yarrow, courtesy of Appalshop.

The Museum of International Folk Art, the author, and the publisher thank all those who so generously gave permission for the reproduction of illustrations herein. Every possible effort has been made to locate the sources of the illustrations—many of which came from public files—and to obtain the proper permissions.